The Manual of Close-Up Photography

LESTER LEFKOWITZ

International Center of Photography

AMPHOTO
American Photographic Book Publishing Co., Inc.
Garden City, N.Y. 11530

ABOUT THE COVER

Upper left: Three mirrored, perpendicular surfaces meeting at a common point form a *corner cube reflector,* which has the unique property of reflecting light incident on it, from any angle, directly back to the source. This array of corner cubes, here magnified ten times, is from a 50-cent bicycle reflector. Similar arrays were placed on the moon by Apollo astronauts; they now reflect laser light beamed from earth, providing data used to measure the relative movement of the earth's continents and the exact shape of the moon's orbit around the earth to within 6 inches (15 cm) in 239,000 miles (384,622 km)! The original Ektachrome slide was shot at 1.2× with a "macro" lens, using three high-intensity reading lamps for illumination. A filament in the lower right portion of the picture is a plastic trimming, a by-product of the molding operation used to stamp out the bicycle reflector.

Lower left: A day waiting for rain provided soft illumination over a wooden chopping bowl filled with pears. The original slide, made with a normal lens and thin extension tube, encompassed the entire bowl, but exploration in the darkroom suggested this tight, life-size cropping.

Upper right: Usually discarded too soon, roses have many lives—the traditional full, healthy blossom being just one. Left to wilt, they become objects worthy of close scrutiny at approximately life-size. This white butterfly rose, four days past its prime, was softly illuminated by bouncing one light off the ceiling.

Lower right: "Double-jointed" tongues are somewhat uncommon, but fascinating to study and swollen with interest, particularly at half life-size. Judicious cropping of the slide isolated the significant component at a final magnification approaching life-size. Three electronic flash units—one under the chin, another left of the camera, and the third above the head—provided the short duration exposure necessary to freeze the movement of the peripatetic organ. A 90 mm "macro" lens provided polite separation between photographer and subject.

Library of Congress Cataloging in Publication Data

Lefkowitz, Lester.
 The manual of close-up photography.

 Includes index.
 1. Photography, Close-up. I. Title.
TR683.L44 778.3′24 79-14232

ISBN: 0-8174-2456-3 Hardbound
ISBN: 0-8174-2130-0 Softbound

Manufactured in the United States of America

ACKNOWLEDGMENTS

I wrote this book because I thought it would be helpful. If there are errors, confusions, or omissions, they are entirely my fault; please let me know what they are. The good parts come from the sum of the experiences, inputs, trials, and kindnesses in my life—photographic and otherwise—contributed by many unselfish, wonderful people. For those who have had a particular effect on this project, I would like to acknowledge my gratitude, and extend a heartfelt thanks:

To Patt Blue for her inspiration, sensitivity, and artistry.

To my parents who provided the basic foundation: high standards of performance, awareness and curiosity of the world, love of learning, excellence, and clarity.

To Bernard Friedman and Aaron Jarit of Carol Studios who—with standards and generosity that are a credit to the field—bare the responsibility for getting me started in the boundless fascination called photography.

To Professor Brian Thompson at the University of Rochester for believing in me when times were rough.

To Howard Harvey, the most inspiring—and the toughest—English teacher in the world.

To Patt Blue for her moral, and frequently physical, support.

To Cornell Capa who established the International Center of Photography in a way that has helped me and many others grow visually and humanistically.

To Mike Edelson for having faith in my teaching abilities, and pushing me into writing; and for his initiative in planting the seed for this book.

To the people at Bogen, Pentax, Spiratone, Testrite, Vivitar, and other manufacturers for their generous loan of equipment. With particular thanks to Joyce Cambell at Nikon, who was forever cheery and helpful in spite of my unreasonable requests.

To Joel Steinbach at Olden Camera for his friendly assistance and tremendous stock of everything . . . except adapter rings.

To the good people at Amphoto who made the hard parts easy, and especially to Herb Taylor who provided sound advice, little interference, and generously elastic deadlines.

To Terry Green, Kathy Wallace, Bob Reichert, Jeff Mermelstein, Mr. and Mrs. Mocquin, Mom, Baby Sarah Sachs and her parents, Sam Beale, Judy Campisi, Jim Leach, and all the other fine people who helped in countless ways with this book, and who put up with my inversion of the world to get it finished.

To Patt Blue for just being great—before, during, and after.

Lester Lefkowitz
Setauket, NY

CONTENTS

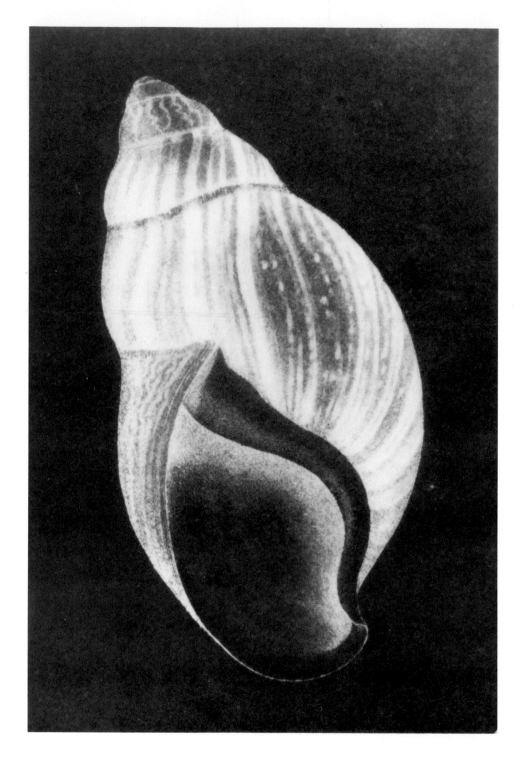

William H. Fox Talbot, an Englishman, was the inventor of the negative-positive process, patented in 1841. Many of his early images are subjects from nature, but this calotype (the name he gave to his process) of a seashell taken in the 1840s is probably the oldest known close-up photograph. It is reproduced here as a negative since no positive print is known to have been made. (*Courtesy Science Museum, London.*)

1 Introduction

The material presented here comprehensively covers the tools and techniques of close-up and macro photography,* and is intended for two groups. The first group is the nonprofessional having a general interest in, and moderate familiarity with, 35 mm photography. The second group includes a broad range of professionals, although not necessarily in photography: scientists, teachers, naturalists, artists, medical technicians, audiovisual specialists, forensic investigators, and industrial photographers.

The written information and extensive illustrations cover specific *practical* aspects, as well as some related and interesting semitechnical background. The thorough, photographer-oriented information should prove useful to anyone with a need or personal desire to accurately, reliably, and creatively record the fine detail in objects and specimens that range in size from 10 inches (25 cm) to 0.01 inch (0.25 mm).

The technical point of view throughout the book applies to the 35 mm single-lens reflex (SLR) camera. However, other than a very few specific details and the use of 35 mm equipment for the illustrations, the information presented applies equally well to larger format cameras.

Considerable attention is paid here to methods and equipment that provide optimum resolution and image quality for those whose subjects and goals require edge-to-edge sharpness. Such techniques are necessary for slide duplication; slide production and photocopying from flat artwork and books; medical, scientific, and biological photography; and similar activities. However, equal space is devoted to straightforward, uncomplicated techniques that will provide satisfactory results for close-up photography in all fields. These latter methods make use of clever applications of the camera and accessories most likely owned by, or readily available to, the moderately active amateur or small institutional facility. Quite often, the only trade-offs in the low-budget approach are a compromise in operating convenience and an increase in set-up time.

AN ASSIST FROM TECHNOLOGY

From the early days of Daguerre, cameras have been used to capture and to share a world that teases us just at the near limit of human vision. But until recently, the large view camera was a necessity for close-up photography be-cause its ground glass provided the required compositional accuracy and critical focus of the *exact* image seen by the lens.

Cameras with simple viewfinders, or with rangefinders separated from the lens, see a field

*In Chapter 2, the formal differences between the terms "close-up" and "macro" are defined. However, throughout the book, when a general reference is made to picture-taking at distances closer than the near limit of conventional lenses, the phrase "close-up photography" is used.

The boundaries to the realm of close-up photography are illustrated by these two photographs. *Below:* With the aid of an inexpensive supplementary close-up lens (see Chap. 3), the author was able to get just a bit closer to the subject than the near limit—about 24 in. (61 cm)—permitted by most normal 50 mm lenses. A black leotard on the model and an inverted printing of the negative produced the results you see here, which appear about half life-size. *Right:* Without a microscope, the magnification limit to a *photomacrograph* (a photograph that is *larger* than the *object*) is approximately 40–50 times life-size (written 40–50×). A reversed 13 mm movie camera lens on a long bellows produced a magnification of this object on the film of 30×. It's the dot above an "i" generated by the typewriter used to produce the manuscript for this book. The final enlargement shows the dot almost 100 times life-size.

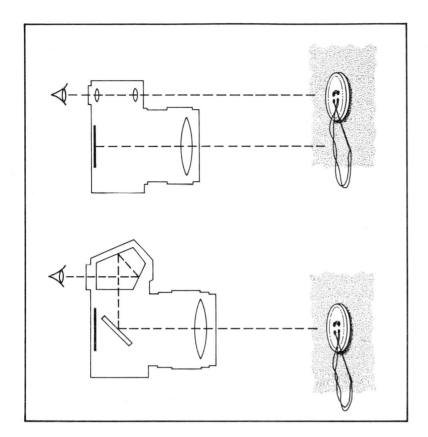
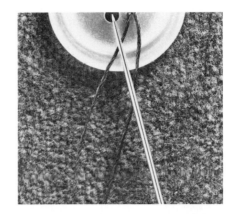
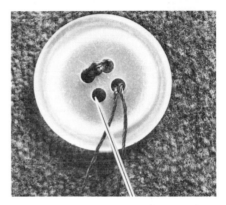

Single-lens reflex (SLR) cameras *(lower pair)* are best for close-up photography because the photographer and the film see the same field of view. Cameras with viewfinders separated from the lens *(upper pair)* will cause parallax errors when used close up—the photographer and the film see different fields of view. However, for limited use at relatively low magnification, the latter camera may be equipped with simple wire-framing devices that provide reasonably satisfactory results (see p. 48).

of view quite different from that seen by the main optic. This discrepancy, called *parallax,* kept the small camera out of close-up situations for all but simple, low-magnification pictures . . . until the invention of the single-lens reflex system. With the SLR it then became feasible for the owner of a relatively modest machine to photograph and experiment in an area heretofore restricted to the professional (see above).

The next major boost to the practicality and, therefore, to the numerical and esthetic growth of close-up photography, came from the advent of through-the-lens (TTL) metering. Prior to this boon, the SLR owner had to be fairly industrious in mastering the details of exposure correction and the uncertainties of handheld metering of diminutive subjects, both significant

factors at all but very low magnification. While many of those considerations are still important today—and a lot of space in this book is devoted to carefully explaining them—TTL metering, if used intelligently, can make life a good deal less complicated for the close-up photographer.

TTL metering had an additional salutary effect. Because it allowed for (caused) the extensive use of SLR cameras for close-up and macro work, it became economically feasible for manufacturers to introduce or expand upon a wide array of *specialized* equipment, which was intended to improve convenience, quality, and quantity.

The close-up photographer has also benefited from new equipment and design improvements intended for conventional distances,

9

but having significant applications in close-up photography. These noteworthy items from both groups are: "macro" lenses, close-focusing telephoto lenses, "macro"-zoom lenses, automatic extension tubes, automatic and semi-automatic bellows, teleconverters, and electronic flash (particularly the inexpensive cigarette-pack-size units).

Although traditional methods are still valid, new equipment and materials are rapidly elimi-nating creative and operational barriers. This book is intended to assist the serious practitioner in keeping abreast of these current advances. An endeavor has been made here to integrate the old and the new: In addition to the *standard* information and techniques that apply to distances closer than the near focusing limit of conventional lenses, all the *new* tools are discussed, with suggestions for creative as well as functional applications.

IT'S NOT THE SAME—IT'S DIFFERENT

We all come to close-up photography *after* making innumerable images of subjects ranging in size from (large) molehills to mountains. This is natural, for conventional photography matches the scope of human vision, whereas close-up work involves subjects that are easily bypassed or literally stepped upon.

In fact, over the years the trend in the development of cameras, films, and most accessories has been to make conventional photography as simple and convenient as possible. We have reached a stage today where a successful picture—at least technically, if not esthetically—may be produced by anyone with an absolute minimum of training, expending almost no effort.

But in the field of close-up photography, be advised that you cannot succeed without a modicum of work and motivation. Unstudied, offhand technique will frequently produce considerably less than adequate results, if not wholly worthless pictures. With the magnification of the image size goes an inevitable, aggravating amplification of conditions that are only minor annoyances at conventional distances. Two examples of such conditions are (1) vibration, and (2) depth of field. Vibration is a serious problem. Through the viewfinder, the slightest movement of subject, camera, or photographer appears to be an aftershock from the San Francisco earthquake. The majority of close-up photographs require a tripod or other mechanical support, and/or supplementary illumination. Depth of field (the front to back zone of sharpness enclosing the subject and defining what is and what is not in focus) is so shallow that even a *short* worm must be photographed in profile at $f/16$, if both ends are to be clearly seen.

Unless your plans include nothing more than a few not-so-close photographs of large, pretty blossoms on bright, windless days, considerable care and thought will have to accompany the extra equipment and specialized knowledge that is necessary in close-up photography. You must be patient and methodical; the assimilation of additional technical information is the easy part. If you tend toward impatience, and find "equipment" immoral, burdensome, constraining, scary, mechanically overpowering, or all of the above, stop right here. You cannot photograph the asexual reproductive process of a jellyfish or the perforations on a Moravian postage stamp with the same apparatus and the same effort used for a child's birthday party. But if you are fascinated by the infinite variety of life, shapes, and textures on the other side of a magnifying glass, and are willing to experiment—to learn in a systematic way from your photographic successes and failures—then initial rewards will become the incentives for further development of visual ideas and technical skills. A lifetime of fascination and heightened awareness in fields far beyond photography is bound to ensue.

Similarly, if your work or avocation requires the services of close-up photography, there is tremendous economic reward and substantial satisfaction in personally being able to produce the required photographs or slides, rather than farming out the project to a "professional." And not to be overlooked are the benefits of having in your hands the mechanical and compositional *control* to decide *exactly* what the final images will and will not contain and convey.

Much of our knowledge of physical and biological phenomena—fluid motion, mechanical collision, small animal locomotion, and dynamics of body systems such as vocal cords and bone joints—comes from using the indispensable camera to mitigate the limitations of the human eye. Many of us have seen Dr. Harold Edgerton's classic photograph of the coronet-like "crown" created when a milk drop splashes into a shallow dish of milk. Here the author has caught a drop just before its crash. A later point in time of the splash phenomenon (of water) is shown on p. 165. Frequently the photography, as such, for these scientific observations is the easy part; setting up the phenomenon in a manner that makes its recording feasible and triggering the camera at the "decisive moment" often take complementary mechanical and electrical skills. To trigger this picture, for example, the camera's shutter was left open in a dark room. Next, the drop was made to fall through and "break" a light beam incident on a photocell. That break started an adjustable time-delay relay, which triggered three standard cigarette-pack-size electronic flash units.

WHY SO MUCH EQUIPMENT?

A casual look through this book can convey the feeling that a depressing amount of equipment is required for close-up photography. In some ways that is true, and in others it is not. First, if you are a professional-level photographer, you are already accustomed to the fact that special equipment is required in special situations. Secondly, it all depends on what you are trying to do, what equipment you have to begin with, and how much you are willing to spend for convenience and optimum image quality. Compounding the situation is the fact that *there are a number of ways to achieve almost identical end results.*

For example, a typical "macro" lens of good quality will very conveniently produce high-quality (high resolution, good contrast, low distortion) images all the way from infinity to life-size. (Life-size means that the image on the film is exactly the same size as the subject.) You can also cover the identical magnification range at one-tenth the cost with an existing camera lens, *plus* approximately three extension tubes, two supplementary close-up lenses, and a lens reversing ring. But the image quality of the "macro" lens is definitely superior at all apertures, while the normal lens used in a close-up situation must be stopped down to $f/11$ or $f/16$ for "satisfactory"

results. However, the photograph of a flower, shell, or insect filling only the central portion of the frame will probably not suffer significantly when using the inexpensive system. On the other hand, a close-up of a painting, tapestry, biological tissue specimen, slide to be duplicated, or other flat object requires the edge-to-edge resolution of a "macro" lens.

Then, too, a fair amount of equipment is required to position and support vibration-sensitive close-up equipment. Even the moderately serious practitioner must have a sturdy, full-sized tripod, tabletop tripod, cable release, geared focusing slide, and maybe even a vertical copy stand.

Finally, the laws of optics conspire to empty our pockets and fill those of the photographic equipment industry. Even the most tentative step closer to the subject requires *something* in the way of accessories. Close-up focusing, for example, usually achieved by extending the lens a considerable distance away from the film, requires extension tubes or bellows. Alternatively, supplementary close-up lenses, teleconverters, or lens-reversing rings may be used, depending on the situation. In any case, it's all hardware. Furthermore, high magnification causes consider-

able loss of light at the film plane. That, coupled with a need to use very small *f*-stops to gain maximum depth of field, inevitably calls for some type of mechanical support for the camera *and* supplementary illumination. Again, more equipment is required, and to make matters worse, unlike conventional photography, each magnification range requires specialized apparatus and techniques if optimum results are to be achieved.

But mercifully, one can get started using an existing camera and lens with a minimum of inexpensive accessories. For more details, see Chapter 3, Supplementary Close-Up Lenses. Much of the material in this book provides alternative means of accomplishing the same end. In fact, I have tried to show ways of obtaining photographs at any desired magnification using *standard* components. The *specialized* equipment is explored as a way of achieving higher resolution, more convenience, and/or greater versatility. Numerous examples indicate the various trade-offs.

BRAND "A" VS. BRAND "B"

As a photographer, and especially as a teacher, I am continuously asked to advise on brands. My answer, frequently unsatisfying to the questioner, is that I will only recommend what I have personally used, and that there is a lot of functionally similar equipment that I have never operated that may even be better.

Everything shown or mentioned here has been used under field and laboratory conditions. The expensive equipment often functions more smoothly, and sometimes performs better than its lower-priced counterparts—no surprises there. But all the equipment mentioned in this book does the job it is supposed to do in at least a *satisfactory* manner, or it would not appear on these pages. It exemplifies the current close-up and macro hardware available from major camera manufacturers, and also accessories that are available from independent suppliers. Do not abandon your present camera and accessories because they are not the Nikon, Pentax, or Vivitar brand I used. Almost all major manufacturers have similar close-up accessories made to fit their own cameras. And the independents, like Vivitar, Spiratone, Bogen, Novoflex, Tiffen, and Testrite, have accessories for all cameras.

Do not rush out and buy every item you see here. The field photographer may never use a copy stand; the person doing close-up photocopying may never need a tripod; and the mammalian zoologist may never use lenses with focal lengths shorter than 200 mm. Nothing is more satisfying than finally obtaining a longed-for piece of equipment after a compelling need was established by some unfortunate first-hand experience.

A bit of advice about camera stores: Many will indicate that a particular item is not made . . . if they don't happen to stock it. Try writing to the manufacturer; ask for a catalog, price sheet, and list of distributors, and then find a store that will place a special order based on *your* selection. Appendix A contains the names and addresses of every manufacturer and supplier cited in this book. Many, where noted, even sell direct via mail order.

CREATIVITY

Because the subject matter of close-up photography is often overtly clinical, prosaic, or uninspiring, little thought is given to creating an image that goes beyond the clear presentation of subject matter. A photograph of a bullet for forensic analysis should be clear, simple, and straightforward. The picture of a microcircuit requested by an electrical engineer to assist him in routing wires must be shadowless, artistically bland, and squarely framed. And the slide of a small graph for a sales meeting, or one of a daguerreotype for an art history lecture, must be lineal and unadorned.

However, the photographic skills traditionally relegated to the scientific or documentation laboratory can be used to create images that possess—and communicate—qualities of feeling, beauty, mystery, dynamics, emotion, or excite-

light, and form. That portion of human development evolves from the total of all our experiences, and blossoms if one is truly committed to an awareness of every facet of life. But by exposing oneself to creative work in all fields, and constantly striving to improve and expand upon what has been done in the past, the road can only lead to self-satisfaction and accolades.

If you are going to show your work, you have an obligation to make it not only technically correct, but visually interesting. Whether for advertising, documentation, or personal interest, if the boundary conditions of "the job" permit even the slightest creative leeway, you must make the end product more than just another banal shot of whatever it is that's in front of the lens.

You can see this approach, for example, in the catalogs and postcards produced by a sensitive museum photographer. Not only do they show the pertinent detail of the artifact in question, but the lighting, camera angle, and background are chosen to enhance the beauty of the piece, clearly define its structure and craftsmanship, and generate awe and excitment in the viewer. Unfortunately such creativity is the exception rather than the rule, and most artifacts are photographed in such a way that, visually, they are on a level with unimaginative newspaper ads.

I would like to recommend a few working procedures and pedagogic techniques that should greatly increase the efficiency and ease with which the mechanics of close-up photography are mastered.

The first of these involves the need for careful tests. I would like to think that the material presented in this book is so clear and understandable that photographic success is guaranteed on the first try. Assuming I am a competent, knowledgeable writer and you are a bright dexterous photographer, the problems that inevitably plague us must then be the consequences of Murphy's first law, which states that whatever can go wrong, will! But whatever the source of the problem, initial results will not always be satisfactory.

Tests that check the feasibility of a particular combination of optics, or zero in on the tricky exposure problems inherent in the photography of minuscule objects, will work out the bugs under friendly, noncritical conditions. Then later, with the strong conviction of experience in one hand and the results of your tests as insurance in the other, you can concentrate on the *subject matter,* confident that the technical gremlins have been routed.

In addition to making tests, it's a good idea to record *all* information in a small, easy-to-carry notebook. First, just the process of writing down the parameters and variables of exposure, equipment choice, magnification, illumination, film type, and pertinent accessories has the power to intimidate the photographer into being a bit more methodical with the tests. Secondly, the results of a test, or even actual picture-taking

sessions, are extremely difficult to interpret without such written help. The one good exposure or sharp image on a roll of film may forever be an enigma if the corresponding mechanical, optical, and exposure data is left unrecorded.

Tests can be less burdensome if results from them are quickly available. Photographers having medium and large format cameras that accept Polaroid backs know the security and efficiency inherent in instant feedback. With 35 mm cameras, other routes are necessary. If you are confronted by a worrisome project, such as a high-magnification situation with tricky lighting or new equipment, and if time, subject, and location permit, expose a test roll on black-and-white film, leave all the equipment and the subject in place, and immediately develop the film. In this situation, having a studio with a nearby darkroom is an asset; but if a good deal of your photography is done at home, the kitchen sink serves well for developing a quick test roll. The entire procedure takes less than 30 minutes, and only requires a small, inexpensive, daylight developing tank, thermometer, a few chemicals, and a light-tight changing bag.

The film need not even be carefully washed or dried when performing a test. With a $5\times$ to $10\times$ magnifying loupe you can check the negatives for proper exposure and focus, adequate depth of field, appropriate illumination, and any unsharpness caused by subject motion. For color-slide photography, a local lab that will process transparencies within 24 hours is not always available. Here, too, black-and-white film can be used for the tests; then the exposure data can be extrapolated to the ASA rating of the color mate-

An array of ferocious-looking dental drills has been used to illustrate two methods of generating large images of small objects. *Left:* A photo taken on Plus-X film at the near limit—24 in. (60 cm)—of a good-quality 50 mm conventional lens. With the entire array only 1³/₁₆ in. (30 mm) across, its image on the negative was just 0.12 in. (3 mm), which therefore required a $35\times$ enlargement to produce this photograph. Delineation of detail is poor due to enlarging the negative beyond the resolution capabilities of the film/lens combination, a situation called *empty magnification. Right:* A "macro" lens permitted the photographer to get much closer to the subject and to fill the entire film frame with the image. Therefore, only a $4\times$ enlargement of the negative was necessary to produce the print. Here, grain is insignificant and sharpness is excellent.

rial. See p. 239 in Chapter 10, Exposure, for further discussion on exposure tests.

While infinite scope for experimentation is one of the most attractive aspects in the field of close-up photography, and fiddling with new approaches and techniques is one of the best ways to develop skill and stimulate creative ideas, one must resist the temptation to try *everything* at once. As mentioned earlier, there are numerous ways to achieve identical results. It is recommended that you use *one* method at a time, become comfortable and confident with it, then do some tests with a second approach. Loading up with lots of equipment in one trip to the store, and then attempting in a single week to use it all successfully in 12 different ways is the quickest way I know of to become disenchanted with this field. A methodical approach is best.

ISN'T THERE ANOTHER WAY?

People often ask if it wouldn't be just as easy to photograph a very small object with a camera and normal lens set as close as they will conventionally focus, and then greatly enlarge the negative and crop out the extraneous portions. If lenses and film had higher resolution than they do, and if films were grainless, to *some* degree you could. (Of course with color slides for projection, such a procedure is impractical since cropping must be done in the camera.)

However, there is a law of physics called *diffraction* (see Appendix C) that ultimately limits the resolution capabilities of even a "perfect" lens, and thereby governs the degree of *useful* enlargement of a negative or slide. Beyond that useful magnification limit, big enlargements do produce prints with decidedly larger images, but without any more clarity or information in the fine detail of the subject—a situation called *empty magnification*.

The illustration below graphically compares the appearance of high magnification *on the film* with high magnification obtained by enormously enlarging a small portion of a negative containing a *low* magnification image. The results are very interesting.

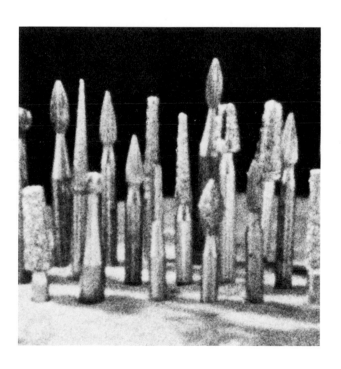
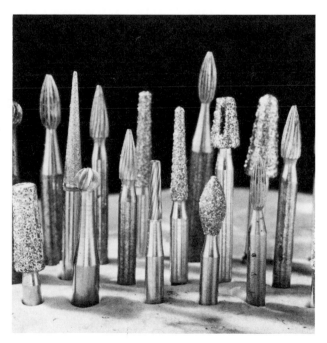

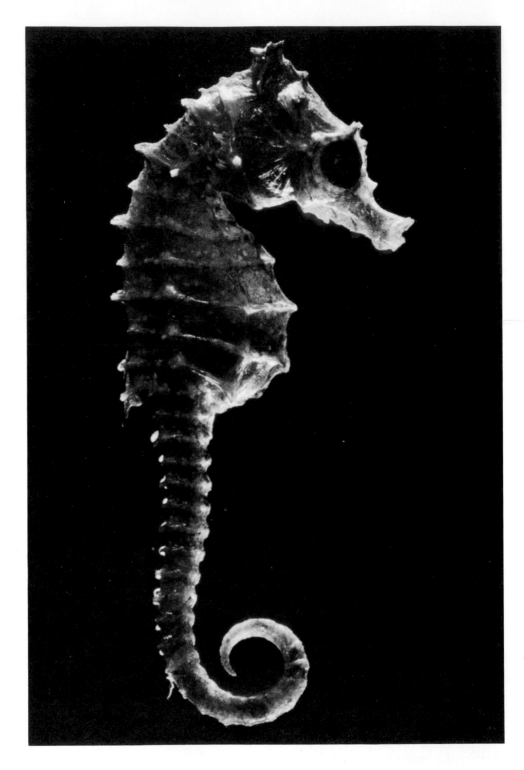

Without some familiar visual reference or written information, the size of uncommon subjects may be a puzzlement. For scientific illustration, such ambiguity is inappropriate; at other times, it might provide an additional fillip. The picture on p. 20 quickly dissipates uncertainties as to the size of the seahorse. Within this chapter, information is provided on procedures for determining *magnification*.

2 Preliminaries

Close-up photography is somewhat like having a girlfriend or boyfriend. If you just want to get a *little closer,* there are usually no serious obstacles, and you can proceed without any formal rules, regulations, or even a very sophisticated technique. As you approach *ever closer,* the need becomes greater for more understanding of the subject and the principles involved. Finally, when you are *extremely close,* all visual and physical sensations become very exciting and highly magnified. With ever-increasing energy expended in the pursuit of the prized specimen, the inclination to permanently capture the subject becomes almost overwhelming. First-time practitioners may have some difficulties, generally in relation to how close they want to get. But those initial difficulties quickly give way to tangible success and even to boastful professionalism, as fascination with the new experience becomes the incentive for continued perseverance.

So in preparing to embrace the subject, one must learn some of the terminology of the field, and develop an understanding of the basic principles involved. Equipment selection, approach to subject matter, and even the esthetics of close-up photography require an understanding of what is formally meant by *magnification, depth of field,* and *focal length.* And whether one uses an inexpensive close-up lens or a sophisticated bellows, specific techniques for focusing and stabilizing the camera are common to all close-up situations.

MAGNIFICATION

A common query from the novice of close-up photography is, "How close can I get with a particular piece of equipment?" It is a fair question because in conventional picture taking we have developed an intuitive sense for the approximate size of everyday images on the film as a function of our distance from the subject.

In close-up photography, however, the distance between the front of the lens and the subject—called the *working distance,* **W** —is only a few inches, and a very small change in that distance produces extreme changes in the amount of subject seen by the camera, and in the size of the image on the film. For example, a 55 mm "macro" lens produces an image on film that is half life-size (i.e., the image is half as big as the actual subject) when the front of the lens is 4¼ inches (11 cm) from the subject. (A 25-cent piece fills about half the frame at that distance.) By moving only 2 inches (5 cm) closer, an image *twice as large,* or full life-size, is produced. (The quarter now fills the frame.)

Furthermore, a telephoto lens that focuses to 6 inches (15 cm) will produce considerably more magnification than a normal lens focused at the same distance. So "how close" is somewhat misleading.

What *is* of concern to the close-up photographer is the *magnification,* **m,** which relates the size of the *image* on the film to the *actual size of the object.* Throughout this book and in many picture-taking situations, a knowledge of at least the approximate magnification is necessary for (1) selection of appropriate equipment and attachments, (2) exposure correction, (3) techniques that optimize sharpness, and (4) determi-

Unlike the photo on p. 18, a sense of scale has been provided by the hand. The print at right presents the subject at life-size, whereas the image on p. 18 shows this unusual fish—covered with thin, bony plates and swimming with much difficulty in an upright position—at 12 times its actual length of ½ in. (13 mm). Unlike most seahorses, which are 2–8 in. (75–200 mm) long, this miniature variety is found only off the west coast of Mexico. Seahorses (and pipefishes) are unique: Their breeding habits find the female forcing her eggs into the male's pouch, where the eggs are fertilized and gestate until birth.

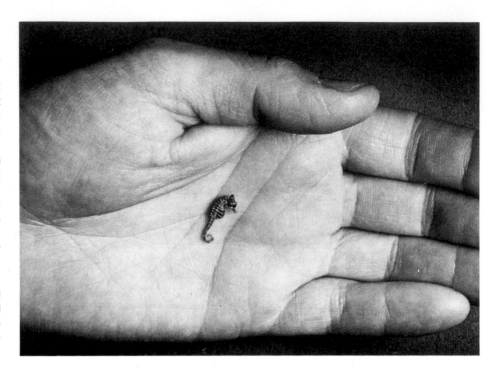

nation of available working distance.

For example, to photograph an ant that might be ½ inch (13 mm) in length, one could choose attachments that provide about three times ($3\times$) magnification. The ant would then impressively fill the entire 1½ (36 mm)-inch-wide frame of a 35 mm camera. To say that the lens is about 1 inch (44 mm) from the subject is much less meaningful.

Another need to know magnification, as will be seen later, is that when taking extreme close-up photographs, it is almost impossible to focus by rotating the lens barrel in the conventional way. Instead, the close-up camera/lens/accessory combination is assembled to provide a particular magnification or range of magnifications, and that entire system, or the subject, is moved forward or backward until the subject is in focus in the viewfinder.

Finally many objects in the realm of close-up photography are fascinatingly unfamiliar and are photographed against plain or ambiguous backgrounds; therefore, no sense of scale is present in the final picture. Yet photographers are often asked, "How big was that bug, bud, worm, wart, fish, feather, pebble, pit, newt, or nubbin?" And, if the pictures of those objects are for scientific or commercial purposes, the photographer, as a matter of course, must indicate to the client or audience the actual magnification figures.

Very simply *magnification is the ratio of the image size to the actual size of the object* being photographed. In this book, we will be concerned primarily with the image size on *film,* and that ratio of film image size to object size is designated as **m**. If the *final magnification* of a print or projected slide is discussed, **M** is the symbol used. Both ratios are found simply by dividing:

$$m = \frac{\text{Image Size on Film}}{\text{Object Size}}$$

$$M = \frac{\text{Image Size on Final Print}}{\text{Object Size}}$$

In this book and in other writings, the term *reproduction ratio* or *image ratio* is frequently used instead of, or interchangeably with, "magnification."

Image Ratio =
Image Size on Film:Object Size

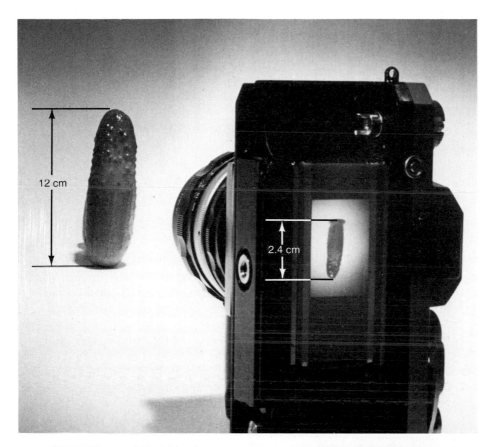

Left: A screen in the camera's film guides allows us to see the *image* of the pickle produced by the lens. On the negative (*below*), the *image* is 1 in. (2.4 cm) long. Since the original dill gherkin was 5 in. (12 cm), the magnification on film, **m**, is 1 in. ÷ 5 in. (2.4 cm ÷ 12 cm), or **m** = 0.2×; and 1:5 as a ratio.

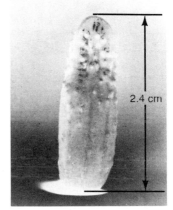

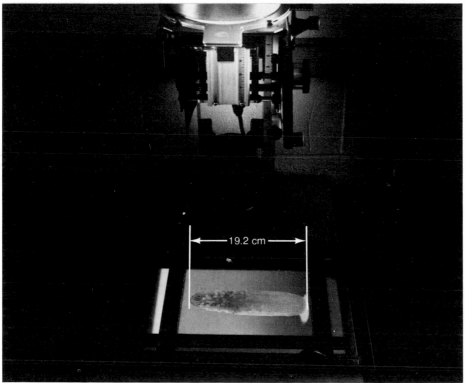

Left: The negative above can be enlarged to any desired size. As it hangs on my wall (*below*), the pickle portion of the picture is 7½ in. (19.2 cm) long. Therefore, the *final magnification*, **M**, is 7½ in. ÷ 5 in. (19.2 cm ÷ 12 cm), or **M** = 1.5×. As a ratio, it is 1.5:1.

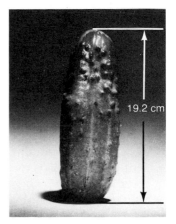

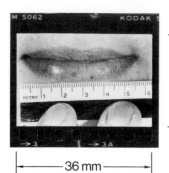
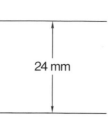

24 mm

36 mm

The following three examples illustrate the concept of magnification:

1. *"Large" objects.* A smile measures, let's say, 2¼ inches (63 mm) from left to right. If it were to be photographed with a close-up lens that allowed the *image* to just fill the long dimension of a 35 mm frame — that is 1″ × 1½″ (24 × 36 mm)—then:

$$m = \frac{36 \text{ mm}}{63 \text{ mm}} = 0.57, \text{ written } 0.57\times,$$

or about half life-size. The symbol "×" stands for "times magnification."

Reproduction ratios are written for convenience so that the *image* is "1" when images are *smaller* than life-size, and the *object* is "1" when the *image* is *greater* than life-size. Therefore, from the smile mentioned above,

m = Film Image Size:Object Size
m = 36 mm:63 mm
m = 1:1.8 (63 divided by 36).

Note, then, that a magnification of $0.57\times$ is the same as an image reproduction ratio of 1:1.8. This latter ratio, to further complicate things, is sometimes found written as a fraction, 1/1.8, in this case.

2. *"Medium" objects.* If a quarter that is 24 mm (almost exactly 1 inch) in diameter is photographed in such a manner that it just fills the 35 mm frame (which, again, is 24 × 36 mm),

$$m = \frac{24 \text{ mm}}{24 \text{ mm}} = 1\times, \text{ or}$$

m = 24 mm:24 mm = 1:1

This is exactly a 1:1, or 1×, or life-size-image ratio as shown in the accompanying illustration.

3. *"Small" objects.* Photographing a grain of rice that is 6 mm (about ¼ inch) long, so that it appears 30 mm (1¼ inch) long as measured on the negative, produces:

$$m = \frac{30 \text{ mm}}{6 \text{ mm}} = 5\times, \text{ or}$$

m = 30 mm:6 mm = 5:1.

Since the *image* is now five times *larger* than life, the image ratio is written 5:1 (30 divided by 6).

Magnification, m, can simply be determined by temporarily placing in the scene a facsimile of a ruler. Since the film (and viewfinder) size is known—1″ × 1½″ (24 × 36 mm)—and is constant, a simple division of 36 mm by the amount of ruler showing (in millimeters) across the long dimension in the viewfinder quickly produces m. (Many camera viewfinders do not show the entire 24 × 36 mm format, but rather about 5–10 percent less to allow for slight cropping by slide mounts. Such an error in the final calculation is seldom significant.)

The actual division of the amount of the ruler showing into 36 has been done for you in the accompanying figure. For other film formats, divide the ruler image into the appropriate dimensions: e.g., for a 2½-inch square (60 × 60 mm) format, divide *millimeters* showing into 60.

Facing page: The smile (left) was photographed such that its image fills the frame width. That entire frame is reproduced here life-size, with the ruler showing 63 mm. Since the "35 mm" frame (35 mm refers to the outside width of the film stock) has an image area 24 × 36 mm, the magnification on film, m, is found by dividing 36 mm (image size) by 63 mm (object size), or $m = 0.57×$ (1:1.8). The image of the 24 mm diameter coin and 24 mm of the ruler alongside of it (center) just fills the 24 mm frame height. Therefore, the image and the object sizes are identical, and $m = (24\text{ mm} \div 24\text{ mm}) = 1×$ (1:1). A millimeter rule placed next to the rice (right) shows a grain 6 mm long. Measuring its image on the film yields 30 mm, so that $m = (30\text{ mm} \div 6\text{ mm}) = 5×$ (5:1), all before cooking.

Though any ruler can serve to determine magnification data (described above) the scale at right eliminates the need for any arithmetic. Use an office copier to make a facsimile of this scale (be certain the machine doesn't "reduce" a bit; some do). Placing it alongside the subject so that its length fills the long dimension of the viewfinder of a 35 mm camera provides instant magnification. (Do not use this with other formats; see text.) It also indicates exposure correction in terms of time (E.I.F.) and "stops" for cameras without through-the-lens meters (see p. 72). At right we see an area 10 cm long, at a magnification of slightly over 0.4× (1:2.5). Few people have a double crease in their elbow.

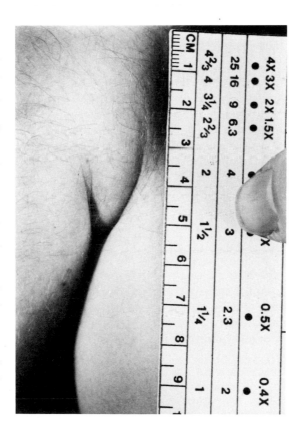

	MAG.	E.I.F.	STOPS
4X 3X 2X 1.5X · 25 16 9 6.3 · 4⅔ 4 3¼ 2⅔	1X	4	2
	0.7X	3	1½
	0.5X	2.3	1¼
	0.4X	2	1
	0.3X	1.7	¾
	0.25X	1.6	⅔

THE NEAR LIMIT OF CONVENTIONAL PHOTOGRAPHY

Almost all standard lenses for modern 35 mm cameras, regardless of focal length, have a near focusing limit that produces a maximum magnification of about one-tenth to one-eighth life-size, i.e., 0.10× (1:10) to 0.13× (1:8). For 28 and 35 mm wide-angle lenses, that corresponds to a working distance, W, of about 1 foot (30 cm). For the normal 50 mm lens,* W is approximately 2 feet (61 cm), as shown in the illustration on p. 42. Moderate telephoto lenses,

*A 50 mm lens on a 35 mm camera is considered "normal" because it provides pictures that approximate the primary angle of view seen by the human eye.

100–135 mm, leave about 4 feet (122 cm) of working space in front of the lens when they are focused at their near limit.

The reasons for this limit are: (1) additional complication and cost in building a focusing mount that allows the lens to extend very far from the film (a necessity for close-up focusing); (2) lens aberrations (degradation in image sharpness and contrast) appear when a lens designed for normal photography—approximately 3 feet (1 m) to infinity—is used for close-up work; and (3) loss of light intensity on the film when a lens is extended far from the film for close focusing.

Special equipment and techniques permit circumvention or conquest of these problems; and to a substantial degree, that is what this book is about. The myriad of fine photographs proves that difficulties are easily overcome.

THE THREE MAGNIFICATION RANGES OF CLOSE-UP AND MACRO PHOTOGRAPHY

Three basic magnification ranges have been defined for this field of photography: (1) close-up, (2) extreme close-up, and (3) macro. The boundaries of each range are somewhat arbitrary and vague, but generally, each range encompasses a unified level of sophistication in equipment and technique, and each implies a need for progressively more patience in handling the subject matter.

The Close-Up Range

Pictures taken closer, and therefore with more magnification than the near limit of conventional lenses ($m = 0.1\times$, approximately), are defined as being in the *close-up* range . . . up to a magnification of one-half life-size, i.e., $0.5\times$ (1:2). For noncritical work, little more than a tripod or flash, a few inexpensive supplementary close-up lenses, and/or small extension tubes are required; so is a modicum of care. Chapter 3, Supplementary Close-Up Lenses, and Chapter 4, Extension Tubes and Bellows, will further delve into these subjects.

The Extreme Close-Up Range

When the image size on the film approaches the actual size of the object itself—between half and full life-size ($0.5\times$–$1\times$, or 1:2 to 1:1)—one is working in the *extreme close-up* realm. The size of common subject matter found here would be such that its fine details would be examined visually with a conventional magnifying glass. Equipment required for such magnification includes long extension tubes, bellows, or special "macro" lenses. Problems with focusing, depth of field, and vibration begin to require considerable care.

The Macro Range

Once the *image* on the film becomes *larger than the object* itself, one has formally entered the *macro* range. The Greek *makros* means "large," and above a ratio of 1:1 ($1\times$), pictures are indeed larger than life. (It is interesting to note that so-called "macro" lenses from reputable manufacturers have special focusing mounts designed to permit photography in the *close-up* and *extreme close-up* ranges, yet they are termed "macro" lenses. Some do just reach $1\times$.) With existing equipment, which includes conventional lenses used in reverse, teleconverters, true macro lenses, and long bellows, images up to about 35 times life-size, i.e., $35\times$ (35:1), are the upper limit of *photomacrography*.

For greater magnification, a microscope is necessary, and the process of taking pictures through one is called *photomicrography*. A number of adapters are made that permit 35 mm cameras with removable lenses to be used on standard microscopes, but such technique is beyond the scope of this book. If not available directly from your camera manufacturer, microscope adapters, for most cameras, can be obtained from Edmund Scientific Company and Vivitar. See Appendix A for the addresses of these companies.

Each photograph represents one magnification range in close-up photography. *Upper left:* Without accessories, normal 50 mm lenses will focus to about 24 in. (61 cm) and produce a magnification on film of 0.1× (1:10). *Upper right:* A supplementary close-up lens attachment brought magnification on film into the *close-up* range, **m** = 0.2× (1:5). *Lower left:* A "macro" lens made this photograph in the *extreme close-up* range. Here **m** = 0.9× (1:1.1), almost life-size. *Lower right:* **m** = 2.5× (2.5:1), well into the true *macro* realm, via a bellows.

IMAGE QUALITY CONSIDERATIONS

We take for granted the phenomenal image sharpness and clarity in the average nonclose-up photograph. With very little concern for technique, all 5 feet (1.5 m) of Aunt Sadie, or even the entire mountain called Rushmore can be squeezed onto a postage-stamp-size chip of film, then enlarged to almost any dimension, with every detail distinctly delineated.

Unfortunately, the optical and physical facts of close-up life are such that if we bring to close-up photography the same optical expectations and extemporaneous technique we have thrived on in conventional photography, results will be appreciably less than satisfactory.

You will find, in fact, that focusing is extremely critical and painstaking; depth of field is frustratingly small, and it dwindles almost into nonexistence as magnification increases; and camera and subject steadiness is a never-ending battle.

DEPTH OF FIELD

From general photographic experience we know that for some distance in front of, and for some distance behind the point of focus, the image is acceptably sharp. This zone of adequately clear focus surrounding the object focused upon is called the *depth of field*. The decline in sharpness is gradual on either side of the exact plane of focus, and no specific location exists where the picture goes from sharp to fuzzy. The illustrations overleaf demonstrate this concept.

For a typical photograph taken outdoors with a 50 mm lens at *f*/4, with the subject 10 feet (3 m) away, the depth of field is a full 3 feet (0.9 m). Anything within that zone will be rendered quite sharply. But put that identical lens, still set at the *same* aperture, on extension tubes so that it can focus at 1× (1:1)—about 2 inches (5 cm) from the subject—and the depth of field is only one sixty-fourth of an inch (0.4 mm). This is not a far-fetched possibility since these are the conditions you might encounter photographing an insect in the dark woods with a handheld camera.

So depth of field, what little there is, is of great concern to the close-up photographer. The accompanying table indicates the depth of field at various image ratios (magnifications) as a function of aperture. The unfortunately shallow depth of field is all too obvious, and this can lead to unsharp picture areas when the object has a relatively large amount of three-dimensional depth.

Whether for conventional or close-up photography, the *amount of depth of field is determined by aperture and by image magnification. The smaller the aperture* (the higher the *f*-number) *the greater the depth of field.* Therefore, unless some special effect is desired, as on p. 29, use small apertures such as *f*/8, *f*/11, and *f*/16 whenever possible.*

Lack of a tripod and a low level of available light required the photograph at left to be made handheld at 1/125 sec. at *f*/4. Shallow depth of field is all too obvious, as is some unsharpness caused by too slow a shutter speed for the relatively high **m** of 1× (1:1). Electronic flash enabled the image at right to be recorded at *f*/16, providing four times the depth of field, with an effective, motion-stopping exposure time—due to the short flash duration—of 1/1000 sec. Plant is a golden ball cactus (Echinocactus).

*At very high magnifications, usually greater than 0.5×, apertures of *f*/16 and smaller will actually give *poorer* results due to a light propagation phenomenon called diffraction. If you plan to work in a range that high, check Appendix C and p. 84.

Table 2-1
CLOSE-UP DEPTH OF FIELD FOR 35 mm CAMERAS*

Magnification on Film, m	Field of View (in.)	(mm)	Total Depth of Field at: † f/2 (in.)	(mm)	f/4 (in.)	(mm)	f/8 (in.)	(mm)	f/16 (in.)	(mm)	f/32 (in.)	(mm)
0.10× (1:10.0)	9½ × 14⅛	240 × 360	½	13.0	1	26.0	2	52.0	4³⁄₁₆	106.0	8¹⁵⁄₁₆	211.0
0.15× (1:6.7)	6¼ × 9½	160 × 240	¼	6.1	½	12.0	1	24.0	2	49.0	3⅞	98.0
0.20× (1:5.0)	4¾ × 7⅛	120 × 180	⁵⁄₃₂	3.6	¼	7.2	⁹⁄₁₆	14.0	1⅛	29.0	2¼	58.0
0.25× (1:4.0)	3¾ × 5⅝	96 × 144	³⁄₃₂	2.4	³⁄₁₆	4.8	⅜	9.6	¾	19.0	1½	38.0
0.33× (1:3.0)	2⅞ × 4¼	73 × 109	¹⁄₁₆	1.47	⅛	2.9	¼	5.9	½	12.0	¹⁵⁄₁₆	23.0
0.50× (1:2.0)	1⅞ × 2⅞	48 × 72	¹⁄₃₂	0.72	¹⁄₁₆	1.44	⅛	2.9	¼	5.8	⁷⁄₁₆	11.0
0.75× (1:1.3)	1¼ × 1⅞	32 × 48	¹⁄₆₄	0.37	¹⁄₃₂	0.72	¹⁄₁₆	1.50	⅛	2.98	¼	6.0
1.0× (1:1.0)	1 × 1½	24 × 36	0.009	0.24	¹⁄₆₄	0.48	¹⁄₃₂	0.96	¹⁄₁₆	1.92	⁵⁄₃₂	3.8
1.5× (1:1.5)	⅝ × 1	16 × 24	0.005	0.13	0.010	0.26	0.164	0.53	³⁄₆₄	1.07	³⁄₃₂	2.13
2.0× (2:1.0)	½ × ¾	12 × 18	0.003	0.090	0.007	0.18	0.014	0.36	¹⁄₃₂	0.72	¹⁄₁₆	1.44
3.0× (3:1.0)	⁵⁄₁₆ × ½	8 × 12	0.002	0.053	0.004	0.11	0.008	0.21	¹⁄₆₄	0.43	¹⁄₃₂	0.85
5.0× (5:1.0)	³⁄₁₆ × ⁵⁄₁₆	4.8 × 7.2	0.001	0.029	0.002	0.058	0.005	0.12	0.009	0.23	¹⁄₆₄	0.46
10× (10:1.0)	³⁄₃₂ × ⅛	2.4 × 3.6	0.0005	0.0132	0.001	0.0264	0.002	0.052	0.004	0.106	0.008	0.21
20× (20:1.0)	0.05 × 0.07	1.2 × 1.8	0.0002	0.0063	0.0005	0.0126	0.001	0.025	0.002	0.050	0.004	0.10
30× (30:1.0)	0.03 × 0.05	0.8 × 1.2	0.0001	0.0041	0.0003	0.0082	0.0007	0.017	0.001	0.033	0.003	0.066

*Data are for *symmetrical* lenses of *any* focal length and for **m** obtained by lens extension, including "macro" lenses. For asymmetrical lenses (most SLR wide-angle, telephoto, and "fast" normal lenses), see Appendix B. See Table 3-1, p. 44, for corresponding values with supplementary close-up and "macro"-zoom lenses.

†A. Depth of field is about equally divided on either side of plane of focus.
B. f-stops indicated are those actually marked on lens aperture ring; effects of lens extension on effective aperture at the film plane have been incorporated into these depth-of-field values.
C. Data are based on a 0.03 mm (0.012 in.) circle of confusion.
D. To get depth of field at f/2.8, f/5.6, f/11, and f/22, multiply the depth of field at the next lower f-stop by 1.4.
E. Shaded portion indicates combinations of aperture and **m** where diffraction effects can cause serious loss of resolution of fine detail (see p. 84 and Appendix C).

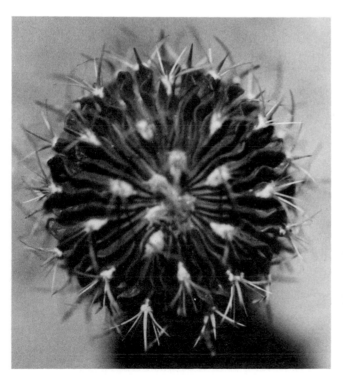
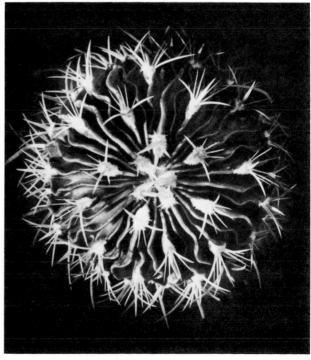

 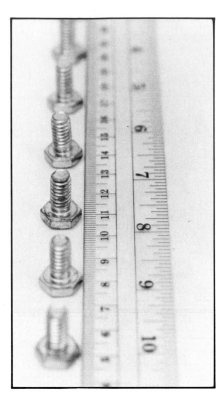 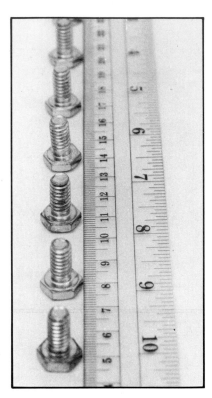

Depth of field increases as aperture is decreased (*f*-number increased). From left to right, apertures were *f*/2.8, *f*/5.6, and *f*/16, respectively. These examples, all shot at **m** = 0.25× (1:4) and focused on the 11-cm mark, show that it is difficult to say exactly where depth of field begins and where it ends. The subjective nature of depth-of-field tables and scales can be realized by holding this page various distances from your eyes. Also, by comparing the images exposed at *f*/2.8 and *f*/5.6, one can see that, as stated in the text, when close up, depth of field does indeed *double* with each *two*-stop decrease in aperture diameter.

In close-up photography, depth of field doubles every time the aperture is closed down two stops.

Also *depth of field decreases as magnification increases*—the bane of every photomacrographer! The accompanying illustration and the table on p. 27 clearly show this problem.

Optimizing Depth of Field

At magnifications above 0.1× (1:10), depth of field is about equally divided on either side of the specific plane focused upon. Therefore, for maximum depth of field, focus halfway between the nearest and farthest part of the subject. (This is contrary to the rule for normal photographic distances, where the depth of field is one-third in front of, and two-thirds behind, the subject focused upon.) However, with subjects having dimensions that exceed the available depth of field, even at the smallest apertures—a fairly common occurrence in the field of photomacrography—focusing "in the middle" will not do the trick. It is usually better, at least esthetically if not scientifically, to adjust the point of focus so that at least all the important *foreground* detail, rather than background, is in focus.

When the depth of field is very shallow, try to position the subject or the camera so that all of its important parts fall in a plane parallel to the film. This can be a tremendous help in using whatever depth of field is available; and it is ex-

 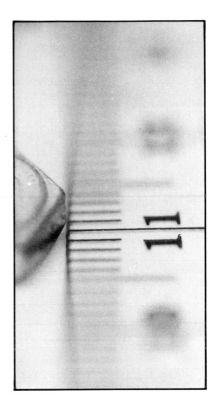

Depth of field decreases drastically with increasing magnification, as can be seen from these pictures, all taken at f/5.6. From left to right, magnification on film was **m** = 0.12× (1:8), the near limit of most normal lenses; **m** = 0.25× (1:4); and **m** = 1× (1:1). Going from one-quarter (1:4) to full (1:1) life-size decreases the depth of field by a factor of 10! It is also fairly clear that the depth of field is about equally divided on each side of the point of focus (the 11-cm mark), a situation unlike that found at conventional distances where total depth is usually estimated to be one-third in front of and two-thirds behind the plane of focus.

Maximum possible depth of field may not always be in order, at least when considering esthetic and visual impact. The photograph taken at **m** = 1× (1:1) and f/22 (*left*) shows one front leg of a 2-lb (1-kg) land turtle (tortoise). The picture has good overall sharpness, because the front-to-back dimensions of the leg fall within the available depth of field. But at f/4 (*right*), the claws are considerably more striking and startling, though at the expense of overall definition.

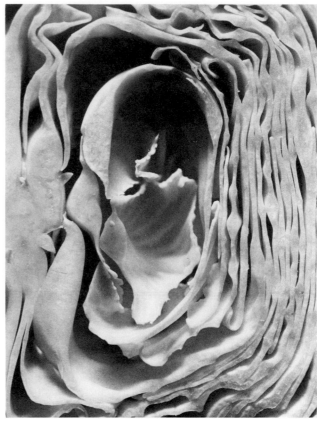

The niggardly shallow depth of field inherent in close-up photography must be conserved at all costs. Keeping the camera parallel to the important details in the subject will save what little depth of field there is for the most good. Above life-size, and when photocopying, such alignment is an absolute necessity (see p. 147). *Upper left:* Half a cabbage photographed at *f*/11, and **m** = 0.4× (1:2.5), is unsharp at top and bottom due to the skew alignment between camera and subject shown at lower left. *Upper right:* A vast improvement results when parallelism exists between camera and cabbage, shown at lower right.

tremely important when copying or photographing flat objects, where edge-to-edge sharpness is a necessity, such as duplicating slides, or photographing artwork and printed material in books, or even coins.

Many photographers erroneously believe that short-focal-length (wide-angle) lenses have greater depth of field than normal or long-focal-length (telephoto) lenses. In fact, if the lens-to-

subject distance is adjusted so that, with each lens used, the subject just fills the frame or forms a particular size image on the film (which is usually the case in close-up photography), then, *all lenses provide the same depth of field at the same aperture, if the image size on the film is made the same.* With wide-angle lenses you must get closer to obtain a given magnification; a telephoto lens provides more working room between the lens and the

subject; but both have the same depth of field if **m** and the *f*-stop are equal. If you're skeptical, see the illustrations on pp. 70 and 71.

Previsualizing Depth of Field

Extremely shallow depth of field can cause additional esthetic problems because viewing and composing are done with the lens automatically wide open. What you see through the viewfinder of an SLR used in close-up situations is a totally blurred background and foreground. However, for the actual exposure, the lens will be automatically or manually closed down to the desired small aperture, and previously indistinguishable detail will make itself apparent *on the film* due to increased depth of field (see the accompanying illustration).

If you have a depth-of-field preview button on your camera (it's a control that temporarily closes the lens down to the "taking" aperture as you look through the lens), activating it will pro-

vide a *rough* idea of the final appearance of foreground and background. But contrary to all the advertising hyperbole, activation of the depth-of-field preview control will *not* really show you whether all the important parts of the subject will be adequately sharp. Closing the lens down to *f*/16, for example, a typical aperture in close-up work, the viewfinder becomes *64 times dimmer* than when the lens is at *f*/2. The effect is like going directly from the beach on a sunny day into the public restrooms, where all the light bulbs have been broken by vandals. If you and the subject are not in a hurry, more information can be gained from the depth-of-field preview if you hold your eye to the camera for a few minutes while depressing the preview button. This will give your eye a chance to become accustomed to the darkness.

How do you know if everything will be in focus in a three-dimensional subject? For critical work—scientific, medical, advertising—measure the subject and use the table on p. 27. If that is impractical, some test exposures on a roll of

The image in the viewfinder of an SLR camera is a product of the lens at its widest aperture, regardless of the actual *f*-number set. We *see* a depth of field different from that which will prevail on the *film* when the lens is closed down to the preset aperture at the moment of exposure. A picture taken at *f*/16 has eight times more depth of field than we see through an *f*/2 lens! *Left:* An ice-encased dogwood bud as seen through an SLR. Note the insufficient depth of field for this subject. *Center:* The results, when photographed at *f*/11, include distracting background. *Right:* Also at *f*/11, but with a white card held behind the bud. A camera's depth-of-field preview control helps previsualize the results.

 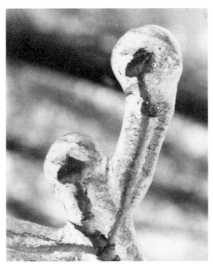 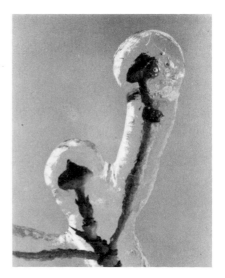

black-and-white film and quick development may be in order. See Chapter 11, Some Working Suggestions. Eventually you will develop a feel for what will and what will not be in focus. For casual situations abide by the following:

- Focus in the middle (front to back) of the subject.
- Use smaller apertures, $f/8$, 11, 16, unless a special effect is desired (see footnote on p. 26).
- Align the camera parallel to the main plane of the subject.

There are depth-of-field optimizing techniques that involve larger format cameras, spe-cial lenses with very small apertures, and considerable calculation; they are beyond the scope of this book. For the vast majority of work with 35 mm cameras, the techniques suggested here will yield optimum results.

Flat subjects do not, theoretically, have any "depth." But they are usually photographed with the material filling the entire frame, so edge-to-edge sharpness is mandatory. To allow for possible lack of parallelism between subject and camera, and especially to correct for any lens aberrations that occur when conventional lenses are used in close-up situations, $f/11$, or even $f/16$, is still advised. If the lens is specially designed for close-up work, $f/8$ is usually optimum, but see Appendix C.

FOCUSING

At $f/16$, total depth of field varies from about 4 inches (10 cm) at $0.1\times$ (1:10), the beginning of the close-up realm, to only 0.15 inch (0.4 mm) at $3\times$ (3:1), three times life-size. But having just indicated that the optimum point of focus is in the middle of the subject, and in the middle of the depth-of-field zone, it becomes clear that the camera must be carefully and accurately focused to within a fraction of an inch, or less. Unlike conventional picture taking, if the camera or the subject moves toward or away from each other even a very small amount, the picture will be *totally out of focus.* The higher the magnification, the more critical the focus.

This translates into a need to hold the camera and subject extremely steady in the low-magnification range, preferably bracing yourself and/or the camera against a support. At the higher-image ratios, a tripod, copy stand, or similar fixed support is a necessity. An alternative is an electronic flash, at least up to $1\times$ (1:1). While it is impossible to handhold a point of focus to within the tolerances noted above, one can make use of the very short—1/1000 sec. and less—duration of small electronic flash units. For more information on this subject, see Chapter 8, Lighting. Armed with a flash, you can move the entire camera back and forth to focus, rather than trying to "freeze" at any one point. Then trip the shutter and flash just as you sense that

you are about to glide into focus. The high speed of the flash arrests all motion. With a little practice it works very well. It is particularly useful in some field situations, where a tripod might be next to impossible to set up as you stalk an elusive creature.

Focusing in the close-up and macro ranges is quite different from the rotate-the-barrel technique suited for conventional distances. If you use that technique in close-up situations, here's what happens: As the focusing mount on the lens is rotated, the lens itself moves in and out, either away from the camera for close subjects, or close to the film for distant subjects. For close-up, and especially macro work, that amount of extension becomes considerable, particularly in proportion to the small lens-to-subject distance. What is also important to note is that this change in lens position also changes the magnification. Therefore, while you are carefully trying to focus on some tiny object, the lens-to-subject distance *and* the magnification are changing. But when the magnification changes, a new lens-to-subject distance is required. If that sounds like musical chairs, it is. To make matters worse, rotating the lens barrel jiggles the whole setup, and that vibration is magnified as much as the subject's image. That is *not* the way to focus to hair-width accuracy.

The standard close-up focusing technique is

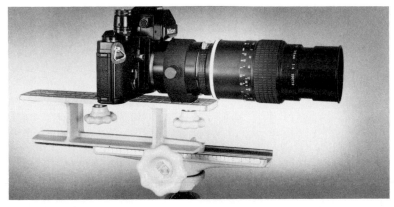

Geared focusing slides greatly simplify close-up focusing above 0.5×. Beyond 1×, they're a virtual necessity. Such slides permit the fine back-and-forth motion of the camera/lens system required for accurate focusing of small objects where depth of field verges on nonexistence. *Lower left:* The Novoflex slide is smooth and compact, the author's choice for a fine, all-around unit. *Lower right:* Better vertical copy stands have built-in focusing slides; this one is from Pentax. *Top:* This large, extremely well-made slider from Linhof is appropriate for weighty systems and larger-format cameras. (Also see p. 149).

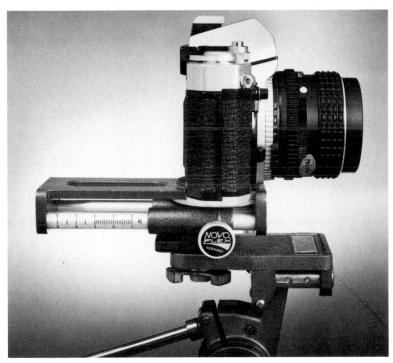

simply to set a particular *magnification* by choice of appropriate attachments, and focus by slowly *moving the entire camera and lens, as a unit, back and forth until the image appears sharp in the viewfinder.* If, at the point of focus, the object under- or overfills the frame, change the magnification (by rotating the lens barrel, or by adding or subtracting attachments), and focus again, as suggested.

Specially geared *focusing rails* are made that fit between a tripod or copy stand and the camera. These allow the entire close-up system to be racked back and forth for focusing with accuracy and smoothness. They are particularly useful at

magnifications greater than 0.3× (1:3), and are almost a necessity above 1× (1:1).

Cameras without single-lens reflex viewing cannot focus in this manner, since the viewing window of a non-SLR camera is displaced from the lens axis. The resulting difference, *parallax,* between what the viewfinder sees and what the lens sees becomes unacceptably large in the close-up range. However, the next chapter does show how these cameras can be used for close-up photography up to 0.5× (1:2) by just using a ruler or a simple wire frame, and some inexpensive close-up lenses.

Many close-up pictures are taken in a posture more appropriate for petting a small dog than for achieving fine photographic results. Most subject matter makes no effort to position itself for the convenience of the photographer. *Lower left:* The photographer's semi-erect, unbraced posture made focusing on these Indian pipes difficult. Exposure was *f*/5.6 and 1/125 sec.; the large aperture left depth of field insufficient. *Lower right:* Getting down in the vegetation gave a better perspective and enabled the photographer to brace his elbows. The additional support permitted exposure at 1/15 sec. and *f*/16, providing more depth of field. Background clutter was eliminated with a dark sweatshirt.

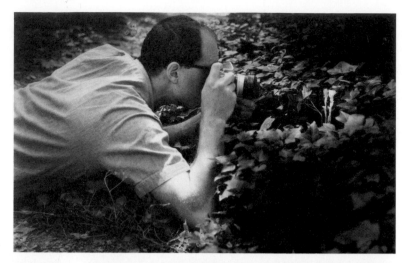

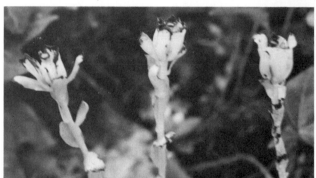

CAMERA STEADINESS

Taking close-up photographs is much like using a telephoto lens in the sense that not only is the image magnified, but so are any vibrations, subject motions, or sloppy focusing. The illustration above compares two pictures taken at a magnification of half life-size — 0.5× (1:2). One was casually handheld, while the other was exposed with the photographer's elbows firmly on the ground.

Without any support, and without a flash, 1/125 sec. at 0.5× (1:2) and 1/250 sec. at life-size are suggested as the slowest shutter speeds for handholding . . . and that assumes you are concentrating intensely, and not breathing.

At magnifications much greater than 1:1 (1×), it is virtually impossible to handhold a camera and obtain acceptably sharp results. Depth of field is almost zero, focusing is extremely critical, and the slightest bit of camera vibration, photographer shake, or subject movement is catastrophic.

The need for a small aperture to insure adequate depth of field and more secure focusing forces the use of a slow shutter speed to obtain sufficient exposure. A small aperture like *f*/16 passes very little light through the lens, and to compensate for the low intensity of light on the film, a long shutter speed is necessary. This further adds to the need for mechanical support. See Chapter 7 for complete details.

An obvious suggestion is "more light" so that both a small aperture and high shutter speed can be used. In fact, auxiliary lighting, particularly electronic flash for handheld situations, is used a great deal in close-up and macro work, and it will be discussed in some detail in Chapter 8, Lighting.

Even with the camera attached to a mechani-

The lack of a tripod should not inhibit photography when slow shutter speeds are required. Stools, automobile fenders, fence posts, logs, garbage cans, tricycle seats, and bricks all make excellent, if unorthodox, ersatz supports. The elbow at left was photographed at 1/8 sec. from the position shown below.

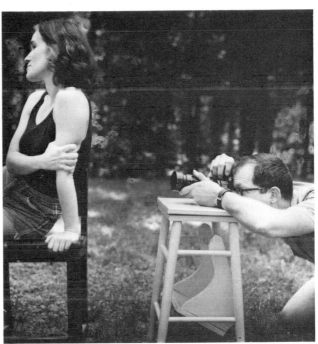

cal support, the pressure of your finger on the shutter-release button can set up image-destroying vibrations. With the camera on a tripod or copy stand, always use a cable release, which should be *at least* 12 inches (30 cm) long, and have a lock for long time exposures. At magnifications in the macro range, consider using a rubber-bulb air release. It's like a super-long cable release, except it uses a rubber squeeze bulb to force air down a very long, flexible tube to a plunger that screws into the camera's cable release socket. It transmits virtually no vibration. The Rowi unit comes in a compact pouch, with 34 feet (10 m) of tubing that may be cut to any length. The "Super" model will trip the camera from as far as 80 feet (24 m) away. It's ideal for surreptitious nature photography.

If a cable release is not at hand, and if the required shutter speed falls within the available speeds on the camera, a self-timer, if the camera is so equipped, is a good alternative. It gives the close-up apparatus about 12–15 seconds to stabilize before the shutter automatically trips.

A final antivibration technique for photography in extreme close-up situations, and, more importantly, in the macro range: At the instant of exposure, the mirror in an SLR flips up rapidly to permit light to reach the film. As it slams against its arresting stop, small vibrations called *mirror bounce* can cause unsharp pictures, particularly in the range where magnifications exceed $2\times$. A support that is less than 100 percent rigid exacerbates the situation. Therefore, when photographing at half life-size or greater (without flash) with the camera on a tripod, and if the subject does not require constant surveillance, use the mirror lock-up if your camera has this feature. In the *close-up* range it *may* be unnecessary, but there are times when it makes the difference between an image that is super sharp and one that is just acceptably sharp. The illustration on p. 66 shows additional details.

Many wonderful close-up photographs are taken by people who know little about the basic underlying optical principles of close-up photography. But you will be a far better photographer, both technically and creatively, if you have a general understanding of what is happening to the image, and how various parameters affect rudimentary practical considerations such as magnification, **m**, and working distance, **W**.

There are two methods of close focusing: (1) extend the lens farther from the film, or (2) for a given amount of extension, shorten the focal length of the lens. To understand the background for these two techniques, it is necessary to have a good understanding of what is meant by *focal length.*

The *focal length* is the inherent characteristic of a lens that determines the *size of the image for any given lens-to-subject distance.* It is a physical property ground into the lens by careful selection of the type, shape, and spacing of the glass elements. The focal length of a lens can usually be found stamped on its front retaining ring. Simply stated, the focal length is the distance between the optical center of a lens (which is usually somewhat displaced from the "middle" of the lens) and the image on the film, *when the lens is focused at infinity.* Focused on any point *closer* than infinity, the lens-to-film distance—called the *image distance*—will always be *greater* than it is for infinity focus.

Therefore, the closer you want to focus with a given lens, the more the *image distance* must increase. (See Chapter 4, Extension Tubes and Bellows, to learn more about this principle.) Also, as the image distance increases, there is a disproportional decrease in the amount of distance between the optical center of the lens and the object (called the *object distance*). See the illustration below.

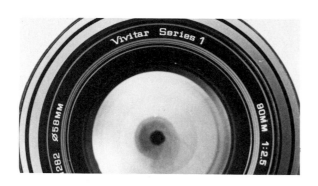

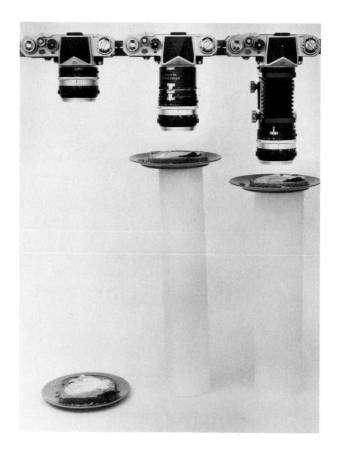

Above: Markings on the front of this lens indicate it has a 90 mm focal length. Do not be confused by the symbol ø, which stands for *diameter;* this Vivitar lens takes filters and other front-mounted accessories of 58 mm diameter. *Right:* Shown here are the relative positions of the three cameras, each having identical 50 mm lenses, used to make the photographs on the facing page. The left-most camera has its lens set at its near limit, providing a working distance, **W**, of 20 in. (51 cm), subject-to-lens-front. On the center camera, 47 mm of extension tubes behind the lens permitted focusing on the subject only 1¾ in. (4.5 cm) from the lens. Still greater extension, 4 in. (102 mm), via a bellows was given to the right-hand lens. It then focused with **W** = ¾ in. (19 mm).

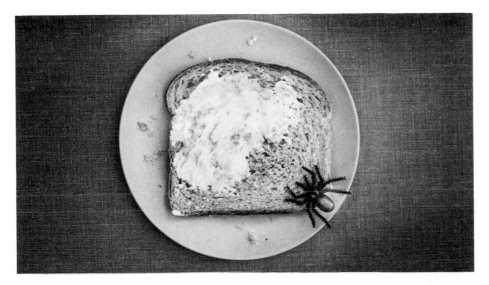

One method of achieving closer-than-normal focusing is by extending a given lens farther from the film; i.e., increasing its *image distance*. As the image distance is increased, the lens-to-subject dimension, the *object distance*, must decrease to keep the subject in focus. Object and image distances are measured from the "optical center" of the lens, a position difficult to locate on most optics. Of more practical use is the *working* distance, **W**, which indicates the actual space between subject and lens rim.

These three full-negative pictures of the spider *Arachnidium latexium* crawling on a slice of Pepperidge Farm whole wheat bread were made with the cameras and their extensions shown in the right-hand photo on the facing page. *Top:* Without any special extension (left-hand camera), a magnification on film of 0.1× (1:10) is the near limit of almost any lens. *Center:* This camera's 47 mm lens extension produced a magnification of 1× (1:1), life-size. *Bottom:* A high magnification of **m** = 2.3× (2.3:1) resulted from the use of bellows behind the lens on the right-hand camera. Working distance for each of these conditions is given in the caption on the facing page.

A second method of generating higher-than-normal magnification is by keeping the working distance, **W**, fixed, but increasing the focal length of the lens. When this is done at close-up working distances, the laws of optics require that additional extension be placed behind the lens to achieve the appropriate image distance. *Below:* The camera/lens/extension systems used to take the pictures at right are shown side by side. Note that in each case, **W** is the same: 6¼ in. (16 cm). The left-hand camera is fitted with a 28 mm lens and a 4 mm extension tube; it produced the photo at upper right, where $m = 0.16\times$ (1:6). At the same working distance, the center camera, sporting a 50 mm lens, required 12.5 mm of additional lens extension, but it achieved a magnification of $m = 0.33\times$ (1:3), the middle right photo. Note that for a given **W**, two times the focal length also doubled the magnification. By fitting a 105 mm lens and 185 mm of extension on the right-hand camera, we reached $m = 2\times$ (2:1) and produced the lower right photograph. (Magnification is greater than one would expect from just doubling the focal length. This is due to the retrofocus design of the telephoto lens.)

The conjugate object/image distance pair is different for each focal length lens, but *for a given object distance,* a longer-focal-length (telephoto) lens provides larger images than a shorter- focal-length lens (either normal or wide-angle). This is shown in the illustration at left; the results are identical to those in normal picture-taking situations.

Supplementary close-up lenses, which attach to the *front* of a prime (camera) lens, provide the second method of close focusing. The combination of the two lenses effectively produces an image that would come from a lens with a focal length *shorter* than the original. The close focus-ing and large image ability are derived from the fact that *for a given image distance* (the lens-to-film spacing), *a short-focal-length lens will produce more magnification than a longer-focal-length lens.* With a particular lens on your camera for conventional picture taking, the image distance is more or less fixed, give or take less than an inch. When a supplementary close-up lens is attached, the focal length of the prime lens is shortened, but the *image distance has not been altered;* hence you are able to move in close. These simple, inexpensive, accessory lenses are tremendously useful devices, and are discussed at length in Chapter 3, Supplementary Close-Up Lenses.

SUMMARY

Magnification, **m**, is the ratio of image size to object size (**m**=image size divided by object size). It may be expressed as a ratio, a fraction, or a decimal, so that an object photographed at one-half life-size is said to have a magnification or image ratio of 1:2, or ½, or $0.5\times$.

For both equipment selection and discussion of working techniques, close-up photography is formally divided into three ranges with somewhat vague borders: from an image ratio of 1:10 ($0.1\times$)—the near focusing limit of most standard lenses—to 1:2 ($0.5\times$), the term *close-up* is used. From 1:2 to 1:1 (life-size) the term *extreme close-up* is used. Producing pictures in which the image is larger than the object (above $1\times$), puts us in the true *macro* range, which extends to about 35–$40\times$; beyond that, the services of a microscope are usually required.

Depth of field is extremely shallow in close-up situations, and decreases with increasing magnification; however, it doubles when the aperture is closed down two stops. Depth of field is not affected by lens focal length, only by magnification and lens aperture. Objects having substantial three-dimensional depth may present a problem: at 1:4 ($0.25\times$), one-quarter life-size, depth of field is ¾ inch (19 mm) at $f/16$; at 1:1 (life-size), with the same aperture, it is only $\frac{1}{16}$ inch (2 mm).

Increased picture magnification unfortunately magnifies effects of camera unsteadiness and inexact focusing. Additionally, the small apertures necessary for adequate depth of field mandate slow shutter speeds. This all boils down to the invariable need for auxiliary lighting, a tripod, or other support as the magnification is increased.

In the extreme close-up and macro ranges it is easier to focus by moving either the entire camera/lens combination, or the subject back and forth, rather than by rotating the focusing mount on the lens.

The focal length of a lens is a fixed property that determines the image size for a given object distance. To make a lens focus closer, the image distance must be increased, and, in fact, the amount of increase is disproportionally large as you get closer to your subject. An alternative method of focusing close with a fixed-image distance is to shorten the focal length of the camera lens by attaching supplementary close-up lenses.

Close-up photography would be patently unexciting if it involved nothing more than physics and formal definitions. The next chapter applies these somewhat detailed but necessary terms to practical, real-world picture taking, using simple, inexpensive, yet marvelously effective supplementary close-up lenses.

Little is required in the way of sophisticated equipment to photograph at moderately close distances. A very inexpensive supplementary close-up lens attached like a filter to my normal optic made this photograph possible. The difficulty consisted of finding a momentary lull in the vigorous mouth motion of the very hungry, 10-day-old Baby Sarah. While flash would have frozen the motion, it would also have destroyed the soft window light and intruded on the mood of mother and child. Only 1 frame in 36 was acceptably sharp.

3 Supplementary Close-Up Lenses

Page 24 in Chapter 2, Preliminaries, briefly explained the reasons for the restrictions on the ability of a lens to focus on very near objects. But despite the restrictions, many marvelous images of tiny objects have been successfully produced. The near-focusing limit of a conventional lens prevents the inappropriate use of the manufacturer's optics, and the subsequent complaint from indignant consumers expecting more from a product than it is capable of offering. Understanding the relatively simple optical problems, and knowing how to get around them with straightforward techniques is all it takes to circumvent these somewhat arbitrary (at least to the knowledgeable photographer) constraints. Here is one of the two principle ways it can be done.

BASICS

Without a doubt, the most convenient and least expensive way to get started in close-up photography is to use supplementary close-up lenses. At the time of this writing, a set of three could be had for under $20. These lenses do for your camera lens exactly what a magnifying glass does for your eye. They are very thin, single-element lenses, quite similar in design to eyeglasses for the farsighted, that attach to the front of a camera's prime lens just like a filter. They come in various strengths, each one permitting close focusing over a particular range of near distances. With the supplementary lens in place, the camera will now only focus in the close-up or near-close-up range, and not within its normal 3-foot (91 cm)-to-infinity range.

If you have a single-lens reflex (SLR) camera, what you see in the viewfinder is what you get on film. Just screw on a supplementary close-up lens, focus by moving the entire camera back and forth, as explained in Chapter 2, Preliminaries, and expose normally. There is no need for any exposure corrections when using these lenses in normal situations. Not close enough? Choose a stronger one and/or use two in tandem. They can even be used on non-SLR's and on simple cameras without interchangeable lenses. Not intended for photography in the macro realm, or even for extreme close-ups, they will, however, provide quite good results with most subject matter up to half life-size, $0.5\times$ (1:2), if used correctly.

The combination of supplementary lens and camera lens effectively provides a focal length *shorter* than the prime lens alone. But the lens-to-film (image) distance remains unchanged. The now relatively long image distance for a short-focal-length lens permits the combination to focus closer than the unmodified lens alone. This effect is shown in the illustration overleaf.

The strength of a supplementary close-up lens is expressed in *diopters,* **D**. Typically these accessories come as +1, +2, +3, and so on, up to +10 diopters. With a 50 mm camera lens, the lower diopter numbers are for the *close-up* range; the higher diopter strengths approach the *extreme close-up* realm. Distortion in the prime lens and in the supplementary lens, and other optical aberrations restrict their use above approximately $0.5\times$ (1:2) as previously noted. The exact limit is dependent on the *f*-stop, the quality and design of the prime lens, and your visual standards.

Two dozen medium eggs are used to illustrate the decrease in the close-focusing limit of a lens when a supplementary close-up lens is attached to the front of a standard optic. The upper camera is situated at the near focusing point of a conventional 50 mm lens: **W** = 20 in. (50 cm). At that distance, the field of view encompassed is indicated by the photograph at lower left. The same prime lens, but with a +3 diopter supplementary close-up lens added, permits the lens to approach to within 9 in. (23 cm) of the eggs and record the scene at lower right. (As is so often the case, time required for the actual photography may be short compared to that required for preparation. For example, over an hour was spent gluing the eggs into the cartons for the right-hand photograph.)

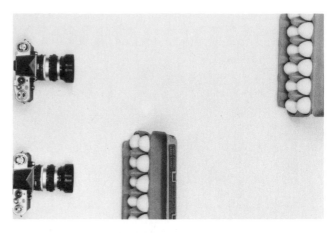

MOUNTING SUPPLEMENTARY CLOSE-UP LENSES

Like filters, supplementary close-up lenses come either with threaded rims that screw directly onto the front of the camera lens, or with plain metal rims in *series* sizes, which require one additional, inexpensive adapter ring.

The screw-in supplementary lens must be purchased to fit the specific diameter of your primary lens; typical dimensions for SLR's are 49, 52, and 55 mm. To determine the size you need, check your camera manual, write to the manufacturer, or just try a few at a camera store. Because it screws directly into the prime lens, the threaded rim supplementary lens is more accurately aligned with the optical axis of the prime lens, and therefore offers slightly more sharpness. Also, this type has female threads on the front, so that your standard lens hood, additional filters, or supplementary lens is easily screwed in.

Series types are recommended for photographers whose lenses have different front-mount diameters, or for those photographers contemplating the purchase of additional camera lenses. If you do change cameras or lenses, the close-up lenses are still usable; simply purchase an inexpensive adapter ring. Series VII supplementary lenses and filters will fit adapter rings for camera lenses having front diameters from 43 to 55 mm; Series VIII covers 51 to 67 mm; Series IX and X are larger still.

Tiffen Optical Company (see Appendix A for their address) makes a wide variety of adapter rings for every conceivable lens. If your camera lens doesn't have a threaded rim that will accept screw-in adapter rings, Tiffen also makes slip-on and set-screw types. Spiratone also has a very large selection of adapter rings for popular 35 mm cameras.

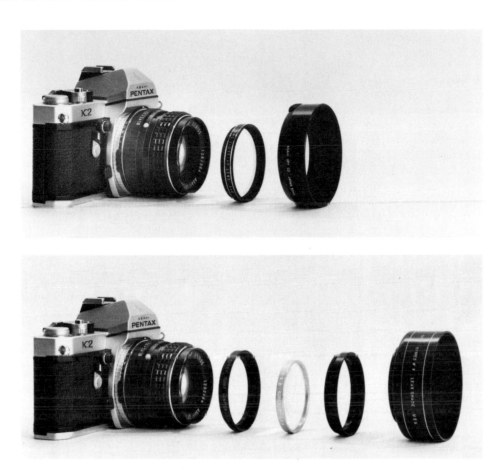

Supplementary close-up lenses are available in two mounting configurations. *Top:* Most convenient are the screw-in variety, with threaded metal rims of a diameter selected to match the female thread on the front of your lens. The front of the supplementary rim is conveniently female-threaded to the same diameter, so that it will accept existing accessories. Their only disadvantage: they will not fit lenses of different front-thread diameter, although that can be solved by Spiratone's "Customizers"—threaded step-up and step-down rings in a myriad of size combinations. *Bottom:* Plus-lenses in series sizes have unthreaded metal rims, but will fit any lens with the addition of an appropriate two-part adapter ring.

CHARACTERISTICS

The diopter value of a lens is nothing more than its focal length, *in meters,* divided into one. A lens can be ground to have either a positive (magnifying) or negative (demagnifying) focal length; those used for close-up work are all positive. A lens having a focal length of $+250$ mm ($+0.25$ m) is therefore $+4$ diopters. The positive sign preceding the power has led to the nickname "plus-lenses." See the accompanying table for conversion of diopters to focal length.

If the camera lens is set *at infinity,* the *working distance,* **W**—the measurement from the front of the supplementary lens to the object—of that plus-lens/prime lens combination is simply equal to the focal length of the *supplementary* lens. However, the camera lens may also be set at some other distance on its focusing scale, which will permit slightly closer focusing, and therefore slightly greater magnification with any particular

close-up lens in place. For example, a $+4$ diopter supplementary close-up lens has a focal length of $(1\text{ m} \div 4) = 0.25\text{ m} = 25\text{ cm} = 10$ inches. Therefore, when attached to *any* prime lens set at infinity, this plus-lens will produce a working distance of 10 inches (25 cm). (Compare that to the normal 24-inch [100 cm] near-focusing limit of a typical 50 mm lens.) And if the focusing scale of that prime lens is set at 24 inches (100 cm) and the $+4$ lens is in place, working distance is a close 7 inches (18 cm), with a proportional increase in image size.

The table on the following page shows depth of field, field of view (the maximum size of the subject area seen by the lens), magnification, and corresponding working distance, measured from the front of the lens, for various dioptric powers on a 50 mm prime lens used with a 35 mm camera.

Table 3-1
SUPPLEMENTARY CLOSE-UP LENS DATA FOR 35 MM CAMERAS WITH 50 MM LENSES

Supplementary Lens Power (Diopters)	Focal Length (m)	Focus Setting of Prime (Camera) Lens (ft.)	(m)	Working Distance* (in.)	(cm)	Magnification, m, on Film		Field of View† (in.)	(cm)	Depth of Field at f/8‡ (in.)	(mm)
+1	1.000	Inf.	Inf.	39⅜	100.0	0.05×	(1:20.0)	18⅝ × 28	47.3 × 71.1	7½	191.0
		15	4.6	32⅜	82.2	0.06	(1:17.0)	15⅜ × 23	39.0 × 58.4	5¼	134.0
		3½	1.0	20⅜	51.8	0.10	(1:10.0)	9⅜ × 13¾	23.8 × 34.9	2	50.0
+2	0.500	Inf.	Inf.	19½	49.5	0.10×	(1:10.0)	9⅜ × 13½	23.1 × 34.3	1⅞	48.0
		15	4.6	17¾	45.1	0.11	(1:9.1)	8½ × 12¾	21.6 × 32.4	1⁹⁄₁₆	40.0
		3½	1.0	13⅜	34.0	0.15	(1:6.7)	6⅛ × 9¼	15.6 × 23.5	⅞	22.0
+3	0.333	Inf.	Inf.	13	33.0	0.15×	(1:6.7)	6¼ × 9⅜	15.9 × 23.9	1³⁄₁₆	21.0
		15	4.6	12¼	31.1	0.16	(1:6.3)	5¾ × 8¾	14.6 × 22.2	¾	19.0
		3½	1.0	10	25.4	0.21	(1:4.8)	4⅝ × 6¾	11.7 × 17.1	⁷⁄₁₆	11.0
+4 §	0.250	Inf.	Inf.	9⅞	25.1	0.21×	(1:4.8)	4½ × 6⅝	11.4 × 16.9	⁷⁄₁₆	11.0
		15	4.6	9¼	24.8	0.22	(1:4.5)	4¼ × 6½	10.9 × 16.7	⅜	10.0
		3½	1.0	8	20.3	0.26	(1:3.8)	3⅝ × 5⅜	9.2 × 13.6	⁵⁄₁₆	7.5
+5 §	0.200	Inf.	Inf.	7⅞	20.0	0.26×	(1:3.8)	3⅝ × 5⅜	9.2 × 13.6	¼	7.2
		15	4.6	7¾	19.7	0.27	(1:3.7)	3½ × 5¼	8.9 × 13.5	¼	6.7
		3½	1.0	6½	16.5	0.32	(1:3.1)	3 × 4½	7.6 × 11.4	³⁄₁₆	5.0
+6 §	0.167	Inf.	Inf.	6½	16.5	0.32×	(1:3.1)	3 × 4½	7.6 × 11.4	³⁄₁₆	4.8
		15	4.6	6½	16.5	0.32	(1:3.1)	2⅞ × 4⅜	7.5 × 11.2	³⁄₁₆	4.7
		3½	1.0	5⅝	14.3	0.37	(1:2.7)	2⅝ × 3⅞	6.7 × 9.8	⅛	3.7
+8 §	0.125	Inf.	Inf.	5¼	13.3	0.41×	(1:2.4)	2¼ × 3⅜	5.7 × 8.6	⅛	2.9
		15	4.6	5¼	13.3	0.42	(1:2.4)	2⅛ × 3¼	5.6 × 8.5	⅛	2.8
		3½	1.0	4¾	12.0	0.46	(1:2.2)	2 × 3	5.2 × 7.9	³⁄₃₂	2.4
+10 §	0.100	Inf.	Inf.	4	10.1	0.52×	(1:1.9)	1⅞ × 2¾	4.7 × 6.9	⅛	1.8
		15	4.6	4	10.1	0.55	(1:1.8)	1¾ × 2⅝	4.4 × 6.6	¹⁄₁₆	1.6
		3½	1.0	3⅞	9.8	0.58	(1:1.8)	1⅝ × 2½	4.1 × 6.2	¹⁄₁₆	1.5
+20 §	0.050	Inf.	Inf.	2⅜	6.0	0.95×	(1:1.1)	1⅛ × 1⅝	2.7 × 4.0	¹⁄₆₄	0.50
		15	4.6	2⅜	6.0	0.95	(1:1.1)	1⅛ × 1⅝	2.6 × 3.9	¹⁄₆₄	0.50
		3½	1.0	2¼	5.7	1.0	(1:1.0)	1 × 1½	2.4 × 3.6	¹⁄₆₄	0.48

*Measured carefully from the front of the supplementary close-up lens to the subject.

†Approximate maximum size of the object seen by the camera; assumes use of entire negative; slide mounts crop out about 10% in each direction.

‡Indicates *total* close-up depth of field with these attachments; depth is approximately equally divided on either side of plane of focus. At f/16, depth of field is double these values; at f/4, half. In general, use f/8 or smaller apertures for good image sharpness. Data are based on a 0.03 mm (0.012 in.) circle of confusion.

§High powers may be reached by stacking (no more than) two close-up lenses; place higher power attachment *closer* to prime lens. Due to critical focus, use close-up lenses above +6 only on SLR cameras.

If you have an SLR camera, use the table on p. 44 to give yourself a rough idea of the choice of supplementary lenses for your approximate object size. Attach the appropriate plus-lens to the prime lens, and focus by moving the entire camera back and forth. (With low power $+1$, $+2$, and $+3$ lenses on a 50 mm lens, you may be able to focus in the conventional manner by rotating the lens barrel.) Small adjustments in field of view and magnification may be made by rotating the lens-barrel focusing ring, and then refocusing as previously described. If the field of view is still too large, i.e., if the subject's image is too small, put on a higher strength plus-lens; if the field of view is too small (magnification is too high), use a lower power attachment.

Supplementary close-up lenses may be stacked together to provide higher dioptric power: the power in diopters is conveniently additive, so that a $+1$ with a $+3$ is equivalent to a $+4$. To keep image aberrations at a minimum, the *strongest* supplementary lens must be placed *closest* to the camera lens, with the weaker, lower diopter lens stacked on top of it. It is important to purchase plus-lenses that are antireflection coated, although only the very inexpensive ones are not. This particularly holds true if the lenses are to be stacked. Also, when stacking, cleanliness is critically important; any fingerprint or dirt causes scattered light to bounce back and forth between the extra lenses, leading to flare (stray light) on the film.

Tiffen, Spiratone, and Vivitar carry very extensive lines of plus-lenses, from $+\frac{1}{2}$ to $+10$, in almost all diameters in screw-in and Series sizes. Most camera manufacturers distribute a less extensive range of plus-lenses that screw into their own lenses or into others with similar front-mount diameters. Some companies sell sets containing a $+1$, $+2$, and $+3$; but the Vivitar kit has a $+1$, $+2$, and $+4$, which, in combination, covers the complete range from $+1$ to $+7$ in whole-diopter increments. Such a set is ideal for starters.

In Chapter 2, Preliminaries, the shallowness of depth of field in the close-up realm was explained. With supplementary close-up lenses, it is actually shallower than the same magnification reached through extension tubes or "macro" lenses. Therefore, focus carefully, select a small aperture, use a tripod and a cable release if feasible, and try to keep the subject parallel to the film plane.

I have spoken highly of these little round circles of magnifying glass that can be had for the price of a few rolls of film. A natural question is, how do they compare to extension tubes, or to "macro" lenses costing fifty to one hundred times as much? If you keep the magnification under $0.5\times$ (1:2), use small apertures, and if the prime lens is of good quality, the answer, in a nutshell, is *surprisingly well for many applications.* The small cost of a supplementary lens lets you get started *today.* These lenses are so small that there is no effort involved in carrying one or two of them around at any time; and there is no light loss, nor need to make exposure corrections for light falloff as there are when using extension tubes, bellows, or "macro" lenses. Of course, they are slow to work with since all but a small change in magnification requires a change in supplementary lens.

The illustration on the next page compares supplementary plus-lenses for image quality with the sophisticated Nikon Micro Nikkor lens, a 55 mm $f/3.5$ optic, beautifully designed to give excellent images not only in close-up work, but in all areas of photography, and to conveniently focus over a range from infinity to 1:1 ($1\times$). At large apertures (here $f/3.5$), the Micro Nikkor is considerably superior. At $f/8$, the difference is more subtle.

It is important to note that very poor results are obtained from the supplementary/prime lens combination when the prime lens is set at large apertures. This example shows that: (1) a plus-lens should be used with the prime lens stopped down to *at least* $f/8$, unless a special effect is desired; $f/11$ and $f/16$ are even better for the high-power supplementaries such as the $+10$; and (2) for the money, a supplementary close-up lens does a very respectable job. I would not recommend this type of lens for quality copying of flat objects (where edge-to-edge sharpness is mandatory), such as documents and small sections of paintings or graphics, especially at magnifications above $0.5\times$ (1:2).

Two final notes on sharpness: First, a com-

Image quality from supplementary close-up lenses is very much dependent on the quality of the prime lens, the prime lens aperture, and the magnification. Fine engraving lines on a 5 peso banknote at **m** = 0.4× (1:2.5) illustrate the potential quality, with each print being the *corner* of a negative blown up to an 8″×10″ (20×25 cm) equivalent. *Upper left:* A +6 supplementary on a 50 mm *f*/1.4 normal lens used at *f*/4 leaves a good deal to be desired. Closing that same lens down to *f*/11 (*upper right*) greatly improved the resolution and contrast. *Lower left:* If good resolution with the lens fairly wide open is required, "macro" optics, like the 55 mm Nikon *f*/3.5 used here at *f*/4, are a necessity. *Lower right:* At *f*/11, the "macro" lens gives the finest results, but do compare it to the results from the vastly less expensive +6 lens.

bination of a +4, +3, +2, and +1 lens does add up to +10, which will produce 0.5×. But a single +10, or even two +5 lenses, will produce an image with much better contrast. Secondly, the quality of the final image is very much dependent on the quality of the prime lens; a plus-lens tends to magnify any defect in the camera lens. Used with a high-quality camera lens at medium to small apertures, supplementary lenses give fine results, especially with three-dimensional objects, where slight distortions are usually not objectionable. When used for *critical* photography of flat subjects, they tend to provide images that are unsharp and a bit distorted at the edges, especially at higher magnifications. But do try them; at low **m**, they are great!

Used with 3-dimensional subjects not requiring the ultimate contrast or sublime corner resolution, plus-lenses do a fine job. For example, a +3 on a normal lens photographed these potatoes, the image of which the author preferred as a negative. However, such accessories are not always appropriate: This UPC bar code from a can of tunafish exhibits poor resolution at its sides and severe distortion across the top; a +10 was used for **m** = 0.5×.

SOME SPECIAL SUPPLEMENTARY LENSES

Take a plus-lens, cut it in half, and you have a supplementary lens that Tiffen calls a "Split-Field" and Spiratone labels a "Proxifar." With it, you can focus on both very near *and* very far objects in the same scene, with a depth of field much greater than that supplied by stopping down the prime lens to *f*/16. See p.48.

With Spiratone's model 10, which is a +3 lens cut in half, you can focus sharply on near objects from 10 to 13 inches (25 to 33 cm), and on far objects from 3 feet (0.9 m) to infinity in the same photograph. These are not just gimmicks; a nature photographer is able to show both a close-up of a specimen *and* its environment in the same scene. The creative possibilities in all areas of photography are significant.

Tiffen Split-Field lenses are available in +½, +1, +2, +3, and +4 diopters, in series and direct screw-in rotating mounts. Spiratone has +1 and +3 lenses available in screw-in mounts, and in Series VII and VIII to fit many popular cameras. As you might imagine, half a plus-lens actually costs a bit *more* than a whole one.

Also from Spiratone are two special supplementary lenses—the "Life-Sizer" and the "Macrovar"—neither of which will win prizes for sharpness, but they are unique and will do certain jobs in a pinch, and very inexpensively.

The Life-Sizer, which is nothing more than a +20 close-up lens, produces a 1:1 image ratio when used with a 50 mm lens. With all due respect to Spiratone, distortion and poor edge resolution occur with this lens, but they are bound to occur with *any* extremely high-powered supplementary lens. However, it may be quite satisfactory for three-dimensional objects, like flowers, where good central sharpness and moderate edge sharpness are satisfactory.

The second special entry, the Macrovar, is a *variable* close-up lens. It attaches like any other supplementary lens, but, by rotating its mount, dioptric powers over the range of +1 to about +10 can be obtained from this single lens, which costs about three times as much as a single supplementary lens, but which covers the range of six separate attachments. It is best used with an *f*/2 or slower lens, since it tends to vignette (slightly darken the corners) if used with an *f*/1.4 optic.

47

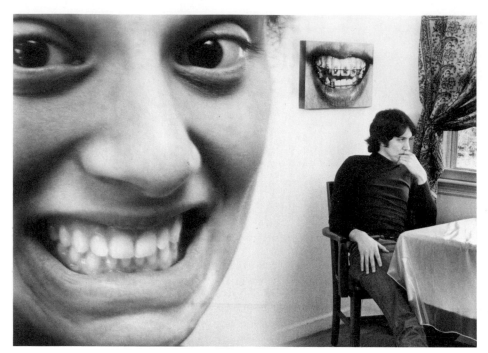

Half a plus-lens (*below*) permits sharp focus over an extreme range from near to far (*left*). However, the scene must be divisible, foreground to background, by a straight line, otherwise the "seam" in the lens will show in the photograph.

USING SUPPLEMENTARY CLOSE-UP LENSES ON CAMERAS NOT HAVING THROUGH-THE-LENS VIEWING

The ability to view through the same lens that the film uses makes close-up photography considerably easier; in the macro range it is a necessity. But if you do not own an SLR camera, don't run out and buy an expensive machine; after a few weeks of crawling around on the ground, you might not like a close-up view of the world. Rangefinder cameras, and other cameras having viewfinders separate from the primary lens will do just fine for starters. For more than casual or occasional photography, and especially at magnifications greater than $0.5\times$ (1:2), an SLR is mandatory. But here are some suggestions for close-up photography with a rangefinder camera.*

Beyond 3 feet (0.9 m) or so, parallax, the difference between what a camera lens sees and what a rangefinder or simple viewfinder window sees, is relatively insignificant. Closer than that, the discrepancy becomes increasingly problematical, as shown in the illustration on p. 9.

Rather than fight or compromise the opposing views, it is easier to disregard one. The solution is to abandon the viewfinder and compose and set object distance with either a ruler, or preferably with a wire framing device (p. 50).

The numbers in the table on p. 44 are the data necessary for both composing and focusing with a ruler, and for building the wire frames. The wire frames are really much preferred for convenience and for accuracy, but for occasional work, a tripod, a few plus-lenses, and a good ruler will work well, *if you are careful and accurate.* But accuracy is a must; shallow depth of field in close-up situations, slight discrepancies in focal-length tolerances between actual equipment and data in the table, and varying spacing between prime and supplementary lens can contribute to unsharp images. The use of small apertures like $f/11$ or $f/16$, for greatest depth of field and therefore greatest focusing tolerance, is mandatory.

*Owners of M-series Leicas can obtain Leica Visoflex accessories that will convert their rangefinder camera into a very fine SLR.

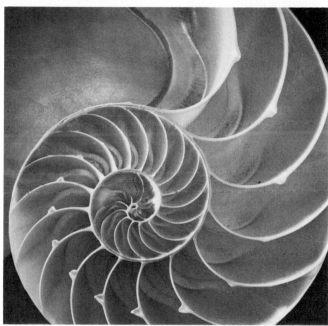

With a little patience, it is definitely possible to use supplementary close-up lenses with cameras lacking SLR viewing—at least up to about 0.5× (1:2). Careful "aiming" of a tripod-mounted camera, and use of a ruler for exact measurements (Table 3-1) of the field of view and the distance between plus-lens and subject (*upper left*) produced the photograph of the chambered nautilus (*lower left*). (The squid-like creature lives in the outermost chamber. As the animal grows, successive chambers become too small and are closed off; the gas-filled cells give the occupant buoyancy. Edward Weston made a number of eloquent photographs of the nautilus shell.) *Upper right:* Wire frames (next page) provide a second method of photographing close up without SLR viewing. *Lower right:* A centipede has been "captured" with such a frame and on-camera electronic flash.

An alternative to measuring lens-to-subject distance, or using wire frames, is to place a piece of ground glass (available from Kodak dealers) or even household wax paper on the film-plane tracks in the back of the (empty) camera. The image can be carefully composed and focused on this ersatz viewing screen, the film inserted (after removing the temporary screen), and exposures made. Of course subject and camera must be rigidly fixed, and only one magnification or

Here's a good method to check the positioning and focus of wire frames on a non-SLR camera. Illustrator's frosted acetate, Kodak diffusion sheeting, or even household wax paper, is laid across the film tracks for a screen, while a magnifying loupe is placed on top to examine the image. Set the lens at its widest aperture, while the shutter is kept open by setting it to "B" and using a locking cable release.

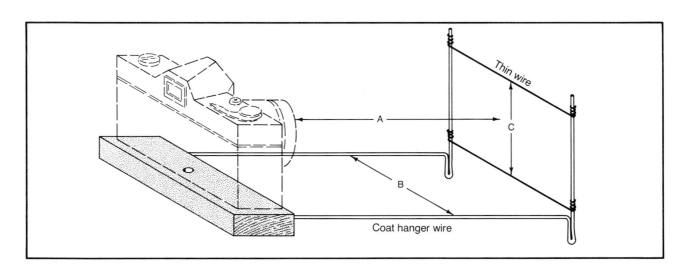

Table 3-2

DIMENSIONS OF WIRE FRAMES FOR USE WITH SUPPLEMENTARY CLOSE-UP LENSES ON 35 mm CAMERAS WITH 50 mm LENSES

| Supplementary Close-Up Lens (Diopters) | Dimensions for Camera Lens Set at 3½ ft (1 m): | | | | | |
| | A | | B | | C | |
	(in.)	(cm)	(in.)	(cm)	(in.)	(cm)
+1	20⅜	51.8	14	35.6	9⅝	24.4
+2	13⅜	34.0	9½	24.1	6⅜	16.2
+3	10	25.4	7	17.8	4⅞	12.4
+4	8	20.3	5⅝	14.3	3⅞	9.8
+5	6½	16.5	4¾	12.1	3¼	8.3
+6	5⅝	14.3	4⅛	10.5	2⅞	7.3
+8	4¾	12.0	3¼	8.3	2¼	5.7
+10	3⅞	9.8	2¾	7.0	1⅞	4.8

Note: Use apertures of *f*/11 or *f*/16. Potential errors exist due to the vagaries of optical and mechanical tolerances; take test photographs before attempting critical work. See text for further details.

image size is obtainable until the film is removed and the screen reinserted. But if you are photographing a large number of similar-sized objects, such as 8″ × 10″ (20 × 25 cm) photos for conversion into slides, this is an ideal procedure. It may also be used to check the accuracy of the wire frames after they are inserted into their wooden block supports.

The wire frames work well if they are carefully made and centered, and if they are used with lenses stopped down to the smallest aperture. They are very good for fieldwork, particularly with flash. Some nature photographers have even made them for SLR cameras. When photographing a moving insect, focusing through the lens becomes almost impossible, but the wire frame outlines the in-focus area, which can be observed without looking through the camera.

The Eastman Kodak Company makes a specially modified Instamatic camera that is available with a set of close-up lenses and factory-made frames. It uses 126 cartridge film and flashcubes or electronic flash for illumination. It is a convenient system for producing informal close-up pictures and slides in classrooms and labs; magnification up to 0.3× is possible. Nikon produces similar wire frames and corresponding plus-lenses for the Nikonos underwater camera—a fine system for deep (and rainy) close-ups.

Kodak's version of a simple close-up camera with a mechanical framing/focusing structure is their Ektagraphic Visualmaker®. It uses 126 cartridge film, has electronic flash, and is supplied with two frames and corresponding plus-lenses for covering 3″×3″ (7.6×7.6 cm) and 8″×8″ (20×20 cm). Though limited by its two fixed magnifications, the Visualmaker is simple to operate and is a good choice for classroom preparation of slides of artifacts and pictures in books.

PERSPECTIVE DISTORTION

You may have seen the perspective distortion apparent in close portraits taken with a normal lens; noses and chins appear disproportionately large, much to the consternation of the subject's mother. This is due to the fact that the foreground objects are, in proportion to the overall scene, considerably closer to the lens than the middle and background objects.

Similar perspective distortion occurs in all close-up photography done with normal or wide-angle lenses, and, in fact, the effect grows with decreasing subject distance. It is always present in photographs taken with supplementary close-up optics on normal focal-length lenses because, as mentioned earlier, the combination of those two lenses effectively produces a shorter-focal-

length (wide-angle) optic. Most often the distortion is unimportant—certainly it should not inhibit you in the least unless you are doing critical scientific recording. In most cases, it doesn't matter, and when photographing flat objects, such as slides, leaves, cloth, and walls, there is no distortion at all. However, for three-dimensional objects, the foreground segments may appear disproportionately large and exaggerated.

In conventional portraiture, noses and chins are cosmetically compressed by the use of longer-focal-length prime lenses. Since supplementary close-up lenses can also be used with telephoto lenses, the same corrective results, with reestablishment of proper-looking perspective, are possible in close-up photography.

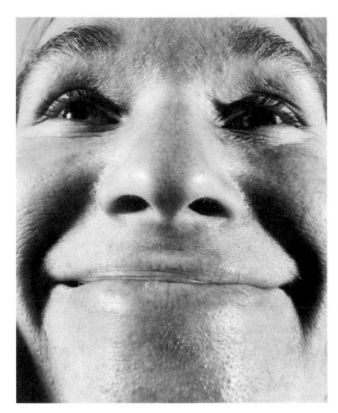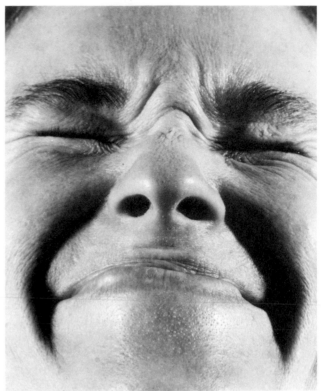

As in conventional photography, perspective distortion occurs if wide-angle—and even normal—lenses are used relatively close to the subject. These portions close to the lens appear disproportionally large; sections farthest from the lens look too small. Note the large chin and broad nose at left, taken with a 28 mm lens, compared to a more "natural" rendering at right shot with a 135 mm telephoto. Such distortion may be exploited intentionally, if a short working distance is not a problem, or avoided for accuracy.

SUPPLEMENTARY CLOSE-UP LENSES USED ON WIDE-ANGLE AND TELEPHOTO LENSES

Plus-lenses are not restricted to use on normal-focal-length lenses. They can be used on wide-angles, but the laws of optics are such that they provide only a minimal increase in magnification, while introducing considerable distortion and image degradation. Plus-lenses are particularly useful on longer-than-normal-focal-length lenses, because not only do they produce reasonable quality images with the desired magnification, but they do it with proportionately more working room.

In nature work, especially, the ability to produce the required magnification from safe working distances is highly desirable, if not at times mortally imperative. A nearsighted frog might be

considerably more cooperative if camera and photographer do not disturb his or her lily pad. Venomous snakes, bees, fire ants, tarantulas, and other potentially misanthropic creatures are best photographed from a conservative vantage point. A long prime lens with an appropriate supplementary close-up lens will provide the extra space that can often spell the difference between success and failure, or even prevent personal injury.

There are other situations in which closeness between the camera and the subject is not always desirable. For example, under studio conditions, space must be left for lights. If the camera is too close to the subject, the lighting has to

The advantage of longer-focal-length lenses in close-up photography is illustrated at left. The right-hand camera has a normal 50 mm lens fitted with a +6 and a +4 (= +10) supplementary close-up lens, for a magnification of 0.5× (1:2). Working room, **W**, between lens rim and subject is a skimpy 4 in. (10 cm). However, **W** is directly proportional to prime-lens focal length. Therefore, the 105 mm lens on the left-hand camera mated to a +4 supplementary also provides 0.5×, but leaves slightly over 8 in. (20 cm) of working room, *double* the figure for the 50 mm lens. In close-up photography, additional working room is almost always an asset, whether the space is needed for lighting equipment, access to inconveniently situated subjects, or for a safety barrier between misanthropic creatures or subjects with unpleasant breath. It is very important to note that *regardless of the focal length, all lenses provide the same depth of field at the same magnification and* f-*stop*.

Table 3-3
MAGNIFICATION OBTAINED FROM SUPPLEMENTARY CLOSE-UP LENSES
USED WITH WIDE-ANGLE AND TELEPHOTO LENSES FOR 35 mm CAMERAS

Prime Lens Focal Length (mm)	(m)	Supplementary Close-Up Lens (Diopters)	Magnification, m, with Prime Lens Set at 6½ ft (2 m)	Field of View (in.)	(cm)	Working Distance, W (in.)	(cm)
28	0.028	+4	0.13× (1:7.7)	10⅝ × 7¼	27.1 × 18.5	8¾	22
		+5	0.16× (1:6.3)	9 × 6	22.6 × 15.0	7⅛	18
		+10	0.33× (1:3.0)	4⅜ × 2⅞	11.0 × 7.3	3¾	9
35	0.035	+3	0.13× (1:8.0)	11⅜ × 7½	28.8 × 19.2	11¼	28
		+5	0.20× (1:5.0)	7¼ × 4⅞	18.4 × 12.3	7⅛	18
		+7	0.27× (1:3.7)	5¼ × 3½	13.4 × 8.9	5¼	13
105	0.105	+1	0.18× (1:5.6)	8 × 5¼	20.5 × 13.3	26¼	68
		+2	0.28× (1:3.6)	5 × 3⅜	12.9 × 8.6	15¾	40
		+4	0.50× (1:2.0)	2¾ × 1⅞	7.1 × 4.7	8¾	22
		+5	0.62× (1:1.6)	2¼ × 1½	5.8 × 3.9	7⅛	18
135	0.135	+½	0.16× (1:6.3)	8⅞ × 6	22.5 × 15.0	39⅜	100
		+1	0.23× (1:4.4)	6¼ × 4	15.8 × 10.4	26¼	67
		+2	0.37× (1:2.7)	3⅞ × 2½	9.7 × 6.5	15¾	40
		+3	0.54× (1:1.9)	2⅝ × 1¾	6.7 × 4.4	11¼	29
200	0.200	+¼	0.19× (1:5.3)	7⅝ × 5	19.3 × 12.6	52½	133
		+½	0.25× (1:4.0)	5⅝ × 3¾	14.3 × 9.6	39⅜	100
		+1	0.36× (1:2.8)	4 × 2⅝	10.0 × 6.7	26¼	67

Notes: All data are approximate and depend on vagaries of optical and mechanical tolerances. Apertures of *f*/8 and smaller are recommended for satisfactory image definition. Use of any camera except an SLR is *not* recommended.

enter at very shallow oblique angles, causing deep shadows in three-dimensional objects. More room between camera and subject allows for the lights to be placed closer to the camera axis. This is further discussed in Chapter 8, Lighting.

Selection of the appropriate close-up lens is usually made by trial and error, a reasonable approach with an SLR camera. However, to save considerable time, the magnification and working distance for many camera lens/supplementary lens combinations is found in the table on the preceding page. The magnification can also be easily determined by dividing the focal length of the camera lens by the focal length of the supplementary lens. The table on p. 44 provides the conversion from power in diopters to focal length in millimeters.

$$m = \frac{\text{Focal Length of Camera Lens}}{\text{Focal Length of Supplementary Lens}}$$

This simple division provides the approximate magnification when the camera lens is focused at infinity. Setting the camera-lens focusing scale closer than infinity will result in slightly greater magnification, as indicated in the table on p. 52. If an *exact* value of **m** is required, temporarily placing a ruler in the scene, as described in the illustration on p. 23, will provide accurate data.

Since plus-lenses are sold and marked in diopter values, the last equation is easier to use if it is written in terms of diopters, **D**. Remembering that the power in diopters is equal to the focal length *(in meters)* * divided into one, we get

$$m = (D) \times (\text{Focal Length of Prime Lens, in Meters})$$

Plugging various combinations of prime and plus-lenses into this formula, one finds, as noted earlier, that very low magnifications result from supplementary close-up lenses used in combination with wide-angle (short-focal-length) lenses. This is shown in the table on p. 53. But the illustration on p. 55 graphically shows that considerable magnification ensues even when low diopter supplementary lenses are used with long-focal-length prime lenses.

Conversely, if prime lenses are changed, but the magnification is held constant by varying the power of the plus-lens, the working distance *increases* in proportion to the increase in prime-lens focal length, as shown at the top of p. 53. The additional working room obtained from long lenses is apparent from this illustration and from Table 3–2 on p. 53.

The rapid magnification increase caused by the addition of plus-lenses to telephotos, and the need to keep **m** below 0.5× for good image definition require the use of very low-dioptric-power supplementary lenses, including +¼ and +½ for the longer lenses at low magnification. If you happen to have a long lens, try these attachments; you will be pleased with the results if medium to small apertures are used.

Some relatively recent "close-focusing" telephoto and "macro-focusing" zoom-telephoto designs permit focusing over the range from infinity to a near distance that provides a reproduction ratio as high as 1:3 (0.3×) or more; see Chapter 5, "Macro" and Close-Focusing Lenses. Such a continuous range is convenient, especially if you are inclined toward close-up photography. But if you already have an "old" telephoto, you can add on the close-focusing capability in the form of plus-lenses. The illustration p. 56 shows that similar quality, if not convenience, can be had for a lot less money if you use small apertures with your current optic and a close-up lens.

*If the focal length of the camera lens is given in millimeters, as it usually is, just multiply it by 1 m/1000 mm to get the equivalent in meters. For example, a 135 mm camera lens has an equivalent focal length in meters of:

$$(135 \text{ mm}) \times \frac{1 \text{ m}}{1000 \text{ mm}} = 0.135 \text{ m}$$

If a +3 diopter lens is then put on that prime lens, which has its focusing ring set at infinity,

$$m = (+3) \times (0.135) = 0.4\times$$

Therefore, that combination would provide a magnification of 0.4× (1:2.5), not quite half life-size.

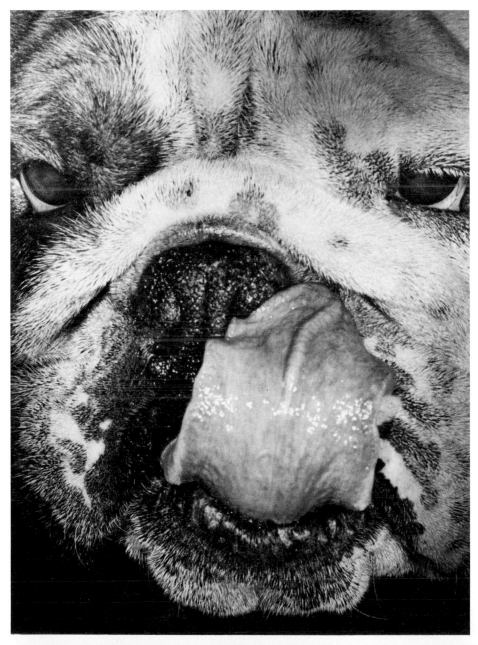

The combination of a telephoto optic and a supplementary close-up lens provides a good, inexpensive method of working up to half life-size at comfortable working distances. For beginning nature photographers, such combinations are recommended. And since many photographers already have, say, a 135 mm lens, the additional investment is only a few dollars. However, medium-to-small apertures must be used for better than "acceptable" image quality. The picture at left of an asthmatic-sounding English bulldog shows that proper use of this combination—*f*-stop was *f*/11—produces excellent results. To bring magnification for this photo to about one-quarter life-size, $0.25\times$ (1:4), from the near limit of $0.1\times$ (1:10) fixed into the author's standard 135 mm telephoto, a +1 supplementary optic was used. This long-focal-length prime lens was chosen to prevent the photographer from being slobbered to death. *Below:* Two cameras indicate the relative working distances of a 135 and a 50 mm lens when both are equipped with appropriate plus-lenses to produce a magnification of $0.25\times$ (1:4). The longer-focal-length optic provides over 2½ times the working room.

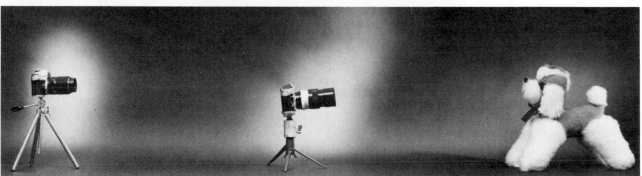

A lobster serves as a "target" to compare the resolution capabilities of three long-focal-length, close-focusing lenses at $m = 0.25\times$ (1:4) and $f/8$. The full frame negative is directly above. Sections of the center and corner of a frame produced by each lens were enlarged 12 times and appear in the center and right column, respectively. *Top row:* Prints from a conventional 135 mm $f/2.8$ Nikon telephoto with a $+1$ supplementary lens; $f/16$ would have improved results significantly. *Center row:* Results from a 135 mm $f/2.5$ Vivitar close-focusing telephoto, specifically designed to produce well-resolved images from infinity to $m = 0.25\times$ (1:4). *Bottom row:* A "macro" lens—here a 105 mm $f/4$ Nikon—designed primarily for close-up photography produced the sharpest results. A close second in performance was the Vivitar, though unlike the "macro," its limit is $0.25\times$ (1:4). The top row does finish third, but this was a severe test, and what price glory.

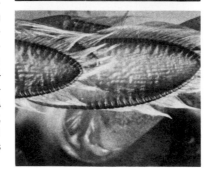

56

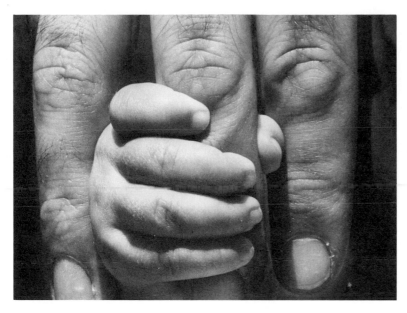

Though the resolution test on the facing page displays the limitations of a conventional lens/plus-lens combination, the two photographs of these less-demanding human subjects indicate the potential of that combination under less severe conditions. Optimum performance from these accessories was sought by photographing in direct sunlight, permitting an f/16 aperture to be used. *Far left:* A 135 mm telephoto was chosen so that the author could photograph his own strange toes. Without the addition of a +1 supplementary lens, the feat would have been impossible. *Near left:* The 105 mm lens used for this photograph normally stops at **m** = 0.15× (1:7). Addition of a +3 supplementary increased **m** to 0.33× (1:3). Small hand belongs to baby on p. 40; larger hand to her daddy.

SUMMARY

Supplementary close-up lenses are inexpensive, simple, very useful devices that attach to the front of a camera's prime lens like a filter. Their strength and magnification ability is expressed in diopters, with the +1, +2, and +3 lenses covering the magnification range (on a 50 mm prime lens) of 0.1×–0.3× (1:10–1:3). The higher strengths, +9 and +10, provide up to half life-size (0.5× or 1:2). Plus-lenses may be stacked to increase power; the diopter numbers are additive, so that a +3 used with a +2 equals a single +5. Place the higher strength supplementary lens closer to the prime lens when stacking; it is best not to combine more than two, or at the most, three. In all cases, the convex side of the plus-lens must face the subject.

If close-up photography is done with a rangefinder camera or with a simple camera having a viewfinder window not providing through-the-lens viewing, drastic differences, called parallax, will occur between what the viewfinder sees and what the prime lens sees. A simple wire-framing device may be constructed for such cameras to outline the field of view seen by the lens, and to establish correct working distance for proper focus. Alternatively, a tripod and careful measurement with a ruler, using data from the table on p.44, will be satisfactory for some work.

No exposure compensation is necessary when using supplementary close-up lenses.

Plus-lenses work well on telephoto lenses. In such cases, a low-diopter supplementary lens provides considerably more magnification than the use of that same supplementary lens on a normal-focal-length prime lens. More importantly, proportionally more working room is available in front of a telephoto/plus-lens combination at the same magnification. The use of a longer lens also prevents perspective distortion, which is sometimes a problem when photographing three-dimensional objects.

Supplementary lenses do unbalance the optical corrections of the prime lens; the edges of the image suffer considerably more than the central portion of the frame. However, very acceptable results can be obtained by using medium to small apertures: f/8–16. Magnification should be kept below half life-size, i.e., 0.5× (1:2). For critical, uniform sharpness when photographing flat documents, maps, artwork, etc., above 0.3× (1:3), supplementary close-up lenses may or may not provide acceptable sharpness; much depends on the quality and optical design of the prime lens. You are advised to do a test with your equipment and special subject matter. Get a set; they are extremely useful!

So many of Nature's creations reveal their wonderful delicacy, their intricacy, their artistically balanced morphology only at fairly high magnifications. This contour feather from the underside of a goose was photographed at **m** = 3× (3:1); it appears here 21 times life-size. Though simple plus-lenses expedite magnifications up to about life-size, extension tubes and bellows are required for the *extreme close-up* and true *macro* ranges of photography.

4 Extension Tubes and Bellows

It has just been shown that supplementary close-up lenses provide an inexpensive, convenient method of achieving magnifications up to about half life-size in all situations except where maximum possible edge and corner sharpness are required. A second technique that provides close focusing is extension of the camera lens away from the film plane by insertion of extension tubes and/or bellows between the camera body and prime lens. The illustration on p. 36 outlines the optical principle. With such extension, magnification as high as $20\times$ (20:1) and greater is feasible; and when coupled to specially designed lenses, or even to conventional lenses "reversed," resolution across the entire field can be superb.

Because extension tubes and bellows are somewhat unfamiliar and look a bit formidable, some people are hesitant to use such "sophisticated" equipment. But in many cases they are no more difficult to use than supplementary close-up lenses, and their capabilities and the world they can open are truly impressive.

The shorter extension tubes duplicate the magnification range available from supplementary close-up lenses, which is about 0.1–$0.5\times$ (1:10–1:2). The longer ones extend beyond that range. When used with a 50 mm lens, extension tubes stretch to life-size the $0.1\times$ (1:10) magnification found at the near-focusing limit of a conventional optic. Used with shorter-focal-length (wide-angle) lenses, higher magnification ratios, up to 2:1 ($2\times$), and even 3:1 ($3\times$) are practical if the lens is reversed (p. 63).

MAGNIFICATIONS GREATER THAN LIFE-SIZE

For true *photomacrography* (greater than 1:1 [$1\times$] image ratios), a considerable amount of lens extension is required, and it is here that the bellows finds most of its use, providing a range from about $1\times$ (1:1) to $4\times$ (4:1) with a normal lens, and up to $20\times$ (20 times life-size) when used with short-focal-length lenses.

The higher magnifications do require more care in setup and in attention to operating details, but the exploration and recording of the small, busy world behind a magnifying glass is well worth the effort. Too many people pass up this relatively unexplored area due both to a lack of awareness of its limitless possibilities, and to doubts in their own abilities and the capacity of their equipment. Inspiration gained through viewing photographs taken at magnifications greater than life-size, and a few hours spent poking around with a bellows on a camera should quickly eliminate the first obstacle. As far as your own abilities and the capacity of your equipment are concerned, if you can operate a camera reasonably well and have access to a tripod, you can learn to take glorious photographs at 2, 5, and even 10 times life-size. But you do need patience . . . and some of the following information.

Depending on lens focal length, extension tubes, either singly or in combination, are required for magnification in the range from about 0.3× to 1× (1:3 to 1:1). Used with *reversed* normal and wide-angle optics (p. 63), magnifications as high as 2× (2:1) and 3× (3:1) are possible. *Top:* This photograph shows the position of an extension tube between the lens and camera body. Male and female mounts on the tube must, of course, match fittings on lens and camera body. In addition to the tubes made by manufacturers for their own lines, Spiratone (shown here) and Vivitar have models for almost any camera. *Center:* Pentax's unique variable-thickness extension, available for their cameras and all universal screw-mount lenses. However, automatic diaphragm operation is sacrificed. *Bottom:* Tubes frequently come in sets of three, as this 25, 18, and 6 mm trio from Pentax. The left-most tube is less expensive, but its lack of a protruding pin indicates manual operation of lens diaphragm will be required—not recommended for fieldwork.

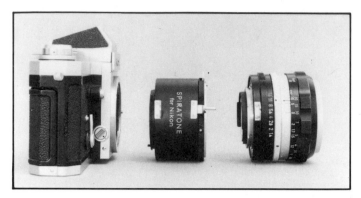

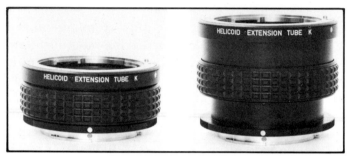

EXTENSION TUBES

The above illustration shows an extension tube and its relative position on a camera. The tube, or *ring* as it is also called, is basically a metal donut and has no glass elements. Tubes typically come as a set containing three different lengths. Each tube, individually, or in combination with others in the set, provides focus in some portion of the close-up range. Although each tube has a fixed length, the usual extension range of the prime lens adds a bit of magnification flexibility to any given lens/tube combination.

For SLR's, both automatic and manual extension tubes are available. The *automatic* tubes retain the automatic diaphragm operation of the prime lens. Just focus and shoot; the lens automatically stops down to the preselected aperture at the instant of exposure. Also retained is the full-aperture, through-the-lens (TTL) metering capability, if the camera is so equipped.

Simple *manual* extension tubes do not provide connection to the internal lens diaphragm pin from the SLR body. Therefore, it is necessary to focus and compose with the lens aperture set wide open, and then manually close the diaphragm to the required *f*-stop just prior to exposure. If a camera has TTL match-needle metering, it will work with a manual extension tube; however, if that metering system is of the popular full-aperture type (i.e., the lens normally remains wide open as the meter needle is centered by aperture or shutter-speed adjustment), the viewfinder will become darker when setting the diaphragm to smaller apertures.

Unfortunately, with manual tubes, if the camera is not on a tripod, the chances of getting

a sharp picture are slim. Close focusing must be accurate to within a fraction of an inch, yet it is almost guaranteed that while the photographer adjusts the aperture ring to close it down to the correct *f*-stop, he or she will move the camera considerably more than that fraction of an inch. Manual tubes do make a good, inexpensive second set when very long extensions are required for high magnification. In such situations, a fixed camera support is a necessity, so that the focusing problem just mentioned will not be a factor.

Automatic tubes, however, eliminate these problems. For fieldwork, where quick camera operation is mandatory for capturing elusive creatures or swaying fauna, the automatic tubes are a necessity. In fact they are strongly recommended for *all* work. At the time of this writing, a fully automatic set of three (for almost any SLR) could be had for $40–90, depending on camera type and brand of extension tube.

The rear end of an extension tube has a male flange or thread that matches the camera; the front requires the female flange. Virtually all manufacturers of interchangeable-lens cameras provide extension tubes for their own brands. In addition, Vivitar and Spiratone, among others, make sets for all the major cameras. (Orange juice cans and toilet-paper tubes, along with plenty of black tape, have been successfully used for extension tubes. If you are adventuresome and careful, and if you line the inside with black velvet for protection against flare, results will be gratifying, although convenience may suffer.)

Usually, with a given prime lens and a typical set of three tubes, small gaps will exist at specific magnifications in the range between $0.1 \times$ (1:10) and $1 \times$ (1:1). For example, suppose a 50 mm lens focuses to 22 inches (56 cm); this lens, used with a set containing an 11 mm, 18 mm, and 36 mm tube can magnify all the way up to $1.3 \times$ (1.3:1). But the correct length of extension for $0.10–0.20 \times$, $0.45–0.58 \times$, and $0.84–0.96 \times$ cannot be assembled from these components. The vast majority of times these small gaps will not be missed. But if a particular subject must be precisely framed, such as the photocopying of artwork for slide production, individual tubes of very short length are available for most cameras to provide the necessary intermediate lengths. Alternatively, a $+1$ supplementary close-up lens on the front of the prime lens, in addition to the extension tube, will nicely fill the gaps.

IMAGE QUALITY WITH EXTENDED LENSES

In Chapter 2, Preliminaries, three reasons were given for a manufacturer's restriction on the near-focusing limit of conventional SLR lenses to a distance that provides approximately $0.1 \times$ (1:10) magnification. The particular reason of concern here is that image quality deteriorates when a lens is used much closer than its design limits. Trying to beat the system by inserting extension tubes between camera and lens, or by attaching supplementary optics to the front of a prime lens, will make that deterioration (called *field curvature*) evident, through fuzzy corners, slightly curved images of straight lines, and unsharp edges.

The higher the magnification, the more these aberrations manifest themselves, and the smaller the aperture required for good results. For magnifications of $0.5 \times$ (1:2), an aperture of $f/8$, and even smaller, is recommended. But if magnification is kept below $0.5 \times$ (1:2), and if small apertures are used, results can be surprisingly good for all but the most critical applications, such as photographing small flat objects or documents where edge-to-edge sharpness, uniformity, and freedom from distortion are needed.

Image quality using conventional lenses with extension tubes and bellows is also very dependent on the optical design of the particular prime lens used. Some lend themselves admirably to close-up work; others, which may be marvelous at far distances, fall apart when they get too close to the subject. For SLR lenses, the slowest available version of a particular focal length will *usually,* but not invariably, perform best on extension tubes; this is especially true at magnifications greater than $0.5 \times$ (1:2). See p. 63.

For example, 50 mm $f/2$ lenses usually give better overall image quality at all apertures than do fast $f/1.4$ or $f/1.2$ lenses. In all cases (except at extremely high magnifications of $2 \times$ and greater, as explained in Appendix C), apertures of $f/11$ or $f/16$ will provide the best possible

A set of extension tubes in my pack made this shot possible during a hike in a California redwood forest. Each mushroom cap was smaller than the tip of my pinky, requiring a 27 mm tube on a 105 mm lens for a 0.3× (1:3) magnification on film. The dramatic lighting resulted from the fact that the mushrooms were growing out into the light from the lower half of a rotting, black log. The small amount of background clutter—mostly white fungus—that did appear on the negative was burned in during printing in the darkroom.

image when conventional lenses are used with close-up equipment. The results will probably be entirely satisfactory, if not superb, for typical three-dimensional subjects that fill only the central portion of the frame.

The performance of a standard lens pressed into service for close-up duty cannot be determined *a priori* by the user in any simple way other than by trying it. The most critical test is a flat subject having lots of fine detail—like crisp new currency—evenly lighted, with the camera on a tripod or solid copy stand, and carefully aligned parallel to the subject. Half a test frame blown up to 5″ × 7″ (13 × 18 cm) or even to 8″ × 10″

(20 × 25 cm) will clearly indicate strengths and weaknesses, especially when compared with other lenses at identical aperture and magnification. But a test like this may be more critical than necessary; photography of three-dimensional objects does not always require superb edge-to-edge sharpness.

Lens designers call the range from 0.5× (1:2) to 1× (1:1) "optically difficult." Conventional lenses generally perform quite poorly at these magnifications. The use of these lenses with supplementary close-up lenses is not recommended for such image ratios. On the other hand, appropriate lengths of extension

Fine engraving lines on a 5 peso banknote again serve as a "resolution target," this time to compare performance at f/8 of three normal-focal-length lenses pushed to **m** = 0.85× (1:1.2) via extension tubes. Each print is the corner of a full frame negative enlarged to 8″×10″ (20×25 cm). *Upper right:* Fast f/1.4, expensive lenses invariably "fall apart" optically when used at high magnification. In close-up imaging, considerably superior performance can be expected from a slower lens (*upper left*), here a 50 mm f/2 from the same manufacturer as the f/1.4. *Lower left:* a 55 mm f/3.5 "macro" lens, designed specifically for close-up photography, serves as a standard. In this case, the slowest lens (smallest maximum aperture) is the best.

tubes will put a conventional lens in the extreme close-up range; but, as noted earlier, image quality is very much dependent on the particular lens design and on subject matter. In any case, an aperture of $f/11$ is more or less a necessity.

For ease of operation, and for really fine image quality in this optically problematic area,

"macro" lenses must be used. They are specially designed for superior performance in the *close-up* and *extreme close-up* ranges, even at large apertures. For the serious practitioner, I strongly recommend them. "Macro" lenses are discussed at length in Chapter 5, "Macro" and Close-Focusing Lenses.

REVERSING LENSES FOR MAGNIFICATIONS GREATER THAN LIFE-SIZE

When a conventional lens is used for magnifications close to life-size and greater than 1:1, a better image is obtained by using extension tubes (or bellows) and *reversing the lens so that its rear element faces the subject.* Standard camera lenses are designed for a *small image* (lens-to-film) *distance* and *a larger object* (lens-to-subject) *distance.* But with a lens of any focal length at magnifications greater than life-size, the image distance is actually *greater* than the object distance. Therefore, by reversing a lens in such instances, the proper distance relationships are reestablished, and image quality is greatly im-

proved. Catastrophic image deterioration will result at magnifications greater than 2 or 3× if the optic is not reversed, as is shown on the next page.

Additionally, the retrofocus design of most SLR normal and wide-angle lenses is such that by merely reversing them with a simple, inexpensive adapter ring (without any extension tubes at all), magnifications slightly greater than life-size automatically ensue.

For example, a typical 50 mm $f/1.4$ lens requires 50 mm of extension to achieve 1.2× (1.2:1) magnification. By simply reversing the

Most normal and wide-angle SLR lenses generate image ratios above life-size *without* extension tubes simply by reversing them front to back. All that is required is an inexpensive *reversing ring* (camera manufacturer, Spiratone, Vivitar, Edmund Scientific). Still greater magnification is achieved by interposing extension tubes (or bellows) between camera and reversed lens (*upper right*).

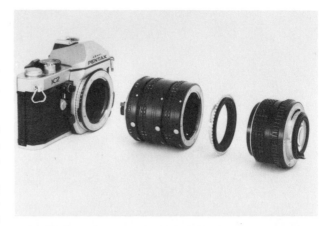

Photographs of a bit of grandmother's old lace clearly display the importance of lens reversal to improve optical performance when magnification goes above life-size. *Below:* A sense of scale is provided by the 25-cent coin in this 0.4× (1:2.5) photo taken at *f*/8 with an unreversed *f*/2 lens. At four-tenths life-size, image quality is excellent. *Center right:* 150 mm of extension did produce a 3× (3:1) image with the unreversed 50 mm lens, but picture quality is "soft", to say the least. *Lower right:* Improvement in resolution is overwhelming when the lens is reversed. And only 95 mm of extension was needed.

lens, the same magnification and better image quality are achieved, and, as an added bonus, the working room is *doubled* from 1½ to 3 inches (4 to 8 cm). The gain in working room will vary, depending on lens design, but the technique of lens reversal for optimum optical performance is valid for all SLR lenses used for magnifications greater than life-size. As can be seen in Chapter 5, "Macro" and Close-focusing Lenses, *this is true even for the so-called "macro" lenses.*

The accompanying table indicates magnification and available working distance from a number of reversed lenses when used singly, and with extensions. You will notice that when reversed, the focusing mechanism of a lens is rendered inoperative, so that there is no opportunity to make small changes in magnification and framing size. That "fine tuning" will have to be done by adding short extension tubes, or, at high magnification, using a bellows which, of course, is adjustable.

Reversal of a lens disconnects the automatic diaphragm and part of the automatic metering capabilities of any camera. Therefore, the camera must be placed on a tripod or copy stand, focused with the lens wide open, and manually closed down just prior to exposure. This is not as much of an additional effort as it sounds; at magnifications greater than 1×, a camera should not be handheld, anyway.

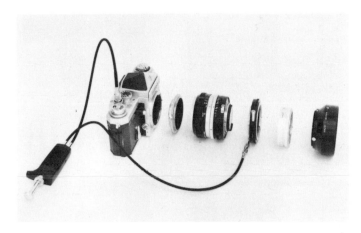

Lens reversal disconnects automatic aperture linkage. For static subjects, this presents no problem, although TTL metering must be operated in the "stop-down" mode. A need to observe changing subjects up to the instant of exposure requires a dual-cable-release system, exemplified by the Nikon components at left. Similar accessories are available for most cameras. Closest to the body is the reversing ring (or it can be preceded by extensions, if necessary). Next is the lens, followed by a special ring having a *female* bayonet for the lens and accepting one leg of a dual-cable release. Cable release and ring activate lens diaphragm when cable plunger—also attached to shutter release—is pressed. The last ring mates lens shade to system.

Table 4-1
TYPICAL CHARACTERISTICS, REVERSED vs. UNREVERSED SLR LENSES

Lens Focal Length (mm)	Extension Tube Length (mm)	Unreversed			Reversed		
		Magnification, m	Working Distance, W (in.)	(cm)	Magnification, m	Working Distance, W (in.)	(cm)
28	0	0.05× (1.0:20.0)	20	51.0	2.32× (2.3:1)	2	5.0
	8	0.25× (1.0:4.0)	2⅞	7.3	2.57× (2.6:1)	1⅞	4.7
	13	0.55× (1.0:1.8)	1½	4.0	2.75× (2.8:1)	1⅞	4.6
35	0	0.07× (1.0:14.0)	20	51.0	1.29× (1.3:1)	2⅝	6.7
	11	0.41× (1.0:2.4)	3¾	9.5	1.64× (1.6:1)	2⅜	6.0
	36	1.09× (1.1:1.0)	1½	3.8	2.40× (2.4:1)	2	5.4
50	0	0.10× (1.0:10.0)	20	50.0	1.13× (1.1:1)	3¼	8.2
	18	0.44× (1.0:2.7)	4⅜	11.0	1.44× (1.4:1)	2⅝	6.7
	36	0.80× (1.0:1.3)	2¼	5.7	1.89× (1.9:1)	2½	6.2
	49	1.09× (1.1:1.0)	1⅝	4.3	2.06× (2.1:1)	2⅜	6.0

Notes: Data are for typical SLR lenses, with focusing ring set at 24 in. (0.6 m); individual lens designs will provide slightly different values. In general, the reversing technique is inappropriate for longer-than-normal SLR lenses.

Nikon and others produce very useful adapter rings that permit their reversed lenses to continue to retain the automatic diaphragm function (see the illustration above).

Most through-the-lens metering systems will work with reversed lenses, but in the "stop down" or "manual" mode: the viewfinder will darken as the aperture is adjusted to center the meter needle. Fully automatic cameras that select *and set* the aperture or shutter speed at the instant of exposure must be placed on "manual." See your camera's instruction booklet and Chapter 10, Exposure.

When reversed, the rear glass element of the lens protrudes, and is dangerously unprotected by any lens mount recess or lens shade. To shield the lens from stray, image-degrading light, and from scratches and accidental bumps—a common occurence when only millimeters from your subject—Nikon, for one, makes a ring (a "BR-3" ring) that fits the back of *their* lenses, or other lenses with Nikon mounts. It shelters the glass, and is also threaded to take 52 mm filters and lens hoods. For other brands of lenses, get the appropriate Spiratone "T-Flange." Filters and hoods may be attached to the T-Flange with tape.

If you do not have any of these rings at hand, a makeshift shade and/or filter holder can be rigged from black tape (Scotch #235 photographic tape is ideal).

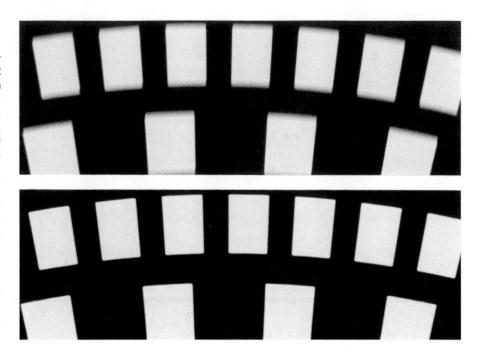

It is timely to mention one particular source of vibration that can manifest itself at high magnifications. *Mirror bounce* is caused when the upward-moving camera mirror comes to an abrupt stop at the top of its swing, just as the shutter opens. Speeds of 1/30, 1/15, 1/8, and 1/4 sec. are particularly prone to the problem on some cameras. Ideally, one should use a camera with a mirror lock-up capability, or electronic flash. An optical encoding disc was photographed at 4× and 1/15 sec. without mirror lock-up (*top*). Locking the mirror up eliminated the unsharpness (*bottom*).

USING EXTENSION TUBES

The usual admonitions concerning careful technique must be heeded, and each becomes more relevant with increasing magnification: (1) Close focusing is very critical. To make the job easier and more secure at high-image ratios, you might consider using the type of relatively inexpensive eyepiece magnifier shown on p. 127 in Chapter 6, Special Equipment and Combinations. (2) Magnified vibration in subject, camera, and/or photographer, and the small apertures required for adequate depth of field and good lens sharpness necessitate a stable tripod, copy stand, or electronic flash at magnifications greater than 0.5× (1:2). If the camera is hand-held below that magnification, use a high shutter speed (at least 1/250 sec.), and brace your body if possible. (3) Use a lens shade whenever feasible to avoid loss of image contrast due to excess stray light (flare).

In Chapter 2, Preliminaries, I mentioned using a camera's mirror lock-up feature, if it is so equipped, to further eliminate mirror bounce as a source of vibration. Because long extension tubes used with short-focal-length lenses can easily produce magnifications as high as 3× (3:1), which in turn magnify the effect of that vibration threefold, it is important here to reiterate the caution. The accompanying illustration shows what can happen if the mirror lock-up isn't used. If your camera does not have this feature, make the mounting of equipment and subject as stable and as solid as possible. That includes use of a *heavy* tripod.

Choice of extension-tube length depends on area of coverage desired in the scene, which translates into *magnification* in the table on p. 67. Two fundamental principles govern that choice:
1. For a given focal length lens, higher magnification is achieved by using longer extensions.
2. For a given length of extension, short-focal-length lenses will provide more magnification than longer-focal-length optics.

Both relationships can be seen from the data in the table on the next page.

The most common way to select the amount of extension required to frame a particular scene is to use the principles just mentioned, and then try different combinations until one works.

Table 4-2

EXTENSION TUBE DATA FOR TYPICAL SLR LENSES ON 35 mm CAMERAS

Lens Focal length (mm)	Extension Tube Length (mm)	Magnification, m, Range	Nominal Working Distance, W, Range (in.)	(cm)
24	5	0.22–0.35	4–2⅜	10–6
	8	0.37–0.48	2¼	6
	11	0.50–0.56	2	5
	15	0.59–0.66	1⅞	3
	19	0.77–0.89	1	2.5
	22	0.90–1.00	½	1
28	5	0.20–0.34	5–2¾	13–7
	8	0.29–0.40	3–2⅜	8–6
	11	0.38–0.53	2	5
	15	0.49–0.64	1½	4
	19	0.69–0.80	1	2.5
	27	0.96–1.10	½	1
35	5	0.14–0.30	8–5½	20–14
	8	0.21–0.38	7–4	17–10
	11	0.30–0.45	4½–3⅛	11–8
	19	0.53–0.71	2¾	7
	27	0.74–0.90	2	5.5
	30	0.85–1.00	1¾	4.5
50	8	0.15–0.26	11–7½	28–19
	14	0.26–0.37	7½–5	19–13
	21	0.42–0.52	3–¾	9.5
	27	0.54–0.63	3	8
	36	0.69–0.79	2½	6
	47	0.92–1.00	1¾	4.5

Lens Focal Length (mm)	Extension Tube Length (mm)	Magnification, m, Range	Nominal Working Distance, W, Range (in.)	(cm)
90	11	0.12–0.25	30–16	77–40
	18	0.21–0.34	19–12	48–31
	27	0.32–0.45	13–10	32–25
	36	0.42–0.54	11–8	27–21
	54	0.62–0.75	8–7	20–17
	81	0.95–1.10	5½	14
105	18	0.17–0.29	28–18	71–46
	27	0.26–0.39	20–15	50–38
	36	0.35–0.47	17–13	42–34
	54	0.53–0.66	12–11	31–27
	81	0.79–0.90	9½–8¾	24–22
	105	1.00–1.10	8	20
135	18	0.14–0.25	44–26	112–66
	27	0.21–0.32	30–22	77–55
	47	0.36–0.47	20–17	51–43
	74	0.55–0.67	15–13	38–33
	102	0.78–0.88	12–11	31–28
	120	0.90–1.00	10	26
200	18	0.10–0.23	95–44	242–112
	27	0.14–0.28	70–34	178–86
	47	0.24–0.38	46–32	116–80
	102	0.52–0.69	28–23	71–59
	150	0.77–0.94	23–20	58–52
	200	1.00–1.20	20–18	52–46

Notes: A. Data are actual measured values for representative SLR lenses in focusing mounts that provide a range without extension tubes of approximately ∞ to 0.1× (1:10).

B. Tube lengths were those available to the author; other brands vary somewhat in thickness, producing proportional differences in magnification.

C. W was measured from the subject to the front of the lens rim, and will also vary somewhat, depending on manufacturer's design.

D. Some lenses may provide poor definition when used close-up; see text for details.

A second method is to use a ruler and some division (as per Chapter 2, Preliminaries, p. 20) to determine **m**, appropriate magnification for the subject; then switch to the table on p. 67 and select a lens/extension-tube combination that will work. (Extension tubes and bellows usually come with data sheets containing information similar to this table.)

A third way to select the amount of extension required is to use the simple relationship that expresses the required extension distance, **E.D.**, in terms of the magnification desired, and the focal length, **F.L.**, of the lens in use. This expression holds true for a lens with its focusing collar set at *infinity* and mounted in the conventional front-forward position:

$$\text{Extension Distance} = \\ (\text{Magnification}) \times (\text{Focal Length}), \text{ or}$$

$$\textbf{E.D.} = \textbf{m} \times \textbf{F.L.}$$

If the lens' focusing ring is not set at infinity, thereby providing slightly more extension, somewhat greater magnification can be obtained. And if the lens has been reversed at high magnification to improve image resolution, the exact image size will be anywhere from 20–100 percent smaller or greater than calculated from the aforementioned formula. The exact amount depends on lens design, focal length, magnification, reversing-ring thickness, and even how deeply the lens is recessed in its mount. The best thing to do is to try it, and if an exact magnification figure is required, use the ruler technique suggested in the illustration on p. 23, in Chapter 2, Preliminaries.

Examples: An extension tube that is 50 mm long will produce a $1\times$ (life-size) magnification when placed behind a 50 mm lens set at infinity. (With the lens set at 20 inches (51 cm), $\textbf{m} = 1.1\times$ or 1.1:1.) That same 50 mm ring will generate a twice life-size image, $2\times$ (2:1), if placed behind a 25 mm lens set at infinity, and only a half life-size image, $0.5\times$ (1:2), when installed on a 100 mm optic.

From the equation for extension distance, **E.D.**, comes an interesting observation: If a lens (set at infinity) of a particular focal length has extension tubes equal in size to that focal length added to it, a $1\times$ (1:1) magnification will always result. Add tubes two focal lengths long, and $2\times$ (2:1) ensues; add extension distance equal to three times the focal length, and $3\times$ (3:1) results; and so on. So to get, for example, a magnification of $2\times$ (2:1) with a 105 mm lens, over 8 inches (210 mm) of tubes or bellows are required. (Most extension-tube sets offer little more than 50 mm.) But if a 28 mm lens is used, only slightly more than 2 inches (56 mm) are necessary.

EXTENSION WITH VARIOUS FOCAL LENGTH LENSES

We can see in Table 4–2 on p. 67, that frequently a number of extension tube/prime-lens combinations provide almost identical magnification. The obvious question is, why use one combination over another? To answer that, consider the *differences* between two such combinations:

(1) *Working room*— This is an important consideration if you cannot, or should not, approach the subject too closely, or need room for lights or other equipment. As was discussed with supplementary close-up lenses used on telephoto optics, *at any given magnification, long lenses provide proportionately more working room than their shorter-focal-length counterparts.* The same holds true for extension tubes, and can be seen in the illustrations on pp. 70 and 71.

(2) *Perspective*—Exaggerated foregrounds and compressed perspective occur with wide-angle and telephoto lenses, respectively, as shown in the illustration on p. 52, in conjunction with the discussion on use of various focal length prime lenses with supplementary close-up lenses. In most close-up situations, perspective is not a major consideration; whatever happens, happens. However, for scientific recording purposes, or for advertising integrity—or lack of it—the apparent perspective of a scene may be a consideration. Also see pp. 70 and 71.

A *third* difference can be added if one takes into account the optical performance of various lenses when used in particular close-up ranges. For example, the performance of some wide-angles is notoriously poor above $0.2\times$, as are

The mating of a 135 mm telephoto lens and a 27 mm automatic extension tube provided just the right combination of magnification—0.3× (1:3)—and working distance —22 in. (56 cm)—to "capture" this flitting butterfly. Lepidoptera seemed particularly sensitive to the proximity of the lens, invariably fleeing in a most annoying fashion at the instant he/she came into focus in the viewfinder. A longer lens, say a 200 mm, would probably have eliminated that problem by adding 50% more working room between lens and skittish butterfly (47 mm of extension tubes would be required on a 200 mm lens to achieve the same magnification). *Below:* Crashing through the Everglades with little regard for personal safety, the intrepid photographer stalks the wild butterfly. Late afternoon, summer sunlight provided sufficient illumination to dispense with flash and to create translucent backlighting. The pistol grip/ cable-release mount permitted more stable support for the handheld shutter speed of 1/250 sec., particularly when focus was achieved by moving camera and fixed lens back and forth, rather than by rotating the lens barrel.

super-fast $f/1.2$, 50 mm lenses. Photographically comparing the results of one with the other is the only proper test.

If working distance is not as important a consideration as amount of magnification or available extension, then, as noted earlier, one should consider the following: A short lens on a given length of extension will provide proportionally more magnification than will a longer-focal-length lens used with that same extension. Therefore, high **m** can be achieved by using wide-angle lenses on relatively short tubes.

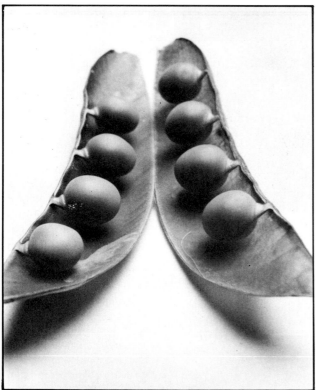

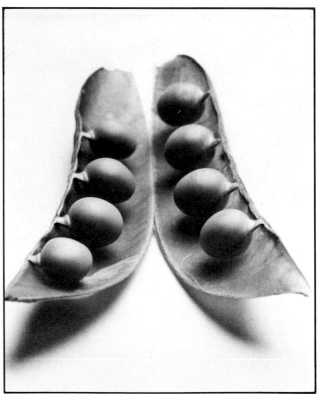

These eight photographs should put to rest the unfounded belief that wide-angle lenses have great depth of field, while telephoto optics generate shallow depth. From left to right, the pea pod was photographed with a 28, 50, 105, and 200 mm lens, respectively. Each print represents the entire negative, exposed at f/8 and at a magnification of 0.35× (1:2.8), achieved through use of appropriate length extension tubes on each lens (see Table 4-2). In all cases,

focus was on the second pea from the front in the right half of the pod. Notice that *with magnification and aperture the same for each image, depth of field is identical in all four pictures, regardless of focal length.* In the photo taken with the 28 mm lens, the last pea in each row is out of focus; that condition is the same in the picture from the 200 mm telephoto. Therefore, close-up photographers, who are always searching for some hidden cache of

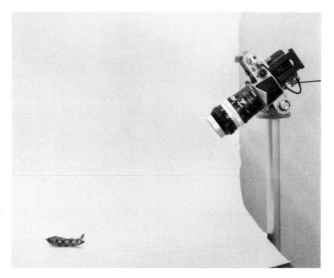 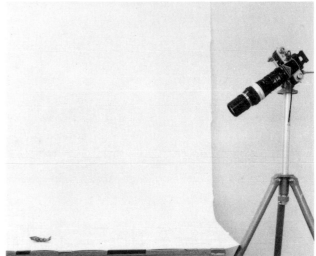

additional depth of field, will not find it in the optics of a wide-angle lens. Rather, they should choose a focal length that provides the required magnification with the extension at hand, or achieves the necessary working distance. The top row of pictures does show the dramatic range of lens-to-subject distances for the same magnification, varying from a crowded 2½ in. (6 cm) for the 28 mm optic to a roomy 34 in. (86 cm) in front of the 200 mm telephoto.

What is different, of course, is the perspective. Apparent separation of the front of the two pod halves, and the spacing between peas is markedly different between the two extremes of focal length. Shorter-focal-length optics will always make foreground objects appear larger—an optical effect that may be exploited for creative purposes, or avoided in the name of accurate presentation.

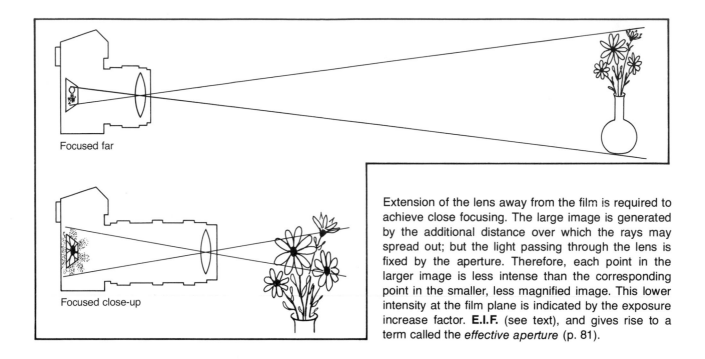

Focused far

Focused close-up

Extension of the lens away from the film is required to achieve close focusing. The large image is generated by the additional distance over which the rays may spread out; but the light passing through the lens is fixed by the aperture. Therefore, each point in the larger image is less intense than the corresponding point in the smaller, less magnified image. This lower intensity at the film plane is indicated by the exposure increase factor. **E.I.F.** (see text), and gives rise to a term called the *effective aperture* (p. 81).

EXPOSURE CORRECTION FOR LENS EXTENSION

It turns out that the exposure you *think* you are getting is *not* the exposure you *actually* get when you extend a lens forward *with tubes or bellows.* If a camera is equipped with through-the-lens (TTL) metering, then the reduction in image brightness at the film plane due to the "overextended" lens is automatically sensed and compensated for. Therefore, the following explanation is not relative unless: (1) you use a handheld or on-camera, but not a TTL meter; (2) your work involves high magnification—4× and greater—where, due to a very long bellows-extension, light intensity at the film plane may be so low as to render some TTL meters inoperative.

The intensity of light at the film plane is determined by: (1) the brightness of the scene, (2) the diameter of the lens aperture that controls the amount of light getting through the lens, and (3) the distance between that lens aperture and the film (the approximate image distance). As can be seen in the accompanying illustration, the greater the image distance is for a given lens, the more the light captured by the lens spreads out. With a great amount of exten-

sion, one does get a larger image, but the *amount of light entering the aperture does not change.* Therefore, each portion of that large image is less intense than it would be if it were small.

A normal lens moves only a few millimeters when focusing from infinity to its near limit; this has little effect on the image intensity. But, as shown in the accompanying illustration, the amount of extension required to focus in the *close-up* and *macro* ranges becomes disproportionately large as the magnification is increased. At a magnification of only 0.2× (1:5), the light loss at the film plane is equivalent to slightly over half an *f*-stop, already a significant factor for color slide film. At full life-size, 1:1 (1×), the intensity drops by *two* complete *f*-stops. It is obvious that if the drop in film-plane light intensity is not sensed by a TTL meter, or if appropriate correction is not made with a manual meter reading, results could be catastrophic.

Again, please note: Supplementary close-up lenses *do not* require this so-called bellows-extension correction factor because there is no change in image distance or in effective aperture with the powers normally used.

Light falloff at the film plane due to lens extension will lead to serious underexposure, unless compensation is made in lens and/or shutter settings. TTL meters, sensing light intensity at the film plane, automatically correct for any drop in illumination. Lacking TTL motoring, oorrootion muot be made using the equation on p. 74, or the simple scale or table on p.75. An example of failure to correct for **E.I.F.** is shown above: The negative, shot at **m** = 1× (1:1), is two stops underexposed. The light yellow corn is rendered with **E.I.F.** compensation in the lower photo.

DETERMING LENS EXTENSION EXPOSURE FACTOR*

Many texts and manuals have a profusion of equations that relate lens focal length, image and object sizes, image and object distances, and lens aperture to exposure increase factors. But, in fact, the whole procedure is straightforward and simple: All necessary exposure correction can be based on one thing—*magnification*. Once you know **m,** the exposure increase factor is easily obtained from (1) the accompanying table, (2) a simple equation, or (3) the use of the exposure correction/magnification scale on p. 23 in Chapter 2. The specific combination of prime lens, forward or reversed, and extension device does not enter into the correction factor.* The only thing that matters is their final result: **m.** *For this correction, you do not need to know extension distance or even focal length.*

In all cases, the *exposure increase factor,* **E.I.F.,** is a number that is used to *correct* the exposure by taking the *conventional exposure* (initially determined by a handheld or non-TTL meter, or the film instruction sheet, neither of which assume significant lens extension), and *multiplying the shutter speed by the* **E.I.F.** Alternatively, the lens may be *opened* an amount equivalent to the **E.I.F.,** remembering that a one *f*-stop increase lets in *twice* as much light, a factor of two; two stops quadruples the light reaching the film, a factor of *four;* three stops is a factor of *eight,* etc. The **E.I.F.** may even be "distributed," partly to decrease the shutter speed, partly to open the aperture. However, depth-of-field and lens-resolution requirements usually dictate a fixed (small) aperture, so the **E.I.F.** is usually applied to the

*Exposure correction formulas and the data in the tables give standard information for *symmetrical* lenses (lenses that provide the same magnification forward or reversed). But, in fact, the great majority of modern SLR lenses are *asymmetrical* to some degree, especially wide-angles and telephotos, although normal-focal-length optics can have the same problem. Users of TTL metering can disregard this fact. With the help of Appendix B, others must correct the **E.I.F.** data above when working at magnifications above $0,5×$ (1:2). The degree of asymmetry is indicated by **P,** the *pupillary magnification factor;* its effect can amount to changes in published **E.I.F.** data of half an *f*-stop at 1:1 with standard 50 mm lenses, and a full *f*-stop with moderate telephoto or wide-angles at the same magnification. Users of "macro" lenses can disregard this factor, since these lenses are almost perfectly symmetrical.

Without TTL metering, correction for lens extension light loss must be calculated and applied manually. (The equation below or Table 4-3 may be used.) This scale, reproduced. from p. 23, is much simpler, faster, and more convenient. If placed in the scene (see instructions, p. 23), corrections in terms of shutter speed change or ASA alteration (apply **E.I.F.** in both cases; see text), or in required increase in aperture, are read directly off the scale.

shutter speed.

A third option in applying the required correction is to *divide* the film's ASA by the **E.I.F.** That modified film speed is then set on the non-TTL meter, which is used to take all readings at that particular magnification. If the magnification changes significantly, a new modification of the ASA index will be necessary.

To see how simple use of the **E.I.F.** really is, take as an example a 50 mm lens set at infinity and placed on 25 mm of extension tubes on a camera *without* TTL metering. A scale equivalent to the illustration on p. 23, and duplicated above, has been prepared on a piece of cardboard. By placing it in the scene so that it fills the long dimension of the frame, the following reading can be taken from the scale:

$$72 \text{ mm}; \mathbf{m} = 0.5\times; \text{ and } \mathbf{E.I.F.} = 2.3$$

Now assume that a handheld exposure meter calls for an exposure of $f/11$ at 1/60 sec., and that you are using a film with an ASA of 64. Without Table 4–3 on the next page—a table that indicates appropriate changes in speed or aperture as a function of magnification—you could simply divide the ASA by the **E.I.F.**:

$$\text{Corrected ASA} = \text{Nominal ASA} \div \mathbf{E.I.F.}$$
$$= \frac{64}{2.3}$$
$$= 28$$

The corrected ASA of 28 is then set on the meter, which now indicates $f/11$ at 1/30 sec., *or* $f/8$ at 1/60 sec.

Alternatively, it was noted above that the shutter speed may be *multiplied* by the **E.I.F.**:

$$\text{Corrected Shutter Speed} = (\text{Nominal Shutter Speed}) \times (\mathbf{E.I.F.})$$
$$= 1/60 \text{ sec.} \times 2.3$$
$$= 1/26 \text{ sec.}$$

(Remember, when shutter speeds are multiplied,

they are fractions.) Most cameras do not permit a setting in between the marked shutter speeds, but 1/30 sec. would certainly be close enough. So, the correct exposure is $f/11$ at 1/30 sec.

Alternatively, an **E.I.F.** of 2.3 is slightly more than one f-stop (one stop would be a factor of 2); so instead of $f/11$ at 1/30 sec., $f/7$ at 1/60 sec. is equivalent if a high shutter speed is more important than a small aperture. To save yourself the conversion of **E.I.F.** to f-stops, the table on the next page provides all the necessary data.

The exposure scale in the illustration on p. 23, assumes it is being looked at through a 35 mm camera having a 36 mm viewfinder width. It will not work with other format cameras; however, from the information on the exposure scale and in the table on the next page, a similar scale can be made for any format camera. At the same *magnification*, all cameras require the same **E.I.F.**. To simplify things, all exposure correction information is embodied in one simple formula, which can be carried with you, or engraved into your neckstrap:

$$\mathbf{E.I.F.} = (\mathbf{m} + 1)^2$$

For example, a very common ratio in close-up photography is 1:1 (slides are copied at that magnification). Since $\mathbf{m} = 1$,

$$\mathbf{E.I.F.} = (1 + 1)^2 = (2)^2, \text{ or}$$
$$= 4$$

A starting exposure of $f/16$ at 1/15 sec. would be corrected to $f/16$ at 1/4 sec., $f/8$ at 1/15 sec., or $f/11$ at 1/8 sec.; all three are equivalent corrected exposures. However, these corrections should not be applied to readings that have been taken with TTL meters, or to systems employing plus-lenses. If the close-up accessories consist of *both* extension tubes or bellows, *and* plus-lenses, the correction factor that must be applied to the non-TTL exposure readings is an amount equal to that required if the extension tubes or bellows were used alone.

74

INCH		1		2		3		4		5		6
4X 3X 2X 1.5X	1X		0.7X		0.5X		0.4X	**MAG.**	0.3X		0.25X	
● ● ● ●	●		●		●		●		●		●	
25 16 9 6.3	4		3		2.3		2	**E.I.F.**	1.7		1.6	
4²⁄₃ 4 3¼ 2²⁄₃	2		1½		1¼		1	**STOPS**	¾		²⁄₃	
CM 1 2 3 4 5 6 7 8 9 10 11 12 13 14 15												

Table 4-3

EXPOSURE INCREASE FACTOR, E.I.F., FOR LENS EXTENSION*

Magnification, m	Field of View for 35 mm Format (in.)	(mm)	E.I.F. † Multiply Shutter Speed by	OR	Increase Aperture by (stops)
0.10 × (1.00:10.00)	9½ × 14³⁄₁₆	240 × 360	1.21		¼
0.20 × (1.00:5.00)	4¾ × 7¹⁄₁₆	120 × 180	1.44		½
0.30 × (1.00:3.30)	3⅛ × 4¾	80 × 120	1.69		¾
0.40 × (1.00:2.50)	2⅜ × 3½	60 × 90	1.96		1
0.50 × (1.00:2.00)	1⅞ × 2¹³⁄₁₆	48 × 72	2.25		1¼
0.60 × (1.00:1.70)	1½ × 2⅜	40 × 60	2.56		1⅓
0.70 × (1.00:1.40)	1⁵⁄₁₆ × 2	34 × 51	2.89		1½
0.85 × (1.00:1.20)	1⅛ × 1⅝	28 × 42	3.42		1¾
1.00 × (1.00:1.00)	1⁵⁄₁₆ × 1⁷⁄₁₆	24 × 36	4.00		2
1.25 × (1.25:1.00)	¾ × 1⅛	19 × 29	5.06		2⅓
1.50 × (1.50:1.00)	⅝ × 1⁵⁄₁₆	16 × 24	6.25		2⅔
1.75 × (1.75:1.00)	½ × 1³⁄₁₆	14 × 21	7.56		3
2.00 × (2.00:1.00)	⁷⁄₁₆ × 1¹⁄₁₆	12 × 18	9.00		3¼
2.50 × (2.50:1.00)	⅜ × ½	9.6 × 14	12.30		3⅔
3.00 × (3.00:1.00)	⁵⁄₁₆ × ⁷⁄₁₆	8.0 × 12	16.00		4
3.50 × (3.50:1.00)	¼ × ⅜	6.9 × 10	20.30		4⅓
4.00 × (4.00:1.00)	³⁄₁₆ × ⁵⁄₁₆	6.0 × 9.0	25.00		4⅔
5.00 × (5.00:1.00)	³⁄₁₆ × ¼	4.8 × 7.2	36.00		5¼
6.00 × (6.00:1.00)	0.16 × 0.24	4.0 × 6.0	49.00		5⅔
7.50 × (7.50:1.00)	0.13 × 0.19	3.2 × 4.8	72.30		6¼
10.00 × (10.00:1.00)	0.09 × 0.14	2.4 × 3.6	121.00		7
12.50 × (12.50:1.00)	0.07 × 0.11	1.9 × 2.9	182.00		7½
15.00 × (15.00:1.00)	0.06 × 0.09	1.6 × 2.4	256.00		8
20.00 × (20.00:1.00)	0.05 × 0.07	1.2 × 1.8	441.00		8¾
25.00 × (25.00:1.00)	0.04 × 0.06	0.96 × 1.4	676.00		9½

***E.I.F.** holds true when not using through-the-lens (TTL) metering.

A. This table, or the ruler on p. 23, must be used to correct exposure when using other than TTL metering and when magnification has been achieved through the use of extension tubes, bellows, or "macro" lenses. It should *not* be used with supplementary close-up lenses or "macro"-zoom optics.

B. Many wide-angle, telephoto, and *f/*1.4 normal lenses may require additional correction for the pupillary magnification factor, if TTL metering is not used. See the footnote on p. 73, and Appendix B.

C. **E.I.F.** is only a function of magnification; therefore, except for the "field of view" column, these data are valid for any format camera.

†*A.* High **E.I.F.** values frequently necessitate long exposures. However, shutter speeds longer than ½ or 1 sec. require correction for film reciprocity failure, a correction factor not compensated for by TTL metering (see p. 240).

B. The conversion of **E.I.F.** to correction in *f*-stops was made using the relationship:

$$\text{Increase in Stops} = (\text{Log } \textbf{E.I.F.}) \div 0.301$$

COMPARISON OF EXTENSION TUBES AND SUPPLEMENTARY CLOSE-UP LENSES

It is interesting to note that in the *close-up* range, 0.1–0.5× (1:10–1:2), both supplementary close-up lenses and extension tubes provide almost identical pictorial quality when used with the same prime lens at equal *f*-stops and magnification.

The reasons for using one over the other in this range are not terribly compelling: (1) extension tubes are less delicate than glass lenses and need not be handled so carefully; (2) a set of plus-lenses is slightly less expensive than a set of automatic extension tubes; (3) with extension tubes, exposure compensation must be made (although it is automatic with TTL metering) for light falloff due to increased image distance. As previously described, it is a function of magnification, and amounts to slightly more than one *f*-stop at 0.5× (1:2). With supplementary lenses, no compensation is necessary since the image distance remains relatively fixed; (4) depth of field with extension tubes is somewhat greater than with plus-lenses at the same magnification— the difference between the two increases as **m** increases, and is about 20 percent at one-fifth

life-size (0.2× or 1:5) and 35 percent at half life-size (0.5× or 1:2).

With conventional lenses used between half and full life-size, image quality with extension tubes will probably be somewhat better than corresponding results from supplementary close-up lenses. Part of the problem comes from additional flare introduced when supplementary lenses are stacked to obtain higher powers. In addition, the extension-tube system will give substantially more depth of field at equal *marked f*-stops, which is usually more important at this image ratio than the attendant loss of one or two stops in light intensity caused by the long image distance.

In all cases, however, it is the *prime lens*—its general quality and characteristics at short object distances—that governs the final results. At *f*/16, most systems will perform quite adequately if *critical* image sharpness and contrast are not of concern. If they are, you should be using a "macro" lens. For more information on this subject, see Chapter 5, "Macro" and Close-Focusing Lenses.

AN INEXPENSIVE KIT

A suggested all-purpose kit to carry with you includes a single 14 mm automatic extension tube, a +3 diopter supplementary lens, and a lens reversing ring to be used with your camera and normal lens. Even if your plans do *not* include close-up photography, such small, inexpensive, easy-to-carry equipment offers the mechanical capability if the occasion should arise.

Nothing prohibits an extension ring *and* a plus-lens from being used simultaneously on a camera lens; each does its part to get you closer. The table on p. 77 shows the tremendous flexibility of such a combination **m** from 0.1 to 1.5×. The few gaps are relatively small, the biggest one between 0.5 and 1×. The entire range of 0.1–2× can be covered with the addition of a +1 supplementary lens and a 25–30 mm tube.

Assembling the pieces is a bit slow if you have to change magnification quickly as a rare moth flutters by. But otherwise such a small kit

is ideal for backpacking, bicycle trips, and even street photography. This erector-set approach doesn't have the convenience of a sophisticated "macro" lens, with its continuous infinity-to-1:1 focusing range, nor can it match the critical edge-to-edge sharpness that a "macro" lens provides even at large apertures. But it *is* lighter, smaller, and much less expensive.

If you happen to be carrying a wide-angle and a telephoto lens, e.g., a 28 mm and a 135 mm, those two lenses in combination with the kit will encompass a focusing range that is just short of mind-boggling.

If you happen to be carrying two or three prime lenses and *no* close-up equipment, you will be pleased to know that *reversed, prime lenses can be used as supplementaries in front of other prime lenses.* Such a combination produces extremely good quality, high-magnification (greater-than-life-size) images, although some precautions must be heeded. See Chapter 6, Special Equipment and Combinations, p. 179.

Five small, inexpensive components, used singly and in various combinations and permutations, supply the means to do an incredible range of close-up photography. Coupled to a 50 mm normal lens (preferably slow, $f/1.8$ or $f/2$, see p. 63), magnification capabilities go from $0.1\times$ (1:1) to twice life-size, $2\times$ (2:1)! Used with common wide-angle and telephoto lenses, as noted in the table below, possibilities are mind-boggling! The two plus-lenses, two extension tubes, and a reversing ring neatly mate into the compact package shown at the far left, and fit into a 50 mm lens case.

Table 4-4
MAGNIFICATION CAPABILITIES OF A SIMPLE, INEXPENSIVE CLOSE-UP KIT USED WITH CONVENTIONAL SLR LENSES

Components	Magnification, m, Range (\times)	Working Distance W (in.)	(cm)
With 50 mm Lens			
+1 lens	0.05–0.15	31–13	80–34
+3 lens	0.16–0.26	13–8	33–20
14 mm tube	0.27–0.37	7–5	18–13
14 mm tube, +3 lens	0.41–0.51	4–3	11–8
27 mm tube	0.52–0.63	3½–2¾	9–7
14 mm & 27 mm tubes	0.80–0.92	2	5
Reverse ring	1.10	3½	9
Reverse ring, 14 mm tube	1.40	3	8
Reverse ring, 27 mm tube	1.60	2¾	7
Reverse ring, 27 mm & 14 mm tubes	2.00	2½	6.5
With 135 mm Lens			
14 mm tube	0.11–0.22	56–29	142–74
+1 lens	0.14–0.27	40–22	101–56
27 mm tube	0.21–0.33	31–21	79–53
14 mm & 27 mm tubes	0.32–0.43	22–17	56–43
+3 lens	0.43–0.59	13–10	33–25
With 28 mm Lens			
+3 lens	0.09–0.20	13–5	33–13
14 mm tube	0.49–0.63	1¾–1	4.5–3
Reverse ring	2.30	1¾	4.5
Reverse ring, 27 mm tube	3.30	1¾	4.5
Reverse ring, 14 mm & 27 mm tubes	4.00	1¾	4.3

Note: See the illustration above.

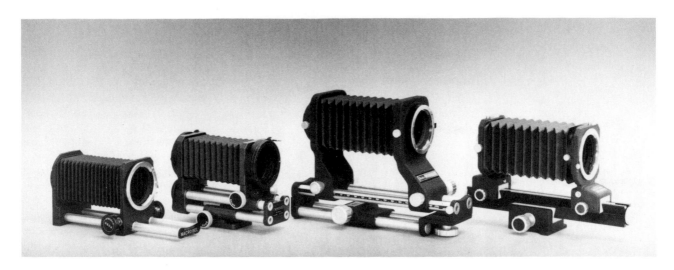

These bellows represent the range of extension accessories available for high magnification photography. At left, an inexpensive Spiratone unit, devoid of sophisticated features, but quite serviceable if used with care; a good choice for initial explorations in photomacrography. Next, a fine, compact Novoflex bellows. Operation is extremely smooth, with the lower pair of rails comprising the tracks for the built-in focusing slide. Most unique is retention of automatic diaphragm operation with lenses in their front-forward position. It's like having a continuously variable set of automatic tubes with 45 to 128 mm of extension. Third from left, Vivitar's large, sturdy offering that extends to a long 200 mm. The first three bellows are available to fit popular cameras. Front and rear mounts on the Spiratone and Vivitar entries may be customer-changed at a future date to accommodate other cameras and lens brands. The Pentax unit at right is typical of the well-made accessories supplied by camera manufacturers. In addition to a built-in focusing rail, there are provisions for lens reversal and dual-cable-release operation of lens diaphragm.

BELLOWS

Bellows, as can be seen in the accompanying illustration, are just a pleated form of extension tube. Instead of providing a fixed amount of lens-to-film separation, however, they are flexible—usually of accordion-folded leather or vinyl—extending typically along a track over a 1- to 6-inch (45- to 152-mm) range. Their ability to provide considerably large image distances that generate high magnification (8× or more with short-focal-length lenses) makes them particularly useful in the *macro* (greater than 1×) range.

Bellows also permit the use of very long, 135–300 mm lenses in the *extreme close-up* range (1:2–1:1, or 0.5–1×) when a great amount of working distance is needed in front of the lens for safety, or for scientific or field applications. In such situations, their ease of alteration of image distance makes them considerably more conve-

nient than extension tubes.

Because the folding bellows cannot be squashed infinitely thin, the residual lens-to-film separation that exists even with the bellows at minimum extension usually leads to a *minimum* magnification of 0.8–1.0× (1:1.2–1:1) when used with a standard 50 mm lens. When used with longer lenses, minimum magnification will be proportionally less.

There are also special *short-mount* lenses having focal lengths of approximately 135 mm that are specifically designed for bellows, permitting *continuous* focusing from infinity to about 1.5× (1.5:1). Short-mount lenses of lesser focal lengths are also available for magnifications of 1.5× and up. These are discussed on pp. 98 and 99 in Chapter 5, "Macro" and Close-Focusing Lenses.

Very small, common objects can provide visual surprises when viewed through a lens/bellows system at magnifications in the true macro range. Unaided human vision is such that we have difficulty seeing any detail in subjects smaller than about ⅛ in. (3 mm) overall. But photographed at, say, 3× (3:1), as was done here, heretofore unknown information often manifests itself in surprising ways. For instance, these "dried bananas" are actually caraway seeds picked off a loaf of rye bread. The author used a bellows with a reversed 50 mm *f*/2 lens at *f*/8.

BELLOWS CHARACTERISTICS

A basic bellows has a male adapter on its rear standard to fit the camera body, and a female mount on the front standard to accept the camera's lens. Be sure to specify camera brand and model when purchasing a bellows. At the time of this writing, bellows were available at costs ranging from $25 to almost $200. That's quite a range, but the surprising thing is that the inexpensive equipment does work, if a bit stiffly. The more you pay, the sturdier, more versatile, easier-to-use equipment you get.

Almost all camera manufacturers produce a good quality bellows to fit their own cameras . . . and no others. Some accessory suppliers, such as Vivitar, Spiratone, and Novoflex (see Appendix A for addresses), make units with adapters to fit all major brands of cameras and lenses. Often these suppliers have bellows that contain features not found on those sold by camera manufacturers. Furthermore, front and rear standards of the independent brands are usually available

with T-mount threads; if you change cameras or lenses, all that is necessary is the purchase of inexpensive male and/or female T-mount adapters to fit the new equipment. Use them to replace the old adapters, and the bellows are still fully usable.

The accompanying illustration depicts an array of bellows units and indicates relevant features. Many more are available from numerous companies, but I have used these and can personally recommend them. Whichever bellows unit you buy, make certain that the controls lock rigidly, that nothing is loose, and that extension movements operate smoothly. If you buy a used unit, check for pinholes in the pleated bellows material: Hold one hand over the front opening and place your eye up to the rear end. With the bellows fully extended, shine a very bright light, such as the bare bulb from a table lamp or a high-intensity reading light, all around and over the bellows while looking inside for light leaks.

Table 4-5

BELLOWS EXTENSION DATA FOR VARIOUS LENSES ON 35 mm CAMERAS

Lens (mm)	Position	Magnification, m, Range for 45–185 mm Bellows Extension (\times)	(Image Ratio)	Typical Working Distance, W, Range (in.)	(cm)

Standard SLR Lenses in Focusing Mounts—Lens Set at Infinity

Lens (mm)	Position	(\times)	(Image Ratio)	(in.)	(cm)
24	reversed	4.3–10.5	(4.3:1–10.5:1)	1½–1$\frac{7}{16}$	4.0–3.7
28	reversed	3.7–8.8	(3.7:1–8.8:1)	2–1¾	5.0–4.5
35	reversed	2.9–6.8	(2.8:1–6.8:1)	1⅞–1⅝	4.8–4.1
50	reversed	1.5–4.5	(1.5:1–4.5:1)	2⅝–1⅞	6.8–4.8
85	normal	0.5–2.5	(1:2–2.5:1)	8⅞–3½	22–9.0
	reversed	0.5–2.5	(1:2–2.5:1)	8¼–3	21–7.8
105	normal	0.4–1.7	(1:2.5–1.7:1	13–4¾	32–12
	reversed	0.3–1.5	(1:3.3–1.5:1)	17–4	42–10
135	normal	0.3–1.5	(1:3.3–1.5:1)	22–8½	55–22
200	normal	0.2–1.1	(1:5–1.1:1)	50–22	127–56

Short-Mount, Bellows, Enlarging, and Movie Camera Lenses

Lens (mm)	Position	(\times)	(Image Ratio)	(in.)	(cm)
13	reversed	9.0–20	(9:1–20:1)	⅜–¼	1.0–0.7
25	reversed	4.5–10	(4.5:1–10:1)	¾–½	2.0–1.5
35	reversed	1.7–5.8	(1.7:1–5.8:1)	1½–1	4.0–2.5
50	normal	1.0–3.5	(1:1–3.5:1)	3⅛–1⅝	8.0–4.2
	reversed	1.4–4.0	(1.4:1–4:1)	2½–2	6.5–5.0
75	normal	0.38–2.3	(1:2.6–2.3:1)	11–3½	27–9.0
	reversed	0.63–2.4	(1:1.6–2.4:1)	7½–4	19–10
105	normal	0–1.2	(∞–1.2:1)	∞–5⅞	∞–15
	reversed	0–1.5	(∞–1.5:1)	∞–6⅝	∞–17
135	normal	0–0.8	(∞–1:1.3)	∞–11	∞–29
150	normal	0–0.6	(∞–1:1.7)	∞–15	∞–38

Notes: *A.* Typical bellows for 35 mm cameras have an extension range of 45–185 mm. Those with larger (or shorter) maximum (minimum) extension will modify the maximum (minimum) magnification proportionally (see p. 69).

B. While data presented are accurate for author's equipment, slightly different values may be expected from lenses of various manufacturers.

C. A magnification of "0" indicates that the lens/bellows combination is capable of focusing at infinity (∞).

D. The fact that a particular lens-focal-length/bellows-extension combination is *capable* of producing a particular magnification does *not* mean that the image quality at that magnification will be satisfactory. In general, standard SLR lenses, *including* "macros," should be reversed when **m** is greater than life-size, 1\times (1:1) (see p. 63). Also, standard SLR lenses, *except* "macros," should generally be used at apertures of *f*/11 or *f*/16 between 0.5\times and 1\times (1:2 and 1:1) for best image resolution. Above 1\times (1:1), see Appendix C for suggestions on choosing a compromise between depth of field and image resolution deterioration due to diffraction.

Everything previously noted concerning extension tubes—exposure correction, magnification determination, reversing lenses to lessen aberrations—holds true for bellows . . . only more so. Magnification with a bellows attached to a lens set at infinity is still the extension length divided by the focal length of the lens (see p. 68). Therefore, a standard 50 mm lens on a 6-inch (152 mm) bellows provides a 3× image.* Attach a 24 mm optic to that same bellows and a magnification of 6× results at maximum extension. If more working room is needed, a 135 mm lens on a fully extended 6-inch (152 mm) bellows will provide slightly greater-than-life-size (1×) images, while leaving over 10 inches (250 mm) of working room in front of the lens. That is over two-and-a-half times as much working distance as is available from a 50 mm lens used at 1×. The table on the opposite page provides appropriate data.

For super-high magnification, bellows units may be strung together, and/or used with very short-focal-lenth lenses; but patience is required. The equation for the exposure increase factor, **E.I.F.** = $(m + 1)^2$, for extension tubes (p. 74) also applies for bellows. It's relatively easy, mechanically, to achieve an impressive magnification of 20×, but the exposure factor is 441. Therefore, a calculated exposure (from a handheld meter) of 1/8 sec. at $f/5.6$ becomes 55 sec. at $f/5.6$, even before further correction can be made for film reciprocity failure.†

Extreme sensitivity to minute vibrations unfortunately goes hand in hand with high magnification. The slightest breeze, or tremors from footfalls, traffic, air conditioners, refrigerator motors, machinery, or even ringing telephones can all cause grief. The illustration on p. 66 shows how to eliminate one possible source of trouble. Obtaining sharp photographs at magnifications greater than 1× takes much resourcefulness and patience. Chapter 7, Positioning and Supporting Techniques, provides some hints. Electronic flash is excellent for freezing vibrations; Chapter 8, Lighting, gives details.

Another consideration is the problem of dim viewfinders. Consider the following: The *marked f*-numbers on a lens are calculated assuming the normal focusing distance of the lens is used; officially they are called *relative f-numbers*. But as soon as a lens is extended to produce a magnification greater than 0.1× (1:10), those numbers are no longer valid. That is, in fact, what the **E.I.F.** is all about. In the discussion on correction of exposure for lens extension, we noted that the light intensity on the film plane is *not* what one normally expects. That loss of light also affects the viewfinder brightness.

Photographers that do close-up work define an *effective aperture* that describes the light intensity *at the film plane*— for a given magnification and for a lens set at a particular relative (marked) *f* stop *as though the lens were set at the effective aperture*. It is for this difference between relative and effective aperture that the **E.I.F.** must be applied. The relationship is:

$$\text{Effective } f\text{-number} = \text{Relative (Marked) } f\text{-number} \times (m + 1)$$

(see the footnote on p. 73). For example, the table on p. 80 indicates a number of combinations of bellows extension and prime-lens focal

*Actually a normal camera lens should never be used in its front-forward position at such high magnification. However, reversed, it will be anywhere from fairly to highly satisfactory, depending on optical design, subject matter, and **m**, if stopped down to $f/5.6$ and smaller. Above 10×, any good quality normal lens will give *excellent* results if reversed (but see Appendix C for optimum aperture). Also, when reversed, wide-angle and normal SLR lenses will produce slightly *more* than the calculated magnification obtained by dividing the extension length by the focal length; telephoto lenses give somewhat less.

†With very low-light intensity on the film, as occurs in high-magnification photomacrography, the film does not respond properly, and *additional* exposure is required to compensate for this effect when exposure times are longer than about half a second. Details are in Chapter 10, Exposure. Correction for reciprocity failure, as this effect is called, is an *addition* to the **E.I.F.** required for lens extension. TTL meters *do not* compensate for reciprocity losses.

length that will produce $3\times$ (3:1). If the lens is set wide open for viewing and composing at a marked (relative) aperture of $f/2$, then:

$$\text{Effective } f\text{-number} = (f/2) \times (3 + 1),$$
$$= (f/2) \times (4), \text{ or}$$
$$= f/8$$

Therefore, the light getting to the film and to the viewfinder of an SLR, even with the lens wide open, is only equivalent to what $f/8$ would supply for normal, nonclose-up photography. A dim viewfinder makes focusing—which is already critical—and composing that much more difficult, and provides strong incentive to add auxiliary lighting.

The fascination with minute objects viewed at many times life-size keeps you going in the face of all this adversity.

USING BELLOWS

First-time users like to rack the bellows all the way out, attach a lens, and look. Often they are surprised at seeing nothing. But a 50 mm lens reversed at the end of a 7-inch (18-cm) bellows provides approximately $5\times$ (5:1) magnification with a working distance of only 2 inches (51 mm) in front of the lens. The depth of field is only 0.001 inch (0.03 mm) at $f/2$. Also, uninitiated photographers forget that on most bellows the lens aperture must be opened *by hand*. If the lens happens to be set at $f/11$ when you attach it, the aperture will stay at $f/11$, but the long bellows extension causes the *effective aperture* at the film plane, and at the viewfinder, to be equivalent to $f/66$. These are the reasons you may not be able to see anything through the lens without first making the proper adjustments.

The solution: First make sure the aperture is wide open, position the camera or subject so that it is about one-focal-length distance from the lens, and then move it (camera or subject) back and forth *slowly* until focus is found. A geared focusing slide is almost a necessity at magnifications greater than $1\times$. Also, the eyepiece magnifiers shown in Chapter 6, Special Equipment and Combinations, p. 127, are very helpful for fine focusing in this magnification range.

The same parameters of image quality, lens selection, and lens reversal that applied to extension tubes also apply to bellows. At magnifications greater than $1\times$, reversing all conventional SLR lenses is a necessity. The lens used will usually depend on (1) the equipment that you own, (2) the magnification that you require, (3) your resolution and contrast requirements, and (4) the working distance that is desired. The first parameter invariably takes precedent over the rest; you work around the others as well as you can within budget limitations.

Short-mount bellows lenses and so-called "macro" lenses, which are both designed to provide superior optical performance in the 0.1–$1\times$ range (see Chapter 5, "Macro and Close-Focusing Lenses), also work quite well in the true *macro* range, up to about $2\times$ (2:1), without reversing. This permits convenient retention of the automatic diaphragm and automatic metering capabilities if such a lens is used on automatic extension tubes, or on automatic bellows such as the Novoflex. Chapter 6, Special Equipment and Combinations, comments on specialized true macro lenses that are specifically designed for ratios above 1:1 ($1\times$).

The table on p. 75, and the data on correction for the pupillary magnification factor in Appendix B (which should be noted when using most SLR lenses, except "macro" optics) provide all the necessary information for exposure correction required with bellows extension if TTL metering is *not* used. If it *is* used, disregard these two correction factors, but remember that the bellows disconnects the link between the camera body and the internal diaphragm activation pin on the lens. Therefore, TTL metering must be placed in the "manual" or "stop-down" mode in the same manner as noted on p. 65 for nonautomatic extension tubes.

The considerable **E.I.F.** values required for high-magnification work generally dictate very long exposure times. Beyond 1/2 sec. for color film and 1 sec. for black-and-white film, reciprocity failure can lead to serious underexposure. Consult Chapter 10, Exposure, for further information on this subject.

Except with lenses longer than approximately 135 mm, bellows always produce magnifications greater than life-size. But as noted on p. 63, above 1× (1:1), SLR lenses should be reversed for proper optical performance, a procedure that can be accomplished with the simple reversing ring shown in the illustration on p. 64. Unfortunately, lens reversal disconnects the automatic diaphragm mechanism. However, a dual-cable-release system, shown on p. 65, can also be used on a bellows. It will reactivate the automatic diaphragm function at times when, for example, one must observe small, live creatures at full (bright) aperture up to the instant of exposure. Shown here is a Pentax bellows with built-in provisions for automatic diaphragm operation via a dual-cable release.

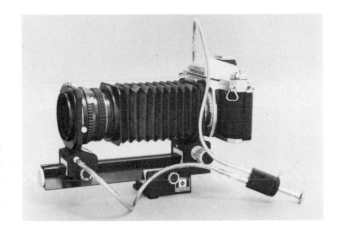

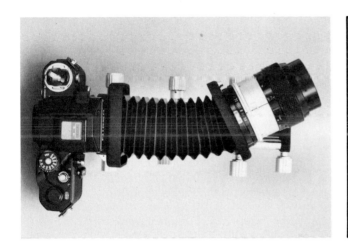

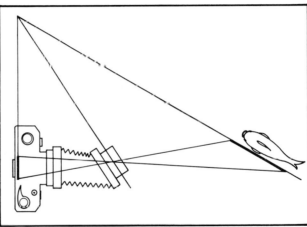

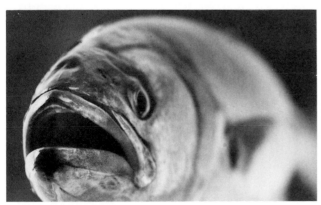

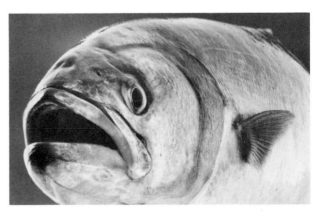

The swing and shift movements of a view camera are available on the front standard of some sophisticated bellows to provide sharp focus in a plane *not* parallel to the film. A diagram of the *Scheimpflug principle* (above right) indicates the procedure: An *infinitely long* plane at almost any orientation will be in focus if the plane of the film, plane of the lens, and plane of the subject all meet in a common line. As an example, a 21-in. (53-cm)-long bluefish was photographed at $m = 0.28×$ (1:3.5) (*left*);even at f/11, little is in focus. But by using the articulated Nikon bellows (*above left*), the entire length of this hapless fish was brought into focus (*right*).

Photographing at high bellows-generated magnifications, one must acknowledge an unbeatable optical frustration called *diffraction*. Diffraction is the spreading out of light as it passes through a small aperture, *increasing* as the aperture *decreases*. Photomacrographers must be cautious, since woefully shallow depth of field tempts use of small *f*-stops. But the *effective* aperture, the aperture "causing" diffraction, is the marked aperture (also called *relative aperture*) multiplied by **m** + 1 (see p.81). For example, at **m**= 2.5× (2.5:1) used for these photographs, a marked aperture of *f*/22 effectively became *f*/22 (2.5 + 1) = *f*/77. A pile of common peppercorns shot at *f*/5.6 (*left*) (effective aperture *f*/20) appears to lack sufficient depth of field. Closing the lens to *f*/22 (*right*) does give more depth, but notice that *nothing* in the right-hand picture (effective aperture *f*/77) is as sharp as the top two peppercorns in the left-hand photo (exposed at an effective aperture of *f*/20). Appendix C, p. 259, discusses diffraction at length.

WARNING! DIFFRACTION

Throughout this book the implication has been that the smallest lens aperture will always yield the best results, because it will maximize the shallow depth of field inherent in close-up photography, and mitigate any aberrations present in lenses not specifically designed for short object distances.

However, as one works into the true *macro* range, the long bellows extension results in *effective* apertures at the film plane of $f/45$, $f/64$,

$f/90$, $f/128$, $f/180$, and even higher when the prime lens is set at $f/16$ or $f/22$ for magnifications of $2 \times (2:1)$ and up. The optical phenomenon called *diffraction* will then actually cause the image to become *less* sharp, with resolution *decreasing* rapidly if the lens is closed down beyond some optimum marked *f*-stop. As shown in the illustration above, this is an important consideration, and further working details are given in Appendix C.

Bellows have finite length. If the extension provided by one unit is insufficient, couple a pair together with an extension tube. A platform (here made of plywood) is required to keep the assemblage rigid and properly supported. The tiny size of this burned-out filament in a bulb from the glove compartment of the author's car required an **m** of 8× (8:1). But 4.5× (4.5:1) is the limit of most bellows with a reversed 50 mm lens. Mating a Vivitar and Spiratone bellows as shown resulted in the desired extension. A shorter-focal-length lens, say a 28 mm, would have reached 8× (8:1) on a single bellows, but the 50 mm f/2 lens was chosen because of its superior optical performance at this magnification. Of course, you don't *have* to build such a contraption; Chap. 6 suggests alternative high-magnification techniques.

SUPER EXTENSION

There are special cases when extremely long extensions are necessary. Examples include: (1) a need for unusually long working distances *and* high magnifications, such as when photographing dangerous or remote industrial or medical procedures, or when recording behavior of misanthropic or skittish animals and other biological species; (2) a desire for high-resolution photography (scientific, forensic, medical, or professional) at magnifications greater than $10\times$ (10:1) without buying the expensive *true* macro lenses.

In the first case, telephoto lenses with focal lengths greater than 200 mm may be necessary.* Mounted in reverse for, let's say, $2\times$ (2:1) magnification, such a lens needs about 18 inches (46 cm) of extension; even at $0.5\times$ (1:2), a 4-inch (10-cm) extension is required. But 18 inches (46 cm) is more than two-and-a-half times the length of the average bellows, and 4 inches (10 cm) is double what is available from the usual set of three extension tubes.

In many cases, using bellows for the $0.5\times$ (1:2) situation would not be acceptable. For example, when doing nature photography in the

*The use of teleconverters is an alternative means of achieving very long working distances. Pros and cons of that procedure are covered in the beginning of Chapter 6, Some Special Equipment and Combinations.

Above: With proper support, there is no limit to the number of bellows that may be strung together. Such prodigious extension would most likely be assembled where extreme working distances were required. For example, a teleconverter (p. 113) and the 105 mm "macro" lens above, as mounted, will image subjects at 9× (9:1), with 4 in. (10 cm) of working room. A 50 mm optic by itself on a pair of bellows leaves **W** at only 1½ in. (3.8 cm). *Right:* The American Museum of Natural History was not about to let me photograph the *Star of India*—world's largest blue star sapphire at 563 carats—in *my* studio. To shoot this bauble *in situ* posed some problems: It was resting about 6 in. (15 cm) behind a very thick slab of impenetrable glass, and design of the display case made tripod positioning such that **W** = 28 in. (71 cm) at **m** = 0.5×. A bellows and a 200 mm lens solved the problem.

field, the loss of the automatic aperture that occurs with most models of bellows can be a serious hindrance when stalking a quick-moving creature. And some people find bellows too delicate or vibration prone for crashing through thickets or bouncing off talus. In such cases, a series of three or four *large* automatic extension tubes (maximum size is typically 40 mm, although Pentax has one 100 mm long) will usually provide the necessary extension in a more solid form, with automatic aperture operation, for all but the most extreme extension requirements. Such a long stack is prone to considerable friction on the automatic aperture pin, so check for proper functioning of that mechanism.

The 18-inch (46-cm) extension required for 2× (2:1) with the reversed 200 mm telephoto can be provided by bellows in tandem . . . if you own three bellows. Alternatively, you can make your own super-long extension (p. 88).

The second case previously cited—high quality images at high magnification with standard lenses—also calls for extreme extension. While special short-focal-length, high-resolution, true macro lenses—which would not require so much extension—are available (Chapter 6, Special Equipment and Combinations), they are a luxury for occasional use. However, at 10× (10:1) and greater, a *good* conventional 50 mm SLR lens, which usually has better resolution

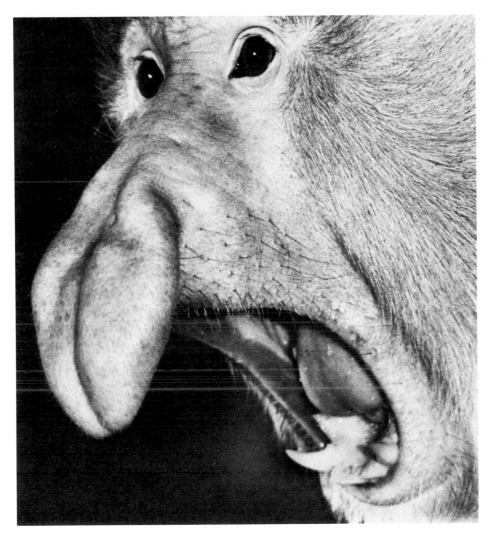

Above: Check the automatic diaphragm pin for free operation when stacking a number of automatic extension tubes. *Loft:* Tho combination of tubes above added 47 mm of extension to a 200 mm lens to achieve a combination of long working distance—46 in. (116 cm) and **m** = 0.25× (1:4). Subject was a leaf-eating proboscis monkey, photographed with electronic flash. Only older males of the species develop the prominent appendage on their nose. These are the only monkeys that readily take to water.

than a wide-angle, will provide *excellent* quality if it is reversed. A 50–55 mm "macro" lens (also reversed), which is frequently at hand, might even be a bit better. But 10× (10:1) with a 50 mm reversed lens requires 22 inches (55 cm) of extension. This too you can build yourself. By the way, a 28 mm wide-angle lens at 10× still needs 12 inches (30 cm) of extension—longer than the average bellows—and it seldom has the image quality of a good 50 mm optic.

Very solid, fixed-length extensions can be made from pipe or wood, and male and female T-flanges from Spiratone can be epoxied at each end. Small changes in magnification can be accomplished by adding conventional extension tubes. With a homemade design, the most im-

portant consideration is to place adequate light baffling inside the tube to prevent image degradation from the large amounts of flare that develop when such long extensions are used. The illustration on the next page shows some homemade devices that have been used quite successfully.

If you are not a "do-it-yourselfer," or are bothered by the military appearance of the finished product, lenses from 8 and 16 mm movie cameras will give fine results at high magnification. And because of their short focal length, one of these lenses on a single bellows can often magnify above 10×. Chapter 6, Special Equipment and Combinations, (p. 131) provides details.

Extension tubes of any length may be homemade at very low cost. Prime design criteria are rigidity and elimination of internal reflections. The 16½-in. (42-cm) wood tube (*top left*) produces excellent quality images at almost 10× (10:1) with a reversed normal 50 mm lens. Internal reflections are eliminated with black flock material (B.D. Co. or Edmund). Camera/tube mating is accomplished with a Spiratone "T"-mount epoxied to one end; the opposite end (*top right*) sports a Series VII-to-VIII step-up ring for mounting various lenses in reverse via adapter rings. A ¼-20 "T"-nut (*center right*) provides tripod mounting sockets. *Center left:* 2-in. (50-mm) PVC drain pipe, mounted via hose clamps on a plywood base for stiffening, also makes excellent, lightweight extensions. Flat black paint mixed with sand inhibits reflections off the interior walls. The 27-in. (69-cm) center tube (*directly above*) and a reversed 35 mm lens generated a magnification of 22× (22:1) for the picture at right. It's the background behind George Washington on a dollar bill.

Extension tubes and bellows not only cause decreased illumination at the film plane, but with single-lens reflex (SLR) cameras there is also less illumination in the viewfinder (see p. 82). Split-image and microprism focusing screens tend to go black and become useless at high magnifications and/or under dim lighting conditions. Sometimes moving your head slightly as you look through the viewfinder will help, but it is best to use the ground-glass collar that surrounds most split-image or microprism spots. Some cameras have provisions for replacing the standard viewfinder screen with ones more suitable for close-up work. (See Chapter 6, Special Equipment and Combinations.)

A second minor annoyance occurs with SLR's if a long lens and extension tubes or bellows are used. The mirror inside the camera may clip some of the image along the edges as it appears *in the viewfinder*. However, when the mirror flips up during the actual exposure, *a full size frame is recorded* on film. Unfortunately you just have to guess at the extra amount that the film will record but that you can't see. For critical work, make sure you can *see* all that you need in the viewfinder. Alternatively, if a fixed situation exists, the camera back can be opened (without film in the camera, please), and a ground glass or piece of household waxed paper can be placed across the film-support rails. When the shutter is opened (use a locking cable release and the "B" shutter setting), the image can be critically focused and composed on this temporary viewing screen.

SUMMARY

The relationships governing magnification, depth of field, exposure correction, and working distance are identical for bellows and extension tubes; the tubes are smaller than bellows; they are of fixed length, and are typically used below life-size (1:1) magnification, although they may be stacked together or used with short-focal-length lenses for more image magnification. Bellows permit much greater and continuously variable extension, typically providing $1\times$ through $4\times$ with a normal 50 mm lens, and $8\times$ and more with shorter-focal-length lenses.

Conventional camera lenses are not designed to be used for close-up and macro photography. Small apertures, such as $f/8$, will provide satisfactory results, although in the optically problematical 1:2 to 1:1 range, $f/16$ may be required. Beyond 1:1, reversing a conventional lens will improve its performance. In general, slower lenses will give better results than those having large maximum apertures.

When used with long lenses, both tubes and bellows provide magnification in the *close-up* and *extreme close-up* ranges; and with bellows somewhat into the *macro* range, but with more working distance in front of the lens than is obtained from normal or short-focal-length lenses on the same amount of extension.

For fieldwork, automatic extension tubes and automatic and semi-automatic bellows are preferred, because they maintain the automatic diaphragm function of a camera/lens combination.

The greater the extension, the higher the magnification, which may be calculated by dividing the extension length by the focal length of the lens (if the lens focusing mount is set at infinity, and if it is used in the front-forward position). Reversing a normal or wide-angle lens will increase the magnification considerably for a given amount of extension, and it is a convenient way to attain image ratios greater than life-size.

If a camera has through-the-lens (TTL) metering, correction for decreased illumination at the film plane due to lens extension will be automatic. External metering requires exposure compensation based on amount of magnification. The illustration on p. 74 provides a simple, convenient system for determing **m** and the corresponding amount of exposure correction.

Extension tubes, bellows, and plus-lenses may be used in any combination that provides the required magnification.

Higher magnifications, especially greater than $1\times$, require rigid tripod- or copy-stand mounting of camera, extension, and lens, plus a steadfast subject to minimize vibration. The use of a flexible cable release is essential, and mirror lock-up provisions should be used if a camera is so equipped.

"Macro" lenses provide an ease of magnification change unrivaled by any other close-up system, not to mention superior image quality. Such an optic is an ideal choice for photography that explores the soft-hued topography, the unique structure, the overlooked regions, the forgotten niches of the human body.

5 "Macro" and Close-Focusing Lenses

Prior to the advent of large computers, new types of glass, and antireflection coatings, lens design was as much an intuitive, sophisticated, "black art" as it was a fairly straightforward science. It typically took many months of tedious hand calculations to compute the curvature, thickness, and spacing of each of the glass elements in a new lens. Time, available materials, and scattered light bouncing off of every glass surface restricted designs to three, or at the most, four lens elements—a frustration to optical engineers who knew that more elements could correct the image aberrations that prevented the development of extreme wide-angle, compact telephoto, close-focusing, large-aperture, and other lenses that photographers were craving.

The early 1950s saw the marriage of large, fast, digital computers; special formula glasses with novel light-bending properties; and newly perfected antireflection coatings that could diminish reflected light from a glass surface to less than 1 percent (without the coating the figure is 4 percent). Freed from hours of punching a hand-calculating machine, lens designers turned to increasing the maximum aperture of normal lenses from an average of $f/4$ to $f/2$, and even to $f/1.4$. The 1960s saw the development of wider wide-angles, and longer and faster telephotos. At the end of that decade, a number of manufacturers introduced so-called "macro" lenses that could focus continuously from infinity to one-half and even full life-size, and do it easily and sharply. The present decade seems devoted to combining fast, wide, long, and close in various permutations, and sometimes all in one colossal achievement, called a "macro-zoom" lens.

A standard camera lens does a commendable job for a considerable amount of close-up and macro photography; with a set of extension tubes, a few plus-lenses, and a lens reversing ring, you're in business. But normal lenses are designed for normal photography, for focusing on subjects that are comfortably viewed by our eyes without the aid of a magnifying glass. As with so many other endeavors requiring devices, machines, and contrivances, equipment that is specially designed for a particular application offers superior performance, easier handling, and emptier pockets. Following is a rundown of optics that are primarily intended, or have special provisions, for the close-up and macro ranges.

SO-CALLED "MACRO" LENSES

A lens that can focus continuously from infinity to one-half or even full life-size is commonly, but erroneously, referred to as a "macro" lens. Remembering that the true macro range begins at, and extends beyond life-size ($1\times$ or 1:1), we can only shake our heads at the hyperbole of advertising executives who stretch a pseudo-scientific term to fit their *close-focusing* products.

Proper terminology or not, these lenses are a joy to use. The double helix in the focusing mount permits the lens to be extended as far as necessary to achieve a magnification of $0.5\times$ (1:2), and also regress back toward the film for infinity focusing, or for any distance in between. With the addition of an automatic extension tube, usually supplied with the lens, continuous

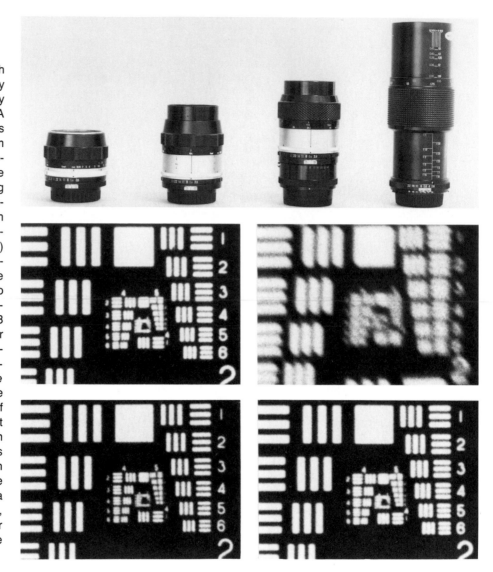

Top: The ease with which "macro" lenses go from infinity to half life-size is indicated by the two left-most lenses: A twist of the lens barrel has quickly brought a 55 mm Nikon from focus on far objects to 0.5× (1:2), with the ability to stop anywhere along the way. As with most "macros," an additional extension tube (third lens from left) is required to cover the 0.5× (1:2) to 1× (1:1) range, finally putting the image in the true *macro* realm. Exceptions to the need for additional extension are Vivitar's 50 mm *f*/2.8 and 90 mm "macros," the latter at far right. Excellent resolution and contrast over *the entire negative, at all image ratios and apertures,* is the second claim to fame of "macro" lenses. *Center left:* At *f*/8 and 0.5× (1:2), a 50 mm *f*/1.4 conventional lens gives fine performance directly on axis, but the corner of the negative (*center right*) is a disaster. With a "macro" lens, however, center and corner are just about equally fine (*bottom pair*).

focusing in the *extreme close-up* range from 0.5× (1:2) to full life-size is available. (With some lenses, like the Vivitar 90 mm *f*/2.8 "Macro," a photographer can go all the way from infinity to 1:1 without stopping in the middle to add an extension tube; and all this just by twisting a collar as you do with a conventional optic.)

At all magnification settings, automatic diaphragm operation is retained—a great convenience. The optical design of "macro" lenses is such that even at large apertures, extremely good resolution and contrast, without any significant linear distortion, are found across the *entire field*—true "flat-field" performance—and

are achieved over the entire close-up range. A lens with such optical characteristics is practically a necessity when photographing medium to small flat objects with fine detail across the full frame. Examples include slide copying, photographing stamps and documents, producing slides from artwork and printed matter, and microfilming.

Designed to be used where sufficient depth of field is frequently lacking, "macro" lenses have apertures to *f*/32. (Above 0.1×, depth of field at *f*/32 is twice that at *f*/16.) Conventional lenses have minimum aperatures of *f*/16 or *f*/22. Lens settings smaller than that actually

Information provided by scales on "macro" lenses is frequently confusing, or missing entirely. For example, take the optically superb 90 mm *f*/2.5 Vivitar (*far left*). Image ratio scales exist *only* for the 0.5× to 1× range, where an additional extension must be added. Similarly, exposure correction markings apply *only* to the 0.5× to 1× realm. Also, though distances for the near and far magnification ranges are indicated, they are measured from the *film plane*. But the close-up photographer needs figures on *working distance*; at 0.5× (1:2), disparity between marked distances and actual **W** is 50%; and at 1× it's 70%! The 105 mm Nikon (*near left*), also optically marvelous, is equally stingy with data. Image ratio scales are provided for all ranges up to 1:1, but distance is again measured from the film plane. Additionally, no exposure correction scales exist at all. You'd better have TTL metering, or the "ruler," on p. 23.

produce *less* resolution due to the interaction of light with the edges of the aperture, a phenomenon called *diffraction*. However, the need for as much depth of field as possible when working with three-dimensional objects is often a more important consideration than a slight loss in image sharpness. But if the lens is closed down too far, or if the *effective f*-stop at the film plane is very small due to a large exposure increase factor (at 3×, a *marked,* or relative aperture of *f*/32 is an *effective* aperture of *f*/128), the degradation due to diffraction will more than cancel any gains in depth of field. See Appendix C for some guidelines, and the illustration on p. 84 for a pictorial example.

An added bonus with many "macro" lenses is that results at *normal* photographic distances are often superior, or at least equal, to the image quality of conventional optics.

What is the price of such marvelous convenience and performance? About one-and-a-half to two times the cost of a good 50 mm lens, and a smaller maximum aperture, typically *f*/3.5 or *f*/4, which leads to a somewhat dimmer viewfinder. There is also a minor annoyance: At *far* distances, the focus setting of these lenses tends to be somewhat sensitive to even slight amounts of focusing-ring rotation. This is due to the fact that the mechanics of the focusing mechanism are designed more for the *close-up* range,

which requires substantial lens extension, than for the far range, which requires very little. But don't let that stop you from buying one; just be careful when focusing near infinity.

Other than the dimmer viewfinder, the slow maximum aperture is not really a hindrance, since one seldom uses *f*-stops larger than *f*/4 anyway, at least in close-up photography where depth-of-field requirements usually dictate *f*/8, and frequently smaller.

The usual trial-and-error addition and subtraction of plus-lenses and/or extension tubes to conventional lenses required to arrive at a desired framing/magnification setting is entirely eliminated with the "macro" lens. In the infinity-to-1:2 (0.5×) range, focusing and framing are accomplished in the standard manner by rotating the lens barrel; beyond that magnification, as with all focusing in the *extreme close-up* range, it is usually easier to focus by moving the entire camera/lens assembly, or the subject, back and forth.

Some manufacturers engrave a magnification scale right on the lens barrel, so setting to a particular image ratio is convenient for those who must know the exact enlargement. Also the distance scales on all lenses, macro and otherwise, are calibrated from the *film plane* to the subject. In their advertising literature, manufacturers unfortunately indicate "closest focusing

Near right: Lack of exposure correction scales on a 55 mm "macro" lens proved an inconvenience when used with a camera lacking TTL metering, so appropriate data at ⅓-stop intervals were scratched into the lens barrel. Additional exposure required for the 0.5× to 1× extension was marked on the extension ring in no uncertain terms. *Far right:* The top "macro" lens has its front element well recessed and protected from flare. Such was not the case with the lower optic, so a lens shade was added to block contrast-destroying stray light.

distance," without mentioning that it is measured from the film plane and not from the front of the lens, which would be more useful. In close-up photography the impression can be misleading if one considers that a fully extended "macro" lens is 6–10 inches (15–25 cm) long. Of course it is most useful to indicate the maximum magnification; then, regardless of focal length, two lenses can be compared with regard to potential image size.

Flare—excess stray light entering a lens from outside its field of view—is a particularly bothersome problem in close-up photography, so lens shades should be used at all times. To keep their expensive, well-designed products from being abused by photographers who do not use lens shades, the manufacturers of the better brands of "macro" lenses have built them with the front elements deeply recessed into a well-blackened barrel that is an integral, nonremovable part of the lens, as shown in the illustration above.

On a hiking trip, sometimes there is barely room in a pack for a camera with just one lens; in such cases, a 50–55 mm "macro" is a good lens to bring along. With it you can photograph alpine scenery *and* detailed close-ups of lichen, mountain flowers, and tiny animal life.

If you intend to do a fair amount of close-up photography for work or pleasure, it is advisable to purchase a good 50–55 mm "macro" lens, *instead of* the standard lens, when buying a new camera. When was the last time you really needed an aperture of *f/2*?

"Macro" Lenses with Focal Lengths Longer than 50–55 mm

Originally, "macro" lenses had focal lengths equal to those of the normal lenses supplied with new cameras. However, with a 50 mm lens at 1:2 (0.5×), working room is typically only 4 inches (10 cm), a bit tight if lights or fidgety animals have to be considered. Today, 90, 100, and 105 mm "macro" lenses are readily available, and provide twice the working distance in front of the lens than that of a 50 mm version. (Nikon even makes a 200 mm "macro.") These longer-focal-length lenses are also excellent moderate telephotos for portrait, sports, and candid work. Price is somewhat more than for a good conventional 90–105 mm lens that does not have super close focusing ability, but the greater cost is justified by the additional versatility.

The flat-field resolution, overall quality, and convenience of "macro" lenses have made them popular for copying flat artwork for slide production. Here the longer working distance of a 90–105 mm "macro" lens is a *disadvantage,* since it would require a much taller copy stand for average size artwork . . . and probably a step stool for the photographer.

94

Left: A portion of a wonderful collection of masks of the Iroquois Indians' False Face Society. The collection, on display at New York's American Museum of Natural History, provided subjects to exhibit the potential of "macro" lenses. This photograph could have been taken by any lens, though the typically small maximum aperture of a "macro" makes focusing in relatively dim indoor situations a bit tricky. A quick turn of the focusing barrel generated 0.15× (1:7) (*lower left*). Further rotation, plus the addition of the accessory extension tube, produced 0.7× (1:1.4) (*lower right*).

"Macro" lenses are associated with high-resolution photos of flowers, bugs, pathological tissue samples, and flaws in postage stamps. However, their optical characteristics are such that image quality in the *non*close-up range is usually equal to—often better than—a conventional lens of similar focal length. For a new camera, close-up photographers should consider a 50 mm "macro" lens *instead of* the normal lens. Similarly, consider a 90 or 105 mm "macro" instead of a conventional moderate telephoto.

EXPOSURE CORRECTION WITH "MACRO" LENSES

The need for, and method of, exposure correction in the *close-up, extreme close-up* and *macro* ranges is no different for "macro" lenses than it is for conventional optics used with extension tubes or bellows. In both cases the lens is extended considerably farther from the film than the distance used by the manufacturer in the calculation of the marked (relative) *f*-stops. But here too, if a camera has through-the-lens (TTL) metering, the light falloff is automatically sensed, and there is no need for any special compensation. (However, if exposure times are longer than 1/2 sec., correction for film-reciprocity failure is usually required. See Chapter 10,

Exposure.)

When using a handheld meter, or under other conditions where TTL metering is unavailable or inoperative, the corrections for exposure as a function of magnification, given in the table on p. 75, also apply here. Unfortunately, not all manufacturers indicate magnification on the lens barrel, and if they do, it is often for the infinity-to-1:2 range or for the 1:2 (0.5×) to 1:1 (1×) range where the additional extension tube is attached (see the illustrations on pp. 93 and 94). Lacking direct magnification data, the simple ruler technique outlined in the illustration on p. 23, is quite satisfactory.

Conventional lenses must be reversed when used in the true macro realm, or image quality is unbearable (p. 64). One would expect that "macro" lenses, optimized at 0.1× (1:10), would also perform better above life-size if reversed. To test that assumption, two pictures of a section of human colon were taken at 10×, one with the lens front-forward, the other with it reversed. Only on a 16" × 20" (40 × 50 cm) print was even a small difference discernible. *Above:* A full frame print from the *unreversed* setup.

USING "MACRO" LENSES IN THE TRUE MACRO MODE

Conventional lenses are designed for optimum performance when focused at infinity; the so-called "macro" lenses are optimized at an image ratio of approximately 1:10 (0.1×). Using a close-up lens (which is really what "macros" are) in the true *macro* range (greater than life-size images), by installing it on a bellows or extra extension tubes, places more room between lens and film than between lens and subject. But the 1:10 design point implies a *short image distance and a large object distance.* Therefore, better performance is obtained in the macro realm if the lens is turned around so that the rear element faces the shorter distance. Pages 63 and 64 in Chapter 4, Extension Tubes and Bellows, show the need for and mechanics of reversing lenses.

Because these lenses have flat-field designs, one can usually get away with using them in the front-forward position up to about 2× (2:1). (That is in direct contrast to a conventional lens that produces atrocious images if used unreversed at 2×, as shown in the illustration on p. 64.) The advantages of retaining the automatic diaphragm and exposure-meter coupling (assuming automatic extension tubes are used) by keeping the lens mounted front forward, often outweigh the slightly better image quality obtained by reversing the lens, at least up to 2×. For critical work, test each lens both ways.

At magnifications greater than 2× (2:1), a "macro" lens should be reversed. This will give beautiful results with crisp images, edge to edge. (Chapter 6, Special Equipment and Combinations, shows how teleconverters may be used with "macro" lenses to produce high magnification [2–6×], good image quality, and *considerably more* working room than is available if the same lens is reversed on a bellows extended to produce equal magnification.) Of course it is advisable to stop down the lens to $f/5.6$ or $f/8$—in this case for adequate depth of field and less critical focus —and use a cable release and a firm, stable camera support. As noted in Chapter 4, Extension Tubes and Bellows, remember to protect the bare, exposed rear element on the reversed lens from physical damage, and from flare-producing stray light.

Another advantage of "macro" lenses is their ability to ensure good optical performance in the true macro realm without reversal. Remember, "macro" lenses are primarily designed for the *close-up* range and are optimized for best image quality at 0.1× (1:10). But they do work fine front-forward for all but super critical applications, right up to 3× and often higher. In this position, the lens retains its automatic diaphragm operation, important when photographing live or other moving subjects. The lower camera has been equipped with three automatic tubes and a "macro" lens for 2× magnification *with* automatic aperture operation. On the other hand, conventional lenses must be reversed (upper camera) when used beyond 1× (1:1), or optical mayhem results (p. 64). Loss of automatic diaphragm function can be regained, but it requires a dual-cable-release system (see p. 65) and a bellows, certainly less convenient than the "macro" lens.

SHORT-MOUNT LENSES (BELLOWS LENSES)

Optics with this family name were *the* working tool of the serious practitioner of close-up and macro photography . . . until the introduction and rapid embracing of the versatile "macro" lenses just discussed. Basically the optical design of the short-mount lens is similar, and sometimes identical to that of the "macro" lens. But the glass elements are fixed in a simple mount that has no focusing provisions of its own, i.e., no ability to move the lens with respect to the camera body, and therefore focusing must be done with a bellows. Often these lenses have no automatic diaphragm mechanisms. Such an assembly is short in length, hence the name.

Why the special mount? Consider the following: Before the advent of "macro" lenses with continuous focusing abilities from infinity to life-size, a bellows was used to provide the necessary variable extension for that range. Now at infinity focus, the image distance must be exactly one focal length. But a conventional lens already has sufficient extension built into it so that it can focus at infinity. If that standard lens is put on a bellows, where even at *minimum* extension the collapsed pleats will separate the lens from the camera body by at least an additional 1½ inches (38 mm), it will not be able to focus at infinity, or even moderate distances. By using a lens of at least 135 mm focal length (approximately), and *shortening* the normal built-in extension, i.e., eliminating all rear protrusions and leaving only the glass in a simple mount, a system is assembled with the capability of focusing from infinity to slightly above life-size.

These "bellows" lenses are not only designed for flat-field, low-distortion performance in the *close-up* range, but the longer focal lengths required for infinity focus on a bellows also provide more working room, which is quite often a considerable convenience in this field.

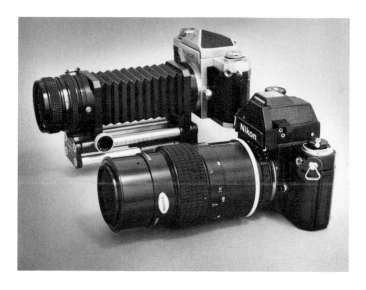

Though short-mount and "macro" lenses have the same optical qualities, their mounting configurations are quite different. A 105 mm lens and an automatic bellows, both from Novoflex (top camera) provide the same imaging capabilities—infinity to life-size—and optical characteristics as the 105 mm "macro" lens from Nikon (lower camera).The bellows system is slower to focus and not as rugged, but if you already have a bellows, a short-mount lens can provide "macro" lens optical quality at a much lower price.

Shorter-focal-length bellows lenses are available for use *unreversed* in the true *macro* range. They provide high magnification without impractically long extensions. Novoflex has a 60 mm $f/4.5$ Staeble-Katagon that will furnish magnifications of 0.6–2× (1:1.6–2:1) on the average bellows. Spiratone has a good-quality 35 mm $f/3.5$ Macrovar that generates magnifications of 1.5–6× (1.5:1–6:1), and costs, at the time of this writing, less than the price of 15 rolls of black-and-white film. Both companies offer adapters for fitting their lenses to almost any bellows. Extremely high-quality, short-mount lenses, which are the ultimate in photo*macro*graphic optics in each of their design ranges, are available from microscope makers such as Zeiss and Leitz (see p. 131).

So why use a bellows/short-mount-lens system which, compared with a "macro" lens, is not as mechanically sturdy; is considerably more difficult to support, focus, and change magnification when handheld; and does not generally have an automatic diaphragm (Pentax, Nikon, and Novoflex are exceptions) or full-aperture TTL metering provisions? (Many people have answered these questions by making the occupation of the bellows pleater a dying art.) The primary reason is that the bellows/short-mount lens combination is considerably cheaper—at least half the price, and less—for comparable optical quality. Therefore, you can get true flat-field, high-resolution, corner-to-corner sharp-

ness at a moderate price. And that savings multiplies as you add other focal length lenses to cover different image ratios. For relatively little money, you can have a set of lenses that provides superior quality, even at moderate apertures, when compared with the compromises inherent in conventional lenses used in close-up situations and at very small apertures.

Remember, when a lens is reversed for photography in the macro mode, many, if not all, of the automatic features are lost; therefore, a standard SLR lens is no better than a short-mount lens, unless the type of double-cable-release system shown in the illustration on p. 65 is used. But many short-mount lenses are now available with automatic diaphragms and can also be used with double-cable-release mechanisms.

Secondly, automatic "macro" lenses for SLR's are available only in focal lengths of approximately 50 and 100 mm. Short-mount lenses, which have the same optical quality as the "macros," come in many focal lengths from 25–200 mm; this gives considerably more versatility in choice of magnification and working distance.

Bellows/short-mount lens systems can be very useful to the serious practitioner of close-up and macro photography. They provide a great magnification range and good image quality at a moderate price, and are very practical for fixed situations such as studios and laboratories. For fieldwork, at magnifications under 1× (1:1), the "macro" lenses are far more suitable.

These two photographs of a preening scarlet ibis demonstrate the difference between the normal image magnification capabilities of a conventional telephoto (*left*) and a close-focusing telephoto (*right*). The former's limit is about 0.1× (1:10), whereas the close-focusing 200 mm Vivitar Series 1 provides images up to 0.4× (1:2.5). Also, a *well-designed* close-focusing lens will provide better image quality in the close-up range than will a conventional telephoto/extension-tube combination (see p. 101).

CLOSE-FOCUSING LENSES: WIDE-ANGLE AND TELEPHOTO LENSES WITH SEMICLOSE-UP CAPABILITIES

It has already been mentioned that the near-focusing limit of conventional lenses is fixed at a distance that provides approximately 0.1× (1:10) image magnification. For a 50 mm lens, that typically leads to a 19-inch (49-cm) working distance; the corresponding working distance for lenses of other focal lengths can be found in the accompanying table. Recently the optical constraints on the close-focusing performance of wide-angle and telephoto lenses inherent in conventional designs have given way to some clever legerdemain by the ever-tinkering engineer.

Basically, designers have borrowed a technique used in zoom lenses: Particular lens elements inside the main assembly are *moved in relation to one another* to change performance characteristics. Inside the close-focusing lens, over the normal range (infinity to $\mathbf{m} = 0.1\times$), all

elements are locked in a fixed order and spacing, and the entire assembly moves in and out in relation to the film; i.e., the image distance changes in relation to object distance in the conventional manner discussed in Chapter 2, Preliminaries. But as the focusing collar is further rotated to move into the close-up realm, not only does the main part of the lens continue to move forward, but certain elements, usually the rear ones, change their spacing with respect to the other components. This all happens continuously, without the photographer having to move his/her eye from the camera.

Close-focusing lenses do not have the same properties as the "macro" lenses discussed at the beginning of this chapter, even though many hyperbolic advertising spreads call them "macrofocusing lenses." "Macro" lenses magnify to

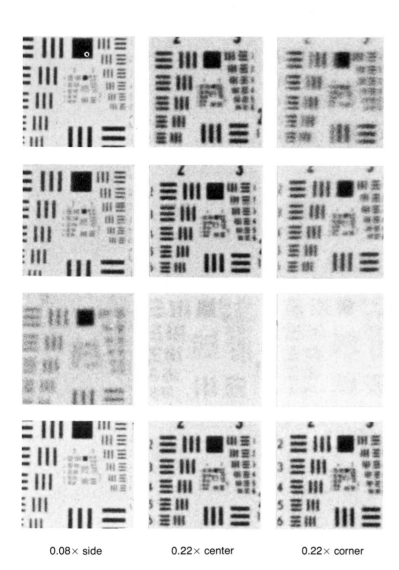

Standard 135 mm telephoto on extension tubes

High quality 135 mm close-focusing telephoto lens

Cheap, poor quality 135 mm close-focusing telephoto lens

105 mm "macro" lens

0.08× side 0.22× center 0.22× corner

Resolution capabilities of various long-focal-length close-focusing systems were compared using a standard U.S. Air Force resolution target. All exposures were at $f/8$ on Panatomic-X film. The left column tested each lens for nonclose-up performance, the target being imaged on the far side of the negative in each case. For close-up capabilities at 0.22× (1:4.5), both center and corner of film frames were examined. The mechanical reproduction of this book may mitigate some difference between each lens, but for sure you can learn to be leery of very inexpensive, off-brand lenses. Otherwise, differences in performance usually show up in the corners; and frequently those differences do not matter, particularly if you're not photographing resolution targets.

1:1 (1×) with their accessory extension rings; whereas close-focusing lenses typically magnify only up to 1:4 (0.25×). The "macro" lens has excellent resolution—even at $f/5.6$—at all distances. The close-focusing lense (at least a good one) is excellent below 0.1× (1:10), but above that, it can't compete with the "macro" lens, especially at the near limit of the close-focusing optic's range, where it should be stopped down to approximately $f/11$ if good contrast and edge resolution are desired.

The close-focusing lenses, in all fairness, *should be compared with other telephoto and wide-angle lenses that do not have close-focusing capabilities.* Then their advantage is that they *also* permit forays into the fringes of the close-up world. They are not intended, and should not be used, for such tasks as photocopying, producing slides from artwork and documents, and other critical applications.

The close-focusing long telephotos, particularly, are excellent choices for fieldwork and portraiture, where a telephoto lens is, primarily needed, but where it is also desirable to have both the convenience of focusing in the *close-up* range without fumbling with accessories, *and* close-up image quality considerably superior to conventional long lenses used with special close-up accessories. Of course the extra-long working distance associated with long-focal-length

Subjects worthy of serious respect, like this cozy pair of venomous northern copperhead snakes, are best photographed with "long distance" close-up equipment. A long-focal-length, close-focusing lens around 200 mm is highly recommended for nature work. If you haven't purchased a long telephoto lens yet, buy one with close-focusing capabilities when you do. Dangerous animals should only be approached by photographers who are thoroughly familiar with the habits of the particular creature.

lenses (see pp. 68 and 70), whether for conventional or close-up subjects, is another very important asset of this family of optics.

A lens such as the Vivitar 200 mm $f/3.0$ close-focusing telephoto would be a good choice for the nature photographer. It is a fine general-purpose long telephoto, and it also conveniently provides a 1:4 image ratio at a 3-foot (1-m) working distance.

In emergencies, close-focusing lenses can be pushed to magnification ranges higher than their design limits by adding supplementary close-up lenses or extension tubes in the manner outlined in Chapter 3, Supplementary Close-Up Lenses, and Chapter 4, Extension Tubes and Bellows. Used in this way, close-focusing lenses will usually give better performance than non-close-focusing lenses of equal focal length fitted with the same accessories. In such impromptu situations, an aperture of $f/8$ or $f/11$ is advised.

Image quality varies considerably between brands of close-focusing lenses. Usually the expensive ones give "macro" lenses a small challenge, at least in the central portion of the frame, when compared at apertures of $f/8$ and smaller. In addition, there are unusual perspective and creative possibilities that exist with a wide-angle lens that focuses into the close-up realm.

In preparation for this book, I tested a number of close-focusing lenses that ran the gamut in price range. The image in the *viewfinder* of one or two of the inexpensive off-brand models was very poor, and an 8″ × 10″ (20-×-25-cm) print from a frame exposed at $f/8$ looked like it had been shot through an unwashed drinking glass that had recently held milk.

I suspect that to get on the close-focusing bandwagon without paying the fare, some manufacturers just lengthened their helical focusing mounts without altering optical design or adding

Nikon's unusual Medical-Nikkor lens incorporates a focusing light and a built-in ring flash (the flat pack houses the power supply) that provides shadowless illumination for medical, industrial, and scientific requirements. Its 200 mm focal length allows close-up shooting from a distance, with magnification changes and focusing from 0.06× (1:15) to 3× (3:1) accomplished by installing any one of six auxiliary plus-lenses. Yashica/Contax has a similar unit.

the cams necessary to change lens-element spacing. So if you do purchase an inexpensive close-focusing lens, take a few pictures with it in the camera store before you buy it, and see if the results are satisfactory to you. There are some good buys around, if you are careful, although the expensive models always have much more substantial mechanical construction that will stand up to more abusive treatment and prolonged use.

Users of TTL meters need not make any adjustments for exposure correction as they focus into the *close-up* range (greater than 0.1×). However, external or handheld metering does require compensation for lens extensions that magnify greater than 0.1× (1:10). The table on p. 75 and the illustration on p. 74 provide the necessary data, which should be copied and taped to a safe place on the lens barrel. Close-focusing telephotos and wide-angles have fairly large pupillary magnification factors (see p. 73) that can cause incorrect exposures if extension tubes are added to produce magnifications greater than approximately 0.5× (1:2). Therefore, the aforementioned data must be modified either through calculations as explained in Appendix B, or through a test exposure series as described in Chapter 10, Exposure, p. 239.

AN UNUSUAL CLOSE-FOCUSING TELEPHOTO

Nikon makes a very special 200 mm lens that fits only their cameras; it was specifically designed for the *close-up* and *extreme close-up* ranges. Called the "Medical Nikkor," it is intended for clinical use, particularly during surgery, where photographic records are required both for pathological and teaching purposes. Since the lens does not have conventional focusing, various magnification ranges—from 1:15 to 3:1 (0.07 to 3×)—are attained through the addition of supplementary plus-lenses of appropriate power. Unlike plus-lenses on conventional optics, this long prime lens and its supplementary close-up lenses were carefully designed for proper optical performance in the *close-up* and *macro* ranges. The long focal length provides a working distance four times that of a standard 50–55 mm "macro" lens, which helps keep the photographer and surgeon out of each other's way. The extra distance is also appreciated by patients being photographed for dermatologic, oral, and orthopedic studies.

Two other novel features make the lens useful to the medical, scientific, and biological photographer: (1) a magnification numeral is automatically imprinted in the corner of each frame, and (2) a built-in electronic ring flash around the front of the lens provides shadowless illumination while its short duration cancels the effect of any motion by photographer or subject. It is a lens for the specialist. (Contax has recently introduced a similar lens.)

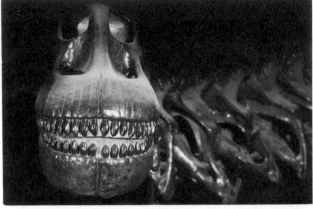

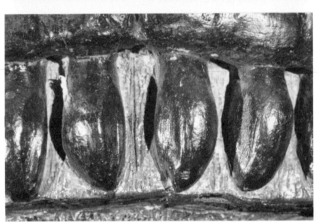

A local brontosaurus willingly posed for pictures that demonstrate the versatility of a macro-zoom lens. *Upper left:* Using a Vivitar 70–210 mm optic at its 70 mm setting, three-quarters of the beast's 67 ft (20 m) and 60,000 lbs (27,272 kg) were squeezed onto the film. *Upper right:* At the 210 mm telephoto setting, a more formal head-and-shoulders portrait was possible. *Right:* Switching to the macro mode, a 0.3× (1:3) image of his (her?) teeth shows an array of "grinders," indicating a plant-eating animal, and giving the photographer cause to have less concern for his safety than the size of this creature might warrant. *(Dinosaur courtesy of Am. Museum of Natural History.)*

MACRO-ZOOM LENSES

These recent wonders are somewhat like a mobile home: It is convenient to have all the amenities and conveniences in one portable package, but it is expensive, and there are some definite compromises.

A macro-zoom is primarily a zoom lens, typically covering the moderate-to-long telephoto range, which also permits focusing in the *close-up* realm. It does *not* operate in the *macro* or even in the *extreme close*-up range. The typical near-focusing limit provides only a 1:4 (0.25×) image ratio, although some, like the Vivitar Series I 70–210 mm model, go to 1:2 (0.5×).

This type of optic has two distinct, mechanically separated focusing ranges; the first covers the infinity-to-1:15 ratio. That is the range in which the zoom operates. By moving a collar or rotating a special ring, the close-up mechanism is engaged, and close focusing becomes possible. The zoom does not operate in the close-up mode

of the macro-zoom lens; in fact, the optic functions rather like a fixed-focal-length, close-focusing lens. In the normal range, the lens is zoomed, i.e., its focal length changed, by sliding a collar or rotating a ring; the photographer remains fixed, the image size changes, and focus is maintained.

Some versions, such as the Vivitar Series I 35–85 mm *f*/2.8, are not true zooms but "variable-focal-length" (VFL) optics; they must be refocused with each adjustment of focal length. This is usually a minor drawback, since focusing and focal length changes are accomplished by adjusting the same ring. But if you are following athletes or other rapidly moving objects, the true zoom is more convenient.

In the close-up mode, macro-zoom lenses vary with the focal-length setting that is fixed internally when the lens is shifted out of the zoom range. In general, close focusing is avail-

Most macro-zoom lenses must be considered zoom lenses with close-up capabilities, not "macro" lenses that also zoom. When in "macro" mode (usually 0.3× at most), image quality of many macro-zooms is not good in the corners. *Upper left:* Half a negative of a book illustration taken with a conventional macro-zoom confirms this. Halftone dots are only resolved in central portion of negative (the ear). However, new flat-field designs, like Vivitar's 90–180 mm optic, are surprisingly good (*lower left*). *Right:* For comparison, the same scene by a true "macro" lens is shown here.

able only at the shortest focal-length setting of the zoom lens. It would be convenient if it occurred at the other end of the zoom range, since that would provide more working room.

The question of utility and convenience versus image quality, regarding the *standard* zoom lens, has been the subject of debate for almost two decades since the first commercial zoom was marketed for SLR cameras. The addition of close-focusing capabilities further complicates the issue. With an average of 15 glass elements, and a list of features that includes everything but x-ray vision, zoom lenses cannot compete on a point-by-point examination of image resolution, contrast, and distortion with prime-focal-length lenses that are designed without the burden of all-around versatility.

In general, the close-up quality of the best macro-zoom is about comparable to that obtained from an $f/1.4$ normal 50 mm lens used with plus-lenses or extension tubes. In both cases you will get adequate-to-good close-up performance *if the lens is stopped down* to $f/11$ or smaller. For photography of three-dimensional subjects, these lenses can be quite satisfactory.

At the time of this writing, most of the macro-zoom lenses, (and there are over two dozen of

them) come from independent lens makers rather than from the camera manufacturers, and therefore are available to fit many cameras. As usual, cost and quality go hand in hand, although some less expensive models can provide reasonable performance. But be careful; there are some very poor-quality macro-zoom lenses on the market. A quality optic of this type has a lot of complicated glass and metal; the better ones cost as much as, and more than, a good camera with a normal lens.

These lenses have their greatest application in travel and fieldwork where the need for versatility, minimal equipment, low magnification, quick operation, and reasonable sharpness in the central two-thirds of the frame may be paramount. One of the macro-zooms covering the 40–90 mm range might be an ideal choice for a single lens on a vacation trip. The nature photographer could do a tremendous amount of photography with a 70–210 mm version, a tripod, and maybe a 2× teleconverter (see Chapter 6, Special Equipment and Combinations). He or she could obtain almost life-size images close-up, and use the long zoom capabilities to fill the frame with shy creatures or inaccessible fauna; and with the 2× converter doubling focal length

Though a bit unorthodox, zoom lenses may be reversed to create a variable magnification close-up system. No one advises that such a configuration be used when critical flat-field resolution is required, but at f/11 or f/16, most are quite good in the central two thirds of the frame. Experimentation is in order, and the lens need not have a close-focusing mode when used front-forward. Shown here mounted in reverse are a 43–86 mm Nikon, generating magnifications of 0.23× to 1.3× (lower camera); and a 70–210 mm Vivitar on 63 mm of tubes, which produces 3× to ∞.

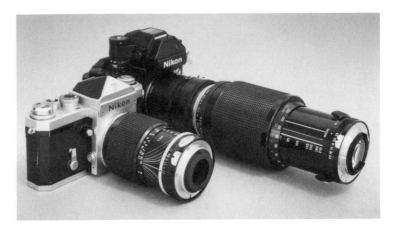

to 420 mm, the photographer could pull in birds, beasts, and otherwise unapproachable subjects. The addition to his/her kit of a single 28 or 35 mm wide-angle lens would give this photographer the added capability of panoramic shots, and complete the range from wide to long.

A zoom is also excellent for color slide photography in candid and restricted situations: Cropping can and must be done in the camera, since there is no luxury of cropping excess image in the darkroom. Here cropping is accomplished simply by zooming in and out (but not in the close-up range).

Some other considerations: With so many elements and sophisticated mechanisms inside, a macro-zoom lens is hefty—typically 2 pounds (0.9 kg)—and it should be handled with considerable care. When zoomed to long focal lengths, use fast shutter speeds if handheld: a minimum of 1/250 sec. in the 200–250 mm range. A tripod and cable release are in order with low light, slow film, and a desire to use small apertures for increased depth of field and/or better optical performance.

Even with modern antireflection coatings keeping scattered light from glass surfaces down to very low levels, a little bit of light from 30 surfaces (15 elements) can cause considerable flare—loss of image contrast—especially when the lens is pointed near the sun or other bright sources, or when bright lights such as lamps and windows appear in the picture. Beware of such problems; often a change of viewpoint can eliminate them in the scene.

Similarly, bright lights just outside the picture area are a problem because zooms do not have effective lens shades. A deep shade that would block stray light when the lens is set at its longest focal length (narrowest field of view) would also vignette the corners of the image to a great degree as the lens is zoomed to a shorter focal length (wider field of view). So lens shades for zooms are rather inadequate, and are designed for the short-focal-length end of the zoom range. At long-focal-length settings you can use your hand to block the sun from falling on the lens, or even use your body if the camera is on a tripod.

Exposure Corrections for Macro-Zooms

All that glass in a zoom absorbs and scatters a considerable amount of light. The marked f-stops, however, are based solely on the diameter of the lens aperture and on its focal length (f-number = focal length/aperture diameter), and they assume perfect light transmission. No correction is made by the manufacturer for the absorption and scattering losses that can easily amount to the equivalent of half an f-stop. Through-the-lens (TTL) metering in a camera automatically compensates for the losses.

However, exposures determined by hand-held and external camera metering must be corrected, especially when using color film, which is less tolerant to underexposure than black-and-white materials. The test series suggested on

Not only is the Asian snow leopard a rare, vanishing species, but a carnivore of considerable danger. It is certainly not the most propitious subject for close-up photography, and any photograph of such an animal is best planned with considerable caution . . . from a safe distance. Even at the zoo, the long working distance provided by a 700 mm lens was required for this photograph. The only practical close-up optics for such situations are the few compact mirror telephotos having close-focusing capabilities. In this case, a 700 mm Questar was used which, without any accessories, can provide a magnification of 0.25× (1:4), with a comfortable 10 ft (3 m), thank you, between man and beast.

p. 239 in Chapter 10, Exposure, can provide the required compensation data for the non-TTL-metered camera. It is important to note that there is *no* need to apply the exposure increase factor (**E.I.F.**) to macro-zoom lenses used in the "macro" mode on cameras without TTL metering. With all lenses that I know of, optical design is such that there is *no* change in the amount of light reaching the film.

In Conclusion . . .

If you happen to like zoom lenses and find the compromises acceptable, or even necessary for your photographic situation, you might consider purchasing a model with the extra convenience of moderately close focusing: a "macro"-zoom. As this is written, major improvements in zoom lens optical quality occur almost monthly as manufacturers rapidly introduce new, more sophisticated designs. In just about every model, a close-up capability is being incorporated into zoom lenses in a manner that continues to see an upgrading in image quality—e.g., the new "flat-field" designs. In some cases, that quality is beginning to approach that found in single-focal-length true macro lenses (see the photographs on the top of p. 105).

MIRROR TELEPHOTO LENSES: VERY SPECIALIZED PIECES OF EQUIPMENT

Nature and wildlife photographers, especially, need to get close-up pictures, but they often cannot get, or are prudently afraid of getting, physically close. The longer the focal length, the greater the working distance for a given magnification; therefore our prudent nature photographer could buy a conventional 800 mm lens that looks like a small cannon, but only focuses to about 60 feet (18 m), and provides a maximum image ratio of approximately 1:15 (0.07×).

To get to 1:2 (0.5×), over 10 inches (25 cm) of accessory extension tubes or bellows (in tandem) would be required, along with some special super mechanics to support it all. The additional extension plus the basic 24-inch (61-cm) lens length becomes quite an unwieldly contraption, and handles more like a length of sewer pipe than a camera. Handholding is out of the question (see the illustration above).

To create a more compact package, and, in many cases, to eliminate the ridiculously long extension lengths required for even moderate close-up photography, mirror lenses hold some clever optical tricks. They are designed with two internal curved mirrors that fold the light path and condense a long effective focal length into a short package: a so-called *catadioptric* design. (Large, reflecting astronomical telescopes have been using this principle for years, which itself is a modification of the first reflecting telescope invented by Isaac Newton in the 1600s.)

A small forward or backward motion of one of the mirrored elements effectively changes the optical path by two-to-three times the amount of actual mirror displacement, permitting close focusing without unwieldly extension.

Some of the mirror lenses have near-focusing limits that are one-half to one-quarter the distance of their conventional all-glass counter-

Facing page: Two tongue-in-cheek pictures were contrived to illustrate the virtues of close-focusing catadioptric (mirror) lenses. Though neither lens can focus at such a close working distance, the upper picture compares the "handholdability" of a conventional refracting 800 mm optic with a compact 700 mm Questar mirror design. The former weighs 8 lbs (3.6 kg), is 24 in. (61 cm) long, and, at its closest focus of 60 ft (18 m), generates a magnification of $0.07\times$ (1:15). The Questar, on the other hand, weighs but 4 lbs (1.8 kg) in an 8-in. (20-cm) package. Its near limit of 10 ft (3 m) produces a $0.25\times$ (1:4) magnification. For consistent performance, even a mirror lens should not be handheld. The lower picture accurately shows the relative working distances of 50 mm (left camera) and 700 mm (right camera) lenses, both set at **m** = $0.25\times$ (1:4) for a picture of a gorilla's wink. *Near Left:* A more serious application of a Questar is evident in this portrait of an Indian fishing owl, taken from 10 ft (3 m) at one-quarter life-size. Since this owl is a nocturnal creature, electronic flash was employed.

parts of equal focal length. These near-focusing limits in turn mean magnifications of approximately $0.25\times$ (1:4) for some of the mirror lenses.

The Celestron 1250 mm $f/10$, for example, is only 11 inches (28 cm) long, and weighs 4 pounds (1.8 kg). At closest focus it provides a magnification of one-third life-size, $0.3\times$ (1:3), *with a 15-foot (4.6-m) working distance.* A 1200 mm lens of conventional design is about 42 inches (106 cm) long, and weighs 12 pounds (5.5 kg); it only provides a magnification of about $0.07\times$ (1:15), and the nearest subject it can focus on must be at least 140 feet (46 m) away!

Catadioptric optics are available in focal lengths from about 500–2000 mm. Cost is comparable to conventional all-glass designs of similar focal length and quality; the better ones may be almost double the cost of a good camera. But unlike conventional, awkward, super-telephotos, as shown in the accompanying illustration, you can *handhold* these compact mirror lenses in sizes

up to about 800 mm focal length . . . at 1/1000 sec., but don't breathe!

A minor problem with the mirror design is the lack of a conventional diaphragm; it always operates "wide open," which is usually $f/8$ to $f/11$. Exposure must therefore be controlled by shutter speed, or with rear-mounted neutral density filters supplied with some models. There is also no control over depth of field. As long as Tri-X film (ASA 400) is not used outdoors on a sunny day, the lack of diaphragm should not pose any problems. Assuming a sturdy tripod is used, which is just about mandatory for all super-telephotos, on a bright day at $f/11$, Plus-X film (ASA 125) can be exposed at 1/250 sec. or Kodachrome 64 at 1/125 sec.

Before investing in such a specialized lens, thought, careful choice, and a first-hand test are definitely in order. Theoretically, conventional telephotos should provide somewhat sharper results than mirror lenses. But under actual field conditions, a compact mirror lens sometimes

The optics of a compact catadioptric ("mirror") lens are represented at right, the zig-zag "folded" light path accounting for the long focal length in a short package. *Catadioptric* refers to a system of mirrors and lenses; in the diagram, the dotted portions are curved mirrors, while the lined areas indicate refracting (transparent glass) elements. These systems can have some unevenness in illumination across the film, and they are also very sensitive to component misalignment, so handle with care.

outperforms its longer counterpart.

The stove-pipe length of the conventional telephoto overhangs the tripod at both ends, and is considerably more prone to vibration and buffeting by slight breezes. However, catadioptric optics require extreme care and precision in assembly. Cheap versions of these lenses can generate images of very poor quality. Also, be aware of the fact that no 1000 mm lens produces images as tack sharp as those from a fine, normal-focal-length lens. But with a super-telephoto, you can take a nice head-and-shoulders portrait of a timber rattlesnake . . . and not have to limp home to develop it.

If moderately close-up photography at *extreme* distances must be done, a mirror lens will do the job. Not all catadioptric designs have close-focusing capabilities; those made by Questar and Celestron do. Both companies provide mounts for any standard SLR camera.

A few notes of caution: Mirror optics have somewhat uneven illumination across the frame, a condition that manifests itself as darker corners in a full-frame print or slide. Unless you happen to be shooting birds against a clear sky, this is usually not too bothersome. However, some mirror telephotos have considerable light loss, even in the middle of the frame, due to less than 100 percent reflection from the mirror surfaces. On the less-expensive models, the loss may be equivalent to one *f*-stop or more from the marked aperture. TTL metering will automatically compensate; with handheld meters, per-

form the type of test mentioned on p. 239 in Chapter 10, Exposure. Similarly, correction for diminished light intensity at the film plane at magnifications greater than $0.1 \times$ (1:10) must also be applied. Here, too, TTL metering automatically compensates; or use a handheld meter and correct the exposure as per instructions for other close-focusing lenses on p. 75.

An interesting curiosity of catadioptric lenses is the fuzzy, donut-shaped images that result from out-of-focus small, bright spots in the scene. We are accustomed to seeing such spots, e.g., highlights reflected off water or openings in dense foliage, as fuzzy *discs*. But the secondary mirror on the rear of the front element of a mirror optic gives the lens an annular aperture, and the discs turn into donuts. In fact, the effect may even be desirable.

Finally, and probably most important, there is another way of achieving the long-range close-up capability of the mirror telephoto in an even more compact package, and for considerably less money, but, as you can imagine, with some serious compromises. Teleconverters, to be discussed in detail in Chapter 6, Special Equipment and Combinations, are available in powers that double or triple the focal length of the lens they are attached to; and they fit behind a lens like an extension tube, to which they are comparable in size. For example, a $3 \times$ converter will triple the focal length of a 200 mm lens. Regular extension rings placed between the converter and the prime lens will generate a 600 mm effective focal

length, with its inherent long working distance, resulting in a 1:4 (0.25×) or even 1:3 (0.3×) image ratio. *The image quality of such a combination is almost totally dependent on the quality of the prime lens.* There are also some significant compromises associated with such an assemblage, the details of which are discussed in the next chapter, Special Equipment and Combinations.

SUMMARY

The versatility, convenience, and image quality of a "macro" lens is unsurpassed, and it is recommended for the person doing a good deal of close-up photography. A "macro" lens permits continuous focusing from infinity to half life-size, and will operate up to full life-size with the addition of an extension tube that is supplied with the lens. "Macro" lenses retain all automatic diaphragm and metering functions of conventional lenses, although maximum aperture is around $f/2.8$ to $f/4$. Reversed on extension tubes or bellows, these lenses produce high quality images in the *macro* realm above 1× (1:1).

The edge-to-edge, flat-field sharpness of a good "macro" lens makes it an excellent choice for photocopying, slide duplication, and slide production from flat artwork; a 50–55 mm lens is good for such work. Lenses of 90–105 mm are also available; they provide more working room in front of the lens, and also make excellent moderate telephotos for general-purpose and portrait photography. A quality "macro" lens gives images as good as, if not better than, a normal lens when both are focused on distant objects.

No exposure correction is required with a "macro" lens if TTL metering is used. If an external or handheld meter is employed, exposure compensation is required, as with extension rings and bellows, and is a function of magnification (see the table on p. 75).

Short-mount lenses have no focusing capability of their own and must be used on a bellows. At focal lengths around 135 mm, these lenses can be focused from infinity to slightly more than 1× (1:1), depending on the maximum extension of the bellows. The long focal length is a convenience in close-up photography, since it provides more working room; however, for magnifications greater than 1×, shorter focal lengths are necessary. Optical correction of short-mount lenses is for the *close-up* range, so image quality is comparable to "macro" lenses. Exposure correction considerations are identical to those noted for "macro" lenses.

By using movable or "floating" elements within wide-angle and telephoto designs, reasonably good optical performance may be obtained both at far and very near ranges. A close-focusing lens typically provides a 1:4 (0.25×) image ratio at closest focus, which makes such a lens considerably more versatile and expensive than its nonclose-focusing counterpart. Here, too, if TTL metering is not used, exposure correction in the 1:10-to-1:4 range is required. Quality varies considerably among brands; check bargain models before buying.

A macro-zoom has the basic properties of a zoom lens, and some of the abilities of a close-focusing (but *not* "macro") optic. Image quality is the compromise associated with zoom-lens versatility. All current designs require a mechanical operation by the photographer to switch from the zoom range to the *close-up* realm. Without TTL metering, exposure correction is *not* required in the close-up mode, though some correction may be necessary due to the light loss from scattering and absorption by the large number of glass elements in the lens.

Photographers requiring close-up pictures at extreme distances might consider the specialized catadioptric, mirror, super-telephoto designs. They are considerably more compact and can focus much closer than conventional all-glass lenses of similar focal length.

Much of the equipment studied so far can be assembled to provide added versatility by combining components in unconventional ways, and using some homemade or makeshift devices. Chapter 6, Special Equipment and Combinations, will delve further into this subject. Such tinkering is often a lot more satisfying than just *buying* what is needed, especially when it provides quality equal to factory-made products, and often in a more convenient, and much less expensive manner.

The resemblance between this 48-hour-old chick embryo and a human embryo at 25 days is remarkable (see Bibliography: L. Nilsson. *A Child is Born*). Its 7-mm length required a 5× magnification on film, which was achieved *without* a bellows. Instead, a 135 mm telephoto and a 28 mm wide-angle were simply mated, face to face. This chapter covers such special, but straightforward, techniques.

6 Special Equipment and Combinations

So far specific components have been discussed, from simple supplementary close-up lenses to close-focusing catadioptric telephotos, each one being designed to function over a particular working range. With some lenses, such as the macro-zooms, that range is already quite extraordinary. However, the capabilities of any one piece of equipment may be further expanded by using it in combination with other close-up hardware, or by adding relatively simple attachments that are normally used for conventional photography. For example, enlarging and cine lenses have desirable optical characteristics for such purposes, and may be adapted for use in a way that provides results superior to those obtained with conventional apparatus. And the savings can be considerable, especially if, to continue the example, access to an enlarger or a movie camera is available.

Additionally, many camera attachments exist, such as special eyepieces and focusing screens, that can make the mechanical operations—and physical contortions—of close-up work easier on the eyes, neck, knees, and back.

All of this hardware should be looked at simply as tools to make technical success more predictable, more consistent, and more comfortable, so that the photographer can concentrate on the subject matter and its rendering in as interesting a manner as possible.

TELECONVERTERS

Looking externally like an extension tube, but having a group of lens elements in its center, a teleconverter, or telextender, as it is sometimes called, effectively increases the image size, i.e., magnification, of a lens whether the lens is used with or without close-up accessories. It is one of the most useful tools you can own for close-up and macro photography. Like an extension tube, if fits on a single-lens reflex (SLR) camera between the prime lens and the camera body. The amount of image magnification is indicated by the "power" of the converter, usually either $2\times$ or $3\times$, although some variable 2–$3\times$ models are available, and Soligor has a $4\times$ teleconverter. (This magnification should not be confused with

m, which is used to define the object/image size relationship.)

For example, a $2\times$ teleconverter doubles whatever size the image would have been on the film had the prime lens, or prime lens and accessories, been used alone. Originally these relatively inexpensive devices—about twice the price of a set of automatic extension tubes—were designed to double or triple the focal length of a normal or moderate telephoto lens so as to provide a considerably greater telephoto effect without the expense of purchasing an additional long lens.

The usefulness of teleconverters in close-up photography comes from the fact that they retain

113

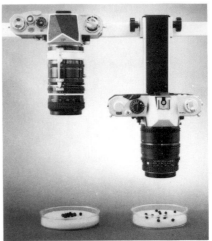

Upper left: A teleconverter is shown by itself and mounted behind a lens. *Upper right:* Teleconverter increases magnification with a given lens *without* decreasing working distance. Here, both cameras are set for **m** = 1× (1:1). The left-hand camera, fitted with a 3× teleconverter, has 3 times the working room of its neighbor. *Below:* Comparison is made between a macro lens—set at 0.5× (1:2)—with (right) and without (left) a 3× teleconverter.

whatever focusing distance is set by the prime lens (or prime lens with extension tubes or supplementary close-up lenses); but they *double* or *triple* the image size, providing a picture that appears as though it were taken *two* or *three times* closer than the actual working distance.

For example, conventional lenses, regardless of focal length, permit focusing to a near limit that provides a magnification of approximately 0.1× (1:10). A 2× teleconverter interposed between the prime lens and the camera body will double the magnification to 0.2× (1:5) *without decreasing the working distance.* On the other hand, the same image size—at half the working distance—can be had from a much less expensive +3 supplementary close-up lens attached to a 50 mm prime lens. But more important than the cost is the fact that a supplementary close-up lens requires no exposure correction, whereas a 2× teleconverter requires a fourfold exposure increase: two *f*-stops *or* a shutter speed that is four times slower. A 3× unit, which would triple

the magnification to 0.3× (1:3), again without altering the working room, needs a three *f*-stop correction, or, equivalently, a shutter speed that is eight times slower.

If a tripod, copy stand, or electronic flash is not being used, slow shutter speeds may pose a problem. But in the field with problem subjects, or indoors with difficult lighting situations, the extra room provided by teleconverters is often quite an advantage. (Coupled with a flash, as will be seen in Chapter 8, Lighting, teleconverters are ideal for nature photography.)

The exposure comparison of teleconverters with supplementary lenses is a bit misleading. For magnifications above half life-size, where the additional working distance is most needed, and therefore where teleconverters are most helpful, plus-lenses are not used. In such cases, the additional exposure correction for a teleconverter is only one to two *f*-stops more than it is for the same magnification reached with lens extension alone (see p. 75).

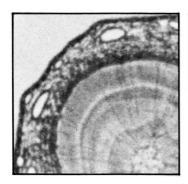
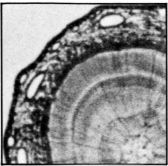

For quite a while, teleconverters were moderately priced devices available from accessory manufacturers only. Now some major camera corporations produce them at considerably higher price and somewhat superior optical quality. Both photographs of a cross section of a pine stem were taken with a "macro" lens at 1× (1:1) and a 2× teleconverter. The converter for the left picture was a standard accessory brand; that for the right, a Nikon TC-1. Prints are sections from 11″ × 14″ (28 × 36 cm) blow-ups.

Teleconverters are particularly useful at magnifications greater than half life-size and into the true *macro* range for two significant reasons. The first is that the short working room found at high magnifications can be a serious problem. At 2× (2:1), a reversed 55 mm "macro" lens leaves only 2.6 inches (67 mm) between lens and subject. Unreversed, with a 3× teleconverter, over 50 percent more space is gained. (If the lens were not so deeply recessed into the built-in lens shade, the gain would be considerably more.) Additionally, the combination of a 2× *and* 3× converter extends that distance to almost 7 inches (18 cm), just the space that might be needed to look into tanks, bottles, cages, or burrows, or when using vertical illumination (see p. 191).

It could be argued that to obtain large working distances above life-size, a 135–150 mm telephoto would provide the same increased working distance as a 50–55 mm "macro" with a 3× teleconverter, with a gain over the latter of a stop or two in illumination at the film plane. This is true, but (1) teleconverters are cheaper than telephotos; (2) above life-size, the long lenses should be mounted in reverse, surrendering auto-diaphragm operation; and (3) if they were conventional telephotos, their optical quality for close-up purposes would probably not equal a *good* "macro" lens/teleconverter combination.

The second reason that teleconverters are useful at magnifications above life-size is that they allow retention of automatic diaphragm and full-aperture, TTL-metering features when photographing at magnifications as high as 6× (6:1). This can be accomplished without the very long extensions, double-cable-release systems, and special adapters (shown in the illustration on p. 65) necessary when a lens is reversed.

The retention of the automatic diaphragm can be very helpful if the subject happens to be moving erratically, such as insects, or flowers on a breezy day. Simply set the prime lens, preferably a "macro" to 1× (1:1) or less, and then attach it, front forward, to the appropriate teleconverter (or even to stacked converters for more magnification). Changes in magnification are made, of course, with the normal extension range built into the focusing mount of the prime lens. *When using a teleconverter, the prime lens is only reversed if the magnification resulting from the prime lens and any attachments (plus-lenses or extension tubes) is greater than life-size without the teleconverter.*

Teleconverters are available for almost all SLR cameras, from Spiratone, Vivitar, and other companies, and are made so that TTL metering and aperture coupling between lens and camera are retained. At the time of this writing, a few camera manufacturers were beginning to produce converters to fit their own lenses. But most units are made by independent companies, and come with two, four, and even six elements (the latter from Komura), the quality and price generally increasing with the number of elements added to control aberrations.

As noted in the examples above, teleconverters may be stacked to increase magnifying power. The total increase in magnification is the product of the individual powers of each. A 3× and a 2× converter coupled to the rear of a prime lens provides six times more magnification than that obtained from the prime lens alone. The extent of image magnification with a teleconverter greatly depends on the quality of the prime lens, but approximately 9× is the limit for any setup of reasonable quality.

Amazingly regular hexagonal facets of an insect eye serve as subjects to demonstrate proper use of teleconverter. *Left:* Normal 50 mm *f*/1.4 lens at *f*/5.6, on extension tubes generating 0.5×, goes to 1.5× with the addition of a 3× teleconverter. Image quality is terrible; the converter is magnifying poor image; fast lenses perform badly on extension tubes (p. 63). *Center:* By replacing normal lens with "macro" set at 0.5×, performance is fine; converter is enlarging a good image to begin with. *Right:* Addition of 2× converter to 3× unit already on "macro" lens doubles magnification and retains image quality. Prints are 14× enlargements.

IMAGE QUALITY WITH TELECONVERTERS

Much has been said about the degradation of image sharpness caused by teleconverters, but a good deal of that commentary is as much folklore as fact, and is a misunderstanding of the use of converters. A teleconverter does decrease the resolving power of a lens. But a very good prime optic, such as a high-quality "macro" lens, has resolution considerably higher than any film. Therefore, even if the sharpness of a good prime lens' image is mitigated, the film is still the limiting factor.

A basic requirement when using a teleconverter is a high-quality prime lens *used at its sharpest apertures,* usually between *f*/5.6 and *f*/11. (If a conventional lens with tubes or plus-lenses is used, *f*/16 may be preferable; do a test.) When used with poor-quality prime lenses, or at apertures other than optimum, the teleconverter will magnify any defects in the prime lens, and results will be unsatisfactory (see photos above).

Difficulties occur in the corners and at the edges of the image, particularly when non-"macro" lenses are used as the prime optic. But quite often, the important parts of three-dimensional objects only occupy the central two-thirds

of the frame, and results will still be quite good. Then the convenience of the additional working room gained from use of the teleconverter more than makes up for any loss in corner sharpness. If optimum definition is necessary across the entire field, a good "macro" lens or other flat-field optic such as an enlarging lens (discussed later in this chapter) will be necessary.

Attempts in gaining additional depth of field by using teleconverters at magnifications greater than approximately 2× or 3× with very small apertures (such as the *f*/32 available in "macro" lenses) will prove to be counterproductive. The resulting problem, called diffraction, has already been mentioned on p. 84, in Chapter 4, Extension Tubes and Bellows, in conjunction with the discussion on high magnification from bellows. It is a situation that cannot be disregarded; Appendix C provides further details. When in doubt, bracket the exposures; i.e., take one photograph at a marked (relative) aperture of *f*/16, another at *f*/11, then *f*/8, and even *f*/5.6 if **m** is greater than 4×. Recording the results of these tests will eliminate the need to bracket for this reason in the future.

EXPOSURE CORRECTION AND DEPTH OF FIELD WITH TELECONVERTERS

Teleconverters work their magic by taking the image as it comes from the prime lens and magnifying it, or spreading it out, so to speak. Since the brightness of the image from the prime lens is fixed by whatever light passes through its aperture, spreading that image out more than normal decreases the intensity of illumination at any given spot on the film. Thus, an exposure correction is required. Cameras having TTL metering will sense this decreased brightness and automatically compensate.

When such a meter is lacking, manual exposure correction is easy. The required increase, in *f*-stops, for the converter *itself* is equal to the power of the unit. For example, a $3 \times$ converter requires a three *f*-stop *increase*. The correction, in *f*-stops, for stacked teleconverters is obtained by *adding* together the powers of the individual units. However, the need for relatively small ap-

ertures, both for adequate depth of field and for acceptable sharpness, will usually presuppose making the necessary correction by changing the *shutter speed* (an exception would be the use of flash). The accompanying table indicates the corrections in *f*-stops or shutter speed.

If the lens (or lens plus extension tubes) that is added to the front of the teleconverter requires conventional **E.I.F.** correction due to the fact that the *lens itself* is set at a magnification greater than $0.1 \times$ (1:10), then that correction must be *added* to the correction already required by the teleconverter. This procedure is really much easier than it sounds.

For example, the proper exposure for Kodachrome 25 on a sunny day is 1/60 sec. at *f*/11. If a subject were to be photographed in sunlight with a "macro" lens set at 1:2 ($0.5 \times$) with a $3 \times$ converter attached, the combination would pro-

Table 6-1

EXPOSURE CORRECTION FOR TELECONVERTERS*

Magnifying Powerng Power of Teleconverter †	To Increase Exposure: ‡		
	Multiply Shutter Speed by	OR	Open Aperture by (stops)
$2 \times$	4		2
$3 \times$	8		3
$4 \times$ (two $2 \times$)	16		4
$5 \times$ ($2 \times$ and $3 \times$)	32		5
$6 \times$ (two $3 \times$)	64		6
$8 \times$ (two $3 \times$ and one $2 \times$)	256		8
$9 \times$ (three $3 \times$)	512		9

*Exposure correction holds true when *not* using through-the-lens (TTL) metering.

†*A.* The power indicated here is the factor by which a teleconverter will multiply any magnification already achieved through conventional means.
B. Image quality and magnification limit of the teleconverter very much depend on the quality of the teleconverter and on the quality of the image presented to it by the prime lens; for close-up photography, a "macro" or other flat-field lens is definitely recommended.
C. Magnifying power of a teleconverter may be increased by placing an extension tube behind it (see p. 118).

‡This exposure correction is in addition to any correction required for lens extension *in front of* the teleconverter. The latter correction (found on p. 75) is a function of magnification *before* the teleconverter is attached. Total correction for both factors is achieved by *multiplying* together both corrections in terms of time, or *adding* together both increases in stops.

vide a final magnification of 1.5× (1.5:1), and the following correction to that basic exposure would be needed:

	Shutter Speed		Increase in Aperture (f-stops)
Correction for magnification (0.5×) of "macro" lens*	2 times slower	or	1
Correction for 3× teleconverter†	8 times slower	or	3
Totals:	16 times slower	or	4

(The corrections in terms of shutter speed must be *multiplied* together; f-stops must be added.)

*See the table on p. 75.
†See the table on p. 117.

If the total correction were made by aperture change, the result would be 1/60 sec. at f/2.8; which is an invitation to a resolution disaster. However, at a magnification of 1.5× (1.5:1), a camera can't be handheld at 1/60 sec; so as long as a tripod is necessary, make the correction in shutter speed and leave the lens at a sharp aperture. Then 16 times 1/60 sec. is approximately 1/4 sec.; therefore, f/11 at 1/4 sec. should be used. (It is interesting to note that the corresponding exposure for a magnification of 1.5× achieved through lens extension only would be f/11 at 1/8 sec.) If you find through tests that your lens is sharpest at f/8, and some depth of field can be sacrificed, then an exposure equivalent to f/11 at 1/4 sec. is f/8 at 1/8 sec. Of course, a TTL meter would give the same results without all the calculations.

Because teleconverters decrease the effective aperture of the prime lens, one might expect an increase in depth of field. However, since the magnification is also increased and depth of field decreases with increased magnification, the depth of field will be approximately what you would expect from any lens used at the resultant magnification and set at a particular marked (relative) f-number (see the table on p. 27).

EXTENSION TUBES BEHIND TELECONVERTERS

If you have only one teleconverter and need more working room or magnification, but have neither an additional teleconverter nor telephoto lenses, a few extension tubes will suffice.

The image magnifying power of a teleconverter can be increased by placing extension tubes or bellows between the converter and the camera body. The amount of additional magnification or exposure correction is not easily calculated, though it is a function of the focal length of the prime lens. Trials, with a ruler to indicate **m** and TTL metering for exposure, will produce useful working data for your accessories. For example, a 52.5 mm tube behind a 2× teleconverter on a 105 mm lens produces magnification results equivalent to a 5× converter (a 2× and a 3×). With the same tube and lens, but a 3× converter, we get 6×; 12, 25, and 50 mm tubes behind a 2× converter on a 50 mm lens simulate 3×, 5×, and 6× teleconverters, respectively.

There are slight differences among teleconverter brands, but the above information is a pretty good approximation. If exact magnification figures are required, temporarily put a ruler in the scene and calculate the exact ratio as indicated in the illustration on p. 23.

Exposure correction for the teleconverter/extension tube combination is equal to that required for a single converter (or stack of converters) having the same image magnifying power as that combination (see the table on p. 117).

The combination of extension tubes and teleconverters is more rugged and compact than bellows, so it is a good combination for high-magnification fieldwork, where subjects tend to be three-dimensional, and edge-to-edge sharpness is not necessary. But do remember to set the prime lens at one of its sharpest apertures. It is regrettable that this extension-tube-behind-the-teleconverter trick cannot be used for general photography, since the combination will not focus at infinity or far distances.

Standard camera lenses, attached in reverse to the front of telephotos, make "supplementary plus-lenses," which generate high magnification and have optical quality far superior to the simple, single-element attachments discussed in Chap. 3. For occasional use, Scotch #235 photographic tape or gaffer's tape can mate the pair *if* front rim diameters are identical (see next illustration). *Below:* A 105 and a 50 mm lens have been joined with tape, resulting in an m of 2.1× (2.1:1). The pair was used to photograph the planaria at left, a stained specimen on a microscope slide. Slight corner vignetting that resulted from using a "main" lens shorter than 135 mm was cropped out in the darkroom.

CAMERA LENSES USED AS SUPPLEMENTARY CLOSE-UP LENSES

It comes as a surprise to most people that a conventional camera lens (it doesn't have to be a "macro") can be used (reversed) in front of a second (unreversed) conventional lens, and the effect is equivalent to use of supplementary close-up lenses, as described in Chapter 3, Supplementary Close-Up Lenses, with two major exceptions: (1) when magnification is anywhere from 0.5× (1:2) to 6× (6:1) (see the accompanying table), and (2) though the lenses are not of special design, image quality is spectacular!

Since it is quite common to be carrying a telephoto and a normal lens, by merely mating the two with some tape, magnification of at least 2× can be attained on the spot. Other combinations will give different image ratios. Here is how and why:

Chapter 3, Supplementary Close-Up Lenses, explained that a simple plus-lens attached to the camera's prime lens permitted close focusing. The focal length of ordinary supplementary close-up lenses varies from 1000 mm (+1) to 100 mm (+10) (see the table on p. 44), and they provide image magnification, when used with a 50 mm prime lens, of approximately 0.1× (1:10) to 0.5× (1:2), respectively. On a 105 mm lens, those same supplementaries give 0.2× (1:5) to 1×(1:1). In Chapter 3, it was pointed out that image quality, especially around the perimeter of the frame, leaves something to be desired, particularly at magnifications greater than 0.5× (1:2). This is due to the fact that the supplementaries are simple, single-element lenses, having no additional optics for the correction of the aberrations that crop up when a normal lens is used in close-up situations.

If, however, a sophisticated multi-element camera lens is used as a supplement, by attaching it to the main camera lens in reverse so that its *rear* element is close to the subject, one gets a close-up system having excellent resolution across the entire field. And because the magnifi-

Nose-to-nose mating of lenses is best accomplished with metal adapter rings. Since no ring (that the author knows of) exists with male threads on both sides, you must construct your own. For most SLR lenses, use two Spiratone or Tiffen Series VII-to-VIII step-up rings. *Left:* Remove the black anodized coating on the Series VIII sides by evenly rubbing the rings on 220-grit aluminum oxide sandpaper placed on a flat surface. *Center:* Clean both rings with a solvent (alcohol, acetone) and join with cyanoacrylate adhesive (Eastman 910® or Super-Glue®). Use caution; your fingers can become glued to the rings instantly! *Right:* The sequence for mating two lenses of disparate diameters is shown here. The main lens, a large 135 mm *f*/2.5 telephoto, first gets a Series VIII adapter ring appropriate for its front rim diameter. Next, an VIII-to-VII step-down ring connects to the homemade male-by-male adapter. Finally, a Series VII adapter ring, of appropriate diameter for the "supplementary" lens, makes the final connection. This configuration of 135 and 28 mm lenses produces 4.8× (4.8:1), with the main lens set at infinity, and 5.5× (5.5:1), when the 135 (a close-focusing telephoto) is set at its nearest distance.

cation of any prime lens/supplementary lens combination is simply the focal length of the prime lens divided by the focal length of the supplementary lens (p. 54), high magnification results from the combination of a moderate telephoto used as a prime lens with a wide-angle or normal lens as a supplementary.

The table on p. 121 indicates the approximate magnification that results from some combinations of popular focal lengths. Note that a prime lens of greater-than-normal focal length is indicated; the use of a shorter focal length will result in severe vignetting—considerable darkening of the frame in all but the central portion. The reasons for that darkening have to do with optical design considerations that are beyond the scope of this book.

For similar reasons, *f*-stop selection for depth-of-field control and proper exposure must be made using the diaphragm of the *front* "supplementary" optic. That operation becomes a bit problematical because with such a makeshift contrivance, the marked *f*-stops on the front lens

no longer indicate the true amount of light passing through the system. In addition, as the aperture ring is adjusted, the light passed through the system does *not* necessarily change by a factor of two between any two adjacent stops.

In such situations, TTL metering is a godsend. Lacking that, the table on p. 121 suggests *approximate* corrections; the data were compiled empirically for a set of *Nikon* lenses. Variations in mechanical and optical configurations in other brands of lenses may cause significant departures from my figures. It is advisable to run tests on *your* combinations, such as the test series suggested on p. 239 in Chapter 10, Exposure. In a pinch, bracket exposures.

The most simple way to join the two lenses front to front is with tape. Scotch #235 photographic tape is excellent for this purpose because it leaves no residue, is opaque, and is relatively inexpensive. If you use a fresh piece of tape each time and rub it on well, and if the two lenses have identical front-ring diameters—which is often the case if they are made by the same manufac-

Table 6-2
REVERSED CAMERA LENSES USED AS SUPPLEMENTARY CLOSE-UP LENSES*

Prime Lens (mm)	Reversed "Supplementary" Lens	Magnification, m	Exposure Correction without TTL Metering: † (Multiply Shutter Speed by)
135	28 mm *f*/2	4.8× (4.8:1)	23
	35 mm *f*/2	3.9× (3.9:1)	11
	50 mm *f*/1.4	2.7× (2.7:1)	8
	105 mm *f*/2.5	1.3× (1.3:1)	2
200	28 mm *f*/2	7.1× (7.1:1)	90
	35 mm *f*/2	5.7× (5.7:1)	64
	50 mm *f*/1.4	4.0× (4.0:1)	45

*Prime lens should usually be set wide open (see text). Data are for both lenses set at infinity focus; somewhat greater magnification can be had by setting the prime lens focus to a closer distance. In all cases, **W** is about 1½ in. (38 mm).

†Correction data were empirically determined from author's lenses, *with front lens set at f/5.6*. (Other brands and lens types may require somewhat different compensation; do a test.) Take reading with non-TTL meter; find shutter speed it indicates for *f*/5.6; multiply that speed by numbers in this column.

turer—a reasonably secure mating is achieved. If the lens fronts are of different diameters, and/or if you need the peace of mind inherent in a metal-threaded attachment, two aluminum adapter rings of appropriate thread diameter can be cemented with special glue, as shown in the accompanying illustration.

Working Procedures

When the lenses are joined, attach the combination to the camera and hold the assemblage up to a bright, uniformly illuminated area, like the sky. You will probably notice some corner vignetting, even with both lenses fully opened. The amount of vignetting depends on the optical and mechanical features of the two lenses. If the corner darkening is minor, and if you are photographing objects that only fill the central portion of the frame, the effect can be disregarded. Or you can crop off the corners later in the darkroom if the final form is a print instead of a slide. Pronounced edge falloff can be considerably improved by adding 10–20 mm of extension tubes between the camera body and the main lens. Of course that will enlarge the image somewhat, possibly decrease resolution a bit, and require some additional exposure correction.

In severe cases of vignetting, when absolutely uniform illumination is required across the field, or even when there is a necessity to increase the magnification above that provided by the pair of lenses themselves, the addition of a teleconverter between the camera body and prime lens will work beautifully. The image-magnifying effect and exposure correction due to the converter will be identical to that obtained when the teleconverter is used behind any lens or lens/close-up-accessory combination (see the preceding section on teleconverters).

A few final notes on camera lenses used as supplementary lenses: In the table on p. 121, exposure corrections indicated are based on setting the *front* lens to a marked aperture of *f*/8. From tests, this has proved to be the best compromise between sharpness and depth of field with the lenses listed. A need for more depth of field may require a trade-off in resolution, and a decrease in the aperture of the front lens may be called for. But as noted earlier, the marked *f*-stops on that lens become nonlinear, so it is better to rely on TTL metering or exposure tests if you are going to experiment with various aperture settings. To reduce stray light, it will help to close down the aperture of the *main* lens to a point just before vignetting becomes detectable in the viewfinder. To do this, hold your "system" up to a bright, uniformly lighted area, and close the *front* lens aperture down to the working *f*-stop. Then, with the camera's depth-of-field preview button depressed, slowly close the prime lens aperture until vignetting is just discernible at the corners, and then open it slightly. If your camera does not have a depth-of-field preview button, leave the prime lens set at its widest aperture.

In the assemblage of close-up accessories, innumerable combinations are possible. *Upper left:* An 11 mm extension behind a standard 135 mm telephoto, followed by a 2× teleconverter, produces an **m** of 0.4× (1:2.5), with **W** a long 30 in. (76 cm). *Upper right:* 107 mm of tubes behind a fully extended 105 mm "macro" lens generates an **m** of 1.5× (1.5:1). Adding a reversed 28 mm wide-angle as a "supplementary" raises **m** to 5.5× (5.5:1), while a dual-cable release provides automatic diaphragm operation. *Right:* A +1 supplementary on the front, and a 10 mm tube on the rear of an 85 mm lens combined to make this photograph at 0.27× (1:3.7).

VARIOUS COMBINATIONS OF CLOSE-UP DEVICES

I have already indicated that plus-lenses and extension tubes can be used together, and that teleconverters will magnify any image, no matter which lens, extension device, or combination thereof was used to form that image. This chapter seems to be an appropriate place to regroup that type of information, which is particularly helpful in the quest for higher and higher magnification, not to mention the savings realized by using equipment already available.

For example, if the supplementary lenses at hand, even when stacked together, provide insufficient magnification, the addition of an extension tube or tubes, or bellows behind the lens will further increase image size. At 1× (1:1)

magnification and beyond, the prime lens should be reversed for optimum optical quality. If exposure is determined without the use of a TTL meter, it is important to remember that supplementary plus-lenses require no exposure correction, but extensions behind the lens do, as per the table on p. 75.

Reversing wide-angle and normal-focal-length lenses on an SLR camera tends to increase magnification significantly for a given extension length. However, for a high-magnification photograph, even with the lens reversed on a bellows at maximum extension, the image may still be too small. A simple supplementary lens placed over the end of the reversed lens may

Table 6-3

CAPABILITIES OF VARIOUS COMBINATIONS OF CLOSE-UP EQUIPMENT*

Combination †	Magnification, m, Range	Working Distance, W (in.)	(cm)	Exposure Correction without TTL Metering ‡	
				Multiply Shutter Speed by OR	Open Aperture by (stops)
52 mm tube, 2× teleconverter, 105 mm lens	0.25–0.62×	59–24	150–61	11	3½
11 mm tube, 50 mm lens, +2 supplementary lens	0.30–0.40×	6½–4¾	17–12	1.4	½
2× teleconverter, 18 mm tube, 90 mm lens	0.42–0.86×	19–10	47–25	5.8	2½
2× teleconverter, reversed 35 mm lens	3.3×	2⅜	6	11	3½
52 mm tube, 105 mm "macro" lens, reversed 28 mm lens	4.4–4.8×	2⅛	5½	11	3½
3× teleconverter, 62 mm tube, reversed 28 mm lens	12.0×	2	5	90	6½

*Values in the table are based on empirical data obtained from assembling author's equipment in combinations indicated. Other brands may generate somewhat different results.

†Listed in order of attachment to camera.

‡These factors were obtained from TTL metering, and therefore, include corrections for the pupillary magnification factor, teleconverter, and lens extension. TTL metering is recommended, particularly when using extension tubes behind a teleconverter, to expedite the exposure correction process when a number of factors must be considered; lacking such a meter, do an exposure test as explained on p. 239.

provide just the extra enlargement that is needed. But unless you have an attachment similar to Nikon's BR-3 adapter ring (see the illustration on p. 65), or a Spiratone T-flange and an adapter ring (see the illustration on p. 119), you may have to carefully make the marriage with black tape.

The system described above will work well, but if a short-focal-length lens is used because of a need for very high magnification, working distance is at a minimum. Considerably more lens-to-subject room is available by using a 2 or 3× teleconverter behind a normal or longer lens that has a supplementary lens (simple plus-lens or reversed camera lens for highest image quality), or extension tubes attached to it. Manual exposure correction must take into account not only the teleconverter (p. 117), but also any correction needed for the extension tubes or bellows used alone (p. 75).

In fact, the combinations and permutations are endless. You can even reverse a zoom lens and use it as a *variable magnification macro system* (see the illustration on p. 106). Your final selection will most probably depend on the equipment available, your inclination to tinker, and on your image-resolution and contrast requirements. The table above was assembled to indicate just a few of the various possibilities, and the accompanying illustrations shows some of the results. Experimentation and tests will determine what works best for you.

Enlarging lenses make excellent close-up accessories: they have flat-field optical characteristics and are designed for short "subject" distances. At magnifications below life-size, use them front-forward; above 1× (1:1), use them reversed. A 50 mm El-Nikkor enlarging lens, shown mounted in reverse on the left-hand bellows above, photographed the bedbug (*Cimex lectularius*) at right at 4× (4:1). The 150 mm Componon enlarging lens on the right-hand bellows makes an excellent short-mount lens for the 0.1 to 1× range where long **W** is needed. Since it's designed to cover 4″ × 5″ (10 × 12 cm) film, this lens produces a very large image circle, making it ideal for use on swing-front bellows used for perspective and depth-of-field control (p. 83).

ENLARGING LENSES USED FOR CLOSE-UP AND TRUE MACRO PHOTOGRAPHY

As previously mentioned, pressing conventional camera lenses into service for close-up work must be done with great care and at small apertures due to the aberration called field curvature. This aberration appears in such optics at very close-focusing distances, and especially in life-size images where results are, at best, marginal.

Furthermore, it was shown that "macro" and short-mount lenses give superior results, this being due to their "flat-field" designs; i.e., they are specially computed to give a sharp image completely across a flat piece of film from a flat subject. And with the shallow depth of field

in close-up photography, most objects can be considered flat.

The same flat-object/flat-image relationship exists in the enlarging process: A flat negative must be enlarged onto a flat sheet of enlarging paper. That requirement, plus the fact that enlarging lenses are designed for relatively short object distances, makes them ideally suited for close-up photography . . . if they are used correctly. Furthermore, the resolution and contrast of a good-quality enlarging lens are generally higher than found in a quality conventional camera lens because the camera lens must be designed with the added burden of a large maxi-

A comparison of two 1× (1:1) photographs of a Japanese maple leaf clearly shows the advantage of using an enlarging lens (*left*) over a normal SLR lens (*right*), the latter never intended for close-up imaging. Though enlarging lenses of 50 mm focal length are usually "optimized" for 10× blow-ups (that becomes 0.1× when used front-forward for photography), they certainly are far superior optically to normal lenses *anywhere* in the close-up or macro range. Their one drawback is lack of an automatic diaphragm. Both prints are sections of 4× enlargements of respective negatives, with the upper left corner of the print being a corner of the negative.

mum aperture. (Enlarging lenses typically open up only to $f/4$.)

In appropriate focal lengths, these refugees from the darkroom are particularly good for photographing documents, copying photographs, making slides from flat artwork, medical and scientific photography, and other applications where excellent, uniform resolution over the entire field is necessary. They are the poor man's "macro" lens, if the poor man happens to have a darkroom.

Unfortunately, these lenses are not the answer to every prayer. For example, if the convenience of an automatic diaphragm is needed to catch unstable subjects, enlarging lenses are not the solution. Also, since they have no mechanical focusing abilities of their own, and act (optically *and* mechanically) like the short-mount lenses on p. 98, a bellows is necessary, though an inexpensive one will do fine.

To get the most out of enlarging lenses: (1) use apertures of at least $f/5.6$, or $f/8$, although the better, more expensive types reach optimum resolution without having to stop down too far; (2) use them over the magnification range for which they were designed; and (3) as with any lens, reverse when necessary to keep the object and image distances on each side of the lens close to design criteria.

If you own a 35 mm camera and an enlarger, you most probably have a 50 mm enlarging lens, which is required to cover that format negative. Enlarging lenses are typically required to make $3'' \times 5''$ (7×12 cm) to $11'' \times 14''$ (28×36 cm) prints; that translates approximately into blow-ups of 3–10×. But, since the object distance is short in enlarging—the "object" is the negative—and the image distance is long, the print becomes the image.

Therefore, if the enlarging lens is used in the front-forward position on a camera, the light will pass through the lens in a direction opposite its path in the enlarging process. So mounted with its *f*-stop ring facing forward, the lens will provide *optimum* performance between approximately 0.3× (1:3) and 0.1× (1:10). However, if stopped down to $f/11$ or $f/16$, most lenses will work very well right up to 1:1. They will certainly give results *far superior* to a conventional camera lens used at the same magnification and aperture.

In their front-forward position for ratios below 1:1 (1×), 50 mm enlarging lenses require very thin extension tubes to change image size;

remember, these lenses have no focusing abilities of their own. And bellows cannot be used for continuous focusing in the *close-up* range because even at their minimum extension, which is typically almost 2 inches (50 mm), magnification will be almost life-size.

But a 50 mm enlarging lens *is* excellent for high-magnification photography in the true *macro* range. *Reversed* on an extended bellows or extension tubes, it performs beautifully up to $10\times$. (Even greater high-quality magnification is possible if a *good-quality* enlarging lens is used and a teleconverter is installed behind the bellows or tubes as can be seen in the accompanying illustrations.

Of course exposure correction without TTL metering is the same as that for any lens at similar magnifications (see the table on p. 75). Conveniently, additional correction for the pupillary magnification factor is not required since enlarging lenses are almost perfectly symmetrical.

Different brands and models of lenses have somewhat different *optimum* magnification ranges. The super-critical worker should test his/her lenses, and be aware, for example, that the famous Schneider Componon is optimized for $6-12\times$ and higher; whereas the Componon-S and Comparon series are at their hair-splitting best at magnifications around $3\times$. Similarly, the $f/2.8$, 50 mm El-Nikkor is advertised as being designed for $2-20\times$. But even outside their "optimum" ranges, all of these lenses will perform considerably better than a standard camera lens.

Professional workers and others who use large-format cameras will probably have access to the longer-focal-length enlarging lenses required to cover bigger negatives: An 80 mm lens is used on $2\frac{1}{4}''\times 2\frac{1}{4}''$ (6×6 cm) negatives, while a 135 mm or 150 mm lens covers the $4''\times 5''$ (10×12 cm) format.

These longer lenses have enough lens-to-film distance to permit front-forward mounting on a bellows and still get near enough to the film to operate in the *close-up* range of $0.1-1\times$ ($1{:}10-1{:}1$). Therefore, when mounted, they make excellent flat-field close-up systems. And an added benefit in some situations is that the longer focal lengths provide considerable working distance.

Additionally, long-focal-length enlarging lenses have a large image circle since they must cover film sizes considerably larger than the 35 mm format. In Chapter 4, Extension Tubes and Bellows, we discussed the special bellows that has a swinging and shifting front and is used for perspective control and increasing depth of field. Such lens movement requires a large image circle, which can be provided in the *close-up* range by a 135 or 150 mm enlarger lens used front forward. The photograph of the fish on p. 83 was taken with a 150 mm Comparon. (Above life-size, the proportionally long extensions required generate large image circles, so that even a 50 mm lens will have reasonable covering power.)

Reversing these long lenses and using extreme extension (p. 124) can result in greater-than-life-size magnifications having very high resolution and contrast, while at the same time providing generous working distance in front of the lens. For certain biological and other scientific applications (with specimens or hazardous substances behind glass, for example), or where space is needed for special lighting equipment, this technique can prove to be invaluable.

VIEWFINDER AIDS

When compared with *close-up* photography, most *conventional* pictures are taken where the lighting is adequate, the depth of field is good, the camera is conveniently at eye level, and the photographer is in a relatively comfortable position. When recording subjects physically similar in size and construction to the photographer, the "human engineering" of a modern camera leaves little to be desired. But I would estimate that less than a third of all close-up photographs are taken with the camera straight ahead and with the photographer *comfortably* behind it, and seldom is the photographer *really* comfortable unless he/she is into gymnastics or yoga.

Of course, the photographer's work can be restricted to large flowers that grow on bushes exactly 4 feet (1.2 m) tall . . . otherwise photographer and camera will invariably be very close to,

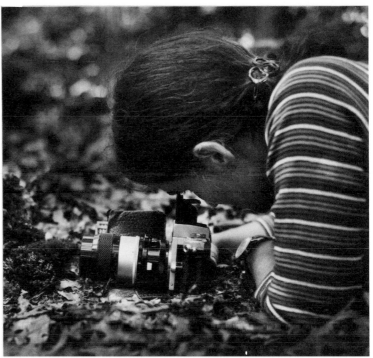

Various accessories exist that can eliminate body contortions—frequently required of the close-up photographer. One of the most useful devices is some form of right-angle eyepiece that permits looking into the camera from the top, so to speak. *Right:* Particularly outdoors, many close-up subjects live at ground level. Often the best photographic perspective is obtained with the lens right in the dirt (better put something under it), which leaves little room for "getting behind the camera." A waist-level finder saves the day, *if* your camera has a removable pentaprism, such as particular models of Canons and Nikons. *Left:* Lacking provisions for a waist-level finder, accessory right-angle attachments are available to fit almost any camera's eyepiece (try Spiratone). This one from Pentax is shown on a camera attached to a vertical copy stand. Such an arrangement frequently saves climbing on a step stool to peer into the viewfinder.

and often on, the ground. The most interesting specimens always seem to be underfoot. Indoors, most close-up photography is easily done on a vertical copy stand (Chapter 7, Positioning and Supporting Techniques). It's much easier to lay a diminutive sample down than to make it stand up. And, if it is a frequent activity, the copying of books and other flat material for the production of slides invariably requires a vertical copy stand.

There are a few small, relatively inexpensive pieces of equipment that can take the backache and the eyestrain out of this methodical, and sometimes critical form of photography. De-

pending on their purpose, these accessories either fit on the existing eyepiece, or, if the camera is so designed, inside the viewfinder. They will make looking into the camera and focusing on the subject much easier and, in the latter case, more reliable.

Eyepieces

Almost any eyepiece or finder that permits viewing from a position *above* the camera is extremely helpful. The accompanying illustrations show some examples. Removable pentaprisms are not found on most cameras, and for those

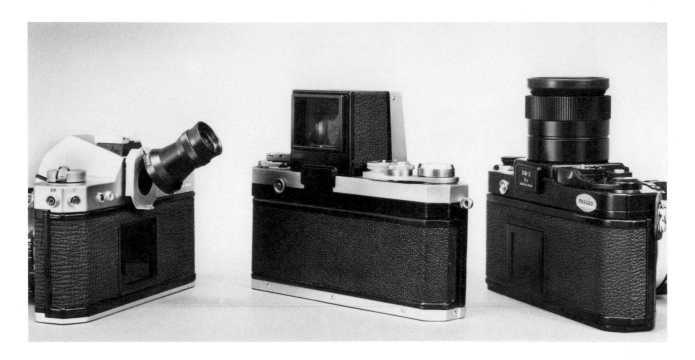

In addition to the finders on p.127, three other types should be noted. Strongly recommended is a swing-away eyepiece magnifier for critical focus in the sensitive macro range. Most manufacturers have one for their own cameras, e.g., Pentax (*left*), or check Spiratone. The other two are from Nikon (similar units from Canon): a "sports finder" (*center*) for long eye relief, and a bright, 6× waist-level finder (*right*).

lacking such a feature, a right-angle finder that attaches to the eyepiece is the best solution. Spiratone has a unit to fit most eyepieces, and the manufacturers of the major brands of SLR's also supply these finders for their own lines. Cameras with removable pentaprisms permit greater versatility in the design of other eyepiece configurations.

A second worthwhile aid is an *eyepiece magnifier*. It is indispensable in the macro mode where almost zero depth of field makes focusing critical to hundredths of an inch. Available from the same sources as just noted above for relatively modest cost, it magnifies the central portion of the viewfinder image about two times. The eyepiece magnifier is usually fitted with an adjustable diopter eyepiece so that you can remove your glasses for easier viewing.

Focusing Screens

Split-image and microprism focusing screens are more or less useless at magnifications greater than half life-size. They are not designed to work with lenses extended far from the film plane, nor in the dim light of effective apertures of $f/4$ and smaller that exist due to the lens extension factor (see p. 81). Luckily, on most cameras the microprism and/or split-image spot is surrounded by a ground-glass ring that functions quite well under these conditions. However, there are better screens for close-up work, and if your camera can accommodate them, the small investment is well spent.

Any screen with a *large area* of ground glass is to be recommended. On conventional screens, the ground glass is only a "donut" in the middle, and the camera often has to be moved to position that donut over the portion of the specimen where critical focus is necessary. (Of course if the subject is truly flat, this is not a problem.) But at magnifications greater than life-size, focusing on one spot, and then moving the camera to another position for the desired composition almost guarantees poor focus. Therefore, a screen

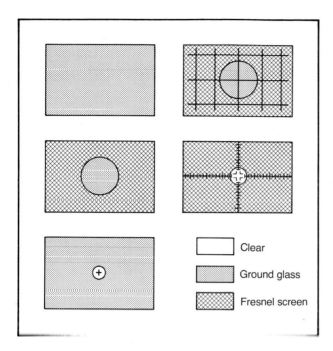

Photographers with cameras accepting interchange-able viewfinder screens should consider an all-matte screen for general close-up work, or one with a clear center spot and cross hair for high *macro* magnifica-tions. Screens with rectangular grid lines speed subject alignment when photocopying. *Left:* Some of the avail-able screens.

that is mostly ground glass will eliminate the need to shift the camera.

A totally different system of focusing is the *aerial image* technique. It is extremely accurate and sensitive, and is especially recommended for work at magnifications greater than $5\times$ (5:1); but it does require an auxiliary eyepiece mag-nifier, such as the types shown in the illustration on p. 128. The appropriate screen for this method is usually all ground glass except for a clear central spot (that is very bright) containing a black cross. As you move your head slightly from side to side, the image will appear to move with respect to the cross. But at the precise point of focus, the cross and the image will appear stationary. This screen is very accurate and very easy to use.

One note of caution: Most TTL metering cameras have their light-sensitive cells *above* the focusing screen. Some screens have different light-transmission characteristics, and compen-sation may be necessary. Instructions with the screens usually indicate such correction, but if in doubt, check with the manufacturer. (Because the correction is a constant factor, it is usually applied by making a one-time adjustment in the ASA setting on the TTL meter.)

Correction Lenses for Eyeglass Wearers

Photographers who wear glasses can obtain corrective lenses that are ground to the user's prescription. They can be installed into the cam-era's eyepiece. Such corrective lenses are avail-able from some of the major camera manufactur-ers, and usually screw into, or slip onto the eye-piece frame. Note that the image coming out of the viewfinder appears to your eye as though the lens were set at infinity, so if you wear bifocals, or have a pair of reading glasses and a pair of glasses used for seeing at far distances, check with an optometrist for a corrective lens with the diopter power appropriate for *far* distances.

Unless you have severe astigmatism, these attachments will work well (they are generally not available with astigmatic correction). How-ever, you must take your glasses *off* when looking into the camera; but you *can* get your eye very close to the viewfinder and once and for all see the *entire* screen.

In fieldwork, when walking is often neces-sary, navigating without your glasses can be a problem. Yet for indoor situations, this attach-ment may be ideal. If the corrective lens is easily removed, you can have the best of both worlds.

129

An unidentified insect flew into my office one summer evening. It wound up in a jar. Months later, little more than the tiny transparent wings remained. One was carefully placed in an enlarger's negative carrier (facing page), and "blown up" 18 times.

THE ENLARGER AS A MACRO CAMERA

Enlarging lenses are good for photomacrography (p. 124), and bellows are frequently used for that type of photography. If an enlarging lens and a bellows are mounted on a vertical stand and a light source is added to illuminate the subject, the result is nothing less than a garden-variety enlarger. And indeed these darkroom instruments do make simple, stable, ready-to-go macro cameras for appropriate subjects.

As previously mentioned, enlargers conveniently make 2–$12\times$ blow-ups of transparent negatives (the "subject") with the enlarging paper acting as the image receiver. By replacing the negative with any thin, transparent, or translucent subject, such as one having a filigreed structure, that specimen will also be enlarged with the quality inherent in the standard enlarging process.

All that is required is a glass negative carrier for the enlarger so that the specimen can be sandwiched flat and motionless between the two pieces of glass. If you do not have such a carrier, two small, clean pieces of window glass will do the job. In some cases even a single piece of glass will do if the subject is relatively flat to begin with. To prevent flare, mask most of the glass with Scotch #235 photographic tape, except a central area equal in size to the film format normally covered by the particular enlarging lens in use. For example, a 50 mm lens will cover a $1'' \times 1\frac{1}{2}''$ (24×36 mm) area; a 75 or 80 mm lens sees a $2\frac{1}{4}'' \times 2\frac{1}{4}''$ (6×6 cm) area. If the specimen is larger, access to a $4'' \times 5''$ (10×12 cm) enlarger and a 135 mm or 150 mm lens will be necessary.

For a final print magnification, **M,** of $3\times$ to $12\times$ (3:1 to 12:1), the image can be projected directly onto a piece of enlarging paper. To get

For transparent or translucent subjects requiring greater-than-life size magnification, enlargers make very convenient macro "cameras." Their optics are generally ideal for such activities, and a bright light source is, of course, built in. *Upper left:* A glass carrier, or a plate glass "sandwich," must be used to support and flatten the subject. Use black tape to mask out a rectangle somewhat larger than the specimen; this prevents flare. Match lens to maximum specimen size: 50 mm for 24 × 36 mm; 80 mm for 60 × 60 mm; 105 mm for 60 × 85 mm; 135 mm for 100 × 125 mm. *Upper right:* Tweezers were used to place an insect wing on the negative carrier; this wing produced the picture on the facing page. *Center left:* Prepared specimens on microscope slides can be quickly inserted into glassless negative carriers. Such a sample produced this image of a human tooth (*left*). As in the camera, the first stage of the "photographing" process produces a *negative* image. *Center right:* In most cases, *f*/8 will be the optimum aperture; thick specimens may require smaller apertures, while enlargements over 12× are best exposed at *f*/5.6 to mitigate diffraction.

131

Specimens—"positives"—placed in an enlarger will, of course, produce negative images. Need a positive? Place the paper negative (dry) in a print frame (*left*) emulsion-to-emulsion with an unexposed piece of enlarging paper; negative print must be closest to glass. Project an even cone of enlarger light onto the frame (*center*) and process normally (*right*). To prevent excessive contrast buildup, make a *low*-contrast paper negative if you know it will be subsequently contact-printed into a positive. Contrast of the positive can also be controlled with variable contrast filters or graded paper.

 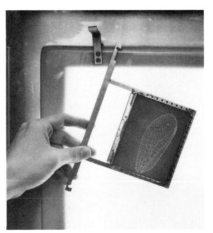 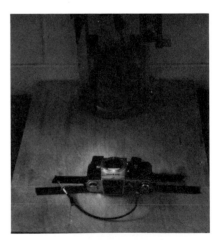

The system above has one major drawback: Subsequent prints can only be the size of the original paper negative. Projecting onto sheet film and producing a conventional negative circumvents that problem. *Left:* The image is carefully focused on a piece of white paper temporarily inserted in sheet-film holder. *Center:* Actual exposure can be made on Plus-X for black-and-white, or Vericolor II Type L for a color negative. You'll need a timer with 0.1 increments. Also remember, *no* safelights. *Right:* The image can even be projected onto 35 mm film, with lensless camera serving as a film holder. However, to focus, camera must have a waist-level or right-angle finder.

as high a magnification as $M = 30\times$ (30:1) or more, the subject must first be projected onto $4'' \times 5''$ (10×12 cm) sheet film. After developing (which can be done in a tray if black-and-white film is being used), the negative must be enlarged again, this time onto paper. This step, of course, requires an enlarger that can handle sheet film. The illustrations at left describe the process and materials.

A curious by-product of the first method—projecting directly onto enlarging paper—is that the object will print as a negative against a black background. This may be desirable; however, the illustrations at left describe a number of things that can be done, in both black-and-white and color, if a *positive* is needed.

SPECIAL LENSES FOR HIGH MAGNIFICATION

Since photo*micro*graphy begins at approximately $50\times$, the practitioner of photo*macro*graphy may be called upon to provide full-frame photographs of objects only 1 mm (.04 inch) long, or even smaller. With just a 50 mm lens and a reversing ring, one would need almost 6 feet (183 cm) of extension for $35\times$ image magnification. If one were willing to sacrifice or did not need good edge definition, a coupled $2\times$ and $3\times$ teleconverter could shorten that stovepipe to slightly more than 1 foot (30 cm), and provide considerably more room for lighting equipment. Unfortunately, standard bellows units typically extend to a maximum of 7 inches (18 cm).

The obvious solution is shorter-focal-length lenses: A 25 mm lens needs just half the extension required by a 50 mm optic for the same magnification. For occasional use, short-focal-length (35 and 28 mm), wide-angle camera lenses, reversed and used at *medium* apertures, may be satisfactory. (At these high magnifications, diffraction caused by very small effective apertures can destroy image sharpness if the lens is set at $f/22$, $f/16$, or even $f/11$. See p. 84 and Appendix C.)

Cine Lenses

Though wide-angle lenses for 35 mm cameras are a reasonably satisfactory source of short-focal-length optics, workers in the field have long known that motion-picture camera lenses, when *reversed,* make excellent photomacrographic optics. Because they are designed to cover a small field (8 or 16 mm film), and must provide high resolution images (for extreme enlargement on a movie screen), they are well suited for this purpose. Although these lenses are not of true flat-field design, results in all but the extreme corners are excellent, and certainly better than with most conventional wide-angle SLR lenses. The most important attribute of these lenses is that they have relatively short focal lengths.

The capabilities of a *used* 13 mm $f/2.5$ Cine Raptar movie camera lens that was bought from Edmund Scientific Company for $10 are shown in the accompanying illustration. A 25 mm Switar lens from a 16 mm Bolex motion picture camera has given equally gratifying results. It is best to use lenses that were designed as "normal" for a given format; zooms, and particularly wide-angles, will not be as sharp. About 15 mm focal length is right for a lens made for Super-8 or old 8 mm film; 25 mm is standard for 16 mm film.

The reversed lens should not be used to photograph subjects larger than the film size that the lens was designed to cover. Therefore, lenses from old 8 mm cameras can be used when objects up to a maximum of 0.19 inch (4.8 mm) are photographed horizontally across the frame. That translates into the suggestion that they not be used for magnifications under $7\times$. Lenses for Super-8 cameras will cover 0.21 inch (6.3 mm), which indicates a minimum magnification of $6\times$. Finally, optics for 16 mm equipment will cover specimens up to 0.41 inch (10.4 mm), which corresponds to a minimum magnification of $4\times$.

True Macro Lenses

True macro lenses are actually *designed* to be used at high magnification. For the practitioner who needs the ultimate in full-field resolution and contrast, and who can afford the expense of specialized optics, the results are truly beautiful.

Photomacrographers have long known of the excellent-quality, high-magnification images produced by reversed movie camera lenses. Their attributes include: (1) short focal length, (2) large maximum aperture, and (3) designs that require high resolution on small movie film (film that is enlarged considerably on a screen). Mounting takes some ingenuity. *Upper left:* A surplus 13 mm movie lens for an old 8 mm camera came from Edmund Scientific for the cost of a few rolls of film. Black tape around its rim facilitated a press fit into an odd-size adapter ring. Two step-up, one adapter, and later a reverse ring made coupling to a set of extension tubes complete. That compact configuration produced the lower photograph of one leg of a tsetse fly (*Glossina,* carrier of African sleeping sickness); **m** $= 9\times$ (9:1). *Upper right:* The 12.5 mm *f*/1.5 Switar is also an excellent movie-lens/macro optic. The solution to reverse mounting: Epoxy Switar's front lens cap onto a metal camera body cap (latter from Spiratone): then drill hole through the pair. *Center:* $10\times$ enlargements of respective negatives show that the surplus movie lens from Edmund (right) provided sharper results than a reversed 28 mm wide-angle SLR lens (left). And the 13 mm needed less than half the extension of the wide-angle.

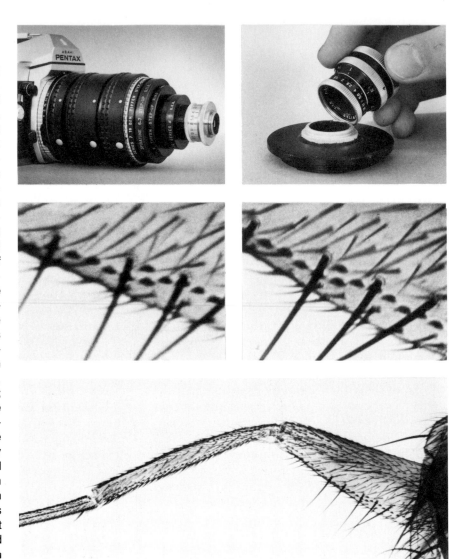

However, to fully realize their impressive potential, careful technique is required at all stages of work. This includes proper specimen preparation and positioning parallel to the film plane; an absolute elimination of all vibration; proper lighting; correct exposure; use of high-resolution, fine-grain film; and good developing procedures.

Among the available brands are the Zeiss Luminars of 16, 25, 40, and 100 mm focal lengths (usually available from Linhof camera dealers); the Bausch & Lomb Micro-Tessars of 16, 32, 48, 72, and 158 mm; Leitz Macro-Summars of 24, 35, 42, 80, and 120 mm (from Leica dealers); and Macro-Nikkors (not to be confused with the popular Micro-Nikkors for SLR cameras, which everyone calls a "macro" lens) in 19, 35, 65, and 120 mm (from Nikon Scientific Instrument dealers). Each macro lens is about as good as is theoretically possible, but is optimized for a fairly limited magnification range.

The ultimate in resolution and contrast, corner to corner, available in lenses for photomacrography is exemplified by the Zeiss Luminars. One of 25 mm focal length is shown here (*upper left*). Designed for magnification ranges where diffraction due to small apertures causes serious loss of resolution, these true macro optics are at their best wide open, typically $f/2.8$. That contrasts with conventional SLR "macro" lenses (really designed for the *close-up* range), which are usually at their best closed down one or two stops. Nikon, Leitz, Olympus, and others have similar lenses. However, theoretically optimum results can only be achieved if a lens of correct focal length is used for the magnification required (see text). The two lower photomacrographs of a section of human lung, taken at $m = 10\times$ (10:1), serve to compare the image quality of a Luminar (*right*) with that of a reversed Switar movie camera lens (*left*). However, it required a $16\times$ enlargement of a *corner* of each negative before the difference shown here could be discerned. Many of these lenses have microscope threads. Zeiss makes a microscope-thread-to-39-mm-"Leica"-thread adapter (very expensive). A Spiratone adapter can make the final transition to *your* camera. The author saved many dollars by epoxying the end of an old microscope tube to a camera body cap (*upper right*).

For example, the 15–20 mm lenses are optimized at around $15\times$; the 20–30 mm optics at $10\times$; the 30–40 mm at $6\times$; 50–60 mm at $3\times$; and the 80–150 mm lenses are designed at around $1\times$. If excellent resolution is required, switch to another appropriate focal length in the series when moving far from the design magnification.

For the Macro-Nikkor, an "EL-to-F" adapter ring is available that will mate this optic to Nikon bayonet fittings on bellows or extension tubes—contact Nikon's Photo-Technical Products Division. Novoflex and Spiratone also have adapters that will join these lenses to any camera. Another helpful hint: Zeiss Luminars are marked in "Stolze" numbers. Numbers 1,2,4,8,15, and 30 correspond to $f/3.5, f/5, f/7, f/10, f/14$ and $f/20$, respectively, for the 25 mm optic *only*. For the 16 mm Luminar, the Stolze numbers represent $f/2.5, f/3.5, f/5, f/7, f/10$ and $f/14$, respectively. True macro lenses do not have automatic diaphragms.

Highly sophisticated photomacrographic camera systems have been designed for the laboratory or research photographer requiring—and able to afford—the ultimate in optical performance, stability, convenience, and versatility. Prominent features of these instruments are: micrometer adjustable focusing stages; bright transillumination matched to individual lenses; provisions for all film formats, including Polaroid® and even television cameras. *Right:* Nikon's Multiphot in a 50×, 35 mm oblique angle configuration. *Left:* Wild's M400, designed more like a microscope, incorporates zoom optics.

SPECIALIZED MACRO SYSTEMS

For those doing scientific-level close-up and macro photography in a studio or laboratory environment, and who require maximum flexibility, versatility, and convenience, along with state-of-the-art performance capabilities, there are specially designed close-up/macro camera systems available. They incorporate a rugged support stand, various format film holders, special close-up and macro optics, illuminating systems, and an elegant specimen stage in one integral package.

Nikon's system is called the Multiphot, Zeiss has the Tessovar, Leitz the Aristophot, and Polaroid its MP-4 (although the latter is not nearly as sophisticated and precise as the other three).

These systems all accept 35 mm roll-film camera backs, as well as 4″ × 5″ (10 × 12 cm) sheet-film holders and Polaroid® film backs. A complete line of accessories for transmitted, reflected, and on-axis vertical illumination, as well as for TTL metering is available. In addition, special vibration-dampened shutters and massive support stands minimize unsharpness due to equipment or specimen motion. With appropriate accessories, motion picture cameras, microscopes, computer scanning equipment, and television cameras may be integrated into these systems.

SUMMARY

Teleconverters double ($2\times$ models) or triple ($3\times$ models) the size of any image formed by a lens with or without close-up accessories. Paired, the total power of two teleconverters is the product of their individual strengths. The usefulness of teleconverters in close-up photography comes from their ability to multiply the magnification of any system without adding additional extension or decreasing the working distance. The loss in light, due only to the converter, is equivalent in *f*-stops to the power of the teleconverter, or to the sum of the powers if two are stacked together. With TTL metering, no exposure correction is necessary. Image quality is very dependent on the quality of the prime lens, and on the use of that lens at its optimum apertures.

The power of a teleconverter may be increased by adding extension tubes *behind* it. To go from $2\times$ to $3\times$, or from $3\times$ to $4\times$, add extension equal in length to *half* the focal length of the prime lens. To go from $2\times$ to $4\times$, or from $3\times$ to $5\times$, add extension equal to a full focal length. These data hold for 50 mm lenses only.

Reversed, conventional camera lenses make excellent supplementary optics when attached to the front of a standard lens having a focal length greater than approximately 100 mm. The total magnification of the pair is obtained by dividing the focal length of the main lens by that of the reversed "supplementary" optic; typically, magnification from $1\times$ (1:1) to $4\times$ (4:1) results. Image quality is far superior to that obtained from simple supplementary plus-lenses or from conventional lenses reversed on a long extension. Light transmission and depth of field are controlled by the aperture of the *front* lens, but in a nonlinear manner. Through-the-lens metering or exposure tests are a necessity.

Close-up accessories may be used in endless combinations to obtain the desired magnification with the equipment at hand. The table on p. 123 indicates a few possibilities. If in doubt, do a test.

Enlarging lenses have excellent flat-field image quality at close working distances, and are therefore ideally suited to be used as short-mount lenses for close-up and macro photography. *Reversed,* a standard 50 mm enlarging lens is ideal for about $2\times$ (2:1) to $12\times$ (12:1) magnifications. *Unreversed,* on very thin extension tubes, the enlarging lens is far superior to a conventional lens used in the *close-up* range, and provides excellent images over the $0.1\times$ (1:10) to $0.5\times$ (1:2) ratios. In most cases, it performs reasonably well (unreversed) at magnifications up to full life-size.

Enlarging lenses with focal lengths of 75 mm or more provide room for, and the convenience of, a bellows for focusing at less than life-size. Reversed, the longer lenses provide proportionately more working room than a 50 mm optic, but also require proportionately more extension.

Right-angle eyepieces are particularly useful when photographing specimens at ground level, or with the camera attached to a copy stand.

Eyepiece magnifiers are strongly recommended to simplify focusing in the very sensitive range above life-size. An additional help in focusing throughout the *close-up* and *macro* ranges is an all-ground-glass viewfinder screen. At magnifications above $1\times$ (1:1), the aerial-image focusing technique is particularly sensitive and accurate, but requires a special viewfinder screen and an eyepiece magnifier.

Translucent and transparent specimens may be conveniently enlarged to high magnifications by placing them on a glass plate in an enlarger. Quality is excellent, and results can be viewed quite quickly.

Normal 15 and 25 mm lenses from 8 and 16 mm movie cameras, respectively, provide images of excellent quality when reversed and used at *any* magnification greater than $4\times$ (4:1) for the 25 mm, and $7\times$ (7:1) for the 15 mm optic.

Providing somewhat better quality than a good, reversed, movie-camera lens are the true macro optics from the microscope manufacturers. Performance approaches theoretical perfection, but each can only be used in a narrow macro magnification range if optimum resolution is to be achieved.

Laboratory and research workers should investigate the versatility, performance, and capabilities of the massive, multiformat close-up/macro camera systems from some of the microscope manufacturers.

Unlike conventional photography, close-up imaging demands constant awareness and attention to the problems of subject, camera, and photographer vibration. Pinpoint sharpness was deemed important to the success of this picture, yet the combination of light breeze and delicate flower conspired to set up a perpetual blur in the viewfinder. The solution: Cut down the damned dandelion—it was in *my* backyard—and bring it inside.

7 Positioning and Supporting Techniques

It is an unfortunate fact of life that magnification of image size is accompanied by a frustratingly equal amount of magnification of any and all vibration and motion. There are four basic sources of this photographer's plague, all of which inexorably lead to blurred pictures: (1) poor support of the camera/close-up system, (2) subject motion, (3) lack of rigidity *between* close-up components on the camera, or vibration induced by the camera's mechanisms themselves, and (4) vibration transmitted to camera and/or subject by external sources.

Compounding the problem of vibration is the frequent need to use slow shutter speeds, which complement the small apertures required for adequate depth of field, and in some cases minimize lens aberrations. Yet it is often the clarity and sharpness of minute, intricate detail in some diminutive creature or inorganic subject that determines the fascination with, and information in, a close-up photograph. Obviously these four sources of grief can be and are routinely overcome. Below are some solutions, but first . . .

THE PROBLEM

Careful photographers have always been reasonably successful in obtaining sharp images if they abide by the well-known rule of thumb governing minimum shutter speeds when hand-holding a camera. For 35 mm cameras, the rule is to use a shutter speed no slower than one over the focal length of the lens (when that focal length is given in millimeters). Therefore, for *conventional photography,* 1/60 sec. is the slowest shutter speed recommended for a normal lens, while a 105 mm telephoto requires at least 1/125 sec., and so on.

But that suggestion is not valid in the close-up realm, and following it can only lead to certain disaster. The reason is found when one looks at the effect of camera and/or subject motion on the *final print.* As an example, if the subject moves, or if the photographer jiggles his or her 35 mm camera only 0.04 inch (1.0 mm) when photographing an object 4 feet (1.2 m) away with a normal lens, the image is "smeared" on the final 8″ × 10″ (20 × 25 cm) print about 0.015 inch (0.38 mm). That is a blur barely detectable by the human eye at normal print-viewing distances. But shake the camera that same amount when photographing at half life-size, and the detail in the print is now smeared 0.16 inch (4.0 mm), an amount ten times the former case. That is a guaranteed photographic catastrophe, as shown on the next page.

The need to prevent or control camera and subject motion must be kept in mind at all times. Often the effects of insufficient attention to this caveat manifest themselves only when the negative is enlarged into a final print, or the slide is blown up on a large screen. But those who have tried to photograph the golden pollen on the stem of a delicate flower on a day when the wind is supposedly gentle enough to becalm a sailboat, know that the problem can also

It takes but a few rolls of film to quickly realize that magnification of image size is burdened with equal magnification of subject/camera/photographer motion. Situations "frozen" by moderate shutter speeds at conventional distances are horrors of unsharpness at close range and similar speed. *Top:* A picture of bulrushes photographed from 4 ft (1.2 m) at 1/125 sec. during a relative lull in a gentle but perpetual sea breeze. *Lower left:* Same conditions, but **m** = 0.4×. In the viewfinder, it was obvious that the plant was in perpetual motion. *Lower right:* The 1/1000 sec. duration of a small electronic flash not only froze all motion, but its relatively bright output when used close-up permitted an *f*/16 aperture. Concurrently, greater depth of field eased focusing sensitivity, but focusing was still difficult.

manifest itself right in the viewfinder.

One excellent technique that arrests camera and subject motion is the use of electronic flash. Its short duration, typically 1/1000 sec., freezes a good deal of image movement, and the added illumination permits smaller *f*-stops, which makes focusing somewhat less critical. Chapter 8, Lighting, discusses flash techniques in detail. But at magnifications above life-size even electronic flash cannot always freeze all vibration. Additionally it may be unavailable, mechanically impractical, or it may create lighting patterns that are not as pleasing as the natural illumination. In those cases, other solutions are sought.

SUPPORTING THE CAMERA

Handholding with Help

Mechanical support for the camera is always desirable but not always practical, especially under field conditions. The greatest tripod in the world is useless if your subject departs as you twiddle with the leg adjustment nuts. There are also environmental conditions, such as swamps, snow drifts, and sand dunes that can damage tripod threads and locking mechanisms more

than the picture may be worth.

A practical boundary for the slowest shutter speed recommended when handholding at various magnifications is necessary. Notice that, as is so often the case in this field, it is *not* lens focal length, but *magnification* that is the determining factor. The accompanying table suggests minimum shutter speeds, compiled from test photographs taken by a group of photographers.

In all cases, a very conscious effort at camera stability is required: elbows tight to body, left hand *under* lens, camera pressed tight against bridge of nose, a gentle press on the shutter release, and all breathing terminated. Further bracing of elbows or hands on the ground, against a tree, on the back of a chair, etc., is definitely recommended, especially if there is a need to decrease the shutter speed below what is suggested in the table.

The handholding problem is exacerbated by the desire or need to use small apertures. Yet the table below implies that vibration-stopping shutter speeds for handheld close-up photography

and small apertures are mutually exclusive, at least with slow- and medium-speed films, even in direct sunlight. (Kodachrome 25, for example, requires *f*/16 at 1/30 sec.)

Of help in fieldwork are high-speed films, such as Kodacolor 400 (color prints), Ektachrome 200 and 400 (color slides), and Kodak Tri-X and Ilford HP–5 (black-and-white prints). The extra two to three stops they provide in aperture or shutter speed may well be worth the larger grain, and less saturation in color materials.

Anything that will mitigate the tremors that even the sturdiest of us impart to our cameras should be considered. When working at minimum recommended shutter speeds or apertures, or when the photographer is contorted in a physically uncomfortable position by the inopportune location of the subject, it is strongly recommended that a number of identical exposures be made to provide a greater chance that at least one will be sharp.

Unfortunately, some of the most interesting subjects are in the deep, dark woods, or under a tree where the sun does not shine. Even more are indoors. Then, lacking flash or other auxiliary lighting, some type of mechanical support becomes a necessity.

Table 7-1
SUGGESTED MINIMUM SHUTTER SPEEDS FOR HANDHOLDING*

Magnification, m	Minimum Shutter Speed †
Arms and Camera Unsupported	
0.1 × (1:10.0)	1/250
0.3 × (1:3.3)	1/500
0.5 × (1:2.0)	1/1000
1.0 × (1:1.0)	1/1000
At Least One Elbow on Solid Support	
0.1 × (1:10.0)	1/125
0.3 × (1:1.3)	1/250
0.5 × (1:2.0)	1/500
0.7 × (1:1.4)	1/1000
1.0 × (1:1.0)	1/1000

*These shutter speeds are for use without electronic flash. Even electronic flash does not mitigate the problem of staying in focus long enough to press the shutter release, a particularly serious problem above 0.3×. At those magnifications, do not try to *hold* the proper distance; instead slowly glide toward or away from the subject, anticipate the moment of perfect focus, and gently push the shutter button. It is also strongly recommended that a number of identical exposures be made to assure one sharp frame.

†People vary considerably in their ability to handhold a camera steadily; tests will determine *your* stability. Telephoto lenses with long extension tubes and/or teleconverters are difficult to handhold firmly; try higher shutter speeds than those indicated here.

Without electronic flash, unsupported handholding is definitely *not* recommended. As above, always brace hands or arms on something, even your knees. This lessens photographers' tremors and makes focusing easier.

141

Lacking true mechanical support, one must improvise to deal with the slow shutter speeds usually required for adequate depth of field. With a little luck, careful camera placement and a *very* gentle touch on the shutter or cable release, sharp, 1/4 sec. exposures are possible up to life-size. *Left:* A T-shirt and a hard rock make an appropriate support for photography at tide pools, fossil digs, and archaeological sites. *Right:* Bean bags (see below) are like carrying around your own rock. (And if you get lost in the woods, you can eat the beans.) *Facing page:* A gadget bag provided the support for a life-size, 1/8 sec. photomacrograph of spore cases on the underside of a fern.

Field conditions frequently prevent use of tripod or copy stand. "Almost tripods" provide alternatives. *Clockwise from left:* A tabletop tripod and substantial ball head are a combination strongly recommended to *any* photographer. The author's favorites are a Leitz tripod coupled to a Slik SL-5 head. Industrial photographers, with metal pipes and brackets at hand to grab onto, might consider this Vise-Grip®/ball-head combination from Print File, Inc. Bean bags are always useful. My three measure 4″ × 6″ (10 × 15 cm), 5″ × 8″ (13 × 20 cm) and 7″ × 10″ (18 × 25 cm), respectively. (I prefer rice in my bean bags.) Testrite's Mini-Stand will disassemble into a backpack; a Leitz ball head has been added for flexible camera positioning. The steadying effects of a monopod allow use of shutter speeds as slow as 1/15 sec. for such subjects as people and flowers. A nifty little triangular platform that goes under a camera is the Tri-Pod from National Camera.

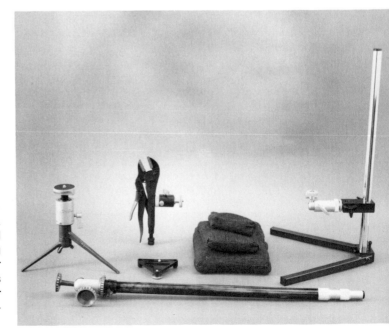

Almost Tripods

The gadgets shown in the accompanying illustration are a lot smaller, less expensive, and easier to carry than a sturdy tripod. For fieldwork, some of these contrivances are certainly better than nothing at all, and if used intelligently can often save the day. And some, like the tabletop tripod and portable copy stand, are, in certain tight situations, better than a standard size tripod.

Again, ingenuity and care determine success. Because they all fit into a gadget bag or backpack, one might be more inclined to take one of these devices on a field trip to guarantee, rather than hope for, sharp pictures. At magnifications above $0.5\times$ (1:2), *some* support is almost always necessary. Here too, a number of identical exposures will increase the odds of at least one sharp frame when you know you are pushing the limits of shutter-speed propriety.

Tripods

For general close-up photography, next to an interesting subject and lots of film, a *good* tripod is *the* single most important piece of equipment that will help assure consistent quality. Expensive "macro" lenses, long bellows, and automatic extension tubes will not provide acceptable results if the image is degraded by camera motion or vibration. A tripod, if properly used, can eliminate two gremlins: photographer-induced shake and imprecise focusing.

I believe in buying the heaviest, strongest, most expensive tripod you can afford . . . and can carry. The common wisdom that small, light tripods are good for 35 mm cameras, and that only larger cameras require sturdier support is, in general, not true. In fact the weight of a medium-format camera on a lightweight tripod often serves to stabilize it; while on the other hand, the mass of a 35 mm camera is not nearly as effective

Sturdiness and rigidity are particularly important attributes of a tripod for close-up photography; one of 5–6 lbs (2.3–2.7 kg) is the minimum recommended weight for a full-size unit. *Left:* The Leitz Tiltall has been a standard for years. In addition to being extremely well made, it has a dual pan/tilt head and invertible center column (shown in operation), all features important in close-up work. *Center:* A support accessory the author has found tremendously useful is Bogen's Super Clamp/Double Ball Head combination. It's very strong, clamps to many things, and easily supports heavy equipment. *Right:* In the studio, a large, husky tripod—one of 10–15 lbs (4.5–6.8 kg), and more—makes life easier. The Vivitar 1321 at left is a reasonable, modest studio unit. Linhof's massive, heavy-weight Deluxe Pro, with its numerous accessories, is probably the ultimate in Gibraltar-like support. A shirt-pocket tripod appears at bottom for comparison.

Invertibility of the tripod column is handy in the studio as well as on location; such a feature can even be used for photocopying (p. 214). Testrite's #2900 (*left*) assisted in creation of the whimsical portrait above. Use of a cable release (or self-timer) and mirror lock up help assure sharpness.

in helping to damp vibrations set up by the camera itself (mirror bounce in SLR's, shutter inertia), or by external forces (wind, footfalls). Of course, putting a large-format camera on a $15 tripod would be carrying this analogy too far.)

Particularly worthy of contempt are the "shirt pocket" tripods that have a dozen or so telescoping sections in each leg, and stand almost 5 feet (1.5 m) when fully extended. Yet they are not much bigger than a cigar when collapsed. If the spindly-legged contraption doesn't collapse from the sheer weight of camera, lens, extension tube, cable release, and lens shade, it will proceed to oscillate like a yo-yo at the slightest breeze, and even magnify, by sympathetic vibration, the tremor initiated by the SLR mirror or shutter mechanism.

Approximately 5 pounds (2.3 kg) is probably the *lightest* eye-level-height tripod that is worthwhile. Once you decide to carry a full-size tripod, it may as well be the sturdiest you can manage. A pound or two more of strong metal is well worth the minor additional physical effort. I know many a petite female photographer who has willingly lugged around a good-sized tripod, putting photographic performance before physical comfort. A sturdy, reliable tripod is the Tiltall (by Leitz). It weighs 6 pounds (2.7 kg) and is well worth its moderate-to-high price and medium weight.

If you frequently work at magnifications greater than $2\times$ (2:1), and your work is entirely at one fixed indoor location, consider a studio tripod of 10 pounds (4.5 kg) or more. The added mass and solidity make it a joy to use.

The accompanying illustrations highlight the basic features that a tripod should have to make it worthwhile for close-up photography. Since fieldwork frequently requires close-to-ground-level camera heights, a tripod with an invertible center column is mandatory, alternatively, tripods are available from Gitzo, Bogen, and Velbon that have joints that permit the legs to extend horizontally, putting the camera only inches from the ground, or adding stability on extremely uneven terrain.

In use, set tripod *legs* to obtain approximate working heights; the center post should only be used for final, small adjustments since it is not very stable when fully extended. Overtightening leg-lock nuts and panheads rarely makes the tripod more rigid, but it can cause stripped threads, especially on inexpensive models with plastic bushings.

Any tripod weighing under 50 pounds (23 kg) can still vibrate if your *finger* is used to press the shutter-release button. Instead, use a cable release, or the camera's self-timer if one is available. And after advancing the film, focusing, or touching the camera or tripod in any way, wait a few seconds for all vibrations to die down before making the exposure.

Dirt and sand can really damage a tripod. Clean threads and joints well after a field trip. And a final suggestion: Never attach a camera in its leather case to a tripod. Aside from being less rigid, there is a strong likelihood that case and camera will be forever joined at the tripod socket.

Copy Stands

For close-up photography, macro work, and photocopying (photographing flat documents, artwork, graphs, etc.), and particularly for the latter two under relatively fixed indoor conditions, a copy stand is more convenient, and generally more stable than a tripod that has been pressed into service to assist in these projects. Positioning of all but fixed subjects is usually more expeditious, since it is easier to move a small object on the smooth baseboard of a copy stand than to struggle with an awkward tripod and a camera made somewhat unwieldly by extension tubes and other accessories.

More important, if a copy stand is set up properly, it guarantees accurate parallelism between camera and subject, a relationship of particular importance when photographing or making slides of flat objects where edge-to-edge sharpness and freedom from distortion is necessary. Producing slides from books, magazines, photographic prints, or artwork; photographing stamps, leaves, coins, maps, cloth; duplicating slides, or making slides from negatives—these are all most conveniently done on a copy stand. A tripod, particularly one with an invertible center post, will certainly work for the occasional job. The volume of work and the physical nature of the subject matter will determine whether the investment in a copy stand is worthwhile.

Though inverting the center column of a tripod will do for occasional vertical photography, a copy stand is far superior mechanically, and orders of magnitude easier to use. As with a tripod, a vertical stand used for close-up photography is usually best if it is strong, heavy...and expensive. *Upper left:* Not a vertical stand in the traditional sense, this clever Pentax Copipod has four telescoping legs and disassembles compactly into the pouch displayed. A great gadget for fieldwork, it will fit any lens with a 49 or 52 mm front thread; other lenses are easily adapted via Spiratone's "Customizer" rings. *Upper right:* Nikon's sturdy copy stand exemplifies the better-made units from the major camera manufacturers. Available with a plain baseboard or, as shown here, in a field case version, the latter compactly houses column and camera support when not in use. *Bottom:* Large stands are particularly useful when photocopying, where big books, prints, drawings, etc., are frequently encountered. At left is a Bogen Technal TC-1; at right a Testrite CS-5. Both are available with accessory photocopying lights.

Much of the benefit of a copy stand is lost if the camera is not accurately parallel to the baseboard. The accompanying illustrations show the type of mechanism employed on some of the better stands to insure proper alignment, and methods of obtaining parallelism for stands that have no such provision.

Slide makers are usually most concerned with the maximum size of the book or artwork that the stand is capable of handling. Column height and lens focal length are the primary factors in determining those dimensions, but the support arm must also be long enough to extend the lens over the center of the largest size copy anticipated. The accompanying table correlates approximate field of view (maximum document size) with camera height and lens focal length, and indicates required extension of the support arm for that maximum field.

As with a tripod, the copy stand should be heavy and rigid. But even small, moderately priced stands will do the job, at least in the *close-up* range, *if* the photographer waits for all vibrations to cease before *gently* pushing the cable release. In general, rigidity, mechanical quality, and convenience increase with price; cost is anywhere from the price of an extension tube set to more than the price of a good camera. For high magnification photomacrography, you will need to buy or make a very solid unit (see the illustration on p. 148).

Chapter 9, Photocopying and Slide Duplicating, has further information on the use of copy stands for flat-object copying, and on the accessory lighting assemblies available for many models.

In all close-up photography, parallel alignment of camera and subject is very important. On a copy stand this usually means camera and baseboard must be parallel. *Upper left:* The better stands, such as this Nikon, have a cradle to ensure proper alignment. A knob controls integral focusing slide. *Lower left:* With stands lacking built-in alignment, level baseboard first, using cardboard to shim appropriate side. Then level camera (*lower right*). If camera back is not flat, place level against lens rim. Finally, remove shims under baseboard to regain a firm footing. An Omega enlarger alignment tool (#479-027) (not shown) is an even handier leveling device; it eliminates the need for shims.

Table 7-2
MAXIMUM OBJECT SIZE FOR COPY STANDS WITH 35 mm CAMERAS

Nominal Column Height		Maximum Object Size for Lens of Focal Length:					
		35 mm		50 mm		100 mm	
(in.)	(cm)	(in.)	(cm)	(in.)	(cm)	(in.)	(cm)
12	30	8 × 12	21 × 32	6 × 9	15 × 23	3 × 4½	7 × 11
18	45	13 × 19	32 × 48	9 × 13	22 × 33	4 × 6½	11 × 17
24	60	17 × 25	43 × 64	11 × 17	29 × 43	5½ × 8½	15 × 22
30	75	20 × 30	53 × 80	14 × 21	36 × 54	7 × 10½	18 × 27
36	90	23 × 34	58 × 86	16 × 24	41 × 61	8 × 12	20 × 30
42	107	27 × 40	69 × 102	19 × 28	47 × 71	9 × 14	23 × 35

Notes: *A.* Dimensions are approximate, varying somewhat with the design of the stand.
B. These values also assume use of the full negative. However, many cameras show 5–10% less in each direction than indicated here to allow for cropping by slide mounts.
C. Required length of camera support arm for a particular lens/column-height combination is approximately half the short dimension of the maximum object size.

Stands for high magnification photo-macrography must be absolutely *RIGID*. Commercially made models, such as Linhof's Universal or their Heavy-Duty Universal, are magnificent, but very costly. The author's homemade edition is as rugged as the best, and an absolute bargain. A minor inconvenience is lack of lifting or counterbalance mechanisms for the horizontal arm/camera platform assembly. Almost every picture in this book requiring a vertical setup was taken with this stand. In conjunction with the vibration-isolation platform on p. 158, it's perfect for *any* magnification. *Construction details:* Four layers of ¾-in. (19-mm)-high density particle board, 20 × 27 in. (50 × 68 cm), glued and clamped together, comprise the baseboard. Those layers create stiffness and substantial mass, the latter required in conjunction with the pneumatic isolation system on p. 158. An adjustable leveling foot (from a hardware store) is installed at each corner (*bottom left*). Column and arm, 30 and 8 in. (76 and 20 cm), respectively, are of 2 in. (5 cm) black pipe (plumbing supply shop). One end of the column is threaded (by the plumbing shop) and mated to a "floor flange," which in turn is screwed to the baseboard (*bottom right*). An identical flange secures the camera platform—a slab of hardwood—to the horizontal arm (*center right*). *Center left*: A 2-in. (5-cm) "T" pipe serves as the sliding bearing. However, the ends sliding over the column must have their threads bored out on a lathe. The local machine shop charged me $15 for that operation and a threaded ½-13 hole in the "T" for the locking knob. Locking knob and ¼-20 camera knob are from Reid Tool Supply (Appendix A).

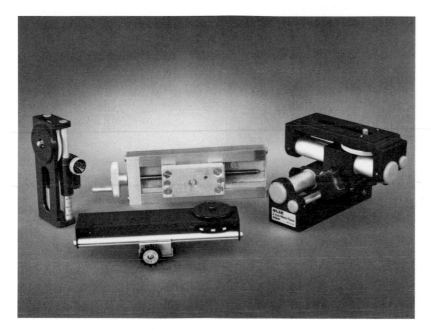

Close-up focusing is accomplished by moving camera/lens system back and forth along the optical axis, with geared focusing slide . Above 0.5× (1:2), slides are strongly recommended; above life-size, they're a necessity. *Left:* This Novoflex unit is smooth and compact; it also appears on p. 33. *Center rear:* Above 10× (10:1), adjustments on photographic slides are too coarse. Instead, use something like the Velmex A2506C shown here, which has a precision lead screw. *Right:* Slik's 2-axis device, like any slider, can be used either under the camera or beneath the subject. It facilitates both focusing and framing. *Center front:* Spiratone's inexpensive, serviceable slider has a rail over 5½ in. (140 mm) in length.

Geared Focusing Slides

For photography at magnifications greater than half life-size, a geared focusing slide should be considered a necessity for any copy stand or tripod. On p. 32 in Chapter 2, Preliminaries, reasons were indicated for the inability to focus above 0.5× (1:2) using the conventional rotate-the-lens-barrel method. Then the text went on to describe the technique of slowly moving the entire camera/close-up system back and forth until critical focus is found. However, it is next to impossible to manually push a tripod, slide a copy-stand arm, or nudge the subject to within the 0.01-inch (0.2-mm) margin required for *approximate* focus at 1:1. At 3× (3:1), precision to about 0.002 inches (0.05 mm) would be required!

The rack-and-pinion gear mechanism of these relatively inexpensive slides (prices begin at about the cost of a cheap tripod) provide the necessary accurate, smooth, linear-positioning control. Because this type of focusing adjustment is a necessity at magnifications greater than 1× (1:1), most of the better, higher-priced bellows have built-in focusing slides (see p. 78).

But as convenient as these focusing slides may be, their grearing is actually too coarse for precise focus above approximately 5× (5:1). The slightest touch of the pinion knob moves the camera more than the minuscule 0.001-inch (0.025-mm) focusing tolerance. And very often, the process of tightening the slide's locking knob shifts the camera totally out of focus. For such high-magnification cases, a Velmex laboratory-type, lead-screw linear slider can be used; it is capable of adjustments as fine as 0.0002 inch (0.005 mm).

More than one of these precision slides may be combined perpendicular to each other, providing very precise motion for both focusing and framing. If the majority of your photography is at these elevated magnifications, such positioning and focusing control will be necessary. But since the cost of a Velmex unit is only a little less than the price of a normal camera lens, you can use the very precise laboratory slide for *focusing.* Then mount the *specimen* on either a two-axis photographic slide, or on a pair of inexpensive single-axis slides, such as the Spiratone units, placed perpendicular to each other.

If you lack a focusing slide and are working indoors with the camera in a horizontal position and the subject on a table, it is usually easier to focus by gently moving the subject back and forth, rather than by trying to move an ungainly tripod. Since the subject is usually quite near to the lens, it is easy to do that while looking through the camera.

Constraints

Whether the camera moves or the subject moves, the result is still a *blur*. A quality camera on a 50-pound (23-kg) tripod cannot take a sharp picture at 1/125 sec. of a spider web swaying in the breeze.

Outdoor situations often require Jobian patience, communication with the wind god, and, frequently, electronic flash. None of those accoutrements is necessary if the subject is a vein of mica in a 10-ton boulder. But photographing specimens such as plant life, *in situ,* at fairly high magnifications (0.5×, or 1:2, and above) can be particularly challenging on all but *completely* windless days. (Only photographers are truly aware of absolutely dark rooms and perfectly windless days.) It is for the plant and animal life that electronic flash (Chapter 8, Lighting) can be particularly advantageous. However, without one, there are still ploys that you can use to calm things down.

If the specimen is found abundantly, and is not an endangered species, you might consider removing it from its natural location or means of support, and placing it in a more convenient and protected environment. (Insects will last awhile in a bottle, but many plants begin to wilt immediately.) If you feel guilty about such uncouth and artificial machinations, and are a firm believer in "take nothing but pictures, leave nothing but footprints," you can use a roll of Scotch #235 photographic tape to constrain stems and such without doing any permanent harm. Even a shoelace works quite well.

Unless you are at the top of a mountain or in a gale, there are periods when the wind will momentarily stop . . . usually. If you are extremely patient and alert, you can catch that lull. Position yourself to block as much wind as possible; then concentrate on the subject with your finger on the cable release, and wait until the precise moment.

Indoors, drafts may necessitate turning off such systems as air conditioners and forced-air heaters when photographing wispy subjects at high magnification. Closing windows and doors will also be helpful. If such stillness is unbear-able, surround the subject with a three-sided lean-to constructed from cardboard and tape.

Self-propelled creatures may be permanently immobilized (see bibliography for references on insect preservation) or temporarily anesthetized. Placing insects (they're cold-blooded) in a refrigerator for a few hours is an excellent way of making them very cooperative, live models . . . but work quickly because they warm up fast.

Specially constructed, small glass cages, (for photography only, please) dimensioned to limit the travel of large insects and small mammals are another excellent constraining device. If made very narrow from front-to-back, the animal will frequently move into the zone of good focus and proper field position. It just takes a bit of patience and fast focusing. Polished plate glass from the local glazier has the least optical distortion, but regular window glass is usually quite satisfactory. The cage can easily be assembled with cloth tape, but be careful of the sharp edges.

Lighting is tricky if reflections from the glass are to be avoided. Backlighting, or front lighting with lights at 45 degrees to the lens axis will work well. Also be certain that there are no windows behind the camera to reflect in the glass. The illustration on p. 152 shows one application of this technique.

Glass plates are also excellent for "flattening" subjects with too much three-dimensional depth. The surface of a leaf, for example, is not really *flat,* and at high magnification, various parts may undulate in and out of focus. Cotton, cloth, parchment, grass, and other thin, tissue-like substances can often benefit from flattening between thin sheets of glass.

Inanimate objects requiring support can be propped up with bits of nonhardening modeling clay, which is easily hidden behind the specimen. Paper clips, push pins, and alligator clips, the latter from radio and electrical supply stores, also work well, depending on the situation.

Even cooperative human subjects need physical constraint when photographed close-up. The illustration on p. 153 shows one possible approach.

The delicately cantilevered suspension of undoubtedly the most popular close-up subject—flowers—makes it difficult to get unblurred photographs of them in their natural habitats. Flash certainly helps, but if the plant is swaying in a breeze, even a flash-equipped camera can't be focused. Wire plant ties or tape can provide the necessary constraint. The photograph of these Indian pipes, which appears on p. 34, benefited from the makeshift support shown here: a scrap of wood and some tape. Waxy, white Indian pipes (*Monotropa*) contain no chlorophyll *and therefore do not photosynthesize. Rather, they are saprophytic—nutrition is obtained from decaying tissue, usually roots of other plants, which they help to break down.*

Morphological undulations in subjects can cause wavy in-and-out-of-focus patterns in the final print due to the shallow depth of field inherent in close-up photography. Recalcitrant specimens can often be squeezed into submission between sheets of glass. *Left:* Tape secures a sandwich of window glass enclosing a fern frond. *Upper left:* Without the glass to flatten it, portions of the fern are out of focus at *f*/16, **m** = 1× (1:1). *Upper right:* All is sharp when flattened by glass.

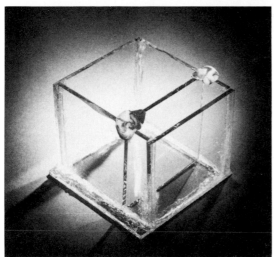

Lower right: Window glass assembled with silicone sealant makes cages for photographing self-propelled creatures. Dimensions must be such that the animal can move freely, yet not so generous as to exceed the range of a focusing slider placed under the camera. *Top:* With flash, patience, one hand on the slider focusing knob, and one hand controlling camera aiming, photographs of a fastidious, tail-cleaning mouse are possible. *Lower left:* This 2-in. (5-cm) cubical tank was constructed to constrain tiny brine shrimp eggs. The movable glass partition, secured with clay, was installed to confine the eggs within the short working distance of a lens set for $6\times$ (6:1) magnification.

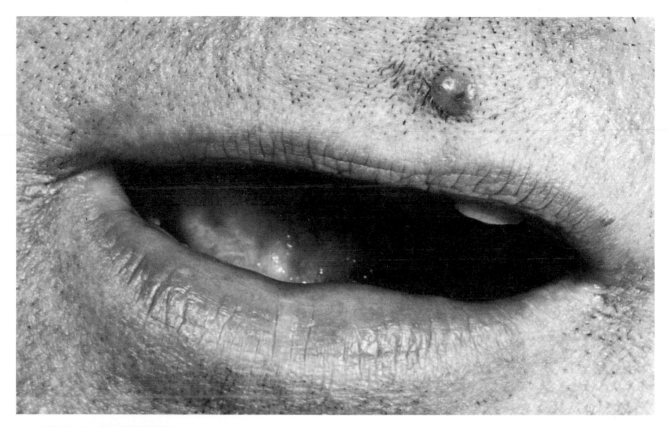

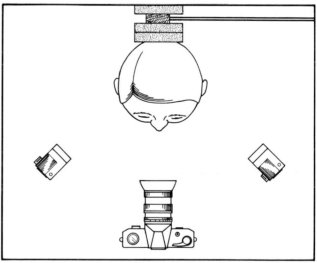

It is generally impractical to confine human subjects in small glass cages. Yet few healthy people are stable enough to keep their mouths in focus—and talk at the same time—while being photographed at half life-size. In preparation for a photographic exhibition "Thirty Feet of Lips," the stability problem noted was solved by placing behind the subject's head a rubber-covered wooden block. The block in turn rested against a wall (*lower left*), permitting the subject uninhibited oral gymnastics, while the photographer froze desired configurations with flash (*top*). Diagram indicates relative positions of components. Mouth at top does not belong to model at left.

Positioning and Support

When photographing with the camera in a *vertical* position, a marvelous device for positioning and focusing small objects is the "lab jack." It is one of those indispensable pieces of equipment that has been around scientific laboratories for ages. A relatively inexpensive, scaled-down version of the scissors-type automobile jack, it has a large knob for gently adjusting height, and is available in a myriad of sizes.

A focusing slide on a copy stand does provide the same vertical-focusing motion as the jack, but a camera loaded with bellows and other paraphernalia, all being pulled by gravity in a downward direction, is often tricky to focus on a geared slide and then lock into place. The lab jack moves only the weight of the specimen, and has no such problem. It is available from Bogen Photo, or from any scientific laboratory supply house.

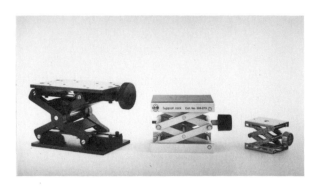

Though geared rails (p. 149) are more conventional, focusing small specimens under a vertical camera setup is frequently easier with a scissors-type "lab jack." Various sizes are available from Bogen photo or lab supply houses. However, above 5× (5:1), conventional lab jacks have too much mechanical play. Instead, use a precision jack of the type sold by optical hardware manufacturers, such as the Ealing 22-8213 shown above left.

VIBRATION

Vibrations Within the Close-up System

At magnifications greater than life-size, internal vibrations within the camera, and imprecise fitting or support of components such as extension tubes and bellows can lead to less than satisfactory pictures. Image-destroying vibration from mirror bounce has already been mentioned on p. 66 in Chapter 4, Extension Tubes and Bellows, where it was pertinent to the discussion of high magnification, since large image ratios compound the problem. A heavy tripod will absorb some of that vibration, if a mirror lock-up is unavailable. Or bean bags can be added as per the accompanying illustration to increase the camera mass.

An even bigger problem, especially with a horizontal setup, is the vibration caused by the cantilevered extension of long lenses, tubes, bellows, and teleconverters. With only the rear end (the camera) of a lengthy combination supported by the tripod, the front sections are prone to seesaw-like oscillations at the slightest provocation such as mirror bounce, shutter motion, or external vibrations from wind, noise, or footsteps.

One solution appears, for example, on the Vivitar 90 mm $f/2.5$ "macro" lens, which has a tripod socket on the extension tube used for the 0.5–1× (1:2–1:1) range. Supporting the system there instead of at the base of the camera greatly helps to reduce the above-mentioned oscillations.

Similarly, cameras with bellows are best supported under the *bellows.* Here again, the better, more expensive units have appropriately placed tripod sockets. Note, however, that it is best to have horizontal setups aligned with some weight imbalance toward the lens, rather than neutral balance or balance toward the camera. Such alignment will further inhibit vibration.

For very high magnification, difficult wind conditions, or a large number of long components, the best solution is rigid unification of the entire system on a single stiff platform. The illustrations on pp. 85 and 155 show such setups, and for extreme conditions, it is definitely the recommended procedure.

Wind-induced vibration in camera systems is another source of blur in outdoor close-up photographs. And long lenses, extension tubes, etc., unfortunately increase the surface area open to pressure. Learning to sense lulls in a breeze must become part of a field photographer's skills. *Left:* Also helpful in inhibiting vibrations are bean bags (see p. 142), which add mass to the system and constrain intercomponent flexing. Additionally, they absorb some vibrations instigated by mirror bounce (p. 66). *Upper left:* A close portrait of a white rhinoceros at 1/8 sec. is unsharp due to wind-caused camera shake. *Upper right:* Bean bags and a partial lull in the wind greatly improved this rendition.

At high **m** in the macro range, less than 100% rigidity between components can play havoc with sharpness, as vibrations from the camera's shutter causes miniscule but photographically significant movement of accessories. Outdoors, wind can cause even more serious intercomponent motion. If flash cannot be used, tying each segment of the system to a rigid base can solve the problem when all else fails. *Left:* Glued-up layers of plywood provide lightweight, stiff support; 1/4-20 bolts from underneath secure camera and bellows. *Lower right:* Lenses, extension tubes, and teleconverters are held with large hose clamps; clamps that are too small can be paired end-to-end. Felt inside the clamp prevents scratches. *Lower left:* 1/4-20 T-nuts (p. 88) provide tripod sockets at various balancing points along the length of the platform.

Filmmakers have produced blur-free movies while traveling on bumpy roads, shooting from helicopters, and even astride horses. Their secret is a battery-powered Ken-Lab gyroscopic stabilizer spinning at 21,000 rpm. Mounted under a camera sporting long-range close-up equipment (*right*), it's the next best thing to a tripod . . . or a skyhook. This photograph of a green tree snake (above) was made with the stabilizer at 1/30 sec. using a 200 mm lens. A comparison segment (*above right*) shows the same scene handheld without the stabilizer. Such portable stability is costly, though gyro-stabilizers are available for hire.

Vibrations from External Sources

If it were not for the unavailability of film in such a location, a deep underground cave would be the ideal place for photomacrography. The rest of the world is never perfectly still.

Vibrations come from motors in cars, sewing machines, fans, industrial machinery; and from compressors in refrigerators, air conditioners, freezers, fish-tank aerators and water pumps. They also come from loud music (no Bach organ recitals during picture-taking sessions), footfalls (taps and high heels on wood floors are particularly bad), and the rumble of traffic.

Although most people are personally insen-sitive to all but the most severe manifestations of tremors from these sources, one only has to look through the viewfinder of a camera set for 15× (15:1), and gently tap a toe to see the problem.

Again, electronic flash can be used for freezing motion, but at very high magnifications even flash can be inadequate. Microscope designers who must contend with vibrations magnified over 1000 times have successfully used three basic methods to reduce vibration-induced blur.

First, the macro system must be as rigid as possible so that any external vibrations do not become amplified by ill-fitting or cantilevered components. Such techniques were suggested in the preceding section.

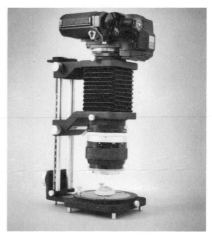

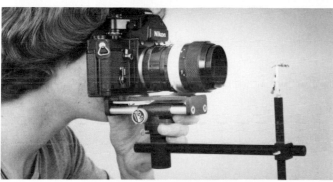

Eliminate *effects* of vibrations by tying subject and camera together such that they vibrate *in unison*. *Upper right:* Olympus, Vivitar (*shown*), and others make "macro" stands that combine bellows *and* specimen stage in one structure. *Lower left:* More clever and versatile is the "Budget," a neat collection of rods, clamps, clips, and mirrors. Attached to the camera, it supports most subjects; accessory mirrors control light. Camera, lens, and subject all move together. I added Novoflex slide for convenience, and with the "Budget" made this photo of a long-bristled smartweed (*upper left*), $m = 0.5\times$ (1:2), *handheld* at 1 sec.!!!

Secondly, camera system *and* subject should be mechanically and rigidly tied together. Then if one moves, so does the other, completely in step, with equal amplitude and frequency (hopefully). This can be a simple yet elegant solution to a frustrating problem. Many ingenious devices, including some for fieldwork, have been constructed by photographers and equipment manufacturers to connect the object to the image, so to speak. The illustrations above highlight the details. An interesting note is that the relatively simple slide duplicators, discussed in Chapter 9, Photocopying and Slide Duplicating, that attach to lenses on extended bellows or tubes owe their capability for sharp results to this exact principle.

The third method of eliminating vibration is the ultimate solution for tremor problems when photographing at magnifications greater than $5\times$ (5:1). It is not for the casual practitioner, nor does the equipment involved come in a leather case with a neck strap.

Solution number three is basically a modification of the two preceding techniques, with the addition of total isolation of the camera and subject from vibrations transmitted through any support structures (walls, tables, floors). Only suitable for fixed locations with a large rigid copy stand, this method does provide the most secure and the sharpest results for a studio or laboratory environment, without regard to all but the most obnoxious oscillations and shocks. If you are really into high-magnification photomacrography (or even photomicrography), and are tired of waiting hours for the world to stop shaking—for only 15 seconds—here is your solution.

A large mass in the form of a heavy baseboard, and heavy, gutty components are the starting point. Ideally, a massive copy stand, such as a Linhof, works well. Not being able to afford one, I made an even heavier, stronger version for less than $50. It doesn't have the convenience of a geared or spring-balanced height adjustment for the camera arm, *but it is solid.*

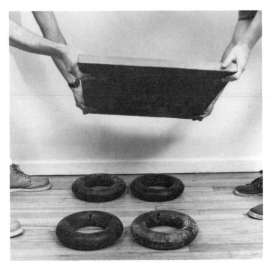
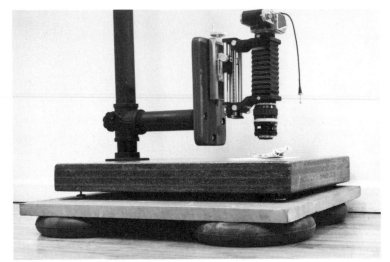

Environmental vibrations are never-ending trouble to the photomacrographer. Refrigerators, air conditioners, traffic, footfalls, etc., all seem innocuous until their tremors are magnified in a 10× photo. The countermeasure is a pneumatic vibration isolation system. Commercial units are expensive; the author's homemade system cost $40 and only transmits vibrations if someone *jumps* on the floor. *Lower left:* "Air springs" are four inner tubes from go-kart tires inflated to 3 lbs (1.3 kg) of pressure. Half the damping mass is provided by a 100-lb (45-kg) slab of cheap stone from a paving contractor or patio supply house. *Lower right:* Another 75 lbs (34 kg) comes from the massive vertical stand (p. 148). *Top:* Both 11× photographs of ballpoint pen lines on paper were taken in a kitchen with a refrigerator running. One was taken on the vibration isolation platform.

The stand and the subject are then insulated from external vibrations by "air springs." The combination of a large mass and a spring makes an extremely effective vibration damping system. However, compressive properties of gases make them far superior to conventional metal springs for absorbing vibrations in the frequency range that effects photomacrography. Commercially, air springs are piston-like devices; but inner tubes from small tires are almost as effective and

orders of magnitude less expensive. A large slab of stone, as shown above, provides the necessary mass for vibration damping.

Similar isolation can, of course, be purchased ready-to-go, usually in the form of a thick slab of steel, terrazzo, or granite sitting on four air springs. Three suppliers of tabletop-sized units are Kinetic Systems, Backer-Loring, and the Nikon Instrument Division of Ehrenreich Photo-Optical Industries (see Appendix A).

At high magnifications, shutter and mirror-flop vibrations are sometimes difficult to eliminate, particularly if electronic flash is unavailable. One solution is to set illumination levels so that required exposure time is on the order of a few seconds. Then, in a darkroom, lock the shutter open and use a film-processing timer to turn lighting equipment on and off.

SUMMARY

Electronic flash can be an excellent tool with which to eliminate many of the problems of camera and/or subject vibrations, at least at magnifications below 5 or 10X (5:1 or 10:1). But without it, or at larger image ratios, other techniques must be used to inhibit the oscillations that lead to unsharp pictures.

Below life-size, one can handhold a close-up camera *if* the high shutter speeds suggested in the table on p. 141 are used. Somewhat slower speeds are feasible if camera, wrists, or elbows are carefully braced. Small portable supports, such as tabletop tripods, Vise-Grip® clamps, and miniature copy stands will work for time exposures if used with care. Although these supports are restricted in versatility, they are a good working compromise for field trips and location work where a full-size tripod may be too much to carry.

A standard size tripod for close-up photography should weigh *at least* 5 pounds (2.3 kg), have a dual panhead, and an invertible center column. The addition of an auxiliary clamp that will support a camera and attach to one of the legs will greatly facilitate low-level work.

Tripods for studio, laboratory, and other fixed locations should be over 10 pounds (4.5 kg), if your photography is frequently above 2× (2:1) magnification.

A vertical copy stand is really a necessity for frequent photocopying, slide production, and photomacrography. As with a tripod, the heavier and more rigid it is, the better. In all cases, the camera and baseboard must be parallel.

Geared focusing slides are required on tripods and copy stands when photographing above half life-size. They provide the required positioning accuracy for critical focus, a tolerance often measured in hundredths of an inch. At magnifications greater than approximately 5× (5:1), a laboratory-type slide having a precision lead screw is necessary. Scissors-type lab jacks are also excellent for focusing vertical camera setups on a copy stand.

Even the gentlest breezes and drafts cause motion in flowers, stems, leaves, and similar plant life. Some type of constraint, such as tape or a wind screen will usually be necessary. Small animals can be corralled within an approximate zone of focus using very small glass cages constructed for the shooting session.

Vibrations *within* the close-up equipment can be as problematical as photographer or subject motion. Accessories for high magnifications above life-size should not be allowed to extend, cantilevered, out from the camera body without additional support under the tubes, bellows, or teleconverter.

Mechanically connecting the subject to the camera/close-up system is a clever way of having the camera and subject oscillate in unison, thereby eliminating the appearance of vibration in the image. Requiring relatively modest homemade equipment, such a technique can even be used for handheld photography.

Images made above 10× (10:1) are extremely sensitive to the ever-present environmental vibrations found in most indoor locations. A very heavy, rigid copy stand placed on a concrete floor may prove satisfactory. Where room vibrations cannot be eliminated, such a stand can be isolated from almost all tremors and shocks by mounting it on a vibration isolation platform.

Color Photographs

The next 15 pages contain a selection of color photographs indicative of some applications of close-up photography. It is the author's opinion that too many images are produced in color *because* color film happens to be in the camera, or *because* frequently it is easier, and more expedient to obtain good color processing —particularly of slides—than to find a good black-and-white lab. But certainly the choice of media should be considered an important creative control, as carefully chosen as the quality of light, the framing of the subject, or the instant of exposure.

One only has to set eyes on the photograph "Marigold Blossom, 1925" by Imogen Cunningham to appreciate the strong esthetic inherent in the sensitive use of "only" tones of grey. Similarly, the rightfully famous close-up photographs of machinery and fauna by Paul Strand, and Aaron Siskind's anthropomorphic paint peelings were recorded in black-and-white, as were the sunflowers and vegetables, respectively, of Paul Caponigro and Edward Weston.

Just as the fine black-and-white image is strengthened because of the photographer's understanding and application of the particular textural and emotional qualities indigenous to the monochrome medium, so too should the *special* possibilities of a large palette be utilized. Certainly the evocative potential of color should be exploited: the special hue of early morning light; the verdant cast on the floor of the forest as sunlight is filtered by chlorophyll; the sallow skin of the infirm or aged —each a special feeling best realized in color.

Individual colors also have salient characteristics that should be exploited to strengthen a visual statement. William Gass has written:

Of the colors, blue and green have the greatest emotional range. Sad reds and melancholy yellows are difficult to turn up. . . . Although green enlivens the earth and mixes in the ocean . . . green air, green skies are rare. Gray and brown are widely distributed, but there are no joyful swatches of either, or any exuberant black, sullen pink or acquiescent orange. Blue is therefore most suitable as the color of interior life. (William H. Gass, On Being Blue, *David R. Godine, Publishers, 1976.)*

Of course, there are less esoteric, but equally valid, reasons for working in color. Color's "reality" is appropriate and frequently necessary for medical, biological, and other scientific recording when a particular hue carries important physical information. Various parts of a subject frequently have similar tonal brightness and will visually blend with each other, or with the background, if photographed in black-and-white. Taken in color, desirable separation between various elements is easily achieved. (On a scale somewhat different than photomacrography, aerial photography is frequently done in color for crop surveys, pollution control, and reconnaissance.)

Significant advances in color-printing technology have made it feasible to produce excellent-quality color prints in a very modest "black-and-white" darkroom, with significant savings over the cost of professional color lab services. Processing is simple and relatively fast. The creative possibilities and tight controls inherent in printing it yourself should be considered.

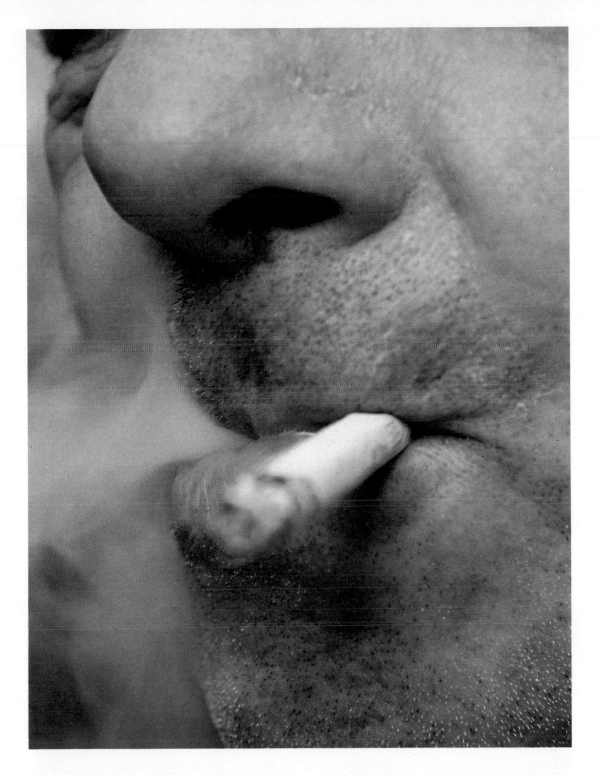

A cigarette was the only thing keeping this man warm on a freezing day in January. When photographing strangers, the close-up photographer must interact with the subject, since surreptitious ploys used in conventional candid photography are rendered useless by close working distances and fussy focus. A long lens is a must; it provides civilized space between skeptical subject and camera. Flash is also unfriendly in someone's face; try fast film instead.

162

I cannot think of a subject in nature that does not provide infinite photographic possibilities. Curiosity, patience, excitement, and a sense of awe are all that is necessary to succeed; the mechanics of picture-taking will follow naturally, simply as a tool. The most gratifying aspect of close-up photography—of any photography—has nothing to do with pictures. Rather, the camera becomes an excuse, a magnifying glass, an entry visa to observe and explore the world. I never really appreciated morning glories until I photographed them. All four of these blossoms are from one vine in my neighbor's garden.

Top: A helium-neon laser beam from upper left is incident on a ¼-in. (6-mm)-thick slab of glass. Part of the light is reflected on the top glass surface at an angle identical to the angle of incidence. Light not reflected goes through the glass, bending (refracting) as it enters, and "unbending" as it leaves, the emergent beam regaining its original angle to the glass. A second beam is also generated at the lower surface, and it can be seen leaving the glass at upper right. *Bottom:* A 39,000-volt spark traced its own image on ASA 64 film: the shutter was left open in a darkened room, lens set at *f*/18; **m** = 1.2×.

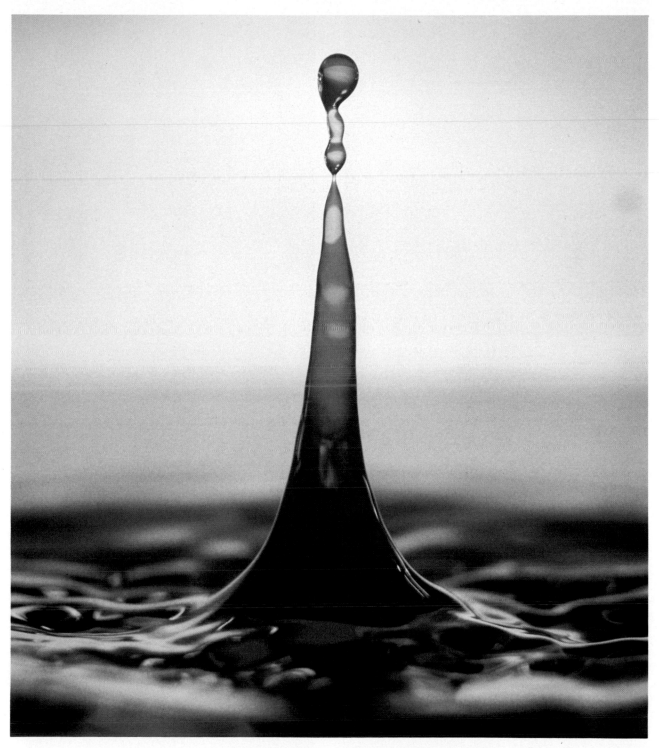

Every time a faucet drips, a beautiful, complex "splash" evolves, governed by the forces of gravity and viscosity. From initial impact of the drop—here the fall was 36 in. (1 m) into ³⁄₁₆ in. (4.8 mm) of colored water—to collapse of the "geyser," total time was only 0.4 sec. The short duration of cigarette-pack-size elec- tronic flash units, typically 1/30,000 sec. on "auto-matic," is ideal for freezing such rapid motion. As with the spark photo at left, the shutter was left open in a darkened room, the short flash of light acting as the shutter. A time-delay relay was used to trigger the flash (see caption, p. 11).

Accurate rendition of colors requires attention to proper match of film and light source. *Upper left:* The tones of white radishes in the hands of a brown-skinned person are too "warm" (reddish) due to use of a 100-watt household bulb (2900 K color temperature) as a light source with tungsten film balanced for 3200 K. More accurate color rendition was achieved *(upper right)* by adding an 82B filter to the lens as per Table 8-1, p. 197. (Without a comparison, the warmer image might be just fine.) *Lower left:* The eye of the same brown-skinned person was photographed using a fluorescent ring light, producing a sickly greenish-yellow cast typical of such a source. Tests determined that a CC40 magenta filter over the lens (or light) would absorb excess green and greatly improve the results *(lower right).*

Slide duplicating requires utmost attention to details and careful tests; there is always that "original" around as a blatant reminder of even small technical errors. The original *(upper left)* was first copied on Koda-chrome 25 *(upper right)*, a film not suited for copying anything but very low-contrast originals. The contrast increase is all too apparent, although with a low-contrast original, or a desire for graphic effects, that con-trast boost could be useful. The lower pair are duplicates on Ektachrome Duplicating Film 5071. The test shot *(lower left)* resulted from exposing with the starting filter pack recommended by Kodak. Comparing that test with the original showed a need for a −35 cyan correction. The second roll *(lower right)* incorporated that modification; it's amazingly close to the original.

Good subject matter is where you find it . . . if you're observant. The most familiar and simple is often the best, though frequently hidden from common view due to physical circumstances and social convention. Time spent exposing film behind the camera can be brief; hours engaged in looking, in thinking, in planning, in researching are more important. Actual approach and equipment used need not be elaborate: The minimum amount of paraphernalia required to do a good job is always best. (Unfortunately, "minimum" is frequently quite a haul in close-up photography of certain subjects.) The author is inclined toward plain, uncluttered backgrounds; they seem to enhance form and texture. The photograph above was made with a single, inexpensive 12-in. (30-cm) bowl-shaped light, with a dark turtleneck sweater serving as a backdrop. The arm of a chair conveniently supported the foot, while the foot's owner, a Pakistani electrical engineer, slouched comfortably. Sharpness is a vital element of the photograph's impact.

The long exposure times frequently required in close-up photography without flash necessitate familiarity with correction for film reciprocity failure (see p. 240). Narrow exposure latitude of color slide films particularly demands such attention—at 1 sec., correction is typically ½ to 1 full stop, an error not noted by any exposure meter. The sea catfish skull photograph was initially taken at f/2.8 and 1/8 sec. *(upper left)* in an attempt to get by with a monopod in relatively dim light using Kodachrome 25 film. Depth of field and sharp-

ness are obviously inadequate. *Upper right:* A tripod, an aperture of f/32, and a corresponding shutter speed —uncorrected for reciprocity failure—of 64 sec. produced this rendition, which is sharp but badly underexposed. Kodak suggests an exposure increase of about 2 stops and the addition of a CC10 magenta filter. *Lower left: Only* that exposure correction has been incorporated here. When the exposure correction *and* filtration are employed, final results are quite good *(lower right)*.

Strange colors and fascinating topography character-ize cultures of fungi, bacteria, and other lower plant and animal life. One familiar example is the velvety green mold that embellishes leftovers long forgotten in the refrigerator. The specimen above, from Carolina Bio-logical Supply Co. (Burlington, N. Carolina 27215) is *penicillium camemberti,* a form of penicillin that imparts the characteristic flavor to Camembert cheese. Its soft, furry texture required four small Tensor-type reading lights glancing across the surface to bring out its three-dimensional qualities. Though the fungus is sharply in focus, it does not have the same apparent definition present in less amorphous subjects. A blue theatrical gel, backlighted under the petri dish with a 30-watt reflector floodlight, provided a contrasting back-ground.

Though the lower photograph looks like an aerial view of an albino-skinned watermelon, the two top pictures debunk such a notion, and once again prove that without some common object in the scene to provide a sense of scale, or without *a priori* knowledge of the subject, we may easily be fooled by a close-up image. It is frequently useful to make one "picture for scale," such as the upper left, when photographing unfamiliar subjects, particularly if they might be viewed without benefit of a caption indicating magnification. These three pictures of the berries of a false Solomon's-seal plant were made at progressively higher magnifications on film of 0.15× (1:1.6), 0.8× (1:1.3), and 2× (2:1), respectively. The slide of the 2× image is enlarged here 5 times, so that the berry in the large illustration is 10 times life-size.

171

Left page: Observing common crickets in a glass cage through a lens set for life-size magnification is fascinating. A geared focusing slide must be continually racked back and forth to keep the insects in focus as they scurry about, with electronic flash, the only practical light source, since it is cool, bright, and freezes any motion. After dining on tomatoes, the fastidious cricket shown above cleans every possible limb and protuberance by drawing it through its mouth; the lower left photo shows one antenna undergoing scouring. (Only male crickets chirp, but no one knows why. Even with their chirpers disconnected, crickets still manage to find each other and make babies.)
Right page: Direct sunlight is usually too harsh for close-up subjects. The lower photograph was taken on a clear, sunny day, while the upper version of the same rose resulted from shielding the flower from direct sunlight with a white umbrella.

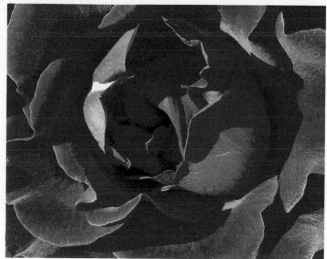

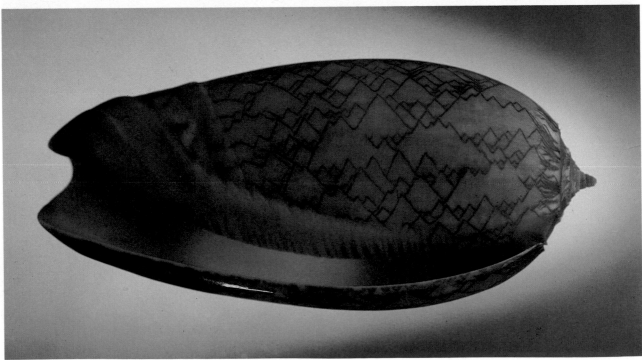

Frequently the success of a photograph is entirely dependent on lighting, either for technical or aesthetic reasons. *Left page, top:* Anyone who has ever put a hand over a flashlight has marveled at our translucency. Replacing the flashlight with an electronic flash prevented any blur due to subject motion. Small strips of black tape were placed under the fingertips to keep thinner sections from becoming overexposed. *Bottom:* The almost perfect triangular markings on this textile cone, found in the Indian and Pacific oceans, are fascinating in themselves; but the beauty of the overall form is strengthened by careful lighting. A small, intense spotlight from underneath, punched through the translucent calcium shell, produced the interior glow. *Right page, top:* Urea crystals are quite prosaic under "ordinary" light, but polarizing filters over the light *and* the lens generate an infinite array of patterns and colors (**m** = 4×). *Bottom:* Fluorescent minerals offer another range of possibilities for close-up exploration. Viewed in white light, this sample of calcite and willemite is decidedly uninspiring. Under short-wave ultraviolet illumination, it glows with brilliant reds and greens.

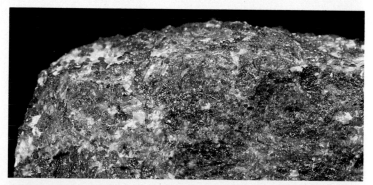

175

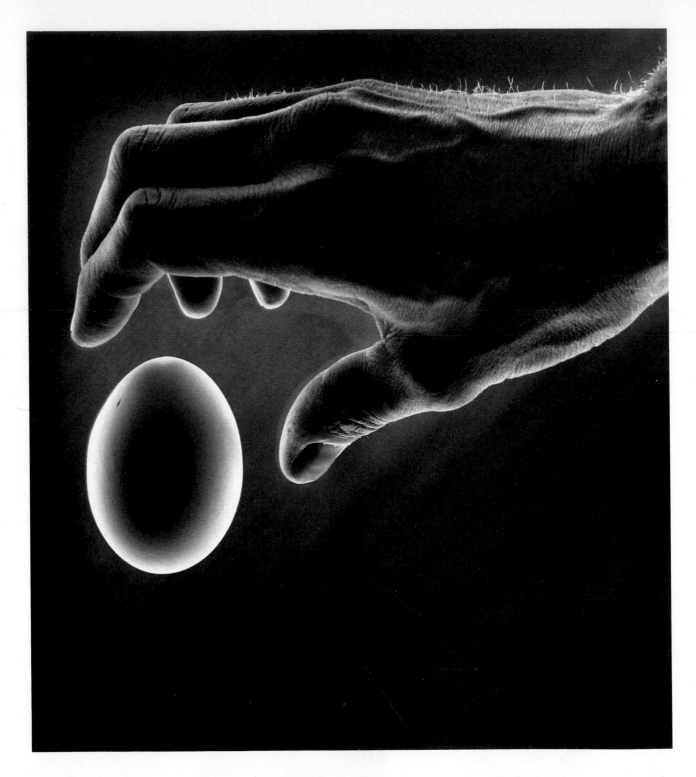

Certainly the most creative aspect of many close-up photographs is the quality and sense of illumination. Here, backlighting adds an heroic, transcendent quality to a basically simple scene. Though not planned initially, major changes occur in the feeling of this photograph as it is viewed upside down or sideways. It was quite a stretch to keep my hand in the scene and look through the camera at the same time.

8 Lighting

The serious close-up photographer must be considerably more adept in the use of artificial illumination than his or her counterpart from the world of reasonable distances, innocuous shutter speeds, and wide apertures. The unfortunate consequences of the inopportune combination of poor depth of field, extreme sensitivity to vibration and motion, optical aberrations, and delicate focus frequently require more light than is naturally available.

Even outdoors in bright sunlight, handheld photography can benefit from the motion-stopping speed of electronic flash. If the hands are replaced by a tripod, self-propelled creatures and wind-blown plants still need their images frozen by high shutter speeds or a rapid flash of light. And besides, *bright* sunlight is frequently unavailable (particularly indoors). Additionally, direct sunlight is one of the least appealing forms of natural light for close-up photography due to the harsh shadows that it casts.

Indoors, illumination levels are entirely too low for the small apertures required in close-up photography. To that is coupled the multi-stop loss of light at the film plane due to lens extension and/or teleconverter exposure-increase factors. Without artificial illumination, the consequential length of exposure time creates extended opportunities for environmental vibrations to blur the picture. Exposures longer than 1 second also cause film reciprocity failure (see Chapter 10, Exposure, p. 240) which, if not compensated for, creates underexposure, increased contrast, and, in the case of color film, severe shifts in hue.

As expected, the need for artificial illumination will increase with higher magnifications.

Flash and "light bulbs" (incandescent lights) are, of course, the two main sources of supplementary illumination. Flash, being portable and powerful (at least close up), is ideal for fieldwork. As already mentioned, its short duration—typically 1/500 to 1/1000 sec., and often faster—is particularly advantageous for handheld photography and/or recording moving specimens. Furthermore, that short duration is necessary for photographing delicate plant and animal life that might be injured by the relatively long-duration of the heat from bright incandescent lights.

On the other hand, lighting with incandescent bulbs has its own list of significant advantages: (1) low cost; (2) a brighter viewfinder image that is so necessary for critical focusing at high magnifications; (3) complete and continuous ability to previsualize and control the texture, information content, esthetics, and overall appearance of the final image; and (4) a greater ease of mechanical positioning, and a greater variety in the textural quality of light, due to the large choice of incandescent equipment available.

The *quality* of light can enhance, or destroy, a photograph. End use must also be considered; function may overide esthetics, dep'ending on who's paying. *Upper left:* Sensual undulations in this landscape are visible only with strong sidelighting. *Upper right:* Broad, soft illumination totally destroys any sense of shape or texture. *Lower left:* The same sidelighting used at upper left is an information disaster on an engineering photo. However, the circuit board is perfect (*lower right*) under the illumination that proved too flat at upper right. ("Landscape" is left over from p. 25).

INCANDESCENT LIGHTING

If exposure times can be kept within reason—that may be anywhere from less than 1 second to as much as 5 minutes—and if a sturdy tripod or other support is available in a reasonably vibrationless environment, close-up pictures can be made without supplemental illumination. For the low-magnification, close-up range, available indoor or outdoor light will often suffice. Above $0.5\times$ (1:2), however, photography is more complicated, especially indoors.

True photomacrography under available indoor light, shot at effective apertures of $f/22$ or $f/32$ on slow- or medium-speed films could easily require exposures lasting many minutes. Added grief at high magnification comes from a camera position that is so close to the subject that it usually blocks what little light there is.

Without auxiliary light, the longer exposures also vastly increase the chance of even subtle environmental vibrations degrading the image. In fact, in a building full of heavy machinery, or in a room situated near a subway or truck route, electronic flash or incandescent illumination with complete vibration isolation (see p. 156) may be the only systems that will provide sharp pictures at very high magnifications.

Another strong argument for supplementary *incandescent* illumination is its ability to *accurately* control the appearance of the final photograph. When properly adjusted, lights can provide completely shadowless images resulting in maximum visibility of detail for the scientist, naturalist, collector, or forensic investigator. Or, carefully aimed, as one observes through the camera's eyepiece, shadows and highlights can be manipulated for dramatic, illustrative, or pictorial effects. The combination of incandescent lighting and the SLR camera gives the photographer almost total freedom to obtain and to previsualize any desired result.

Last, but certainly not least, is the boost that continuous illumination gives to through-the-lens (TTL) metering (if a camera is so equipped). Used intelligently, calculations for effective aperture, lens extension, pupillary magnification factor, teleconverter losses, etc., can be dispensed with at the flick of a switch. But TTL meters will not function in the dim light provided to them by high-magnification photography; supplementary incandescent illumination is required.

This is a good time to mention that the tyro working with artificial lighting invariably creates pictures with too much contrast, empty black shadows, and an overall harsh appearance. (Of course the photographer may answer critics by saying that he or she intended it that way.) One reason for this initial imperfection is that we are used to a single source of illumination. But the sun, unlike a spotlight, comes equipped with the dome of the sky that provides fill-in illumination in the shadows. On overcast or cloudy days, the illumination is even softer. Secondly, the human eye has a much greater brightness range than any film. We can easily *see* detail in heavy shadows that would only record on film as solid black.

So it takes a little practice to match what you see to what you know, or will quickly learn, of a film's capabilities. The best thing to do is to experiment with various lights and reflectors to obtain a variety of "looks." The feedback from the processed film is the best teacher.

INCANDESCENT LIGHTING EQUIPMENT

With small objects, you can use small, inexpensive, but not dim, lights. In fact large, conventional lights would waste a lot of output if their broad beams were used to photograph small subjects. For amateur or professional in the field of close-up photography, ingenuity is much more useful than a truckload of expensive lights. Slide projectors, high-intensity reading lights (Tensor lamps), reflector spotlight bulbs in simple sockets, and relatively inexpensive, small fresnel-lens spotlights are ideal. These and more are shown on the next page.

A good supply of masking and black photographic tape, small mirrors, white cardboard, paper clips, modeling clay, and tracing paper is even more important. They are all used to con-

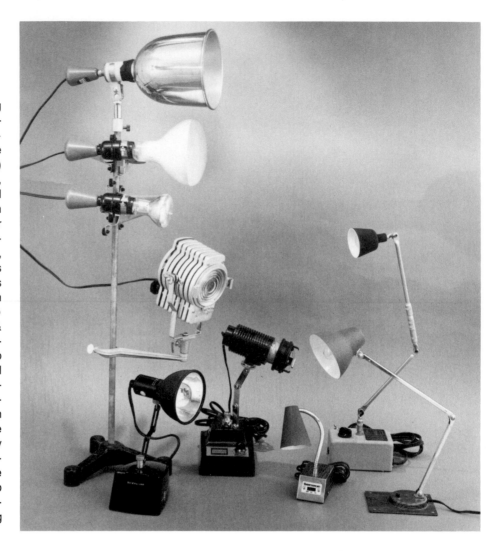

At right is an array of lighting equipment suitable for close-up photography. *Top to bottom on the stand:* Testrite socket and deep, 5-in. (13-cm) diameter aluminum bowl, 100-watt R-40 reflector flood bulb in a Testrite clamp-on socket; 30 watt R-20 reflector spot bulb; Photogenic's Mini-spot adjusts from spot to flood, uses tungsten-halogen bulbs up to 200 watts, and accepts accessory snoots and barn doors. *Foreground from left to right:* A Bausch & Lomb (B & L) Reflector Illuminator provides soft light for **m** up to about 1×; B & L's General Purpose Illuminator has built-in iris, spot focusing, and variable intensity—very useful in the macro range; three Tensor®-type high-intensity reading lights make fine all-around illuminators—the one at rear from Roxter has 5-step intensity and various accessory head positioning supports.

trol the shape, intensity, and reflections of the lights. Reflective properties of small mirrors or white cardboard can frequently subsitute for a second or third light.

When photographing with color film, it is important to note that many small lamps suitable in *size* for close-up work are not of appropriate *color balance*. A simple filter over the camera lens will usually remedy that situation; details are given later in this chapter on p. 196.

BASIC LIGHTING PRINCIPLES

Whether electronic flash or incandescent lighting, there are general rules that apply to the positioning and control of lights. With incandescent lights you can see the effects as you are working, so they are probably best to learn with. The accompanying illustrations display a variety of basic techniques and their pictorial results.

The combinations are infinite, but simplicity should be an element in all setups. Let your eye and practice guide you. (Unfortunately, simplicity will not always be adequate.) In all cases, however, let your eyes—combined with substantial practice *on film* and with experimentation—be your mentor.

Bruce's ear was used as a subject to demonstrate two basic principles of lighting: *Top:* The larger a light is in relation to the subject, the softer the illumination. A corollary: The closer a light is to the subject, the larger it "appears"; as the light is moved farther away, it appears to the subject to be smaller and harsher. Relative position of camera, light, and subject is shown above each photograph. *Bottom:* The closer the light is to the camera axis, the flatter is the rendition of textural details. Conversely, light coming in from the side will emphasize textural dimension. (An unwritten third law suggests that newcomers to artificial lighting invariably create overly contrasty illumination. Remember, film cannot see into dark shadows nearly as well as your eyes.)

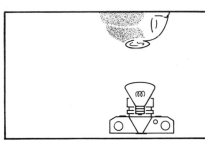 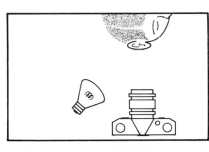 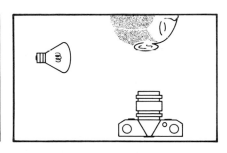

Lighting equipment need not be complicated. Ingenuity coupled with a few reflectors will be quite adequate in most cases. A geriatric Idaho potato serves as a model. *Near right:* An inexpensive 30-watt R-20 reflector spotlight in a Testrite swivel socket was positioned high and to the right of the potato. Modeling (appearance of texture and shape) is strong, but shadows are devoid of any detail. *Far right:* A white index card placed just out of camera view catches spill light from the bulb and bounces it into the shadows, providing significantly more "information" and better separation of the left side of the potato from the background.

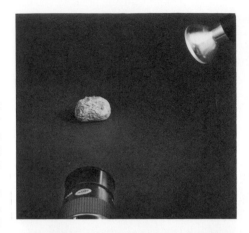

Near right: Supported by clay, a pocket mirror catches spill light from the bulb and puts a highlight on the left rim of the potato. Mirrors reflect more directional (harder) illumination; white cards diffuse and soften the light. So far, only one bulb in use. Field photographers who have only one "bulb"— the sun or possibly one flash—carry aluminum foil to do outdoors what the mirror has done in the studio. *Far right:* To "separate" the potato from the background, a Photogenic Minispot was used to light the backdrop behind the potato. In retrospect, that light may be too close in tonal value to the top of the potato.

Relatively soft illumination is available from almost any light used for close-up photography. This is so because the light fixture is usually large in comparison to the size of the subject, and therefore, tends to *surround* that subject with light. The geometry of such a situation can be appreciated by looking at the top illustration, which indicates the setup used for the photograph below. Another instructive feature of this example is the simplicity of the lighting. It is not always possible to use one light, but a good working approach might be to start with the *intention* of using a single source. Try all possible positions of that one light and add additional lights or reflectors *only* after carefully studying the image in the viewfinder. What was *not* simple about this photograph was the quest for a perfectly smooth egg—like teenagers, eggs are seldom free from all blemishes. After one full hour scrutinizing every shell in the supermarket, 12 perfect eggs were finally assembled into one carton. I am also unable to offer an explanation as to the origin of the "star" in the water drop atop the egg, other than to say it evolves from the refraction of light through the water.

Tremendous variations in the appearance of a photograph result from a change in direction of the primary light. As an example, consider two photographs of a leaf, both taken from identical camera positions. *Lower left:* One sidelight at about 75 degrees to the lens axis produced a rendering emphasizing surface terrain and contours. *Lower right:* Placed behind the leaf, the same light totally flattened perspective, but greatly emphasized the vein pattern. The choice is the photographer's, *if* he or she looks at the alternatives. *Right:* Interesting patterns come from the strangest places. Black cardboard for a background and one light from behind at 45 degrees produced the best sense of form and tone, from the author's point of view, in a slice of Swiss cheese. And the best slice of Swiss cheese was found only after a search through three large packages.

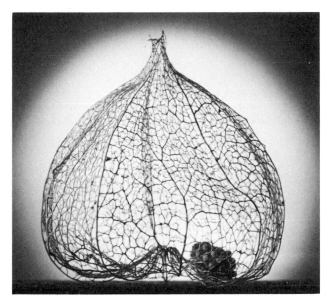

Backlighting has wonderful ability to delineate delicate detail, and increases the information content of a photograph. Directly above are the filigree remains of a Chinese lantern blossom. *Upper left:* To control the shape of light disc behind the dried blossom, a small spotlight was projected onto opal glass. *Left:* Backlighted vertical setups require a glass-topped platform: ⅜-in. (10-mm) plate glass works well. Here, too, a piece of opal glass is used under the specimen, in this case to smooth light distribution from a reflector spotlight. *Lower left:* A parasitic liver fluke found in sheep shows an interesting bright fluorescent area, but little else, when toplighted. *Lower right:* Backlighting greatly enhances structural details.

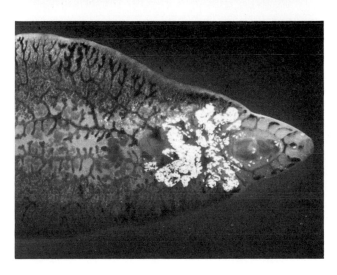

One should not overlook the various possibilities offered by *natural light* at different times of the day, on different days, or from different vantage points. If sunlight is too harsh, wait for a cloud. If rendition of texture is too flat, wait for the sun to drop in the sky where it casts longer shadows. This leaf, trapped in a fence by the wind, appears entirely different in photographs taken on opposite sides of the chicken wire.

BACKGROUNDS AND STRAY LIGHT

Because incandescent lights are very close to the subject, which, in turn, is very close to the camera, care must be exercised to prevent stray light from shining directly into the lens and causing flare, or from falling on the black camera body or lens barrel and causing heat build-up. Use a lens shade whenever possible, and with tricky setups, look at the front of the camera where light that might not ordinarily show in the viewfinder can be seen spilling onto the lens.

A plain background behind the subject is usually best. In the field, a *plain* shirt hung behind the subject, out of focus, can eliminate distractions. In the studio a minor recreation of a natural environment with a *few* twigs or leaves is often more interesting and more believable for plant and animal specimens.

A clean sheet of paper taped to a wall and draped onto the shooting table provides a simple, seamless backdrop for horizontal setups. Light-colored specimens will usually show up best on medium or dark backgrounds. In color photography, backgrounds should usually be complementary to, or contrast with, the subject; if they are too similar the subject may get lost.

The farther the background is from the subject, the more it will be out of focus, an advantage with tattered or textured backdrops. That distance will also permit the background to be separately lighted to control the brightness in relation to the subject.

Light spilling onto the background from spotlights can be controlled by the use of *barn doors,* which are flaps of metal (or homemade of cardboard), attached to the sides of lights. *Snoots,* which are cylinders of metal (or homemade of stiff paper), placed directly on the front of the light housing provide even greater control (see the illustration on p. 180).

If a totally white, shadowless background is required in the final print or slide, the backdrop will have to be flooded with light. A good separation between the background and the subject, along with careful use of barn doors and snoots, will allow the background to be well lighted without spilling additional light onto the subject.

If metallic subjects are to appear metallic in a photograph, they must be surrounded by a "tent"—an enclosure of white paper or frosted acetate generating diffused light in all directions. *Upper left:* For vertical setups, typing paper wrapped around a lens makes an elegantly simple tent. A spiral aluminum "chip" from a drill press demonstrates the difference between tent lighting (*center right*) and conventional, direct lighting (*upper right*). *Left:* Tent vs. spotlight is again compared, here with a silver wine goblet. It's not too difficult to ascertain which half of the illustration was photographed under the tent shown directly above. Tinker toys® provided the framework for the paper walls.

Here are two special lighting devices for close-up photography: Aristo's fluorescent light boxes (*upper left*) are ideal for use as a "tent" or, with an accessory diffuser plate, as a broad backlighting source. Placed inside the light box, metal teeth of this stripped gear (*upper right*) were rendered with appropriate lack of obscuring shadows. *Lower left:* Fiber-optics illuminators provide a small spot of intense, *cool* light almost anywhere, thanks to flexible fiber bundle and infrared filter in power supply. Edmund Scientific distributes this variable intensity unit with one or two fiber bundles. As shown, it nicely illuminated an internal section of head of human metatarsal bone (*right*).

FIBER-OPTICS ILLUMINATORS

For very tight situations, deep cavities, and dark recesses, a "light pipe" provides an excellent method of snaking in a small spot of *intense* illumination. Consisting of an armor-sheathed bundle of hair-like flexible glass or plastic fibers, the source is placed conveniently out of the way while the probe is positioned as required.

Fiber-optic illuminators are particularly useful for lighting the tiny objects found in photomacrography. The commercial units incorporate infrared filters, which permit all the light but lit-tle heat to pass through the fiber bundle. This makes them ideal for photographing sensitive biological specimens.

The high price (about $200 in 1978 for a 500-watt unit) relegates a commercially produced fiber-optics illuminator to the laboratory or commercial studio. People who are not so well funded, but mechanically inclined, can assemble their own from lights, cooling fans, infrared filters, lenses, and fiber-optic bundles available at very low cost from Edmund Scientific Co.

Fluorescent ring lights, such as the Aristo (*left*), generate cool, uniform, flat light almost directly on the optical axis—ideal attributes for scientific and industrial application requiring shadowless illumination and/or accurate rendering of subjects. *Right:* Filtration for color photography can be provided with a gel.

RING LIGHTS

Designed specifically for close-up photography of scientific and industrial subjects, the ring light is a device consisting of a circular light tube constructed to fit around a lens. Because the light comes from all directions and is just about on the lens axis, very flat, completely shadowless (esthetically bland) illumination results.

Unlike most incandescent lights, these ring lights use fluorescent tubes, so that they provide bright light with little heat, a combination sometimes necessary when photographing certain living objects.

The ring light is an excellent source for displaying *maximum information* in three-dimensional objects, photographing groups of small specimens, and illuminating the insides of cavities and recesses, such as in dental and medical photography. It provides reasonably pleasing results with color films, where the various hues of the subject serve to separate details. In black-and-white photography, the results may be too flat for pictorial work; however, for scientific photography, maximum information is usually more important than esthetic considerations.

Some modeling (shading effects) is easily accomplished by placing bits of black tape over some portions of the tube. But be sure to remove the tape as soon as possible; emitted heat and ultraviolet radiation may cause the tape to adhere permanently.

The accompanying illustration shows that even a ring light used too close to the subject will give uneven illumination. Longer-focal-length lenses will eliminate this problem.

Aristo manufactures circular fluorescent ring lights in a number of sizes and intensities. Because fluorescent lights have peculiar spectral qualities that cause a sickly greenish cast in color photographs, color correction (CC) filters are necessary either over the lens or over the fluorescent tube when using color film. The illustration on the next page indicates the appropriate filters available through Kodak dealers in various square sizes in relatively delicate gelatin.

For frequent use, the CC series comes from Tiffen in the more familiar round glass discs. An even more satisfactory solution for color photography is to purchase a sheet of inexpensive Roscolux gel from any theatrical supply house, and cut a donut-shaped piece to fit over the fluorescent tube. Use No. 38 with daylight films and Aristo's W-31 tube. However, do not leave the fixture on longer than necessary; the fluorescent lights will eventually fade the filter, although the sheet is large enough to make about a dozen donuts.

You can also build a very serviceable ring light from a standard 8-inch (20-cm) round fluorescent tube and corresponding fixture, both of which can be purchased from a lamp store. While not as bright and compact as the Aristo units, these homemade fixtures are less expensive and are for the person who likes to tinker. The illustration overleaf provides details.

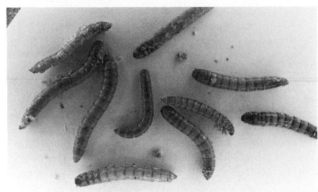

Difficult-to-photograph metallic subjects are rendered more cooperative under ring light illumination. *Upper left:* Dark shadows and specular highlights indicate that this motor armature was illuminated with conventional lights. *Upper right:* Surrounded by the Aristo ring light on the preceding page, the armature displays many more of its secrets. *Lower left:* Care must be taken not to use a ring light too close to the subject, or a dark central area may result. This photograph of mealworm larvae at 0.4× (1:2.5) with a 55 mm "macro" lens illustrates the problem. A longer-focal-length lens would be better in this case. *Lower right:* The author's homemade ringlight started out as a 6-in. (15-cm) fluorescent light. Ballast, starter and on/off switch were removed to an external control box.

An elegant method of providing true on-axis lighting is the system of *vertical illumination* diagrammed at right. All it requires is a small light and a thin glass plate. (Kodak Projector Slide Cover Glass #140-2130 works well, though even a microscope slide suffices in the macro range.) When placed under the lens at a 45-degree angle, approximately 10% of the light incident on the glass is reflected down onto the specimen. At the same time, the lens looks right through the glass—if it's clean—and focuses on the subject. At high magnification, a long-focal-length lens may be necessary to provide sufficient space for the glass between lens and subject. Alternatively, a teleconverter (p. 113) can add increased magnifying power to a normal-focal-length optic without decreasing working distance.

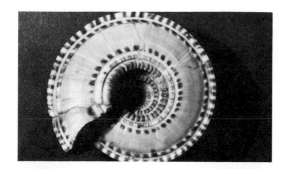

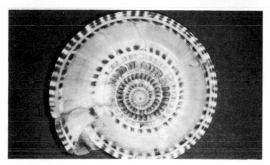

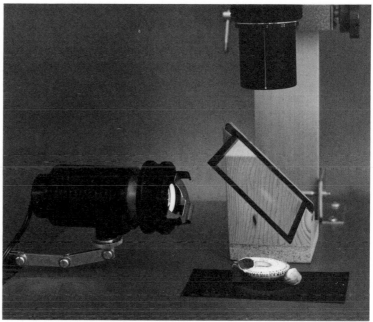

Upper left: Conventional toplight created a severe shadow in the spiral depths of a "sundial" shell (*Architectonica trochlearis*). *Lower left:* The entire ¾-in. (19-mm)-deep cavity is shadow-free when photographed under vertical illumination (*right*). (In fact it's so shadow-free, the sense of depth has been lost). *Right:* Small focusing spotlights are the best light sources; however even a Tensor®-type light, if shaded, will work (p. 194). Here, glass has been simply taped to a block of wood cut at 45 deg. Beam alignment is accomplished by shifting the light while looking in viewfinder.

VERTICAL ILLUMINATION

This is a very clever technique that is easily set up when deep cavities or recesses in subjects must be photographed without shadows for maximum visibility of details. Ring lights, of course, also serve that purpose, but they are somewhat specialized pieces of equipment that the average photographer does not own; and, as shown in the illustration on p. 190, even ring lights can produce uneven illumination when used very close to the subject. Vertical illumination is not quite as easy to use and to set up as a ring light, but for special circumstances or occasional use, it serves very well. Also, the skillful use of such simple equipment makes this technique tremendously satisfying.

The heart of a vertical-illumination system is a thin, clean piece of ordinary glass. A jerry-rigged holder will support this glass at a 45-degree angle in front of the lens, and a small, bright lamp with a snoot over it will prevent spill into the lens. The illustration on p. 190 diagrams the principle, which owes its success to the fact that the glass will reflect about 10 percent of the incident illumination *down* onto the subject. The other 90 percent passes harmlessly and uselessly through the glass. Simultaneously, if the glass is clean and dust free, the camera looks right through the slanted pane. Of course, since 90 percent of the light is ineffective, a fairly bright source is required.

Plain, thin window glass from the hardware store is perfect, but specify "scratch free." For small objects around life-size, a 2½″ × 4″ (6 × 10 cm) piece is about right. At magnifications around 0.5× (1:2), try a 3½″ × 5″ (9 × 13 cm) piece of glass.

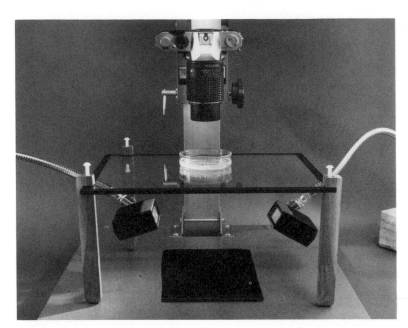

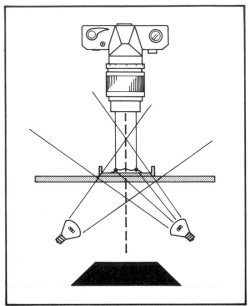

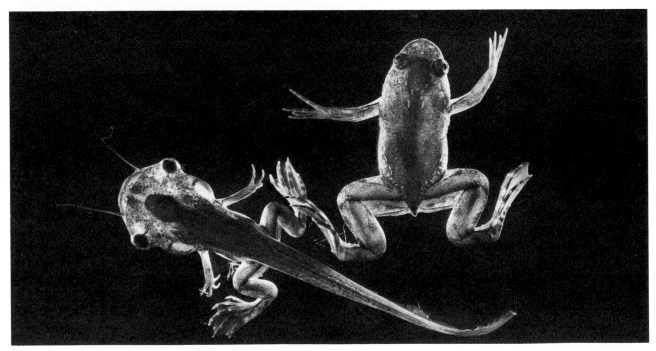

Many specimens scrutinized by the close-up lens are completely or partially translucent. *Dark-field illumination* may be appropriate for such subjects. As diagram above illustrates, a dark background is inserted some distance behind the subject, while light is focused in from the rear at about 45 degrees. Care must be exercised to prevent stray light from directly entering the lens—use a lens shade. *Top*: Two small electronic flash units provided dark-field illumination for the center photograph of a pair of tadpoles in early and latter states of development. Coaxing these two hyperkinetic small fry under the lens *simultaneously* was a task best suited to a saint. Conventional toplighted rendition is shown for comparison (*left*).

Analysis of certain specimens under polarized light provides information unavailable by conventional means. Many minerals and chemicals display their unique structure in a rainbow of colors brought out only by polarized light (see p. 175). Special plastics show internal stress as dark bands, if viewed under polarized light. Engineers apply this phenomenon by making models of complicated structures and studying their stress patterns. Technique of *photoelastic stress analysis* is shown (*lower right*) where a ballpoint pen has been pressed on a slab of photoelastic plastic. *Lower left:* Stress in author's eyeglass is evident when photographed as shown (*upper left*). A polarizing filter over the lens and a sheet polarizer (Edmund Scientific) behind the subject is all that is necessary. Cardboard illuminated by the bulb provides a uniform background of light.

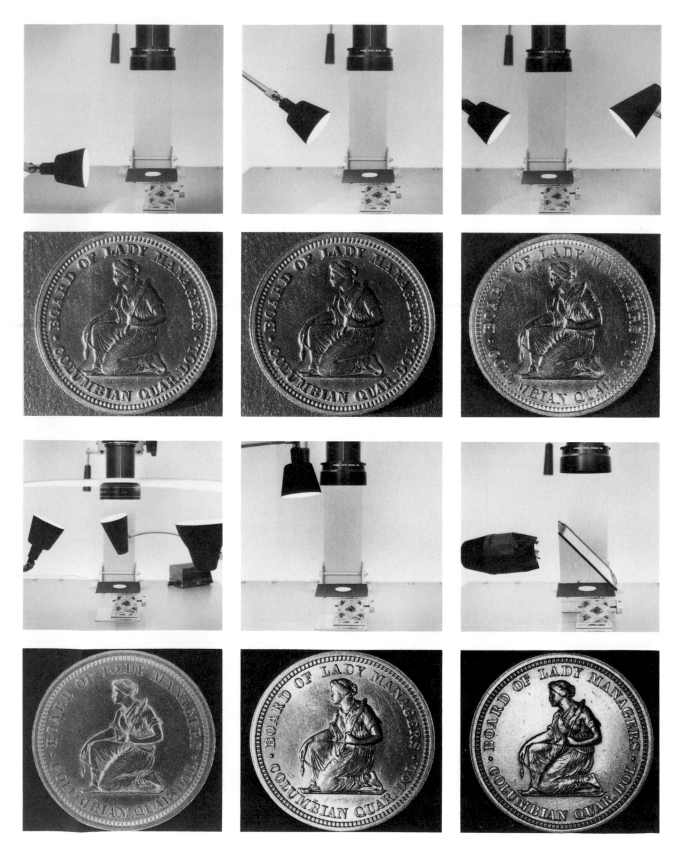

Facing page: The problems encountered in lighting a coin prove instructive even for the non-numismatic photographer. Most incident light is reflected *away* from the lens, making the shiny coin appear dark; yet somehow the raised surface features must be rendered clearly. Above each coin photograph is an illustration showing the corresponding lighting setup. In some cases, the appearance of the coin seems hardly affected by a significant change in the position of lights, but look carefully and you will see *some* difference. (Currently worth about $400, this 1893 "Isabella" quarter is the only commemorative 25-cent piece ever minted in the U.S. It was commissioned for the Columbian Exposition, which celebrated the 400th anniversary of Columbus' discovery of America. *(Coin compliments of Brangandi Coin Co., N.Y., N.Y.)*

Available outdoor light is not as plastic as the possibilities of the studio. However, photographers must be aware of various sky conditions and their effects on subject matter. Though certainly a matter of taste, offhand I can think of no subject I prefer to photograph in direct sunlight rather than under partially or totally overcast skies. I have an aversion to dark black shadows. For example, compare the appearance of a polished spiral troca in clear sunlight (*right*) and under an overcast sky (*lower right*). Metallic and polished surfaces do seem to require soft light. But also look at the two renditions of the same rose on p. 173; the softer version was taken by converting a sunny day to "overcast" with white umbrella (*below*).

Simply stated, light sources must be matched in color quality to specific types of color films, or vice versa. For example, electronic flash has *daylight* quality output that matches daylight film, but the fluorescent tubes in a ring light require special filtration.

In general, the color quality of light, i.e., the relative amounts of colors in the spectrum of "white" light, varies considerably from reddish candlelight at one extreme to bluish skylight in open shade at the other. Our eye/brain combination is extremely forgiving of these variations. Color film is not. Unfortunately, color emulsions are more discerning than the photographer's eye, and the film responds accordingly. Familiar are the orange-looking pictures that result when "outdoor" color films are used indoors, or the morbid green cast afflicting photographs taken under fluorescent illumination, or the overall cool blue imparted to pictures taken outdoors with "indoor" color film.

If the film's color sensitivity does not match the spectral quality of the light, correction filters can be used over the camera lens, or even over the light source, although lens filtration is more common. (It is important to note that in close-up photography it is extremely imperative to *focus with any filter necessary already on the camera lens.* Attaching the filter after focusing results in focus shifts that can become quite severe at medium, and especially at high, magnifications.)

To select the proper film or filtration for a particular light source, a simple method of characterizing color quality is needed. Incandescent sources (hot tungsten filaments, flames, the sun) can be characterized by indicating the approximate temperature of that source on a scale called degrees *Kelvin* (written K). That temperature is used to indicate color quality, and is referred to as *color temperature.* (The science of specifying color temperature is somewhat more complicated than is indicated here, but for our purposes this simplified definition is sufficient.) The higher the color temperature of a source, the greater the proportion of blue and green light to red and yellow light.

A 60-watt household bulb, which is rich in red and yellow and relatively deficient in blue and green, has a color temperature of about 2800 K. A 200-watt household bulb, having a warmer filament than the 60-watt bulb, has a greater amount of blue-light output; its color temperature is approximately 2900 K. Average daylight is 5500 K, and proportionally it contains a lot less red than the above-mentioned light bulbs. "Daylight" film is, as expected, balanced for 5500 K light sources.

"Type B tungsten" color films are balanced for 3200 K. For proper color rendering, bulbs used in photographic lights for color photography should all be 3200 K, and the film should be *Type B;* for slides, that includes Ektachrome 50 Professional and Ektachrome 160 Professional Film and regular Ektachrome 160. Alternatively, daylight films may be used with 3200 K lights *if* a Wratten 80A (blue) filter is used over the lens. However, that filter absorbs the equivalent of *two f-stops* worth of light; under some conditions that may be a significant loss, in which case the Type B film should be used.

For color *negatives,* there are no films that are tungsten balanced in 35 mm size. Therefore, daylight films such as Kodacolor II or Vericolor II must be used with an 80A filter. Conversely, an 85B (amber) filter is required when Type B tungsten film is used outdoors. See the illustrations in the color section.

It is important to note that the color temperature of a bulb is a function of its filament design and *not* of its wattage. *The* professional standard for indoor lamps is 3200 K, and bulbs of that color temperature are available for just about any photographic light, from 75 to 5000 watts. The color temperature should be stamped on the bulb or on its box, otherwise it is probably not 3200 K. For example, a 250-watt household bulb will impart a slightly "warm" (orange) cast to pictures taken with Type B color films, since that bulb has a 2900 K output. But identical looking ECA photographic lamps are designed to emit 3200 K quality light, and will provide the proper color rendition.

Slide projectors and small, high-intensity (Tensor) reading lamps have bulbs with outputs very close to 3200 K. (If the reading lamp, or projector, has a two-position switch, use the

"high" setting.) For many purposes, this type of lamp will be quite adequate. Further information on light-balancing filters for color films can be found in Kodak pub. No. E-23, "Filter Data For Kodak Color Films," and pub. No. E-77, "Kodak Color Films." (Write to Kodak for a copy of the Kodak *Index of Technical Information,* which also contains an order form.) General Electric's free publication, "Photographic Lamp and Equipment Guide" has a wealth of information on almost every conceivable bulb for photographic applications (see Appendix A for addresses of both Kodak and General Electric). The table below provides suggested filtration for a number of common light sources.

Manufacturers of photographic lighting equipment can also recommend the lamp that will provide 3200 K output in their fixtures; often there is a choice of wattage. Lights with lower color temperatures are usually less expensive, will last longer, and are fine for black-and-white photography. But by lamping all fixtures for 3200 K, you can always be prepared for color photography, and you do not have to worry about the color quality of each light.

Illumination that results from an electrical discharge through a gas (fluorescent lamps, and mercury and sodium vapor lights) has a noncontinuous spectrum, i.e., not all colors of the spectrum are present, and certain colors emit disproportionally large amounts of energy. No true color temperature, as such, can be ascribed to these lamps, and each brand requires special filtration with CC filters. Again, the Kodak pamphlets provide the required data. If in doubt, do a test.

Table 8-1

MATCHING LIGHT SOURCES TO COLOR FILMS

Lamp Type		Color Temperature (K)	Suggested Filtration for the Following Films:		
			Type B	Type A	Daylight
Household	40 W	2650	82C + 82A	82C + 82C	82C+82A+80A
	75 W	2820	82C	82C + 82A	82C + 80A
	100 W	2900	82B	82C + 82	82B + 80A
	200 W	2980	82A	82C	82A + 80A
Photoflood	BBA (No. 1), 250 W	3400	81A	N.F.R.	80B
	ECA, 250 W	3200	N.F.R.	82A	80A
	EBV (No. 2), 500 W	3400	81A	N.F.R.	80B
	ECT, 500 W	3200	N.F.R.	82A	80A
Reflector floods and spots	R-20, 30 W	2600	82C + 82B	82C + 82C	82C+82B+80A
	R-30, 75 W	2820	82C	82C + 82A	82C + 80A
	R-40, 150 W	2940	82B	82C	82B + 80A
	DAN, 200 W	3400	81A	N.F.R.	80B
	DXH, 375 W	3200	N.F.R.	82A	80A
	EAL, 500 W	3200	N.F.R.	82A	80A
High-intensity reading lamp	No. 1133 No. 93	2900	82B	82C	82B + 80A
Electronic flash		5500	85B	85	N.F.R.
Slide projector, ELH		3350	81	N.F.R.	80B

Notes: W=watts; N.F.R. = No filter required; Type B films are Ektachrome 50, Ektachrome 160, Vericolor II-L; Type A film is Kodachrome 40. For critical work, conduct a test, especially when using non-photographic light sources. When more than one filter is required, it is best to use gelatin filters (see p. 245).

This tiny (10 mm) hydra typifies the subjects that would be next to impossible to photograph without electronic flash. It sways and stretches, contracts and twists, in a never-ending search for food to ingest at the locus of its six tentacles. Though such motion is fascinating to watch, it makes photography frustrating—unless one uses the motion-stopping abilities and high brightness (for desperately needed depth of field) of modern flash units. Normally, almost a transparent white, this specimen was stained red in preparation for its portrait sitting. **m** = 3×(3:1).

ELECTRONIC FLASH

In this section we will discuss hand-size, "camera-mounted" electronic-flash equipment, not the larger handle-mounted or even the studio-type "strobes." The latter two are generally far less convenient for close-up photography. They are often too powerful, and are too large to conveniently carry for fieldwork, or to position around small subjects.

On the other hand, the cigarette-pack-size units have outputs typically permitting an $f/11$ or $f/16$ aperture at most magnifications with slow, fine-grain film (see p. 203). Their small size allows positioning flexibility, particularly the ability to get close to the lens axis. And the hand-sized package is so portable, one is inclined to carry it at all times to insure consistent, successful pictures when additional illumination is called for under field or location conditions.

The type that takes replaceable penlight alkaline batteries is the best for fieldwork. It typically provides over 150 flashes per set of four energy cells, and spares are easily carried. Units. with fixed, internal, rechargeable cells only give about 50 flashes per charge, and there are few places on the side of a mountain or near a tide pool to recharge them. Note that internal electrical leakage can lessen the power available from a set of batteries; remove them when not in use on a given day. Keeping the flash off except when absolutely necessary will also prolong battery life.

Slight Color Correction

In addition to the features noted above, electronic-flash light output has approximately daylight color quality, so that it can be used directly with all *daylight* color films, and with any black-and-white film. With certain flash units, some photographers detect a color quality that is a little too "cool" (too blue). A Kodak gelatin filter, either CC20Y or Wratten 81A or 81B (available in 2-inch [5-cm] or 3-inch [7.5-cm] squares), permanently taped over the flash will absorb excess blue light. But each of these filters requires about ⅓ f-stop more exposure.

While it might do for photographing a birthday party, a flash mounted directly on a camera is in the wrong position for close-up photography. Minimally, an inexpensive ball-joint flash bracket (*left*) should be used for proper aiming, although you can handhold the unit as per the illustrations on pp. 200 and 205. *Right:* Electronic flash is balanced for daylight type color film. However, some units generate slightly too much blue, which can be filtered with a CC10 or CC20 yellow filter.

Synchronization

It is important to remember that electronic flash must be properly synchronized with the camera's shutter, so that when the flash fires the shutter is fully open. With cameras having shutters *inside the lens,* any shutter speed—1/125 sec. or 1/250 sec. is usually appropriate—may be used (the flash is always faster than the shutter).

Cameras having a shutter *immediately in front of the film*—so-called *focal-plane* shutters, found on most interchangeable-lens 35 mm cameras—will only synchronize with flash at some maximum speed (usually 1/60 sec.) and slower. Consult your camera manual. (Even though the camera's shutter speed may be "slow," the actual exposure time for the picture is determined by the relatively fast speed and overpowering intensity of the flash.) If you are only getting half, or less, of a picture on the developed film, the shutter speed is set too high.

Most cameras have either a switch—"X" for electronic flash, "M" for flashbulbs—or a choice of synch-cord outlets to provide proper synchronization between camera and flash. The "X" position triggers the flash when the shutter is fully opened, and is therefore appropriate for the instantaneous response of electronic units. Flashbulbs take a relatively long time to reach peak brightness after ignition, so the "M" position sets them off *before* the shutter is fully opened.

FLASH—AUTOMATIC OR MANUAL?

For some low-magnification situations, fully automatic electronic flash may be used for close-up photography. But for most situations, the automatic sensor will have to be switched off and the flash used in the "manual" mode. There are four reasons for this, all based on the characteristics of *automatic* operation:

1. *Minimum* allowed flash-to-subject distance is typically 2 feet (0.6 m).

Generally, small electronic flash units *cannot* be used in their "automatic" mode for close-up photography. The sensors on these automatic devices are usually not designed to be operated closer than 3 ft (1 m) to the subject, nor at the small apertures required for adequate close-up depth of field. However, the text indicates three methods of determining correct aperture for nonautomatic flash operation, with the unit either handheld (*right*) or attached to the camera via various brackets.

2. Medium-to-large apertures, inappropriate for close-up photography, are usually specified.
3. The flash makes no provision for light loss at the film plane due to lens extension or teleconverters.
4. The steep angle that the flash makes with respect to the subject when close-up will cause a discrepancy in the amount of light reaching the automatic sensor compared with the light reaching the lens.

However, the advantages of an automatic aim-and-shoot electronic flash when stalking elusive creatures in the field are not to be relinquished unnecessarily. If the operating provisions specified by the manufacturer are heeded, electronic flash can work well at magnifications below half life-size, *if used with a long lens.* For example, a 100–135 mm lens, either a close-focusing model or a conventional telephoto with extension tubes or plus-lenses, or even a long-focal-length "macro" lens, will provide a 3–4-foot (0.9–1.2-m) flash-to-subject distance at $\mathbf{m} = 0.25\times$ (1:4) with the flash mounted on the camera. Such a long lens is usually desirable in field-work anyway, and the long flash-to-subject dis-

tance keeps the flash-to-subject *angle* appropriate for correct reading by the light sensor on the flash.

For most close-up photography, and especially for photomacrography, electronic-flash units must be operated manually. In fact, the small, simple, low-power, inexpensive, *un*automated models are ideal, regardless of your budget or level of photographic sophistication.

As for exposure in the automatic mode, if close focusing is achieved with a supplementary lenses, use the aperture specified by the instruction booklet for the flash. If lens extension is used, open the aperture the appropriate amount for the magnification, as per the table on p. 75.

There is one additional caveat that must be considered if an electronic flash is used in the automatic mode. The automatic sensors in these units are calibrated to read the light returning from a subject, or subject and *nearby* background, that more or less fills the frame. If a small specimen is photographed, say a slim blossom sitting by itself in a field, the lack of substantial area to reflect light back to the sensor can lead to overexposed film. In such cases, either bracket exposures by opening a half, and then a full stop, or use the manual technique outlined in the next section.

Light from a single flash may be too harsh or one-sided, particularly with the positioning difficulties encountered with a flash that's large in comparison to the subject. Page 182 illustrated what can be done with a single light and reflectors to fill in shadows. That same technique can be used with flash, as demonstrated (*left*) with a slab of cardboard attached to a wire. The Spiratone "Macrodapter" bracket on the lens can hold two flash units.

If you want maximum versatility in a "portable" flash system, yet require studio-level capabilities, this somewhat ungainly homemade camera/flash platform is the ultimate gadget. The long, flexible arms facilitate adding side and/ or top rim light accents, even backlight; and once it is assembled for a particular project, the photographer can concentrate on the subject. It's particularly useful to the naturalist seriously photographing insects, small mammals, and even birds, where the platform with a motor-driven camera could be operated remotely. The whole thing comes apart in 2 minutes. Base is ¾″ × 2″ × 16″ (19 × 50 × 406 mm) hardwood. Flange and arms are Atlas microphone components from a local audio store. Arms are topped with modified adapters (see p. 208), to which ball-joint flash swivels are mounted, Cable-release grip is from Kalimar, with a T-nut (p. 88) in the wood base providing a thread for the grip.

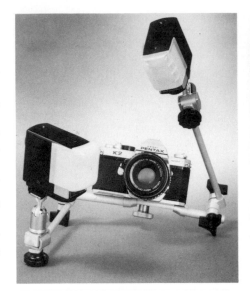
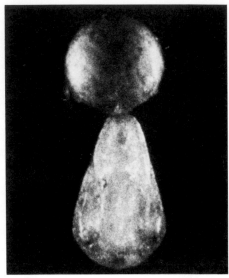

Far right: High brightness, low heat, and a short duration for freezing motion were again the attributes of electronic flash that made possible this photograph of a brine shrimp emerging from its egg. It was caught at **m** = 6× (6:1) while slowly rising in the mini-tank on p. 152. (At 6×, "slowly rising" moved the subject out of the viewfinder in 1 second!) *Left*: An excellent bracket for holding two flash units is this strong, lightweight aluminum system from Lepp.

ELECTRONIC FLASH OPERATION

To obtain maximum illumination, and, therefore, smallest apertures, the flash unit should be set on "manual" and positioned quite close to the subject. A bracket that allows attachment of the flash to the lens, as in the accompanying illustration, is extremely handy, especially for fieldwork. Alternatively, it may be handheld.

Unlike an automatic unit, a manual electronic flash (or an automatic one in manual mode) puts out the same amount of light for the same time duration with each flash. That eliminates two variables. Then the correct *f*-stop for a given flash unit is just a function of magnification, film ASA, and flash-to-subject distance. There are three ways to arrive at the proper exposure.

FLASH EXPOSURE DETERMINATION

Method No. 1

If the flash unit is positioned properly, the laws of physics and optics conveniently combine to permit *all* close-up photographs for a given film to be taken *at the same marked f-number for all magnifications between 0.2× (1:5) and 0.5× (1:2).* In practice, the flash is held—mechanically or by hand as per the illustrations on p. 205—at some small *fixed* distance *with respect to the front of the lens.* As the magnification is altered, the exposure increase factor also changes. But as magnification changes, the working distance, and in turn, the flash-to-subject distance, also varies. The light loss at the film plane due to increased magnification (increased lens extension) *is exactly compensated for* by the increase in intensity of light on the subject, as the working distance and the flash-to-subject distance decreases.

Therefore, once a basic aperture for a particular film ASA rating is determined by tests, all exposures within the limits noted will be the *same* if the flash moves in unison with the lens. *There is no need for any additional calculations.* (This special exposure situation *does not* work if magnification is obtained with plus-lenses or with "macro-zoom" lenses. Supplementary close-up lenses and almost all close-focusing zoom optics do *not* require any lens extension exposure compensation [see pp. 45 and 106], but the flash moving closer with the lens is still increasing the illumination on the subject. Methods No. 2 or 3, which follow, must be used in such cases.)

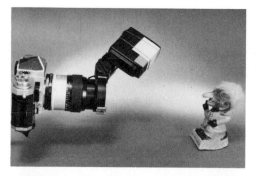

Steps in test sequence for flash exposure Method No. 1 (see text): *Upper left*: Set flash on *manual*. Units having manufacturer's guide number (in ft) over 40 for the film in use will require some attenuation, e.g., artist's frosted acetate, two layers of lens tissue, or plastic diffusers from Sima (*facing page*). *Upper right*: Connect flash to lens such that flash moves with changes in lens extension. Spiratone Macrodapter was used here; Novoflex has a similar bracket. Choose a medium-toned subject. At each magnification, make a series of exposures on slide film, bracketing from *f*/8 to smaller apertures by half-stops. *Lower left*: For each magnification, select slide of best density and make a table for your flash (*lower right*). Note data on author's flash are *not* in perfect agreement with theory in text—good reason for doing a test!

The illustration above shows the steps in the required one-time test sequence. Light output of these compact electronic flash units is such that *f*/16 or *f*/22 is a conveniently appropriate aperture with slow and medium-speed fine-grain films. Light *intensity* for a particular film ASA rating is controlled by placing layers of lens tissue or frosted acetate over the flash head. The test is used to determine the exact number of layers.

Method No. 2

When using supplementary plus, or "macro"-zoom, lenses for close-up photography, the following calculations must be used to determine *the correct flash-to-subject distance for the desired aperture.* (Unlike Method No. 1, the position of the flash with respect to the lens *varies* with magnification.) Method No. 2 can also be used for systems employing lens extensions and teleconverters by photographers who would prefer to do some arithmetic (once), rather than the type of test required for Method No. 1 above, or try both, out of curiosity.

Here the desired *f*-stop is chosen by the photographer, and the correct flash-to-subject distance is arrived at by using a modification of the *guide number* system of conventional flash photography. That system was universally used to obtain all flash exposure settings in the days before automatic flash equipment was available. It is still used today with manual flash units and with flash bulbs. The procedure is very simple. The *guide number* is divided by the *effective* aperture, and the result is the correct flash-to-subject distance.

Therefore, the guide number that is valid for that particular flash unit when used with film having the desired ASA rating must first be obtained. It should be given in the instruction manual that comes with the flash, and is usually listed under the heading "nonautomatic" or "manual" operation. (Lacking an instruction booklet, see the footnote on the next page.)

However, conventional guide numbers are merely *guides* based on use of the equipment in "average" rooms where object distances are

such that reflections off walls and ceiling contribute to the overall exposure. Also, when the flash is brought very close, it no longer acts like a "point source" of light, so the change in intensity with distance is different than at normal distances. Therefore, *the standard guide number must be modified;* dividing it by 1.33 usually works well.

In close-up photography, it is also easier to work with distances in inches (centimeters) rather than in feet (meters). But since conventional guide numbers are for the larger units, we will further modify them by multiplying by 12 (10).

Next, the *effective aperture* is required. (If you are using only supplementary close-up or "macro"-zoom lenses, you can disregard this paragraph, since effective and relative [marked] *f*-numbers are identical with those accessories.) To determine the effective aperture, first choose the required magnification based on the size of

Table 8-2
EFFECTIVE APERTURE AS A FUNCTION OF MAGNIFICATION

Magnification, m	Effective Aperture When Lens is Set at:			
	f/8	f/11	f/16	f/22
0.25× (1.0:4.0)	10	14	20	28
0.50× (1.0:2.0)	12	17	24	33
0.75× (1.0:1.3)	14	19	28	39
1.00× (1.0:1.0)	16	22	32	44
1.50× (1.5:1.0)	20	28	40	55
2.00× (2.0:1.0)	24	33	48	66

Notes: *A.* These effective apertures are for magnification achieved through lens extension; supplementary close-up and "macro"-zoom lenses require no correction.
B. Unsymmetrical lenses may require correction for the pupillary magnification factor (see Appendix B).
C. Very small effective apertures—those above *f*/32—may produce unacceptable loss of sharpness due to diffraction (see Appendix C).

the object and its intended size on the film. For example, if a 1-inch (25-mm) insect is to almost fill a 1½-inch (36-mm) film frame, the magnification—the object size divided by the image size—is about 0.7× (1:1.5). Then find the effective aperture attributable to lens extension for that magnification. Since apertures of *f*/11, *f*/16, *f*/22, or even *f*/32 will be used, the table below, or the equation on p. 81, will show the corresponding effective aperture.

Finally, the flash-to-subject distance can be found. For example, the magnification of 0.7× (1:1.5) is set on a "macro" lens, and the marked aperture on the *f*-stop ring is *f*/16. A flash manual says the guide number for Kodachrome 25 (ASA 25) is 40. Then,

$$\text{Modified Guide Number} = \frac{40}{1.33} \times 12 = 360$$

The close-up flash guide number *in inches* is now 360. For **m** = 0.7× (1:1.5), a relative aperture of *f*/16 becomes an *effective* aperture of *f*/27 (from the table at left or the equation on p. 81). Thus,

$$\text{Flash-to-Subject Distance} = \frac{\text{Modified Guide Number}}{\text{Effective Aperture}}$$

$$= \frac{360}{f/27}$$

$$= 13.3 \text{ inches.}$$

Therefore, if the flash is placed about 13½ inches from the subject (measured from the flash tube), correct exposure will result.

This entire procedure is really quite easy since the modified guide number only has to be calculated once. In fact you might want to make a small chart equivalent to Table 8–3 and tape it to your flash; you will never have to do it again, and the necessary information will always be immediately available.

In practice, hold the flash in the left hand, as in the accompanying illustration, and judge the required flash-to-subject distance. (Knowing di-

*If you do not have a booklet, you can use the calculator wheel on the flash to find the guide number for any film. First set the ASA on the wheel. Then, opposite the 10-foot distance mark will be the corresponding *f*-number. That number, *multiplied by 10*, is the conventional guide number for that film with that particular flash unit. Note that in this case the guide number is calculated for distances in feet. If using metric dimensions, the guide number will be different (take the *f*-number opposite 3 m, and multiply it by 3). Stick to one system or the other and use consistent units.

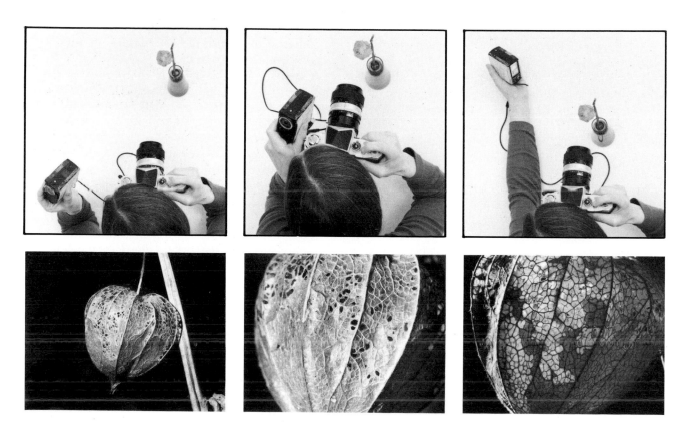

Flash exposure Method No. 2 (see text) provides flash-to-subject distance as a function of **m**. After preliminary tests, careful positioning of the unit at correct distance is all that is necessary for very portable, unencumbered, quickly set-up, flash pictures. *Left pair*: At 0.35× (1:2.8) on Kodachrome 25, a flash-to-subject distance of 15 in. (38 cm) produced proper exposure at *f*/16 for this picture of a Chinese lantern with *my flash. Center pair*: At 0.9× (1:1.1), 9 in. (23 cm) was appropriate. *Right pair*: Do experiment with backlighting, but bracket exposures.

Table 8-3
TYPICAL DATA FOR FLASH EXPOSURE USING "METHOD NO. 2"

m	Flash-to-Subject Distance (in.) at Marked (Relative) Apertures of:		
	f/8	*f*/11	*f*/16
0.25×	31	23	17
0.50×	24	17½	12
0.75×	20½	15	10
1.00×	18	13	9
1.50×	15	10½	7
2.00×	12	8½	6
2.50×	10½	7½	5
3.00×	9	6½	4½

Notes: *A.* Method No. 2 is on p. 203. These data are for ASA 25 film; the flash unit's non-close-up guide number is 32.

B. Actual exposure tests correlated very well with distances calculated from equations on p. 204, except at **m** = 0.25 where tests indicated distances 10% greater than equations predicted. Test your own equipment.

mensions of the lens barrel or other equipment such as the camera body will make this job easier.) Then, without moving the flash, hold the camera, which has been set for the desired magnification, in the right hand and move it back and forth to focus. Just as focus is sensed, gently press the shutter release. Do not try to "freeze" the camera at the position of focus, especially when working at high magnifications. Instead, slowly glide into it and anticipate the moment to trip the shutter.

With a little practice, results are excellent, and you should be able to manage handholding at magnifications up to life-size, and maybe even 2× (2:1). Of course if the camera is on a tripod, positioning is considerably easier, but remember that one of the main attributes of flash is that it permits handheld fieldwork.

The creative possibilities with such a simple, single, light system are really quite extensive. The flash may be positioned at a wide range of angles to the subject as long as it is the proper distance away. Experimentation, thought, and practice will prove worthwhile.

A last note before swearing by your calculations: Do a test to see if picture results do, in fact, conform to your calculated data. Idiosyncrasies in your flash and in your technique may make some differences.

Method No. 3

There are a number of conditions under which the preceding methods will not provide the correct flash exposures. At magnifications much greater than life-size, the flash positioning tolerance becomes small and exposure errors may result. Additionally, at high magnifications, the flash tube becomes very large compared with the subject, which makes exposure determination by way of a formula inaccurate. Furthermore, backlighting, ring flash at high magnification (next section), vertical illumination (p. 191), and multiple flash setups do not lend themselves to simple exposure "systems."

In these cases, as in so many other photographic situations, the correct answers will only come through a careful series of test exposures. Records should be kept of film ASA, magnification, close-up accessories, lens apertures, flash equipment and any variable settings it may have, angle and distance to the subject from the flash, and film developing data. The best and only valid test is one in which only *one* parameter varies, such as the aperture, *or* flash-to-subject distance. Careful analysis of the test results and good record keeping will lead to repeatable, reliable exposures in the future.

RING FLASH

Earlier, the pros and cons of ring lights were discussed with respect to models with fluorescent tubes. Similar units, emitting an electronic flash are also available, and they have the same illumination characteristics.

Because of their fairly bright output, some method of light attenuation is necessary when using medium- and high-speed films. The AC (alternating current from a wall outlet) power supply of Hershey's "Sun Ring", for example, has a three-level power switch. Alternatively, neutral density filters may be used over the lens; however, the viewfinder then becomes dimmer, making focusing more difficult. Donut-shaped rings of typing paper taped over the flash tube also work well. Each layer attenuates the light by about 50 percent (which is equivalent to one *f*-stop).

Exposure determination with ring flash is functionally similar to "Method No. 1," p. 202. That is, if the flash is used on a "macro" lens, or on a bellows or extension-tube-mounted lens, the required *f*-stop should remain more or less constant for a particular film over the magnification range of $0.2 \times$ (1:5) to $1 \times$ (1:1). The physical position and construction of the ring flash, especially at high magnifications, will determine the variances from that rule of thumb. Exposure tests ("Method No. 3," above) are a must!

Because they fit the camera so closely and compactly, ring-flash units handle quite well in the field, especially when stalking fast moving minuscule creatures in rough terrain. Unfortunately, all the ring flashes I have seen, except for the Ascor 1600, require an external battery pack that must be slung over the shoulder or strapped onto the hip; though such a pack typically provides over a thousand flashes. Since most battery packs also rely on the capacitor and electronics in the head of a conventional flash unit, the unit must also be carried and the ring flash must be plugged into it. Such an inconvenience is minor in a studio, but the field photographer would be better off with a more compact system, such as the Capro shown on the next page.

The Medical Nikkor lens (p. 103) is a 200 mm "macro" optic that has an integral ring flash built right into the lens. Available with a portable battery pack, it is a convenient system for shadowless scientific photography.

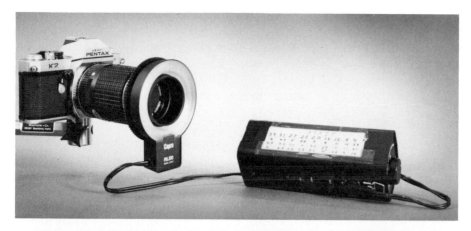

Top: A *ring flash* combines the uniform, glare-free, axial illumination of a ring light (p. 189) with the low heat, bright, motion-stopping output of electronic flash. This Capro RL80 operates on AC, or from a battery pack for convenient portability. Half, quarter, and full-power output gives control of aperture regardless of **m** or ASA. As with any flash attached to the lens, tests should be conducted to determine proper aperture at each magnification *with each focal length lens.* Remember that at the same magnification, a 100 mm lens will put the ring flash twice as far from the subject as a 50 mm optic. Ring flash is ideal for medical, dental, forensic, biological, and natural science photography, particularly in color. In B & W, ring light tends to be too flat for pictorial purposes, though frequently fine for shadow-free scientific photography. If needed, modeling can be achieved by putting black tape over portions of the ring. *Bottom*: Great for color field photography of insects, a ring flash was used for this portrait of a tobacco hornworm.

BOWENS MACRO-LITE

Incorporating the previsualization and pictorial control of incandescent lights with the high intensity and vibration-stopping speed of electronic flash, the Bowens Macro-Lite (U.S. distributor is Bogen Photo) is designed for flexible lighting control in close-up and macro photography on a vertical copy stand.

The dual flash heads incorporate miniature, low wattage, conventional bulbs for modeling lights so that highlights and shadows may be controlled as one looks through the viewfinder. Both flash units may be placed in almost any position via articulated support arms, and a clever ruler/protractor scale provides proper exposure, regardless of the placement of the lights.

Operating on standard house current, the Macro-Lite is a fine system for the serious practitioner who must accurately control the appearance of the subject, and whose subjects cannot tolerate the heat of bright, incandescent lights.

Top: A unique close-up-flash studio system is the Bowens Macro-Lite (from Bogen Photo), which consists of two small AC-operated flash heads on flexible arms. However, unlike other flash units that provide no indication of lighting effects, each Bowens flash head incorporates a low-power incandescent *modeling light*. Highlights, shadows, and reflections created by the modeling lights will be identical to final results from the bright, motion-stopping flash.

Lower right: The author has found microphone goosenecks ideal for supporting various close-up lighting equipment. Base flange is #AD-12; 6-, 13-, and 19-in. (15-, 33-, 48-cm) goosenecks are #GN-6, GN-13, and GN-19, respectively. (Model numbers are Atlas, distributed by Sonocraft.) *Lower left*: Top end is fitted with a Radio Shack #33-371 microphone adapter (left side of photo), which is then cut at the top. A hole drilled in remaining half accepted a ¼-20 bolt used to attach various adapters from Testrite (center-fitting) and others.

FLASHBULBS

Throughout this chapter there has been no mention of flashbulbs; however, the omission was intentional. Yes, they can and have been used for many successful close-up photographs, but there are two good reasons for not recommending them if they are compared with electronic flash.

The first reason is cost. For the price of less than ten sleeves of flashbulbs or flashcubes (12 shots per sleeve), you can get the type of small manual electronic flash that is ideal for close-up photography. Considering the tests and bracketed exposures that are often necessary in this field, the electronic unit will quickly pay for itself.

Relatively long exposure is the second reason that flashbulbs are not recommended. Almost all 35 mm SLR cameras will only take pictures with flashbulbs at 1/60 sec., or at the most 1/125 sec. While that same shutter speed *setting* is required for electronic flash, the actual 1/1000 sec. (and faster) light duration is over 15 times faster than the full 1/60 sec. flash duration of the bulb. But the ever-present vibration and motion problems of close-up photography can certainly benefit from the shorter exposures.

For fieldwork, there is also the carrying and disposal problem inherent in dozens of flashbulbs.

However, for low-magnification, handheld photography, or for high-magnification work with the camera on a tripod, do use flashbulbs if they are available. The additional illumination is frequently far better than nothing at all. Exposure can be determined by "Method No. 2," p. 203, with the necessary conventional guide number found on the package of bulbs or in the film instruction sheet. Make certain the camera is on "M" synchronization.

Somewhat special illumination is required for photographing flat artwork, books, photographs, and such. Slide duplication also has its own particular needs. Chapter 9, Photocopying and Slide Duplicating, discusses the requirements for both situations.

SUMMARY

Little serious close-up photography, especially above half life-size, can be accomplished without supplementary illumination. For hand-held work, electronic flash is recommended. For situations where accurate pictorial control is desired—for texture, emphasis, and overall appearance—incandescent lighting provides the ability to previsualize the final results.

High-intensity reading lights and small, fresnel-lens spotlights are good sources of incandescent illumination. However, a single light often provides pictures with harsh shadows, so that a second fill light, or a reflector catching spill light from the main lamp is usually necessary to put detail in the shadows.

Contrast and textural appearance of the subject can be varied to a great degree by altering the position of the lights. The farther away a light is, the more contrast there is in its illumination. A light striking the subject at a glancing angle of incidence will enhance texture; more direct illumination flattens the final appearance, but lessens shadows that may hide important details. Shiny, metallic, or heavily textured objects often require a "tent" to provide soft light from all directions.

Electronic flash is also useful with cameras mounted on a tripod or a copy stand when environmental vibrations or subject motion are a problem. It is also the best choice when heat from incandescent lights can harm a specimen.

Used with telephoto lenses, electronic flash can be effective in the automatic mode for magnifications below $0.5\times$ (1:2). Above that image ratio, manual operation is necessary. The simple, inexpensive, cigarette-pack-size units are the most satisfactory for close-up photography.

Two methods exist for controlling exposure when using flash. The first consists of adjusting the light output of the equipment with paper filters (based on a one-time test), and then, as magnification changes, altering the flash-to-subject distance exactly in unison with the lens working distance. Method No. 2 takes the guide number supplied by the flash manufacturer, divides it by a factor of 1.33 for close-up photography, and then divides it by the *effective aperture* to determine the correct flash-to-subject distance for a particular magnification. Only the second method may be used if magnification is achieved with plus-lenses. In all cases, tests should be carried out before an important project is undertaken.

For color photography, electronic flash can be used with daylight film, although a slight warming filter over the flash may be preferred. With incandescent fixtures, it is best to use bulbs having a 3200 K color temperature and Type B film. Alternatively, use daylight emulsions and an 80A filter. Fluorescent lamps, and lights with other color temperatures require special filtration.

The scientific, medical, forensic, biological, or commercial photographer might consider specialized equipment, such as ring lights (electronic or incandescent) or fiber-optic illuminators. They are for situations where maximum information and shadowless detail are required in three-dimensional subjects, particularly those with deep cavities and recesses.

Vertical illumination with a small sheet of glass is an inexpensive, effective method of providing shadow-free illumination directly on the lens axis. In some situations, it is even better for photographing the interior of cavities than ring lights, and it requires no specialized equipment.

It is fair to inquire as to the reason for such a photograph in a book on close-up photography. The answer lies in consideration of the alternative methods available to produce such an image. A major plumbing job was too costly; severe dieting too unpleasant; use of a mannequin too artificial. Yet that is the author's hand. Solution: Photograph the bathroom, photograph the hand; carefully cut out hand from an appropriate-size print and paste on print of bathroom. Then photograph the composite paste-up (with close-up equipment). Since contrast is usually increased in any photo-copying operation, print the individual photographs about one contrast grade "too" flat. The larger the original prints, the less defects will show in the final (preferably reduced) photocopy.

9 Photocopying and Slide Duplicating

The single, most frequent use of close-up photography is in the preparation of slides from paintings, photographs, books, charts, maps, X-rays, drawings, etc. Every day, millions of such slides are used to illustrate and convey information in lectures, meetings, theatrical productions, classes, and advertising. Photocopying of flat materials for the purpose of making additional, accurate copies is also a widely used technique, while slide duplication is a very common application of specific photocopying techniques.

Though photocopying is primarily used to faithfully reproduce flat copy, it can just as easily be employed to modify "reality." With appropriate filters, film, and film processing, it is possible to produce a copy that is actually *superior* in color balance, contrast, and/or composition to the original. Or, those same techniques may be applied to radically distort an image in pursuit of creative goals.

Few photographers work for very long without needing or being asked to do photocopying or slide duplication. These procedures are fundamental necessities in many branches of artistic and technical photography, and a knowledge of their fairly straightforward mechanics is very worthwhile. Such image-making incorporates many of the standard close-up techniques already discussed; but to produce *good* images from flat subjects, three requirements that justify a separate chapter must be met. They are: (1) very uniform, glare-free illumination; (2) sharp image definition across the entire frame; and (3) special films.

For this type of work, magnification requirements are rarely above 1:1, unless small details like the engraving lines in a stamp or the brush strokes on a painting are to be studied, or a small portion of a slide is to be enlarged to a full-frame duplicate. Furthermore, because important detail in the subject frequently occupies the entire frame— center, sides, and corners—all methods of optimizing image quality must be properly followed. Careful, clean technique is much more important than fancy equipment.

PHOTOCOPYING AND SLIDE PRODUCTION

Whether the flat material photographed becomes a slide for projection or a copy negative from which enlarged prints are made, the end result depends on the type of film in the camera. The photographic procedures are identical.

Mechanics

The first requirement is that the camera be accurately parallel to, and exactly centered over, the subject. (Flat artwork, printed material, graphs, etc., are commonly referred to as "copy"; but to avoid confusion, the words "original" or "subject" will be used here.) With the shallow depth of field found in close-up photography, a lack of parallelism between camera and subject can cause one side or the other, or sometimes both edges of the picture, to be out of focus. Poor alignment also causes parallel lines in the subject to converge, and rectangular bor-

Stages in the photocopying process are diagramed above. End use—prints or slides—determines film choice; but in either case, slow, fine-grain emulsions are best. Using transparency film (Ektachrome Pro. 50 and Kodachrome 40 for color; Panatomic-X or Fine Grain Positive for B & W), slides evolve (upper path). Negative working materials are chosen if prints are required: Use Panatomic-X or Vericolor II for continuous tone, B & W or color, respectively. B & W line originals (text, graphs, pen-and-ink drawings) are best done on a high-contrast film such as Kodalith or High Contrast Copy film. In B & W, copy prints faithful in tonality to the original usually require special development of the negative (see text).

ders appear trapezoidal. The accompanying illustration shows these effects.

A vertical copy stand is a great convenience when more than a few photocopies or slides are made on a regular basis. However, for infrequent work with flat subjects (except books), or for very large originals, a *horizontal* system can be improvised using a handy wall, a tripod, and some tape or tacks. For such a setup, the illustration on the next page indicates simple procedures used to

align camera and subject parallel to each other. Even if some squatting or knee bending is necessary, set the tripod fairly low so that it is more rigid and less prone to vibration, or an inadvertent kick.

Another alternative, albeit a compromise, to a copy stand is a tripod with its center column inverted. Here, too, parallelism between subject and camera must be arranged. A tripod head having dual pan/tilt flexibility makes the align-

Not all photocopying is done from conveniently flat drawings or single sheets of paper. Books and magazines are frequent sources of subject matter, particularly for slides used in lectures. Parallelism between camera and baseboard, so carefully achieved as per the instructions on p. 147, is for naught when a book spine gets in the way (*upper left*). However, alignment is reacquired by using layers of corrugated cardboard as shims, and a slab of plate glass to hold everything flat. Copying different pages within the book will require changes in the thickness of the shims. With lens apertures of *f*/8 or smaller, and **m** below 0.4× (1:2.5), correct alignment can usually be "eyeballed" by looking at the front edge of the glass at eye-level. *Lower left:* Out of focus, trapezoidal copies result when original and camera are not parallel. *Lower right*: After shimming, results are fine.

ment procedure considerably easier. With a single-axis head, each leg length must be tediously adjusted until all are exactly even. For occasional work, this inverted tripod method gets the job done, but it is rough on the back and knees. Also, the tripod tends to cast shadows on the subject unless care is taken with illumination.

A vertical copy stand is certainly the most convenient support for general photocopying. (See Chapter 7, Positioning and Supporting Techniques, p. 145, for an overview of copy stands.) It maintains parallelism as magnification is changed, provides a convenient method for varying subject distance, and is the only system to use if books and other thick subjects require flattening. Waist-level finders and right-angle eyepieces make viewing even easier when the camera is vertical. If the latter two accessories are unavailable, place the copy stand on the floor or on a low, firm table.

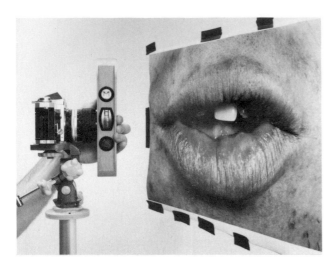
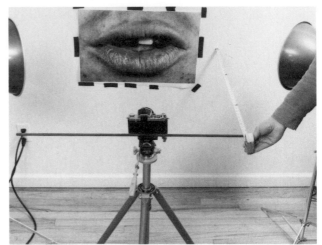
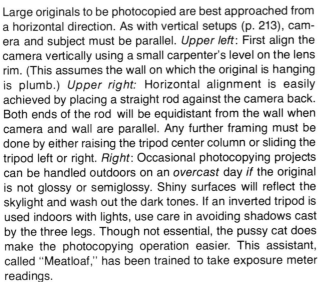

Large originals to be photocopied are best approached from a horizontal direction. As with vertical setups (p. 213), camera and subject must be parallel. *Upper left*: First align the camera vertically using a small carpenter's level on the lens rim. (This assumes the wall on which the original is hanging is plumb.) *Upper right:* Horizontal alignment is easily achieved by placing a straight rod against the camera back. Both ends of the rod will be equidistant from the wall when camera and wall are parallel. Any further framing must be done by either raising the tripod center column or sliding the tripod left or right. *Right*: Occasional photocopying projects can be handled outdoors on an *overcast* day *if* the original is not glossy or semiglossy. Shiny surfaces will reflect the skylight and wash out the dark tones. If an inverted tripod is used indoors with lights, use care in avoiding shadows cast by the three legs. Though not essential, the pussy cat does make the photocopying operation easier. This assistant, called "Meatloaf," has been trained to take exposure meter readings.

Copy-Board Glass

It is not very common to find subjects that will lay so flat on a copy stand's baseboard that they will not benefit from a piece of glass placed on top of them. Even if a subject appears to be completely flat, it will often curl or ripple under the heat of copy lights. In addition to getting image distortion from wrinkles, bumps, and curved surfaces, these irregularities will also cause glare and hot spots due to light reflections. Therefore, with a vertical stand, proceed as follows:

Start by placing a large piece of *black* cardboard below the subject. The color inhibits reflections, and the cardboard permits the subject to be maneuvered for centering in the camera's frame. Place the subject on the cardboard, and put a piece of glass on top of it. If you are shoot-

Subjects to be photocopied are frequently placed under glass to keep them flat. If large areas of dark tones are present in the original, reflections in the glass (from shiny camera parts) will be visible over those dark areas on the final copy. *Left*: Black cardboard placed in front of the camera is the way to avoid such "ghosts." Attach the baffle as follows: Cut a hole in the cardboard just large enough to clear the Series VII male thread of a Series VII-to-VIII step-up ring. Push that thread through the board. On the rear end, attach an adapter ring appropriate for the lens in use. (The majority of lenses use Series VII rings in either 49, 52, 55, or 58 mm diameter; consult your lens manual. *Top*: Reflections in a glass covering an original photograph are clearly visible at left. The third hand belongs to the photographer making the photocopy. Installing the black cardboard eliminated all artifacts and produced the copy at right. (*Original photograph courtesy of Timothy Volk*.) By the way, a *polarizing* filter will *not* eliminate this type of reflection.

ing a book, shim it with cardboard as necessary to achieve parallelism between camera and book page. Glass must, of course, be scratch free and perfectly clean. A lintless wiper, (Sorg Photowipes) lightly moistened with window cleaner can be used on the top of the glass to eliminate *all* dust just prior to exposure. Dust removal is particularly important if the subject has large areas of dark tones where dust will clearly stand out.

For most work, ¼-inch (6-mm) plate glass is best. Its weight helps to flatten books, and its thickness makes the glass less prone to shattering. Order it "scratch free," with all sharp edges and corners rounded to prevent injury. An 11″ × 14″ (28 × 36 cm) sheet should do for most common applications.

The frequent copying of books or magazines might call for the added weight of ⅜-inch (9-mm) or even ½-inch (12-mm) glass for flat-

tening recalcitrant volumes. However, very thick glass does have a slight greenish cast, and it will show up on critical evaluation of color slides. If the weight is desirable but not the color cast, a color correction (CC) 5, 10, or 20 magenta filter over the camera lens will absorb the green. A test will determine which filter strength is necessary.

Although glass is used for almost all photocopying, it is not without its problems. It means two more surfaces for dust to settle upon, and it causes reflections. In both cases, the problem is most severe if the subject is all or partially dark, and almost nonexistent if it is primarily light, such as a typewritten page or a line drawing.

Reflections occur when stray light from the copy lights and reflected light from the subject illuminate the front of the camera. An image of the camera, with all its shiny chrome levers, rings, and hardware then appears in the glass over any dark areas in the subject.

To eliminate these insidious ghosts, simply place a piece of black cardboard as a shield in front of the entire camera, as shown in the illustration on the preceding page. It attaches to the lens with an adapter ring, and is a simple, elegant solution to all the reflection problems . . . except one.

Just about every copy stand in the world has a shiny, chrome-plated column that shows up as a long reflection in the glass if the camera is high up on the stand and if the subject is dark. Until photographic engineers realize that *all* parts of copying equipment should be black, the column will have to be covered with black paper or tape for the occasional problem situation. For a similar reason, keep the copy stand a fair distance away from light-colored walls, or paint the area behind the stand flat black.

Polarizing filters will *not* eliminate these types of reflections since they are nearly perpendicular to the glass. Light is only polarized when it is reflected at an angle. And a final note on reflections in glass: Keep all overhead lights and nearby table or desk lamps off.

LIGHTING FOR PHOTOCOPYING

The occasional photocopying job can be done outside, lighted with nature's own illumination . . . if you don't live in a cold, windy, rainy, or dusty area. A very overcast or even cloudy day is ideal. Bright sunshine causes problems with shadows cast by various pieces of the copy setup. However, uniformity of illumination is of the utmost importance; trees, clouds, and buildings can all cause reflections in the copy-board glass.

Also, outdoors, one must be alert to changes in exposure necessitated by the varying thickness of cloud cover and progression in time of day. Because of these inconveniences, artificial illumination used indoors is much easier, photographically preferred, and considerably more consistent.

Standard procedure for artificial illumination is to have lights on either side of the subject at an angle of 45 degrees to the lens axis, as shown on the next page. Steep angles cause hot spots and glare in the image; shallow angles may lead to uneven illumination, and the chance of some light shining into the lens.

Again, uniformity of illumination is what counts. In general, the farther the lights are placed from the copy stand, the more uniform the light spread will be. A tape measure should be used to set all lights at an equal distance from the subject. Proper (uniform) aiming of the lights can be checked in two ways as shown in the illustration on p. 218.

Through-the-lens (TTL) meters in cameras generally should *not* be used to check illumination *uniformity* since they are designed to average, or partially average, the illumination in any scene.

One does not need sophisticated studio lights for photocopying. Relatively inexpensive reflector floodlights ("mushroom-shaped" bulbs) screwed into inexpensive sockets, such as those made by Testrite, provide more than an adequate amount of light. For black-and-white films, standard 75-, 150-, or 300-watt reflector floods are fine. For color films use 500-watt EAL reflector floods, which have a color temperature of 3200 K. (See Chapter 8, Lighting, p. 177, for

Photocopying illumination calls for at least one light on each side of the original, equidistant from, and at 45 degrees to the optical axis (*upper left*). *Upper right*: Many copy stands come with accessory photocopying lights. This small system from Testrite is satisfactory for originals up to 8″ × 10″ (20 × 25 cm). *Lower left*: Reflector floods (one with a snoot) also work well. For consistency, use a fixture with a tungsten-halogen bulb, such as the center unit from Smith-Victor. *Lower right*: Production photocopying operations are often equipped with electronic flash strip lights.

the discussion on matching light sources with color films.) When illuminating areas larger than the standard 8½″ × 11″ (22 × 28 cm) page size, four reflector floods are suggested.

Conventional, incandescent bulbs, such as the reflector floods, slowly lose intensity, and change color somewhat with use. To insure uniform illumination, replace all bulbs whenever one burns out.

Reflector floods are certainly not the only light source to use for copying. Any lights that can be positioned to provide uniform coverage will work. Quartz-halogen lamps are particularly

good for color work because of the constant brightness and constant color temperature they provide over their relatively long life. Such bulbs are initially more expensive, but compared to conventional lamps, they last much longer, and the actual cost per hour of burning time is three to ten times less. Smith-Victor, Colortran, and Acme-Lite all manufacture fixtures for conventional and quartz-halogen bulbs.

For industrial and other large-volume applications, electronic flash in the form of strip lights may be appropriate. One photograph above shows such a setup.

Uniformity of illumination is of utmost importance when photocopying. Intensity over the subject field must not vary by more than ⅓ of a stop (¼ of a stop if using high-contrast film such as Kodalith). Lack of uniformity may be unnoticed in the viewfinder, but its effects will usually be all too visible on the final print or slide. Most TTL metering systems *cannot* be used to check illumination uniformity because they average or partially average large areas of the scene. Rather, use one of two methods above, after first positioning lights as accurately as possible equidistant from the lens axis. *Left*: Using a handheld meter, take readings off a clean, plain card. Measure all four corners of the picture area and the center, but be careful you don't cast shadows with your hand. *Right*: A pen held as shown will cast one shadow for each light. When the shadows are of equal density, both lights are providing equal illumination.

Polarized Lighting

By placing large polarizing sheets on the copy stand lights, *and* a conventional polarizing filter on the camera lens, the textural and tonal rendition of certain materials may be improved, as shown at right.

For example, paintings done in heavy oil pigments are prone to blotchy, bright reflections, which make for poor copies. A polarizing filter over the lens will not help much since such filters do not eliminate reflections in subjects perpendicular to the camera. Adding polarization to the *lights* allows the amount of reflection to be controlled by looking through the viewfinder and rotating the lens polarizer until the desired effect is achieved.

The same double polarization system creates really dense, saturated blacks in the image of matte black paper, photographs printed in books, and black mounting board. It also tends

to saturate all dark colors, and is good for photographing artwork for slides. Photographs printed on matte and semimatte paper will also appear more contrasty if photographed under such a setup.

The Eastman Kodak Company sells complete light units with large polarizing filters, but they are costly. Very inexpensive "seconds" of plastic polarizing sheets are available from Edmund Scientific Company. They are quite suitable for use over lights, but, as with all polarizing materials, they must be placed fairly far from hot bulbs to prevent melting. Of course the farther from the lights they are, the larger the sheets must be to intercept all the illumination. A polarizing sheet that is 12″ × 12″ (30 × 30 cm) is about right for reflector floods. For long hard use, consider polarizing sheets laminated between glass from the Polacoat Corporation. The accompanying illustration shows some of the mechanics of working with polarized lights.

218

Polarized light has special applications in certain types of photocopying. Each copy light must have a sheet of polarizing material placed in front of it. The axis of polarization of all sheets must be parallel. To do that, view a camera's polarizing filter through the large polarizer to be checked (*left*). Rotate the latter until the former appears totally black, then place an index mark on the large sheet. Repeat for all the polarizers, then install them over lights with the index marks all facing up. A polarizing filter must also be installed over the lens; rotate it for desired effect. A portion of an oil painting is shown in the center row, with (*right*) and without (*left*) polarization. Similarly, a picture in a poorly printed book is shown at bottom.

OPTICS

Image definition when photocopying is most critical, since fine, important detail in the subject typically occupies the entire frame, and all areas must be rendered with equal sharpness. A "macro" lens (Chapter 5, "Macro" and Close-Focusing Lenses), which is designed for the magnification range and flat-field conditions found in photocopying, is ideal. Its ability to quickly change image scale is not a small advantage. Use apertures of $f/8$ and smaller, even with "macro" lenses, to compensate for any depth-of-field unsharpness due to lack of parallelism between camera and subject.

Extension tubes and supplementary close-up lenses used with conventional camera lenses will usually provide adequate results *if* small apertures ($f/11$ or $f/16$) are used and magnification is kept below $0.5\times$ (1:2). With detailed subjects requiring critical sharpness, tests are definitely in order (see pp. 46 and 56).

The correct exposure method for photocopying is to take a meter reading off a standard 18% gray card placed over the subject (*left*). TTL metering is most convenient since correction is automatic for lens extension and/or filters. *Upper right:* A "high key" (mostly light-toned) photocopy of the print is shown on the copy stand at left; gray card *was* used for exposure determination. Using the meter reading obtained off the print itself resulted in an underexposed copy (*lower right*).

EXPOSURE FOR PHOTOCOPYING

There are two ways of determining correct exposure for photocopying. Neither consists of just blindly following the recommendations of a camera's built-in meter, which is easily fooled by the typically large white backgrounds prevalent in printed matter.

Method number one involves placing an *incident* exposure meter on top of the subject and pointing it at the camera. The reading must then be corrected for any lens-extension light falloff or pupillary magnification factor as per Chapter 4, Extension Tubes and Bellows, unless supplementary close-up lenses are used, in which case no correction is required.

The second technique requires an inexpensive Kodak Neutral Test Card (called a "gray card" by most photographers). It is placed on top of the subject, and a reflected light reading is taken off of the card. If a handheld meter is used, be certain that it is not reading its own shadow or the shadow of your hand. Here, too, the reading will have to be corrected for any lens extension, or for filters over the lens if the film/lighting combination requires any. Alternatively, the camera's TTL meter may be used, but (1) switch off the fully automatic mode if the camera is so equipped; and (2) take a reading, with the gray card *completely* filling the viewfinder. If any background is visible, spread out more gray cards (they come six to a package). If the TTL meter happens to be of the spot-reading variety, then the gray card need only cover the

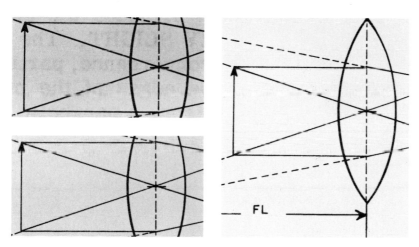

"It appears that our food system is moving away from the good, wholesome, basic, farmer-produced foods toward an overreliance on chemicals," Esther Peterson told the U.S. Agriculture Department's Food and Agriculture Outlook Conference. "Why should a mother ask her children to

"It appears that our food system is moving away from the good, wholesome, basic, farmer-produced foods toward an overreliance on chemicals," Esther Peterson told the U.S. Agriculture Department's Food and Agriculture Outlook Conference. "Why should a mother ask her children to

FL

Though gray-card readings are the basis for obtaining proper exposure when photocopying (*opposite page*), there are some special cases that require additional considerations. Gray card determined exposures are based on the assumption that the white background on a painting, graph, or book page is really "white." But some base materials are whiter, or less white, than others. For example, old newsprint reflects about one stop less light than typing paper. By photocopying with a gray-card reading, one obtains a print that is much too dark (*top*). But by "overexposing" one stop, the rendition is improved (*second from top*). Drawings on vellum require similar correction (about ½ stop), particularly if high-contrast line films are employed. Another problem occurs when copying book pages: Printing from the opposite side of the page may bleed through and be visible in the photocopy (*third from top, left*). Inserting black paper under the page being copied will mask the bleed-through but give about ½ stop more exposure (*lower left*). Kodalith or high-contrast copy film provides the cleanest rendition of line copy (*lower right*).

corresponding spot indicator in the viewfinder. Since a TTL meter automatically compensates for lens extension, use the exact reading obtained from the *gray card.* Disregard the gyrations of the meter when the gray card is removed.

To those who have never used a gray card, the whole system may sound suspect, especially if the subject is a white page from a book, or conversely, a painting of a black cat on a coal pile. But in fact, all films and exposure meters are *calibrated* for subjects of 18 percent reflectance; a gray card is 18 percent reflective. If the exposure is based on such a tone—and it is the reflectance that matters, not the color—then subjects lighter than the gray card will come out properly light in the final photograph. Similarly, subjects darker than the gray card will come out properly dark,

and everything in between will be properly in between. It is a quick, simple, and accurate system for correct exposure (see the illustrations above).

To eliminate the need to take a gray card reading after each change in subject size, when photographing with extension tubes or "macro" lenses, make a series of gray card exposure readings (with TTL meter) at various magnifications, recording the subject size each time. A simple chart can then be made of exposure versus subject dimension for each film type. And again a reminder: If a filter is used over the lens to match color film with the light source, and if the basic exposure reading was taken with anything but a TTL meter, add the correction for the filter to the exposure chart.

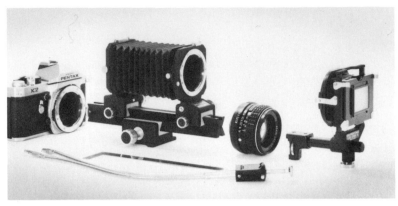

Various slide duplicating systems. *Upper left*: Bellows and macro lens generate 1× or more. Then add a slide holder, exemplified by this Pentax system. *Middle left*: Spiratone's Bello-Dupliscope, a self-contained system for slide duplicating that includes its own lens. *Bottom*: A vertically mounted camera with "macro" lens needs little more than a slide holder and a diffused light source, conveniently provided by the Testrite unit at left (it also accepts a flash), or the poor man's version at right. *Upper right:* A Bowen's Illumitran, with built-in meter and flash—for serious slide duping.

Illumination for slide duplicating may be a tungsten bulb of 3200 K color temperature, or electronic flash. The latter is preferred because of its consistent output and lack of heat, which keeps the original from buckling. Additionally, the duplicating film of choice among most photographers is Ektachrome 5071, which, in 36-exposure cassettes, is balanced for flash illumination. *Top*: Correct flash-to-diffusing-glass distance is determined by tests with normal-density slides, and with the lens at its optimum aperture—usually *f*/8. *Bottom*: Duplicating also provides the opportunity to correct, or intentionally distort, overall color balance. Filters are best placed *behind* the slide so that *minor* dust and scratches on the filters do not show on the dupe.

SLIDE DUPLICATION

Since color slides are so popular and prevalent, it is worthwhile to learn to use the techniques of close-up photography to duplicate, crop, and/or make negatives from them. Unlike prints, which are a generation removed from the original camera emulsion, slides are actually the same film that was in the camera at the time of exposure. So the negative needed to make multiple copies or enlarged and cropped prints is unavailable.

To make duplicate, cropped, color-corrected or image-manipulated slides, or black-and-white or color prints from color slides, the original slide must be photographed. Since the "subject"—a 35 mm slide—and the camera film are the same size, magnification will be 1× (1:1) or greater if the original is cropped.

Special hardware is available for photographing slides at this magnification. This equipment accurately aligns slide and camera, often providing for lateral shifting of the original for cropping, and has provisions for even illumination.

There are two basic types of slide duplicators: the first attaches directly to the close-up camera/lens system and uses external illumination; the second is a light-box-type device that is a combination slide holder and light source, requiring the camera to be positioned vertically above it. Although the latter is considerably more expensive, it does provide substantially more versatility for cropping, filtration, and reduction of larger format originals to 35 mm. Both types are shown on the facing pages.

Regardless of which system is used, it is important that all routes to a sharp image be followed. Performance at a magnification of 1× (1:1) severely tests the capabilities of any lens. If your lens is not a true flat-field optic, a "macro" lens, or an enlarging lens, an aperture of *f*/11 should be used. If only a portion of the original is to be copied and enlarged to a full frame, or if a filmstrip frame is to be enlarged to a 35 mm full-frame slide, both procedures raise the magnification above 1:1, and the lens should be reversed for optimum performance.

223

Illumination

The best method of achieving uniform illumination of the original is placement of a piece of opal glass ("milk glass") behind the slide. All slide-duplicating devices come equipped with such glass. If a homemade setup, as shown in the preceding spread, is used for occasional work, a piece of Kodak Flashed Opal Glass can be used, which is available in a variety of sizes from Kodak dealers. Milk-white *plastic* is *not* recommended because it scratches too easily and is sensitive to heat.

While it is theoretically possible to take a slide-duplicating device of the type shown at the top of p. 222 outside and point it at the sky, problems of color balance, exposure uniformity, and mechanical stability combine to strongly discourage that practice. However, for casual experimentation you might try pointing the duplicator at a very cloudy sky or the sun. *Warning:* Never point a camera at the sun without a slide-copying attachment and the slide in place. Aimed at a clear blue sky, all the duplicates will be excessively blue in color.

If you are using black-and-white film in the camera, any light source can be used, even the bare bulb from a table lamp with its shade removed. With color film, a light of 3200 K color temperature is ideal, and strongly recommended, especially if Ektachrome Slide Duplicating Film 5071, or Ektachrome 50 Professional Film is being used. (See the following section on film types.)

Electronic flash is also a good source of illumination because its output is constant in brightness and color quality, and its short duration helps eliminate the effects of vibrations. When duping with color films, remember that electronic flash has *daylight* color quality.

Ektachrome Slide Duplicating Film 5071 is much better than Kodachrome for duplicating (see next section), but as previously mentioned, it is balanced for 3200 K light sources. However, with proper filtration, 5071 film may be used quite successfully with electronic flash.

Films for Duping

Most slide films are made for projection. They have fairly high contrast, and originals from them look terrific on a screen. But copying anything but very "flat" (low-contrast) slides with conventional transparency materials will result in duplicates with too much contrast. They will have washed out highlights, and a loss—to complete black—of subtle dark tones. See the illustration on p. 157 in the color section.

For noncritical duplicating applications, you can use films like Kodachrome 25 (but not the more contrasty Kodachrome 64), Ektachrome 64, and Ektachrome 64 Professional Film with electronic flash (see preceding section). Alternatively, these films may be used with 3200 K lights and an 80A filter. Or use Ektachrome 50 Professional Film, which is balanced for 3200 K, or Kodachrome 40 (3400 K).

But all of these films are *not* made for duping, and results will definitely be on the harsh, contrasty side. Only tests will determine if conventional films are satisfactory for your applications. With very low-contrast originals, or with projects dealing with graphic or unconventional manipulation, such films may be ideal. Their one advantage is that they are easier to obtain in small camera stores than Ektachrome-Slide Duplicating Film 5071, which is specifically designed for that purpose, as the name implies.

For serious work, the low-contrast 5071 emulsion is strongly recommended, and is available in 36-exposure cassettes. Also note that the dyes in the various *originals* transmit infrared and ultraviolet radiation differently—radiation invisible to our eyes but quite visible to film. Therefore, one type of filtration is required if the original was made on old Kodachrome II, another if made on Kodachrome 25, a third if made on old Ektachrome-X, and so on. Kodak pub. No. E-39 provides filter and exposure data.

Be aware that all Ektachrome *professional* films, and 5071 is one of them, must be stored in a refrigerator or freezer, allowed to thaw out for a few hours prior to use (in the unopened package to prevent moisture condensation), and processed within a week of exposure.

Flashing

For occasional duplicating projects, conventional camera films can be manipulated to provide more than adequate results. The secret to

Choosing film for color slide duplicating must be approached with caution. Emulsions like Kodachrome and standard Ektachromes are designed for photographing the real world and producing a rather contrasty slide—which is ideal for projection. Using such film to photograph a *slide* just adds contrast to contrast. Films like Kodachrome can be used where contrast is no problem, such as duping title slides and other line material. Continuous-tone Images may be duped on Kodachrome using the technique of *flashing* (see text); it may or may not produce results satisfactory to you. Ektachrome 5071 is *the best* film for accurate slide duplicating; it requires calibration tests for optimum results, but the duplicates it produces are amazingly good (see p. 167). *Clockwise from upper left:* Original; duplicate on Kodachrome 25; also Kodachrome 25 but "flashed"; duplicate on 5071 film.

suppressing their inherently high contrast when duping is to use a technique called *flashing.*

Flashing consists of exposing the camera film to a uniform amount of dim light just before the main exposure. This tends to boost the shadow detail without affecting the highlights, thereby lowering the overall contrast. It works well!

In practice, a neutral density (ND) filter is placed over the opal-glass diffuser, or over the camera lens, after the original to be duped has been *removed,* in order to provide approximately 1/100 of the main exposure. An inexpensive ND filter of 2.0 density is usually used; it is available in 3-inch (7.5-cm), and larger, squares.

After the "flash" exposure, the neutral density filter is removed, the slide is inserted in place, and the normal exposure is made. (Unfortunately there may be confusion with terms; this *flashing* technique may be done with electronic flash *or* incandescent lights.) Both flash and main exposures are made at the same aperture and shutter speed. The only drawback to the flashing system is that it requires a camera that can conveniently double expose. Ektachrome Slide Duplicating Film 5071 requires no flashing.

Excellent B & W prints can be made from color slides, but special techniques are required. The critical step is development of the film—usually Panatomic-X—after photographing the slide. Development controls contrast, which must be compressed from the slide (black-to-white density ratio, approximately 300:1) to the print (70:1 ratio at best). *Left*: Copied on Panatomic-X, developed normally in D-76: harsh, contrasty, few middle tones. *Right*: Same film and exposure but processed in compensating developer Ethol T.E.C. at twice the recommended dilution with a 10% increase in recommended time. This print closely matches the appearance of the original slide. *Center*: Film was "flashed" as per text, developed normally; it's a bit flat.

Internegatives for Prints from Slides

The need for either black-and-white or color prints from slides occurs quite frequently. Direct reversal color papers, such as Cibachrome and Ektachrome RC Paper, Type 1993, will make prints directly from color slides without an internegative (a negative made from the slide). Anyone with a modest darkroom can make such prints; however, results with anything but low- or medium-contrast slides are only fair. An opinion shared by most professional photographers is that the finest color prints from slides are made from internegatives. And good internegatives can only be made in a sophisticated lab. Kodak or other professional color laboratories provide this service.

Other creative aspects of the slide duplicating process include sandwiching of two or more originals, radical color change, creation of graphic effects, and titling. Here is a simple way to add titles to existing slides: Print the title on plain white paper in black or a well-saturated color. Transfer letters from art supply stores are ideal, or use a typewriter (go over each line twice), or even hand letter. Photograph that title on conventional slide film as explained earlier in this chapter, making certain that the size and placement of the writing as seen in the camera's viewfinder is appropriate for later placement on top of the slide of the background scene. If a gray card was used for exposure determination, the resulting title transparency will have a clear background. Sandwich it with the background slide and make a copy slide of the pair.

Working Suggestions

When "straight" duplicates of slides are needed, it is usually best—from the standpoint of time, quality, and cost—to send them to a lab that specializes in such things. This may seem contradictory after all these pages on how to do it yourself. But the real reason for expending effort on duplicating procedures is for the creative and corrective controls they offer.

For example, slides that were somewhat underexposed may be fairly well corrected in the duplicating process. And although one should, one does not always crop in the camera when the original is shot. Corrective changes in cropping can be made in the duplicating process.

Another example: Color slides exposed under fluorescent light will have a sickly greenish cast. The confusing variety of tubes from "cool white" to "deluxe warm white" makes accurate filtration at the time of original exposure impractical. Duping with corrective filters is a practical remedy (see the illustration on p. 167 in the color section).

On the other hand, black-and-white prints from color slides can be easily produced using standard slide copying equipment and a basic darkroom. The procedure consists of photographing the slide with 35 mm Panatomic-X film. To decrease the inherent contrast in the slide, which is made for *projection,* overexpose one-half stop and process in a compensating developer, such as Ethol's TEC; but use 20 percent *less* than the recommended developing time. With originals that are abnormally contrasty, double the exposure (open the lens one stop or use the next slower shutter speed) and underdevelop by 35 percent. Results are excellent, as shown above. Alternatively, *flashing,* as described on the preceding page, can be used when you prefer to use a conventional developer, and if you have a camera that can conveniently double expose.

Insidious little specks of dust are particularly bothersome in slide-duplicating operations. They tend to be attracted by static electricity to plastic film base. Also, when working at 1:1 and higher, if cropping is involved, the little specks show up very large. And to make matters worse, because they block light going to the original slide, the dust shows up on the duplicate as *black* marks on light areas of the scene. (Dust on nega-tives used for printing causes *white* specks in the final picture, which is usually a lot less obtrusive.)

"Staticmaster" brushes from photo dealers work well to eliminate clinging dust. So do blasts of air from a household syringe. Small cans of compressed air are satisfactory, but if inverted, the liquid propellant can escape and cause spots on the slide. For very dirty slides or stubborn spots, Kodak Film Cleaner works well.

It cannot be stressed too strongly that successful slide duplication or copying of slides for internegatives depends on careful and thorough exposure tests. Once good results are attained, strict adherence to original conditions will prevent gremlins from sneaking in. When doing initial tests, hold everything fixed as much as possible, except exposure. Keep camera, film, lens, magnification, light type, light intensity, and lamp position constant. Later, during actual production, keep the hardware and mechanical setup the same as it was during the tests. Keep careful notes, and measure things like lamp-to-slide distance if a movable rig is used.

Exposure

Exposure must be accurate if decent-looking dupes are to come forth. That depends on the density of the original slide. But one of the advantages of slide duplication is that up to one, or even one-and-a-half *f*-stops of underexposure, and about one *f*-stop of overexposure can be partially corrected when duplicating.

For initial tests, choose a slide that has a lot of good medium tones, and an overall density that is typical of your work. One that is very contrasty, very flat, or that contains large, light or dark areas in the subject matter should be avoided for test purposes.

Before any special cropping or correcting is undertaken, initial exposure tests should be made at a magnification of $1\times$ with a slide of normal density, contrast, and color. Variations in magnification for the purpose of cropping or copying larger transparencies will require exposure correction due to a change in lens extension.

If no exposure correction is made in the duplicating process for either light or dark originals, the appearance of the duplicates will be

worse than expected. Light originals will produce even lighter dupes, and dark originals will lead to even darker dupes.

When an incandescent light, the sky, or the sun is used as a light source, a camera's TTL meter will give a fairly accurate indication of correct exposure. But all meters of this type are easily fooled by slides—or real world scenes—that have, for example, large areas of sky or very dark backgrounds, as found in some pictures taken with flash. If in doubt, bracket exposures.

TTL meters will conveniently compensate for lens-extension light falloff, and light absorbed by light-balancing and color-correction (CC) filters. But bracketing by half, full, and one-and-a-half f-stops on either side of "normal" is still suggested for initial tests. If you do not have a TTL meter, use the table below for suggested starting points.

If electronic flash is used as the illumination source for duping, it must be set on *manual*. A bracketed series of exposure tests will determine correct exposure, and such a test must be done for every flash unit since the output intensity and light pattern vary from unit to unit. The accompanying table provides the necessary information. If your flash unit provides too much light, move it farther away, or drape a fold or two of clean white handkerchief over it.

Sophisticated slide duplicators, such as the Bowens Illumitran (p. 222), have TTL metering systems to measure the density of originals, even though actual exposure is accomplished by electronic flash. But if you are using a simple electronic flash setup, or incandescent illumination with a camera lacking TTL metering, try the following:

Keep a group of slides as a reference set, one each of the same scene: (1) normally exposed, (2) half an f-stop underexposed, (3) one full f-stop underexposed, and (4) one-and-a-half f-stops underexposed. Also include the corresponding slides by half-stops in the overexposed direction. Do careful exposure tests for duplicating each one, and determine the changes from the normal original that are required for each of the "incorrect" originals. Then visually compare any questionable slides to be duplicated with the test set. It is a simple system that works well; the effort expended on calibration is well worth it.

Table 9-1				
STARTING POINT EXPOSURES FOR SLIDE DUPLICATING AT 1:1				
	Suggested Starting Points for Test Exposures with:			
Light Source	**Kodachrome 25**	**Kodachrome 40**	**Ektachrome Pro. 50**	**Ektachrome 5071**
Direct sunlight 10 A.M.–3 P.M.	f/8 @ 1/15 sec.	f/8 @ 1/8 sec.	f/8 @ 1/8 sec.	f/9.5 @ 1 sec.
Bare ECT photoflood 6 in. (15 cm) from slide	f/8 @ 1/2 sec.	f/9.5 @ 1/8 sec.	f/8 @ 1/15 sec.	f/9.5 @ 1/2 sec.
EAL reflector flood 12 in. (30 cm) from slide	f/8 @ 1/4 sec.	f/9.5 @ 1/15 sec.	f/8 @ 1/30 sec.	f/9.5 @ 1/4 sec.
Electronic flash (G.N. = 32 for ASA 25) 6 in. (15 cm) from slide	f/11 @ 1/60 sec.	f/8 @ 1/60 sec.	f/8 @ 1/60 sec.	f/8 @ 1/60 sec. at 3½ in. (9 cm)

Notes: *A.* Use appropriate filters to match film to light source (see Table 8-1, p. 197).
B. Correction for lens extension, filters required to match film to light source, and film reciprocity failure have been incorporated into these suggested exposures.
C. For best results, use a "macro" or enlarging lens, bracket exposures, and "flash" all films (except Ektachrome 5071) to prevent contrast buildup (see p. 224).

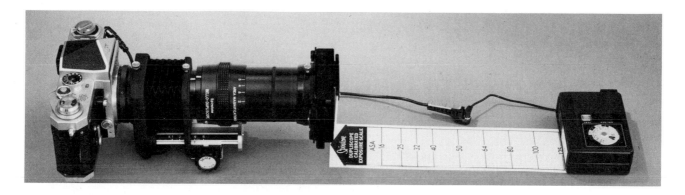

Here's a handy little device from Spiratone for homing in on the correct flash-to-slide-duplicator distance. The white card at right is a calibrated "ruler" that indicates correct placement of the flash as a function of film ASA. While designed for the Spiratone Bello-Dupliscope shown at left, with tests it can be used with any system. Flash must, of course, be raised so it is at same height as the slide.

Color Correction and Color Manipulation

The table below indicates the appropriate filtration change necessary if the original or duplicate has an unsatisfactory color cast. To a reasonable degree, an approximate guess at required filtration for color correction can be made by holding various color correction (CC) filters behind the slide in question while it is held up to a cloudy sky, or to a white sheet of paper that has sunlight falling on it. Deluxe Cool White fluorescent tubes are also a satisfactory source. Ideally, one should have a 5000 K light box, such as a Macbeth Prooflite, or the relatively inexpensive Richards Idealite Illuminator.

If color filters are used for correction behind the opal-glass diffuser—which is the best place for them instead of over the lens—less expensive color printing (CP) filters may be substituted for the CC type. Both types come on flexible base materials in a variety of square sizes, in red, green, blue, magenta, yellow, and cyan. Color saturation of the filter varies anywhere from very weak (05 units) to well-saturated (50 units).

Besides using filters to make things look as *normal* as possible, CC and CP filters, and even highly saturated theatrical gels such as Roscolene (from Edmund Scientific Company, or from theatrical supply houses) can be used to create strange, different, or special effects.

Black-and-white negatives, for example, can be copied onto Kodachrome with colored gels behind them. Pale, stay-at-home types can be turned into bronze-skinned jet-setters. Even different parts of the same originals can be duplicated with various colors created by judicious positioning of gels.

A good way to make colorful title slides is to photograph the original artwork (black lettering on white paper) with High Contrast Copy Film. The resulting dense, black negative with clear letters can be copied on regular color slide film after putting colored gels behind it.

Table 9-2

COLOR CORRECTION OF SLIDES

If Slide is Too	Make Duplicate with This (These) Filter(s)
Red	Cyan *or* (blue and green)
Green	Magenta *or* (blue and red)
Blue	Yellow *or* (red and green)
Magenta	Green *or* (cyan and yellow)
Cyan	Red *or* (magenta and yellow)
Yellow	Blue *or* (magenta and cyan)

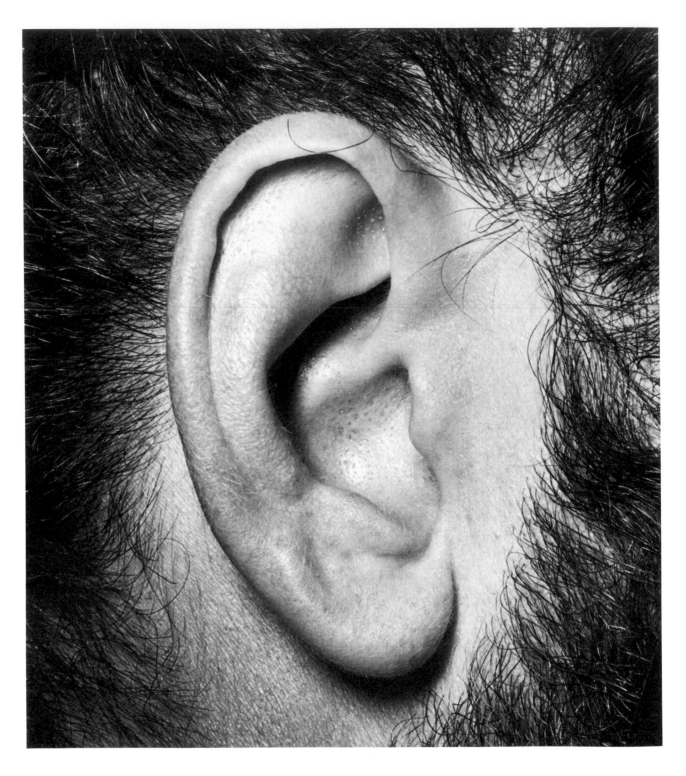

I'm fond of this photograph. The ear seems so strong, so solid, so strange. All that white skin and the bright highlights could easily cause a somewhat inflated reading from a typical center-weighted TTL meter. Such situations are discussed on the following pages. (Thanks to Bruce for putting up with all that tape in his hair and on the side of his head. You can see some of it in the corners of the negative on p. 231.)

10 Exposure

As noted in Chapter 1, Introduction, the development of the through-the-lens (TTL) meter was certainly a boon to the field of close-up photography. When used intelligently, the TTL meter permits the photographer to dispense with all calculations for lens extension, filter, and pupillary magnification factors. It is also much more convenient than external or handheld meters when it comes to metering tiny objects illuminated by small lights.

But TTL meters are not a panacea for all exposure problems, nor do they free the photographer from the need to understand basic exposure theory and practice. Also, not all cameras have TTL meters, and there are times when those that do are unable to benefit from them. In addition, they are useless for exposure determination with electronic flash.

At various places in preceding chapters, basic procedures for determining exposure have been indicated, and relevant information has been provided for any necessary correction factors. This chapter presents both general methods of exposure measurement, and equipment and techniques for dealing with problem situations.

BASIC EXPOSURE THEORY

Chapter 9, Photocopying and Slide Duplicating, indicated that a "Kodak Neutral Test Card" (gray card) should be used to determine correct exposure when photocopying. A gray card is nothing but a piece of medium gray cardboard that reflects 18 percent of the incident light falling on it. When exposure readings are taken from a gray card and are used to set aperture and shutter speed, the film will be capable of recording the maximum range of tones from white to black on either side of that gray. (An analogy might be the setting of a radio's volume control "in the middle" so that loud, soft, and medium passages will be easily discernible.)

It is crucial for every photographer to understand the following piece of information since the calibration of *all* exposure meters and the assignment of ASA values by a film manufacturer are based upon it: *If a meter is pointed at any subject, and aperture and shutter speed are set according to the meter's indications, the final print or slide will have a tone* (not necessarily a color) *equivalent to a gray card.* If the subject happens to be composed of light, dark, and medium tones, and if the meter averages them, the tones in the final image will (on the average) be equivalent to a gray card.

While there are extenuating circumstances, exceptions to the rule, and manipulative possibilities, the above statement can be considered a basic photographic principle. A graphic form of this axiom is presented in the illustration on the next page.

Therefore, whatever subject you point a meter at, be it a handheld, external on-camera, or TTL meter, the average of all the tones in the final image (at least the parts that the meter "sees") will be medium. Even an incident light meter, if properly placed in the subject's position

Top row: Three photographs made of a board containing a white, an 18% gray, and a black patch. Left to right, the meter reading was taken from the gray, white, and black patch, respectively. Real-world scenes exposed with a TTL meter serve as illustrations of metering problems. *Lower row, left to right:* Fossil contains a mixture of light and dark tones, so all is fine. The aspirin fills the frame with white, the meter makes it medium gray (top half); 1-stop correction improves the rendition (bottom half). Meter sees mostly black background, not sewing thread; thread is terribly overexposed; 4-stop correction improves the results.

and aimed at the camera, will cause the average tone in the subject to be rendered as 18 percent reflective. The accompanying illustration shows this principle in operation for typical close-up situations.

If these examples are studied carefully, they should eliminate the frequent failures caused by a misunderstanding of the principles of metering. It is not necessary to carry around a gray card, although some photographers do. Preferably, one should practice identifying medium tones in the subject or surrounding area. But even this writer is more comfortable using a gray card, especially under studio conditions.

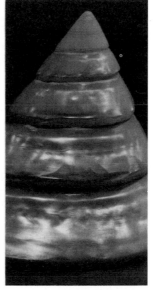

While TTL meters are the godsend of photomacrographers, it is important to note that they: (1) are somewhat dumb, being fooled by subjects displaying "non-average" tonal characteristics, and (2) have brains that simple mindedly attempt to average *everything* to a medium tone. For example (*upper right*), an etched shell has a pearl-like finish reflecting many bright specular highlights. A meter senses that intense light and averages it with the other relatively light-tone portions of the shell—results are a bit gray. Overriding the meter and opening the lens ¾ of a stop created a truer rendition (*upper left*). *Lower left*: It's easy to see why people whose pubic region is infested by *Phthirus pubis* are said to have "the crabs." But the primarily white scene presented to the meter will come out gray (*lower right*) unless "overexposed" one stop. If in doubt, bracket.

USING EXPOSURE METERS

Through-the-lens Meters

Through-the-lens (TTL) meters are certainly recommended for close-up photography. To allow them to display all of their capabilities, a discussion of a few operating details is in order.

First, take the meter reading just prior to exposing, *after* magnification and lighting have been set, and *after* any filters have been put in place over the lens and/or lights. If this instruction is heeded, no calculations and corrections are required for lens extension, pupillary magnification, and filter factors. The only modification to the reading would be one for film reciprocity failure if exposure times are longer than 1/2 sec. (see p. 240), or if black-and-white film is to be underexposed or overexposed to control contrast in conjunction with special developing procedures.

An idiosyncrasy of most TTL systems is that they are affected by light entering *through the eyepiece*. The degree of error caused by such a

"leak" depends on the ratio of light coming in the eyepiece to that entering the lens. Photographers seldom worry about this, because in conventional work the photographer's eye is always up to the viewfinder blocking stray light, and the intensity of light through the lens is reasonably high.

In close-up situations, however, especially at high magnifications, the light intensity at the meter cell can be quite low due to a large bellows-extension factor, even though ambient illumination is normal. That ambient light enters the eyepiece and biases the meter, particularly if the photographer happens to be wearing glasses. An accessory rubber eyecup, sold in most photo stores, will eliminate this problem.

One must be particularly aware of this situation if using a fully automatic camera that sets exposure when the shutter button is pushed. With such a system, there is no need to look through the eyepiece, and with the camera on a tripod, one might be inclined not to, once focus and framing are set. Also note that some cameras have TTL meters with additional readouts on top of the camera, so that an exposure indication can be obtained without even looking through the viewfinder. In both of these cases, it is important that some opaque shield be held over the eyepiece during the exposure reading, unless the viewfinder has a manually actuated built-in eyepiece shutter.

If the camera has a *spot*-type TTL meter, aim the target circle at the portion of the subject to be rendered as a medium tone. If this is difficult because of the morphology of the subject, or if there are no medium tones, as when photocopying an original having a predominantly light or dark background, insert a gray card or other similar medium-toned sheet over the subject and take a reading from it.

Unfortunately, most TTL meters are not of the spot-reading variety, but rather they average or integrate all or part of the scene's illumination. Terms like *center-weighted, bottom-weighted,* or *semi-spot reading* tell absolutely nothing when you want to know *exactly* what the meter is seeing.

For example, suppose the camera's instruction manual indicates that the camera has a center-weighted TTL meter. You are photographing a lush, red rose and some sky is showing in the top quarter of the frame. If the rose is in shadow, the sky is many, many times brighter than the flower's petals. How much is the meter overcompensating for the brightly lighted sky? This cannot be measured, since *center-weighted* means that *most,* but *not* all, of the reading is taken from the center; *some* is taken from the top of the frame.

One solution is to position a gray card in the full frame of the camera's viewfinder, so that it receives the same light as the subject. An alternative is to tilt the camera down so that no sky is visible in the viewfinder; read off the medium tones of the rose (assuming it is blood red), set the aperture and shutter speed, and then recompose as desired, disregarding the protestations of the meter as the sky again appears in the frame. (If the meter is set on fully automatic, it will be necessary to place it on *manual* to accomplish this alternative method.)

If the flower happens to be light-toned, and you want it to come out that way, again tilt the camera so that no sky shows, and use the gray card. If you don't have a gray card, take a reading from nearby medium-toned dirt or green grass (an excellent medium tone) *receiving the same light as the subject.*

In all cases, the *palm* of the hand is an excellent substitute for a gray card. But it is somewhat lighter than 18 percent reflective (regardless of the skin color); so if a reading is taken off your palm, *open the lens approximately two-thirds of a stop.*

TTL Meters Under Low-Light Conditions

Cameras capable of fully automatic operation must have their meters set on *manual* to make use of the following suggestions:

The low light level at the film plane and at the TTL meter cell that is found in many high-magnification situations will frequently render the meter inoperative. A solution that usually works is to indicate a different ASA, shutter speed, and/or aperture than you wish to use. In this way a reading can be obtained. Afterwards, you can make some simple calculations, reset the aperture and shutter speed, and get well-exposed pictures.

For example, few TTL meters will indicate the correct exposure time for a $1\times$ (1:1) photograph taken on ASA 25 film at $f/16$, a common

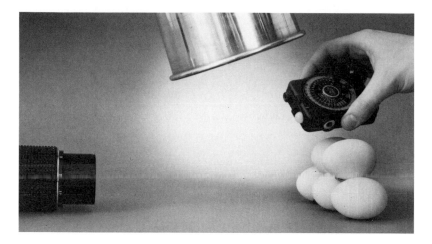

Incident light metering frequently provides correct exposure information when unusually bright or unusually dark subjects "fool" a reflected or TTL reading. Hold the meter, here a Calcu-Light, at the subject and point its white incident-reading sphere *at the* lens. Light falling on sphere must be identical to light falling on subject, a situation not always possible to arrange when lighting small subjects in the studio.

close-up situation. Therefore, open the lens one *f*-stop at a time until the meter responds. When it does, take the exposure time indicated by the now-functioning meter and *double it for each increasing f-stop;* then reset the lens to *f*/16.

To continue the example, if the now-functioning meter reads 1/15 sec. at *f*/5.6, it was opened three *f*-stops (from *f*/16). A reading of 1/15 sec. doubled is 1/8 sec.; 1/8 sec. doubled is 1/4 sec.; and doubling a third time gives 1/2 sec. The correct exposure is therefore *f*/16 at 1/2 sec.

Still not getting a reading? You may not if lighting conditions are weak. The next method involves adjusting the meter's ASA to a higher setting. But first try the ploy mentioned above, and only when you run out of aperture and shutter speeds, do the following: Double, in steps, the meter's ASA value from the true ASA of the film. From the aforementioned example, ASA 25 goes to 100, then to 200, and to 400, or even 800 if necessary. When you finally do get a reading, take the shutter speed that the reading indicates and multiply it by the quantity:

$$\frac{\text{ASA set on meter}}{\text{ASA of film}}$$

(Since you have increased the ASA in steps of two, the division should be simple.) Next, reset to the desired aperture, and further adjust the exposure time by following the steps indicated in the preceding paragraph.

In close-up photography, all of these efforts may still leave the meter needle unmoved or the LED readout unlit. Although it is presented here as a last stratagem, this next technique is one, in fact, that you may want to try first; however, it is only useful if the area seen by the meter is primarily medium or dark in tone.

Place a piece of white typing paper, or the back side of a gray card (it's white), over the subject. The boost in light may be sufficient to get a response from the meter. If so, divide the indicated shutter speed by 5, and an exposure can be obtained. (Good white paper is 90 percent reflective, which is 5 times more than an 18 percent gray card.) Of course this technique can be used in conjunction with the first two boosting suggestions if the appropriate additional corrections to the white-paper-divided-by-5 reading are made.

Finally, under the low illumination levels found inside the camera at high magnifications, most meters will respond very slowly and sluggishly. Be patient and give the meter time to function properly before using any reading.

Handheld Meters

The general operation of a handheld meter is no different than that of a through-the-lens (TTL) unit; and as in the TTL meter, the biggest exposure problem in close-up photography is knowing just what the meter is seeing. The handheld meter adds to this difficulty since it is usually quite large in comparison to the subject.

The extremely narrow 1-deg. acceptance angle of spot meters can provide correct exposure information for scenes having extreme brightness ranges, strong backlighting, etc. To use them close-up, plus-lenses will be required over the main lens, as has been done on the Pentax unit (*near right*). *Far right*: Flash meters, such as this Calcu-Flash, are excellent tools for determining close-up flash exposures. They are used like an incident meter (p. 235); and like any hand-held meter, must be corrected for lens extension, etc.

In situations where nothing but available light is used, the meter's size is no problem. When the meter reads *reflected* light, readings can be taken from a gray card positioned to receive the general illumination falling in the area of the subject. Or your palm can be substituted for the gray card (p. 234) if the aperture is opened about two-thirds of a stop. A third alternative is to read off a large, medium-toned area in the vicinity of the subject, provided it is receiving illumination similar to that incident on the subject (and incident in the *same direction*).

An *incident* light meter can be positioned just over the subject and aimed at the camera. Under the lighting conditions previously described, it will give a correct basic reading. Of course with *any* metering system, if a gray card, palm, or medium-toned surrogate area is used for the reading, and if the subject is unusually dark or unusually light, an additional increase or decrease, respectively, in exposure will be in order. If in doubt, bracket.

Setups using incandescent spotlights for illumination present special problems to handheld meters since the illuminated subject area is frequently smaller than the meter. Attempting a reading often causes the meter to cast shadows or to block the light entirely. There is no simple solution other than to take a reading, and make educated guesses for the possible errors. . . . then bracket. Meters such as the Gossen Luna-Pro have spot-reading attachments that can be a considerable help in measuring small areas.

The specially designed handheld single-lens reflex spot meters are very useful for taking reflected light readings from very small areas, especially if a TTL meter is unavailable. For close-up work, however, supplementary plus-lenses must be attached to achieve short-distance focusing.

The big *however* of handheld meters in close-up photography is the need to take the basic reading they provide and correct for the following:

1. Lens extension (Chapter 4, *Extension Tubes and Bellows*, p. 75)
2. Pupillary magnification factor (Appendix B, p. 256)
3. Light-balancing filters (Chapter 8, Lighting, p. 196)
4. Tone-separation filters for black-and-white film (Chapter 11, Some Working Suggestions, p. 244)
5. Film reciprocity failure (Chapter 10, Exposure, p. 240).

If they are done carefully and methodically, these corrections will give perfect exposures when used in conjunction with a handheld meter.

This is another example of a scene that can cause incorrect exposures when metered with a center-weighted or spot-reading TTL meter. Dark-field illumination (p. 192) was used to enhance the luminosity of an *Aequorea*, a beautiful jellyfish with a transparent center disc. A center-weighted or spot-reading meter sees the large dark disc, attempts to render it as a medium tone, and produces the results at right. "Underexposing" by 1 stop provided better version at left.

Flash Meters

For the serious studio photographer, a number of meters exist that will measure the burst of light provided by electronic flash (and even flashbulbs). Positioned *next to the subject and aimed at the camera* like a standard incident light meter, they give a reading that directly indicates *f*/stops for a film of a given ASA (see the illustration on the facing page).

Like all external meters, flash meters recommend an exposure that must be corrected for all the close-up parameters just noted in the last section. The major drawback of these meters in some close-up photography is their size, which makes accurate positioning of the light sensor in the plane of the subject a bit awkward in situations where the flash unit is very close to the subject. Also, the meter's thickness (the dimension from the base to the flash sensor) may be substantial when compared to the flash-to-subject distance, causing errors in readings.

Most flash meters are fairly expensive, although some are available for the cost of a good conventional meter. All of them, especially the less expensive models, need thorough testing and calibration. And because of the problems noted in the paragraph above, exposures should be bracketed when using a flash meter.

Since the flash must be fired for the meter's benefit to get a reading before the actual camera exposure, some means of firing the flash without tripping the shutter is necessary. If an electronic flash unit is not equipped with an "open flash" button, it is perfectly safe to disconnect the synch cord where it enters the camera body and fire the flash by shorting out the cord with a paper clip or other metallic object.

These meters are primarily studio instruments. Exposures determined by the standard tests and calibrations suggested on p. 202, in Chapter 8, Lighting, are just as accurate, and actually much faster to use for field conditions or even general indoor work. Flash meters, however, are of special value for elaborate, multiple-flash setups.

Exposure correction for combination of lens extension and pupillary magnification factors (or for a reversed camera lens used as a supplementary) is unnecessary when using TTL metering. However, when such metering is unavailable, manual correction of handheld meter reading is required based on p. 72 for **E.I.F.** and p. 256 for pupillary factor. Alternative method that combines all corrections is shown here: Place camera and lens *only* opposite a *uniformly* illuminated wall; set aperture at *f*/11; focus at infinity (wall does not have to be in focus). Take reflected reading from wall and expose as per meter (*near right*): That becomes the *reference frame*. Now extend or reverse lens, or install whatever you wish to test (again, wall does not have to be in focus). Starting from handheld meter reading, bracket exposures by ½-stop increments on *overexposure* side (how many ½-stops you go will depend on magnification); use Table 4-3, p. 75 as a rough guide. *Far right*: Compare results with reference frame. Amount of lens opening required to produce a test frame equal in density to reference frame is correction factor in stops. Use p. 75 to convert that to **E.I.F.**

BRACKETING

The admonition to make additional exposures by bracketing on either side of the assumed "correct" exposure has been given frequently. One might think that by generating such a vast array of exposures, one is bound to be acceptable. Quite the contrary. That scatter technique can only lead to failure when conditions are such that only one exposure is possible before the subject, expression, or optimum position is lost forever. Then, your first guess had better be a good one; not to mention the cost of film, especially color materials, if one tries to guarantee success by sheer volume of exposures.

Bracketing is an extremely valuable *learning aid, calibration tool,* and *problem solver.* When one is learning close-up photography, experimenting with new lighting, or becoming familiar with a new piece of equipment, bracketing is in order. Calibration of flash, slide duplication, and backlighted situations all require bracketing, at least by full *f*-stops with negative materials, and by half *f*-stops with transparency films.

For these situations, you cannot look up the "correct" exposure in a table, although the information found in this book and elsewhere will provide a basis for a reasonable starting point.

How far you bracket on either side of your educated guess is up to you. If the roll is intended for test purposes only, you may as well use the entire length for bracketing a number of different situations. The time and energy required for the photographic setup is usually not small, and the cost and time of developing negatives or slides is the same whether the roll is fully exposed or two-thirds blank. (In tests using negative materials, a tremendous amount of money can be saved by not ordering prints; the negatives will usually provide sufficient information.)

There are other reasons to bracket, especially with slides, where slight underexposure or overexposure cannot be compensated for in the types of printing procedures available to those working with negative materials. If the subject matter permits, consider bracketing under these circumstances: (1) when photographing objects that have predominantly very light or very dark tones, (2) when experimenting with modified development procedures for contrast control, and (3) when photographing subjects containing shiny, specular (metallic-like) segments that generate very bright, fairly large-area highlights—they may inflate an exposure-meter reading.

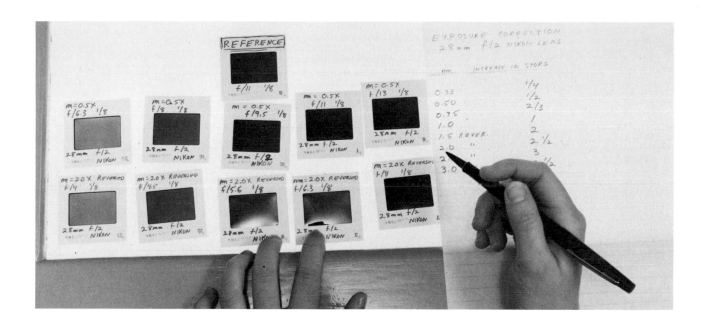

EXPOSURE TESTS AND CORRECTION FACTORS FOR PROBLEM SITUATIONS

Without TTL metering, an actual test on a roll of film is frequently the best, and sometimes the only method of determining correct exposure. Two situations where this is so are: (1) the determination of the pupillary magnification factor (Chapter 4, Extension Tubes and Bellows, p. 73, and Appendix B, Pupillary Magnification Factor, p. 256), which is significant above 0.5× (1:2) when non-macro lenses are used; and (2) the calibration of the aperture settings when a camera lens is used as a supplementary close-up lens on another prime lens (Chapter 6, Special Equipment and Combinations, p. 119).

The procedure for the first situation follows; extrapolation to the second and other conditions should be straightforward. (Note that Appendix B provides an alternative method for finding the pupillary magnification factor.)

The procedure for the first situation consists of first producing a *slide* of a *uniformly* lighted area, such as a wall, or matte board on a copy stand, at a magnification of 0.1× (1:10) or lower. It should be done so that the uniform area completely fills the frame; take an exposure reading with your external meter of the "subject." Use the reading to set aperture and shutter speed.

This *one* exposure becomes the *reference frame.* Next, photograph the identical wall area at various magnifications, bracketing each time in half-stop increments of *more* exposure in relation to the settings for the reference frame. The higher the magnification, the more extreme the bracketing: at 1× (1:1), the half-stop progression should add up to three *f*-stops, or the equivalent in shutter speed; at 3× (3:1), five *f*-stops are in order.

When processed, a comparison of exposures at each magnification with the reference frame will indicate the exposure correction required at each image ratio. (The magnification of 0.1× was chosen as a starting point since lens extension and pupillary magnification factors are insignificant at that magnification (see the accompanying illustration). *Note:* This procedure is actually measuring total correction for *both* lens extension and pupillary magnification factors. Record the results, tape the record to the lens if possible, and use it each time *that* lens, and that lens only, is used. The data cannot be used for other lenses since the pupillary magnification factor changes with lens design and with orientation, i.e., used forward or reversed.

Table 10-1
CORRECTION FOR FILM RECIPROCITY FAILURE

Film	Approximate Exposure Time Indicated by Light Meter:		
	1 sec.	10 sec.	100 sec.
Panatomic-X, Plus-X and Tri-X	+1 stop *or* 2T and 10% less dev.	+2 stops *or* 5T and 20% less dev.	+3 stops *or* 16T and 30% less dev.
Kodachrome 25 and Kodachrome 40	+1 stop *or* 2T and 10M filter	+1½ stops *or* 3.5T and 10M filter	+2½ stops *or* 10 T and 10M filter
Kodachrome 64	+1 stop *or* 2T and 10R filter	Not recommended	Not recommended
Ektachrome Pro. 50	No correction required	+1 stop *or* 2T and 20B filter	Not recommended
Ektachrome 64 (standard and pro.)	+1 stop *or* 2T and 15B filter	+1½ stops *or* 3.5T and 20B filter	Not recommended
Ektachrome 160 (standard and pro.)	+½ stop *or* 1.4T and 10R filter	+1 stop *or* 2T and 15R filter	Not recommended
Ektachrome 200 (standard and pro.)	+½ stop *or* 1.4T and 10R filter	Not recommended	Not recommended

Notes: M = magenta; R = red; B = blue. 2T means multiply the exposure time indicated by the light meter by 2; 3.2T means multiply it by 3.2; etc.; 10% less dev. means decrease normal film development time by 10%. "Not recommended" is Kodak's official recommendation for optimum color balance; however, the author has frequently used exposure times in the "forbidden zones" with excellent results. For further information, see Kodak pub. Nos. E-1 (color) and 0-1 (B&W).

RECIPROCITY FAILURE

An exposure of a given scene at f/2 and 1/60 sec., for example, produces an image having density, contrast, and color equal to that produced by f/2.8 at 1/30 sec., or f/4 at 1/15 sec.

This *mutuality* holds over a particular range and is said to be a *reciprocal* relationship. However, due to the mechanisms governing the interaction of very dim light or very short bursts of illumination with silver halide crystals (the light-sensitive component of film), there are failures of the reciprocity law under certain circumstances. The failures occur at exposure times *longer* than approximately 1/2 sec., as well as at times *shorter* than 1/1000 sec. (The latter occurs with very high-speed flash not usually encountered in close-up photography.)

To continue this example, at f/22, one would expect the corresponding exposure time to be 2 sec. In fact, 2 sec. would produce a negative or slide that is about one f-stop *underexposed* with somewhat more contrast than expected. In color, there would also be a shift in hue from the norm.

The problem is easily corrected by being aware of the condition and making the necessary modifications in exposure and developing times for black-and-white films, and in exposure and filtration for color materials. The accompanying table provides all the necessary information. Close-up photographers who frequently use long exposures should make themselves thoroughly cognizant of reciprocity failure. It is *not* an insignificant consideration, as shown in the accompanying illustration and the illustration on p. 166 in the color section. *Even TTL meters are incapable of dealing with this unfortunate shortcoming of film.*

Note that correction for reciprocity failure must be the *last* factor applied in any exposure situation. Longer shutter speeds or larger apertures are both valid methods of reciprocity failure correction; and the one, or combination of both, that is chosen will depend on considerations such as depth-of-field requirements and on the photographer's ability to keep the subject and/or camera steady for long periods of time.

Long exposures encountered in close-up photography without flash make correction for film reciprocity failure a factor that must be considered. A meter may indicate 10 sec. at *f*/16, but results will not be satisfactory. At speeds longer than 1/2 sec., the sensitivity of film is *lower* than it is at shorter exposure times. *Top*: After correction for the white background, a TTL meter indicated *f*/11 at 10 sec. for Panatomic-X. *Bottom*: Consulting the table on p. 240, exposure was increased to *f*/8 at 25 sec. The antennae and long proboscis belong to a female mosquito; she uses the latter to suck your blood.

SUMMARY

All exposure meters are calibrated in such a manner that whatever they are pointed at will be rendered as an 18 percent reflective medium tone in the final print or slide. Meters are easily fooled by large areas of very dark or very light tones in a scene. Small, intense, light sources or specular highlights can all falsify a reading.

Aim the meter so that it reads as much of the medium-toned part of the scene as is possible. If there is no medium tone, choose an area containing a good mix of lights and darks. With a subject partially in sunlight and partially in shadow, read the important medium tones on the shadow side if the film is a negative material. If it is transparency film, a reading from a medium tone on the lighter portion of the scene usually provides the most pleasing results. However, exposure is best learned by intelligent trial and error coupled with a record of exposures and lighting conditions.

The low intensity of illumination found inside a camera at high magnifications frequently renders a TTL meter inoperative. By taking readings at large apertures, slow shutter speeds, and/or doubled ASA settings, the meter can often be made to respond. Simple calculations will take such a response and convert it to an appropriate shutter speed and aperture.

Bracketing of exposures on either side of an educated guess is strongly recommended when experimenting with new techniques, when photographing subject matter with unusually light or dark tones, or in other situations when the calculation of a correction factor may be uncertain. Calibration of electronic flash, calibration of the aperture ring of a prime lens used as a supplementary, and other circumstances when TTL metering is unavailable or inoperative, all require bracketing. Take careful notes and analyze all the bracketed frames.

Reciprocity failure greatly affects film at both very long and very short exposure times. It must be taken into account frequently in close-up photography since shutter speeds longer than ½ sec. are quite common. Black-and-white film requires additional exposure and modified development; color materials also need more exposure, and they require special filtration.

241

So much of close-up photography—any photography—involves development of a personal style, and that development requires time, experience, and experimentation even more than it requires a book full of facts. Like sticking your head in a hole, you will never know how far you can go until you try it. Some of the suggestions in this last chapter may be useful while you're looking into, through, at, and around holes—and other things.

11 Some Working Suggestions

This chapter contains bits and pieces that did not easily fit elsewhere in the text. An entire book on close-up photography could probably be written having a title identical to this chapter's heading, since so much in this field involves more than camera/lens/bellows/exposure. Some insightful suggestion may have been omitted, but hopefully nothing earth-shaking is missing. At one time or another, you may find the following information useful.

NUMBER ONE

The most important accessory on a summer field trip other than a tripod or an extension tube is insect repellent.

Pressurized spray cans are to be avoided since they require carrying around a lot of weighty propellant that contributes little toward the repulsion of insects. A brand of repellent called *Cutters* is available as a very concentrated lotion or rub-on stick; its active ingredient, di-ethyl-meta-toluamide, effectively dissuades the hungry hordes of little creatures from putting some part of their anatomy into yours. If you want to spend time photographing the bugs instead of ridding yourself of them, carry a plastic bottle or stick of repellent in your camera case, and use it at the first sign of a welt.

BLACK TAPE

Love may make the world go 'round, but black tape holds it together. It can be used to attach filters when no adapter ring is at hand, join lenses nose to nose, repair holes in bellows, support and secure subjects to be photographed, make temporary lens shades, prevent plant life from swaying in the breeze, mask out background areas for backlighted and dark-field illumination, act as barn doors and snoots, and secure props.

Also use it to hold two pieces of glass together—sandwich fashion—when flattening a specimen, as in the illustration on p. 151. Formed into a loop with the sticky side out and wrapped around four fingers, tape can be lightly pressed against black velvet or felt to remove insidious dust. Use tape to control an unruly jungle of flash sync cords in a multi-flash setup. And don't forget to tape together the male-female plug intersection when an extension is added to a sync cord, otherwise there is a good chance the plug will come loose under the slightest stress. In the field, use it to secure specimen bottles and boxes, and to quick-fix broken eyeglasses.

I highly recommend Scotch #235 photographic tape, in the 1-inch (25-mm) width, which has a paper base similar to masking tape, but is completely opaque, matte black, and graciously leaves no residue when removed, even after many days. A large roll is unwieldy to carry; the illustration on the next page shows one possible packaging method for field use.

Other than an inquiring mind and enthusiasm, nothing is more important in close-up photography than black tape. It holds, secures, patches, blocks, prevents, connects, fixes, pads, helps, assembles, puts, joins, repairs, wraps, masks, acts, supports, controls and combines! Material of choice is Scotch #235 black photograph tape, 1 in. (25 mm) wide. *Right*: The roll is too bulky in a field case. Instead, I carry mine wrapped around a flat cardboard.

FILTERS

Filters have been mentioned in various chapters throughout this book in conjunction with color films, where filtration may be required to match the color sensitivity of the emulsion to the color quality of artificial lights, or to correct for hue shifts caused by reciprocity failure. However, filters also play a significant role in black-and-white photography. And there are mechanical aspects applying to all situations that should be noted.

First, any filter unbalances the optical corrections designed into a lens. The degree to which the image sharpness is degraded depends on the thickness of the filter and on the image ratio. If a lens is focused first, and then a filter attached to it, the filter effectively causes the subject to appear displaced from the lens by an amount equal to approximately one-third the filter's thickness. With a standard glass filter being approximately 0.1 inch (2.5 mm) thick, that displacement amounts to about 0.03 inch (0.8 mm), certainly an insignificant shift in conventional photography. But recalling that the depth of field at $1\times$ (1:1) and $f/11$ is 0.04 inches (1.0 mm), one can see that such a shift can be catastrophic in close-up work.

The solution is to compensate for the displacement by *always focusing with the filter in place*. Even then, there is still some minor residual loss in sharpness that is insignificant for all but extreme resolution requirements. If the ultimate is necessary, use *gelatin* filters—they are only about 0.01 inch (0.2 mm) thick—and, of course, focus *after* they are in place. Better still, put a filter over the *light source* if possible, although if it is very bright, this may lead to fading of the filter.

In light of these facts, the common practice of keeping a UV or haze filter on a lens at all times, both for lens protection and the removal of excess blue or haze in *distant* scenes, is not recommended if maximum resolution is required in close-up photographs. However, in a dusty outdoor location, the protection afforded to an expensive prime lens by such a filter is more than worth any slight sharpness loss.

While round glass filters are more common, a far greater variety, at considerably less cost, are available in gelatin or acetate, ranging in size from 2 inches (5 cm) to 6 inches (15 cm) square. In fact, the only practical and economically feasible way of accumulating all the filters necessary for reciprocity failure correction or slide duplicating with color films is to use gelatins.

The gelatin type, being optically clear, must be used over a lens, while the less expensive, less perfect acetate variety (called CP for *color printing*) can be put *behind* a slide to be copied, or over lights. Gelatin filters are preferred over glass filters for the reasons noted above especially when more than one filter is to be used. But

Do not overlook filters as accessories to enhance image quality. Polarizing filters will darken a blue sky in directions perpendicular to the sun's axis. They can also totally, or partially (depending on the angle), eliminate obscuring glare and reflections from non-metallic surfaces. A skylight filter will block excessive blue in color film exposed in open shade. Strongly colored filters can be used with B & W films to enhance tonal separation (below and on p. 247). One caveat, though. In close-up photography, the thickness of filters used over the lens can have a bearing on image quality (see text and below). The photograph at left is an edge view of, from top to bottom, a polarizing filter, a standard glass filter, and a gelatin filter. When possible, put filters on the lights, not the lens. If filters must be over the lens, and if the least effect on resolution in super critical applications is demanded, use the thin, gelatin variety.

Filters can greatly enhance weak tonal separation in B & W photographs. Adjacent sections of a scene that appear differentiated due to color differences may blend as similar tones of gray when rendered in B & W. *Caution:* A filter used over a lens causes the subject to appear displaced from the lens by an amount approximately equal to ⅓ the filter's thickness. In close-up photography, unless the lens is refocused *after* the filter is attached, results can be disastrous. *Left*: A section of human lung tissue at $m = 3\times$ (specimen stained light purple). *Middle*: A #58 green filter was added to the lens *after* focusing. *Right*: Same filter over lens, but focused *after* filter was installed; compare left and right tonally. Dark inclusions are coal dust, a miner's black lung disease.

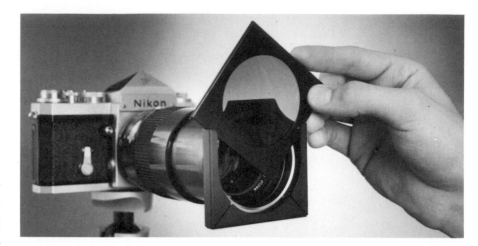

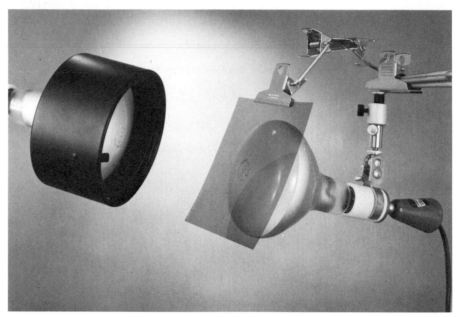

Glass filters come in either screw-in or Series sizes and attach as shown on p. 43. Gelatin filters require somewhat more elaborate support hardware. For most SLR lenses, use gelatins in the 3 in. (7.5 cm) square size. Filter then goes into a Kodak gelatin filter frame (being held, *above,* which in turn fits a Kodak or Tiffen filter frame holder. Holder requires a Series VII-to-VIII step-up ring and lens adapter ring for the final correction. (Nikon gelatin filter holder conveniently eliminates the need for frames. Threaded to fit 52 mm diameter lenses, it can be used on most lenses by adding a Spiratone "Customizer" ring). Use less expensive "CP" filters over lights, but not too close if they're hot. A snoot makes a convenient filter for R-40 bulbs (*lower left*); lacking one, bits of tape and wire will do in a pinch (*lower right*).

gelatin also has its drawbacks. These filters scratch very easily, and are next to impossible to clean. Never touch any part but the corner, and use only a blower to remove dust. (A blast from your mouth also contains droplets of moisture; use a household syringe instead.)

The accompanying illustration shows gelatin filters in use, and Kodak pub. No. P2–1, *Photographic Products Catalog,* lists availability of an immense array of gelatin filters. Consult a Tiffen catalog for a large selection of glass filters.

Black-and-white photography can also benefit from the use of color filters. Two objects having different colors, but of equal reflectance,

will reproduce as identical, indistinguishable gray tones in a black-and-white print. Remember, a filter passes its own color and blocks its complement, so an appropriate filter may be chosen to differentiate between subject and background, or tonally separate various components of a scene. The table at right offers the necessary details.

Kodak pub. No. AB-1, *Filters and Lens Attachments,* has further information on the use of filters. The very scientifically inclined may find the detailed and extensive graphs and charts in *Kodak* pub. No. B-3, *Filters for Scientific and Technical Use,* of interest.

Here are two additional examples of the use of strongly colored filters to enhance tonal separation in B & W photography. *Upper left*: Contrast is poor in this 3× photomacrograph of the tip of an elodea stem. *Upper right*: The cyan (blue-green) color of the specimen lent itself to contrast enhancement with a #25 red filter (red is the complement of cyan). *Bottom*: Not the head of a snake, but the wing tip of an atlas moth photographed with a #12 yellow filter (*left*) and a #47 blue (*right*). Wing appears here about life-size.

Table 11-1
TONAL SEPARATION FILTERS FOR BLACK-AND-WHITE FILM

To Lighten	and/or	Darken	Try Wratten Filter No. (whose effect is)		
Yellow		Blue	6 (W);	8 (M);	15 (S)
Magenta, red, blue		Green	CC50M (W);	32 (S);	35 (VS)
Cyan, blue, green		Red	CC50C (W);	44 (S);	45A (VS)
Red		Cyan, blue, green	23A (W);	25A (S);	29 (S)
Green		Magenta, blue, red	56 (W);	58 (M);	61 (S)
Blue		Yellow	82C (W);	80A (M);	47B (VS)

Notes: W = weak; M = moderate; S = strong; VS = very strong. For more specific technical details and a comprehensive list of filters, see Kodak pub. No. B-3 *Kodak Filters for Scientific and Technical Uses*. These filters are available from Kodak in gelatin, and from Tiffen in glass.

The esophagus of *Ascaris lumbricoides*, a parasitic roundworm found in the human intestine, models for a comparison of extreme enlargement techniques. *Left*: Photographed at 1× with a 50 mm *f*/2 normal lens at *f*/8; print enlargement is 10×. *Center*: Same negative as at left, but enlarged 37 times. *Right*: Also 37× enlargement of negative, but taking lens was high-quality "macro." All negatives are Plus-X developed in D-76.

HIGH RESOLUTION AT EXTREME ENLARGEMENT

Sharpness and grain structure of most photographs taken with conventional low-speed films (Panatomic-X, Agfa KB-14, Kodachrome 25) are usually entirely satisfactory when film is enlarged the 10 or 15 times required to produce an average size print, or a projected image on a screen. However, when extreme enlargements are required for murals, or for analysis of small details within an image for scientific or medical purposes, special films, developers, and enlargement procedures, coupled with all the careful picture-taking techniques already discussed, will produce amazing results at 50× negative enlargement, and more (see the accompanying illustration.) At this time, the special films and developers required are only available for black-and-white photography.

A vital ingredient in this type of work is one of the very thin emulsion (VTE), high-contrast films intended for high-resolution document copying or microfilming. Kodak High Contrast Copy Film 5069 is readily available in factory-loaded 35 mm, 36-exposure cassettes, and is an excellent choice for extreme enlargements. But processed as recommended by Kodak, the film has basically black-and-white tones, and no gray —super high contrast.

However, the almost grainless, extremely high-resolution properties of this type of film can be exploited by developing it in a special low-contrast solution designated "POTA," which can be formulated from:

sodium sulfite	30.0 grams
Phenidone (Ilford dealers)	1.5 grams
water to make	1.0 liter

Details on its use can be found in Marilyn Levy's paper in the January–February, 1967 issue of *Photographic Science and Engineering* (Vol. 11, No. 1).

Considerably more convenient is a similar developer available as a premixed liquid concentrate from the H & W Company via mail order (see Appendix A for the address). They call it "H & W Control."

With careful development technique, the combination of very thin emulsion film and special developer produces the remarkable results shown above. Other films available in 35 mm

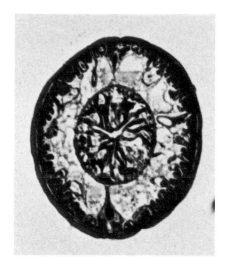 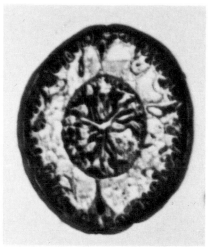

Left: Same conditions as right picture on p. 248, but with high-contrast copy film processed in H & W Developer; book reproduction may mask some of the dramatic improvement over conventional film/developer. *Center*: Same negative as left but blown up with moderately priced enlarging lens (most perform poorly at extreme enlargements). *Right*: 55 mm Nikon "macro" lens produced all 37× enlargements except middle print on this page.

factory-packed cassettes that work equally well are Kodak's SO–115 Technical Pan Film and H&W's VTE Pan Film. The price paid for such grainless resolution is an effective film speed or exposure index (E.I.) of 10 for the high-contrast copy film and 15 for the SO–115. However, H & W's VTE Pan provides a respectable E.I. of 50. (The conventional ASA rating of all films must be disregarded when film is processed in a POTA-type developer.)

Developing instructions are provided with the H & W package, but be aware that this developer is prone to *rapid* deterioration by oxidation. The bottle of liquid concentrate should be mixed *just prior* to actually pouring the solution into the developing tank. Unused concentrate must be stored in small *glass* bottles containing no air.

The enlarging potential present in the specially processed VTE films will not be realized if conventional enlarger lenses are used. Even the most expensive lenses give poor results when used to enlarge at ratios far beyond their design limit, which is usually 10–12× (see the accompanying illustration).

A clever ploy is the adaptation of a 50 mm "macro" lens of the type usually used on a camera. Its flat-field design and high-resolution capabilities at the magnifications required for these extreme blowups produce superb results.

A little ingenuity is required to mount the lens onto an enlarger; its front should face the baseboard. A T-adapter (from Spiratone) with its rear filed flat and screwed or epoxied to a lensboard will usually work.

Of course, to achieve such huge enlargements, the enlarger head must be turned around and the image projected onto the floor. Such a cantilevered setup is quite prone to vibration, so be very careful with steps to ensure rigidity. And don't move during the exposure. Of course parallelism between the enlarging easel (on the floor) and the enlarger (sitting on a bench) must be accurate. Use a level to make certain both are horizontal in two planes.

All the enlargement in the world will be for naught if the image on the negative is not super sharp and well resolved. It's not worth attempting this high-resolution technique unless the original close-up photograph was taken with a "macro" or other excellent-quality, flat-field lens. And unless all methods of eliminating vibrations, providing accurate exposure, ensuring perfect focus, and achieving adequate depth of field are applied in the picture-taking process, the results of tremendous negative enlargement will be tremendous blur.

Close-up photographs frequently involve elaborate preparation, expensive subjects, and technically complicated setups. Such circumstances make it foolish to expose one roll of film, dismantle the quipment, and *hope* the pictures come out. If conditions at all permit, do a quick B & W test (even if final exposures will be in color); develop it in the bathroom, kitchen, barn, or office; and check the negatives with a loupe for sharpness, exposure, lighting, etc. You don't need running water; no need to even wash the film; just check it and throw it out. Text gives details on conforming final film ASA to test film ASA. (*Note*: 315 rolls of film for this books were developed in the kitchen sink shown here, but not all at once.)

THE QUICK FILM TEST

Few commercial photographs requiring tricky or elaborate setups are made until a Polaroid test confirms all is as it should be. The 35 mm practitioner involved with a complicated close-up situation has no such instant security at his or her disposal. However, tests can be done by quickly developing a roll of black-and-white film.

If your developing and printing is done at home, the kitchen sink, a thermometer, a watch, and a daylight developing tank are all that is needed. After the test exposures, the roll of black-and-white film is loaded on the developing reel in a changing bag, or in a closet at night with room lights out. With all chemicals premixed and always ready in convenient quart bottles, you can be looking at the wet negatives in less than 25 minutes. A ten-power loupe (from Edmund Scientific Company) permits critical analysis of each frame for exposure, depth of field, sharpness, and lighting balance.

Extrapolation, for example, to color film having an ASA different from that of the test emulsion is easy. Just divide the test film ASA by the new film ASA. That result multiplied by the shutter speed used for the test will give you the shutter speed for the new film:

New Shutter Speed =

$$(\text{Test Shutter Speed}) \times \frac{\text{Test Film ASA}}{\text{New Film ASA}}$$

Alternatively, the correct *aperture* for the new film is also related to the aperture used for the test exposures by the formula:

New Aperture =

$$(\text{Test Aperture}) \div \sqrt{\frac{\text{Test Film ASA}}{\text{New Film ASA}}}$$

"Black" is a relative term. Depending on tone of the subject photographed, a "black" background may be rendered as a shade of gray. Some materials are *blacker* than others. *Far left*: A photograph of four "black" samples pasted on one board. From top to bottom: black flocked paper, fogged and developed glossy photo paper, fogged and developed matte photo paper, "black" photographic backdrop paper. *Near left*: Seed pod from mimosa tree against black backdrop paper angled at 45 deg., with (*bottom*) and without (*top*) polarizing filter on lens.

BLACK IS NOT ALWAYS BLACK

It is frequently desirable to use a plain black background behind specimens for drama, or for complete neutrality. Lights used to illuminate the subject invariably spill onto the background —usually black paper—causing the paper to record on the film as anything from a dark tone of charcoal to a medium gray.

Snoots (see p. 180) placed over lights will mitigate this problem somewhat, as will moving the background farther behind the subject. But for a slide or print with a super inky black background, these techniques by themselves are often insufficient.

One solution involves the use of a polarizing filter over the lens. The illustration above shows the dramatic improvement in saturation of the background gained by photographing through that filter and angling the background. If the angling is not possible, it will be necessary to place polarizers over the *lights* as well as over the lens (a technique described on p. 219 in conjunction with photocopying). Both polarizing techniques will alter the appearance of highlights and reflections from all but metallic objects, so carefully observe the effects through the viewfinder as the camera's polarizing filter is rotated; elimination of *all* reflections may give the object a very flat look.

Another approach evolves from the realization that the "black" in "black paper" is only a relative term. We see in the comparison photos above that standard black construction paper (or photographers' "seamless" paper) is quite gray when compared to certain other materials. If the subject photographed is predominantly white, such as a tooth, almost any black paper will record on film as maximum black in relation to the white subject.

But for medium- or light-toned—but not white—objects, more saturation in the image of the black background will result from the use of black velvet, black flock material (art supply stores, or the B.D. Company via mail order), or black optical cloth (Edmund Scientific Co.). Photographic paper fogged and developed to a uniform maximum black is also excellent, but use glossy-surface paper. Angle the paper so it does not pick up reflections as seen in the camera.

Edmund Scientific Company also distributes 3M's Nextel Optical Black Spray paint in small pressurized cans. It puts all standard "flat black" paints to shame.

Just a few items a close-up photographer may find helpful . . . unless he or she only photographs people. *Lower left*: Magnifiers for examining (Edmund, Kodak); cards, pad, pencils for notes; rulers for measuring (magnification, flash distance); permanent marker writes on anything (BWS, Inc.); #1 X-acto knife—indispensable, period. *Middle left*: For cleaning camera, lens, *and subject*: Q-tips; #000 spotting brush; lens-cleaning tissue and fluid; Staticmaster dust/anti-static brush (photo stores); Bergeon Blower (National Camera); 4 oz. infant enema syringe (drugstores)—a lot cheaper than cans of com-

pressed air. *Upper left*: Supports/props: bricks, wood blocks; erasers; clay. *Upper right:* Tapes: frosted acetate; Scotch #235 black; gaffer (heavy-duty, cloth from Lowell); Kodak dull black lacquer to kill reflections. *Middle right*: Hold with: plant ties, small C-clamps, soft wire, black button thread, hemostat (lab supply), paper clips, pushpins, alligator clips (radio/electronics store), clothespins. *Lower right*: For specimen examination/preparation: syringe, eye droppers, tongue depressors, tweezers, probes, small spatulas, stainless steel scissors (all items from lab supply company—Appendix A).

Lower left: Fix/hold/wire: locking pliers, standard and jeweler's screwdrivers; nails; small needlenose and diagonal-cutting pliers; penlight; extension cord; 3-way outlet tap; 2-prong adapter for grounded plugs (even a dozen is insufficient; they seem to evaporate). *Middle left*: Build/repair: silicone glue; 2-part epoxy clay; 2-part epoxy glue; cyanoacrylate adhesive (metal-to-metal, metal-to-glass, plastic to whatever); T-nuts (hardware store); threaded metal inserts for machine screws in wood (Brookstone). *Upper left*: To collect specimens: zip-loc plastic bags; cans, jars, bottles, microscope slide boxes (from lab suppliers—Appendix A). *Upper right*: Supports: Tinkertoys®; lab stand and clamps (lab supply). *Middle right*: Clamps ,etc.: stud adapter—makes any light fit any stand (Colortran); Polecat Claw—joins pipe to stand at any angle (photo store); Bogen Super-Clamp—part of a great clamp system (Bogen Photo); parallel jaw machinist's clamps (National Camera). *Lower right*: To control light: black cloth; small mirrors; white cards; large plastic bag doesn't control light, it keeps camera equipment clean. *Not shown*: Aspirin; Band-Aids; dime for phone calls; checkbook.

Appendix A

Addresses of Manufacturers and Distributors

Acme Lite*
4646 Fulton St.
Chicago, IL 60644

Ann Arbor Biological*
6780 Jackson Rd.
Ann Arbor, MI 48103

Aristo Grid Lamp Products
65 Harbor Rd.
Pt. Washington, NY 11050

Ascor Corp.
25–20 Bklyn-Queens Expwy W.
Woodside, NY 11377

Backer-Loring*
65 Walnut St.
Peabody, MA 01960

Bausch & Lomb
1400 No. Goodman St.
Rochester, NY 14602

B. D. Co.*
P.O. Box 3057
2011 W. 12th St.
Erie, PA 16512

Bel-Art Corp.
Pequannock, NJ 07440

Bogen Photo Corp.*
100 So. Van Brunt St.
P.O. Box 448
Englewood, NJ 07631

Brewster, Inc.*
Old Saybrook, CT 06475

Brigandi Coin Co.*
103 W. 45th St.
NY, NY 10036

Brookstone Co.*
127 Vose Farm Rd.
Peterborough, NH 03458

Budget*
P.O. Box 1146
Southwest Harbor, ME 04679

BWS Enterprises*
1763 E. Colorado Blvd.
Pasadena, CA 91106

Capro, Div.
Ehrenreich Photo Optical Ind.
623 Stewart Ave.
Garden City, NY 11530

Carolina Biological Supply Co.*
Burlington, NC 27215

Celestron International
2835 Columbia St.
Torrance, CA 90503

Colotran
Div. of Berkey Marketing Co.
1015 Chestnut St.
Burbank, CA 91502

Ealing Corp.*
22 Pleasant St.
So. Natick, MA 01760

Edmund Scientific Co.*
7782 Edscorp Bldg.
Barrington, NJ 08007

Ehrenreich Photo Optical Ind.
623 Stewart Ave.
Garden City, NY 11530

Ethol
1808 N. Damen Ave.
Chicago, IL 60647

General Electric Co.
Lamp Division
Nela Park
Cleveland, OH 44112

Gitzo
979 3rd Ave.
N.Y., NY 10022

H & W*
Box 332
St. Johnsbury, VT 05819

Hershey Div.*
Leedal, Inc.
2929 S. Halsted St.
Chicago, IL 60608

Int'l Center of Photography
1130 Fifth Ave.
NY, NY 10028

Ken-Lab*
Old Lyme, CT 06371

Kinetic Systems, Inc.*
75 Massasoit St.
Waltham, MA 02154

Kodak Technical Literature*
Dept. 454
343 State St.
Rochester, NY 14650

Komura
Burleigh Brooks Optics, Inc.
44 Burlews Court
Hackensack, NJ 07601

E. Leitz
Rockleigh, NJ 07647

Lepp & Associates*
P.O. Box 662
Davis, CA 95616

Linhof Div.
HPM Marketing Corp.
216 Little Falls Rd.
Cedar Grove, NJ 07009

Lowel Light Mfg., Inc.
421 W. 54th St.
NY, NY|10014

Macbeth
Div. Kollmorgen Corp.
Little Britain Rd.
Drawer 950
Newburgh, NY 12550

National Camera, Inc.*
Englewood, CO 80110

Nikon, Inc.
623 Stewart Ave.
Garden City, NY 11530

Novoflex
Burleigh Brooks, Inc.
44 Burlews Ct.
Hackensack, NJ 07601

Nuclear Products Co.
P.O. Box 5178
El Monte, CA 91733

Omega Div.
Berkey Marketing Co.
25–20 Bklyn-Queens Expwy W.
Woodside, NY 11377

Pentax Corp.
9 Inverness Dr. E.
Englewood, CO 80110

Polacoat, Inc.
9750 Conklin Rd.
Cincinnati, OH 45242

Polaroid Corp.
Industrial Marketing Dept.
575 Technology Sq.
Cambridge, MA 02139

Porter's Camera Store, Inc.*
Box 628
Cedar Falls, Iowa 50613

Premier Photo Materials Co.
500 N. Spaulding Ave.
Chicago, IL 60624

Print File Inc.*
Box 4100
Schenectady, NY 12304

Questar Corp.*
RD 1
New Hope, PA 18938

Radio Shack
Tandy Corp.
Fort Worth, TX 76102

Reid Tool Supply Co.*
2233 Temple St.
Muskegon Hts. MI 49444

Richards Mfg. Co.
Div. M. Brunson Motley, Inc.
5914 Noble Ave.
P.O. Box 2910
Van Nuys, CA 91404

Rosco (Roscolene Gels)
36 Bush Ave.
Pt. Chester, NY 10573

Schneider Lenses
185 Willis Ave.
Mineola, NY 11501

Sears, Roebuck & Co.
4640 Roosevelt Blvd.
Phila., PA 19132

Slik Corp.
Div. Berkey Marketing Corp.
25–20 Bklyn-Queens Expwy W.
Woodside, NY 11377

Smith-Victor Corp.
Lake & Colfax St.
Griffith, IN 46319

Soligor Corp.
AIC Photo, Inc.
168 Glen Cove Rd.
Carle Place, NY 11514

Sorg Paper Co.
Middletown, OH 45042

Sonocraft Corp.
29 W. 36th St.
NY, NY|10018

Spiratone Inc.*
135–06 Northern Blvd.
Flushing, NY 11354

Testrite Instrument Co.*
135 Monroe St.
Newark, NJ 07105

Tiffen Mfg. Corp.
90 Oser Ave.
Hauppauge, NY 11787

Velmex Inc *
P.O. Box 38
E. Bloomfield, NY 14443

Vivitar Corp.
1630 Stewart St.
Santa Monica, CA 90406

Ward's Natural Science
Establishment*
P.O. Box 1712
Rochester, NY 14603

X-Acto Corp.
45–35 Van Dam St.
Long Island City, NY 11101

Carl Zeiss, Inc.
Zeiss House
444 5th Ave.
NY, NY 10018

*Indicates products available
directly via mail order.

Appendix B

Pupillary Magnification Factor

NOTE: When exposure is determined by through-the-lens (TTL) metering, or when using "macro" or other flat-field optics, compensation for the pupillary magnification factor is automatic in the former case and not required in the latter. In both cases, the following information should not *be applied.*

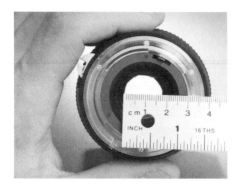 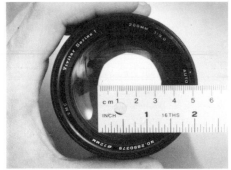

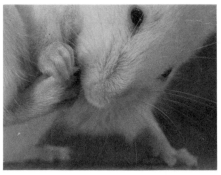 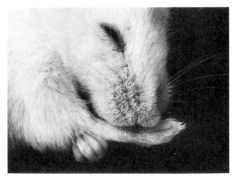

Upper left: Measuring exit pupil of a 200 mm telephoto lens. Aperture has been closed down just enough to see edges of diaphragm blades. *Upper right*: Measuring entrance pupil; measure across same points of diaphragm as used for exit pupil measurement. *Lower left*: Mouse photographed with above lens at 0.75× (1:1.3) is underexposed even after applying 1⅔ stop correction for lens extension as per Table 4-3 (p. 75). Reason: **P** = (17÷33) = 0.5; but Table B-3 (p. 258) indicates exposure correction at 0.75× must be 2⅔ stops when **P** = 0.5 (*lower right*).

Symmetrical and Asymmetrical Lenses

Until the invention of the SLR camera, most lenses were *symmetrical;* that is, for a given image distance, they provided the same magnification whether the lens was used front forward or reversed. However, SLR's, with their internal mirror taking up considerable space behind a lens, required optical engineers to turn to *asymmetrical* designs. With the latter, they are able to provide: (1) lenses with large maximum apertures ("fast" lenses); (2) long telephoto optics whose overall length is actually shorter and more compact than the numerical focal length of the lens; and (3) extremely short-focal-length (wide-angle) lenses whose rear element is sufficiently far from the film to permit SLR viewing, rather than having to lock the mirror in the "up" position and use an auxiliary viewfinder, as would be required with symmetrical optics.

A beneficial consequence of the asymmetry is that most reversed normal, and all SLR wide-angle lenses provide considerably high magnification simply by reversing them, without any ex-

tension tubes or bellows (see p. 63). However, less benign is the fact that the simple equation used to determine the exposure increase factor as a function of magnification, $E.I.F. = (m + 1)^2$, becomes somewhat more complicated, providing E.I.F. values that vary not only as a function of magnification, but also as a function of the *lens design and its position*—forward or reversed—on the camera.

(Almost all published tables on exposure correction for lens extension assume use of symmetrical lenses, as do depth-of-field tables. As will be shown shortly, such assumptions can lead to semidisasterous results, when, for example, a telephoto lens is used in the extreme close-up range to achieve a long working distance, W or a wide-angle lens is reversed on extension tubes to photograph in the macro range.)

The Pupillary Magnification Factor

One can determine the symmetry of a lens by looking at its aperture diaphragm from the front and from the back. A millimeter scale held on the lens, as shown above, will indicate the *apparent* size of the diaphragm as seen from each end. If the apparent diameters are identical, or nearly so, the lens is symmetrical; then standard E.I.F. and depth-of-field tables and equations are valid.

However, if the lens is not a "macro" or other flat-field design (enlarging lens, short-mount optic, true macro lens), there is a good chance that the two measurements will be dissimilar, indicating an asymmetrical optic. The apparent size of the diaphragm as seen from the *back* of the lens is called the *exit pupil*; as seen from the *front*, it is the *entrance pupil*. The ratio of these two terms defines a quantity, P, the *pupillary magnification factor*, whose value indicates the degree of asymmetry:

$$P = \frac{\text{Exit Pupil Dia. (as seen from rear)}}{\text{Entrance Pupil Dia. (as seen from front)}}$$

It does not matter at what aperture the measurement is made, though the largest one that still shows the edge of the diaphragm blades from both ends will introduce the least error. If the lens is symmetrical, $P = 1$.

Table B-1
POTENTIAL EXPOSURE ERRORS WHEN P ≠ 1

m	P	Potential Error (stops)
0.5×	2.5	+¾
	1.5	+⅓
	0.7	−⅓
	0.4	−1
1.0×	2.5	+1
	1.5	+½
	0.7	−⅔
	0.4	−1⅔
2.0× (reversed)	2.5	+¾
	1.5	+½
	0.7	−¼
	0.4	−1⅓

Consequences of P

Table B-1 indicates the serious exposure errors possible without TTL metering, and if E.I.F. calculations or tables are based on symmetrical designs. For example, many 200 mm $f/4$ SLR lenses have a $P = 0.4$. Attached to a bellows to gain substantial working room at a magnification of half life-size, the *required* E.I.F. is 5 (2⅓ stops), whereas most tables and standard E.I.F. equations indicate a factor of 2.5 (1¼ stops). That is a 1-stop error!

P obviously also changes the effective aperture, which in turn alters depth of field. Table B-2 indicates the changes in equations for symmetrical lenses when P does not equal 1. Tabulated data for E.I.F. as a function of magnification, and P, obtained from the corrected equations, are provided in Table B-3 (next page).

Working Suggestions

In practice, one need only find P for each lens as shown in the illustration on the preceding page. A small chart for exposure correction as a function of magnification can then be extracted from Table B-3 and kept with the lens.

A letter to the lens manufacturer or distributor *may* produce data on the pupillary magnification factor, and in some cases, even a graph of E.I.F. values as a function of magnification.

Table B-2

EQUATIONS FOR ASYMMETRICAL LENSES

Equations for Symmetrical Lenses	Equations for Asymmetrical Lenses (Front Forward)	Equations for Asymmetrical Lenses (Reversed)
	Effective Aperture	
$f_e = (f_r\,(m + 1)$	$f_e = f_r\left(\dfrac{m}{P} + 1\right)$	$f_e = f_r\left(\dfrac{1}{P}\right)(1 + Pm)$
	Exposure Increase Factor, E.I.F.	
$\text{E.I.F.} = (m + 1)^2$	$\text{E.I.F.} = \left(\dfrac{m}{P} + 1\right)^2$	$\text{E.I.F.} = \dfrac{1}{P^2}(1 + Pm)^2$
	Total Depth of Field	
$TDF = 2Cf_r\dfrac{(m+1)}{m^2}$	$TDF = 2Cf_r\left(\dfrac{m+P}{Pm^2}\right)$	$TDF = 2Cf_r\left(\dfrac{1+Pm}{Pm^2}\right)$

Notes: f_e = effective aperture; f_r = relative (marked) aperture; C = circle of confusion. More details on effective aperture can be found on p. 81; **E.I.F.**, on p. 73; total depth of field, on p. 27.

Table B-3

EXPOSURE CORRECTION FOR ASYMMETRIC LENSES

Pupillary Magnification Factor, P	Increase Exposure by Multiplying the Shutter Speed by the E.I.F., OR Opening the Lens the Indicated Number of Stops at the Following Magnifications:									
	0.5× (1:2)		0.75× (1:1.3)		1.0× (1:1)		2.0× (2:1)*		3.0× (3:1)*	
	E.I.F.	Stops	E.I.F.	Stops	E.I.F.	Stops	E.I.F.	Stops	E.I.F.	Stops
2.50	1.4	½	1.7	¾	2.0	1	5.8	2½	11	3½
2.00	1.6	⅔	1.9	1	2.3	1¼	6.3	2⅔	12	3½
1.50	1.8	1	2.3	1¼	2.8	1½	7.1	2¾	13	3¾
0.70	2.9	1½	4.3	2	5.9	2½	12	3½	20	4⅓
0.50	4.0	2	6.3	2⅔	9.0	3¼	16	4	25	4⅔
0.35	5.9	2½	9.9	3⅓	14.9	3¾	24	4½	34	5

*Lenses reversed above 1.0× (1:1).

Appendix C

Diffraction, Resolution, and Optimum Aperture

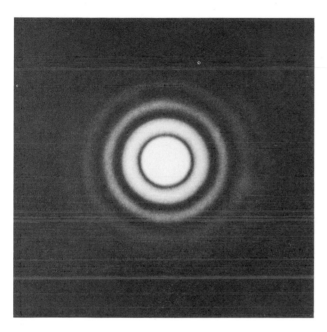

Small lens apertures cause light to spread as it passes the lens diaphragm. This *diffraction* can be shown by using a lens to form an image of a single point of light, then examining that image with a microscope. What we see is not a *point* anymore, but a diffraction *pattern* (*far left*) with a central *disc*, the disc *expanding* as aperture decreases. A photo of a radial section of an insect eye displays diffraction when **m** = 10× and lens aperture is set at *f*/22 (*near left, bottom*). At *f*/4, resolution is vastly improved (*near left, top*).

Throughout the text, it has been mentioned that small apertures ($f/11$, $f/16$, $f/22$) provide more depth of field, but that they also, unfortunately, *decrease* the ability of the lens to faithfully record the very fine details or sharp edges in the subject. And the greater the magnification, the more serious this problem becomes.

In close-up photography at high magnifications, the trade-off between depth of field and our ability to record and discern fine detail must be considered seriously. Choice of the wrong aperture can lead to pictures that are not sharp *anywhere!* The illustrations above demonstrate the phenomenon of *diffraction*—the law of physics that governs the *spreading out* of a parallel beam of light as it passes through an aperture. This spreading causes a *point* on the subject to be imaged as a *blurry circle;* the smaller the aperture, the greater the blur.

The progressive loss of resolution with decreasing aperture diameter (increasing f-number) manifests itself significantly in the true macro range (**m** above life-size) for two reasons: (1) depth of field is so shallow, we are inclined to use the smallest available aperture; and (2) the *effective* f-number at the film plane—the actual quantity that determines the resolution limit—is considerably higher than the marked, or *relative*, f-number due to the long lens-to-film distance. On p. 81 it was indicated that effective f-number = (marked f-number) × (**m** + 1). For example, at 4× magnification and a lens setting of $f/16$, the resolution in the image is equivalent to that obtained from an aperture of $f/80$ in non-close-up photography.

Other Factors

It has been established that for three-dimensional objects, some compromise must be made between depth of field and resolution. Table C-2 on p. 260 indicates suggested optimum marked f-numbers for various magnifications—aper-

The tendency to use small apertures to salvage miniscule depth of field must be weighed against resolution requirements when magnification increases above life-size. Small apertures do increase depth of field, but they also increase unsharpness due to diffraction. *Near right*: A crossline grid was angled away from the lens at 45 degrees. At **m** = 6× and *f*/4 (relative aperture), only a central diagonal strip is sharp. At *f*/32 (*far right*), the depth of field is much greater, but nothing is really sharp. Also see a similar example on p. 84.

tures that provide the best compromise between competing parameters.

However, other factors do affect the final appearance of the image. Space and the scope of this book do not permit detailed discussion of the interrelation between film grain, theoretical resolution, lens aberration, enlarging factors, and human visual acuity. An excellent technical treatment of optimization considerations and their derivation can be found in Kodak pub. No. N12-B, *Photomacrography*. Here, however, some standard working techniques will be presented for those requiring optimum possible results. These techniques have proved valid under actual picture-taking conditions, and are based on sound optical and physical laws and on generally accepted standards of sharpness and resolution.

1. All other factors being equal, film grain can lessen resolution and sometimes even give a false sense of sharpness. For maximum resolution of fine detail, use slow, fine-grain film. (Also see p. 248 for a discussion on the use of super high-resolution, almost grainless films in conjunction with special developers.)

2. In the quest for maximum delineation of detail at high magnification, it is far better to produce as large an image as is possible on the *film*, with minimum enlargement of negative or slide, than to photograph at a lower **m** and obtain a high final **M** by severely blowing up the camera film. The former route will result in an *increased* combination of depth of field and resolution when compared to the latter.

3. To obtain maximum resolution of detail, limit enlargement of the camera film to 8× and use a good-quality enlarger lens set to *f*/5.6. Prints above 8× are possible, of course, but they will contain no more detail or fine structure—a condition called *empty magnification*.

4. The *appearance* of sharpness may be enhanced by contrasty lighting and/or printing the negative on contrast enlarging

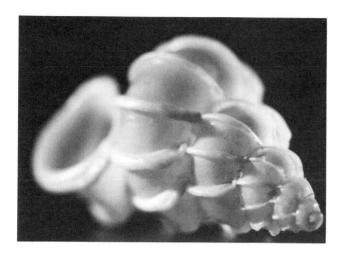 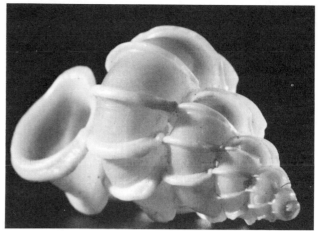

Table C-2 (p. 262) provides *suggested* apertures for the "optimum" compromise between resolution and depth of field. However, the aperture chosen really depends on the subject. How much fine detail is there, and over what portion of the specimen must it be resolved? Is overall delineation more important than well-resolved detail in some small section? If the answer is "yes" to the last question, certainly use a smaller aperture. For example, at **m** = 2.3× (2.3:1), Table C-2 suggests f/6.3. That aperture was used for the first photograph (*left*) of an Australian wentletrap. But the shell is smooth and has no fine detail, so that at f/32 it looks fine (*right*). When critical situations are involved, bracket the apertures; make prints from a few frames, then compare results.

paper. The latter is only possible in black-and-white, since color printing papers have only one contrast grade. However, with color slides, contrast may be increased by duplicating them with Kodachrome 25 or Kodachrome 64 film, rather than with the lower-contrast films specifically designed for "accurate" duping (see p. 224).

5. All these techniques are for naught if basic close-up practices are sloppy. Appropriate flat-field optics, elimination of vibration and subject motion, careful focusing, proper exposure and developing, suitable lighting, and optimum aperture (see accompanying tables) all combine to produce images that are as perfect (technically) as the laws of physics will allow.

Optimum Aperture: Flat Objects

Table C-1 lists suggested camera apertures and subsequent print or slide enlargements that should provide maximum possible resolution of fine detail. Since there is no need to consider

depth when photographing flat objects, factors that optimize *resolution* do not have to be compromised with those that govern depth. Therefore, apertures listed in Table C-1 differ from those found in Table C-2; the latter are to be used for three-dimensional data.

Realizing that diffraction *decreases* with increasing aperture, one might be inclined to use a lens wide open to obtain maximum resolution. However, that conclusion is based on a theoretically perfect lens. Real-world optics also suffer from other aberrations that are mitigated by closing the lens down somewhat.

The numbers given in both tables on the next page assume the print or slide is viewed from 12 inches (30 cm). (See the Kodak publication noted above for other viewing conditions.) The numbers also assume the use of a good flat-field lens, or conventional lens, that performs well when used close-up (see pp. 61 and 133). In both cases, lenses must be reversed when used above 1× (1:1), unless they are specifically designed for high-magnification photomacrography (see p. 135).

Table C-1

SUGGESTED APERTURES AND ENLARGEMENTS FOR OPTIMUM RESOLUTION OF 2-DIMENSIONAL OBJECTS

Magnification on Film, m	Optimum Aperture (Marked f-Stop), f_0 and Maximum Final Magnification, M for:					
	50 mm f/1.4 Normal Lens		50 mm f/1.8 or f/2 Normal Lens		SLR "Macro" Lens	
	f_0	M	f_0	M	f_0	M
0.3×	11	3	8	4	5.6	4
0.5×	16	4	11	5	5.6	6
1.0×	16	7	16	7	6.3	11
1.5×	16	9	11	13	5.6	17
2.0×	16	12	11	14	5.6	19
3.0×	11	18	8	22	5.6	27
5.0×	8	27	5.6	33	5.6	33
10.0×	5.6	39	5.6	39	4.5	39
20.0×	5.6	41	5.6	41	4.5	41

Notes: *A.* Dividing **M** by **m** gives the degree of enlargement of the negative (or slide) permitted for optimum resolution.
B. These are suggested starting points; final resolution also depends on the general quality of the lens and its performance in the close-up range. For critical work, bracket apertures by ½, 1, and even 1½ stops; also see p. 63.

Table C-2

SUGGESTED APERTURES FOR OPTIMUM COMPROMISE BETWEEN DEPTH OF FIELD AND RESOLUTION WHEN PHOTOGRAPHING 3-DIMENSIONAL OBJECTS

Magnification on Film, m	Final Magnification, M	Optimum Aperture (Marked f-Stop)
0.3× (1.0:3)	2.7	14
0.5× (1.0:2)	4.5	11
1.0× (1.0:1)	9	9.5
1.5× (1.5:1)	13	8
2.0× (2.0:1)	18	6.3
3.0× (3.0:1)	27	5.6
5.0× (5.0:1)	37	5.6
10.0× (10.0:1)	45	5.6
20.0× (20.0:1)	45	4.5

Notes: *A.* See *Optimum Techniques of Photomacrography* by William G. Hyzer in the Feb. 1975 issue of *Photomethods* for further data.
B. These data are based on an image blur circle on the film of 0.03 mm.
C. Flat-field "macro" optics must be used, and reversed when appropriate (see p. 63). For critical work, bracket apertures by half, then full stops around these recommendations.

Optimum Aperture: Three-dimensional Objects

Subjects having three-dimensional depth present considerably more problems for the close-up photographer than those that are flat. If there is any significant depth in a direction parallel to the lens axis, a compromise will have to be made between *optimum* resolution of *fine* detail and *reasonable* clarity within a given depth range.

As much as possible, position the subject so that features desired to be sharp are in a plane parallel to the camera (see p. 30).

The data in Table C-2 are *suggested* apertures to be used when one is trying to balance resolution and edge sharpness on one hand with depth of field on the other. Note that if an object has lots of fine surface texture or detail, you will probably find these recommendations valid. However, if less-detailed artifacts are photographed (such as smooth shells or plant stems), apertures that are one, or even two, stops smaller may prove more satisfactory. In this latter case, depth of field will be enhanced, yet lack of resolution will not be missed since the object contains little detail that needs resolving. (This is why many "macro" lenses have apertures to $f/32$, even though $f/14$ is the smallest aperture listed in Table C-2.)

For problem situations, bracketing of the aperture setting is certainly in order, first by half stops, then by full stops. Also, be advised that the optimum aperture is a very critical setting. Closing the lens down just one stop from optimum can result in a catastrophic loss of image detail across the entire picture.

Bibliography

For Inspiration

Abbott, Berenice. *Photographs.* Horizon Press, NY , 1970. (Contains some classic stroboscopic photographs illustrating basic laws of physics.)

Braun, Ernest and David Cavagnaro. *Living Water.* American West Pub. Co., Palo Alto, CA, 1971. (Water in its natural settings—from mist, to dew, to snow— some fine close-ups.)

Burton, Jane. *The Color Nature Library: Small Animals.* Crescent Books, NY, 1978.

Burton, Robert. *The Color Nature Library: Venomous Animals.* Crescent Books, NY, 1978.

Caponigro, Paul. *Sunflower.* Filmhaus, Inc., NY, 1974. (True genius; suggests the infinite possibilities available with one subject.)

Cunningham, Imogen. *Photographs 1910–1973.* University of Washington Press, Seattle, WA, 1974. (Among other wonderful photographs is a series of elegant black-and-white renditions of flowers and plants.)

Dalton, Stephen. *Borne on the Wind: The Extraordinary World of Insects in Flight.* Reader's Digest Press, NY, 1975. (And extraordinary photographs!)

Faulkner, Douglas and Barry Fell. *Dwellers in the Sea.* Reader's Digest Press, NY, 1976. (Classic underwater close-up photographs.)

Feininger, Andreas. *Monograph.* Morgan & Morgan, Dobbs Ferry, NY, 1973 (Classic photographs by a man enormously sensitive to the structure of the natural world.)

——————————— . *The Mountains of the Mind: A Fantastic Journey Into Reality.* The Viking Press, A Studio Book, NY, 1977. (A more comprehensive and lavish collection than the entry above.)

Haas, Ernst. *The Creation.* Viking Press, NY, 1971. (Evocative photographs of God's world by a master of color photography.)

Khuon, Ernst von. *The Invisible Made Visible: The Expansion of Man's Vision of the Universe Through Technology.* NY Graphic Society, Ltd., Greenwich,CT 1968. (An extraordinary look at the physical world through all types of photography.)

Marten, Michael, John Chesterman, John May, and John Trux. *Worlds Within Worlds.* Holt, Rinehart, & Winston, NY, 1977. (Similar to the above.)

Nilsson, Lennart. *A Child is Born: New Photographs of Life Before Birth; Up-to-date Advice for Parents.* Delacorte Press/Seymour Lawrence, NY, 1976. (Many of these classic photographs of the development of the fetus originally appeared in *Life* magazine; should be seen by *everyone.*)

——————————— . *Behold Man: A Photographic Journey of Discovery Inside the Body.* Little, Brown & Co., Boston, MA, 1973. (This brilliant medical photographer applies his extraordinary technical prowess and artistry to the entire human body.)

Teale, Edwin Way. *Photographs of American Nature.* Dodd, Mead, & Co., NY, 1972.

Weston, Edward. *Fifty Years: The Illustrated Volume of His Photographic Work.* Aperture, Millerton, NY, 1973. (Contains the classic vegetables, nudes, and details of nature.)

——————————— . *Photographer: The Flame of Recognition; His Photographs Accompanied by Excerpts from the Daybooks and Letters.* Nancy Newhall, ed. An Aperture Monograph, Millerton, NY, 1971. (A condensed budget version of the entry above.)

White, Minor. *Rites and Passages.* Aperture, Millerton, NY, 1978. (Haunting, mysterious images, many of small objects, by a true visionary photographic artist and poet.)

General Books on Close-Up Craft and Techniques

Angel, Heather. *Nature Photography: Its Art and Techniques.* Fountain Press, London, 1972.

Basic Scientific Photography, pub. No. N-9. Eastman Kodak Co., Rochester, NY, 1970.

Blaker, Alfred A. *Field Photography:Beginner and Advanced Techniques.* W. H. Freeman & Co., San Francisco, CA, 1976.

—————————— . *Photography For Scientific Publication: A Handbook.* W. H. Freeman & Co., San Francisco, CA, 1965.

Close-Up Photography and Photomacrography, pub. No. N-12. Eastman Kodak Co., Rochester, NY, 1977.

Gibson, H. Lou, *Medical Photography: Clinical-Ultraviolet-Infrared,* pub. No. N-78. Eastman Kodak Co., Rochester, NY, 1973.

Infrared and Ultraviolet Photography, pub. No. M-27/28-H. Eastman Kodak Co., Rochester, NY, 1972.

Nuridsany, Claude and Marie Pérennou. *Photographing Nature: From Magnifying Glass to Microscope.* Oxford University Press, N.Y , 1976.

Photography As A Tool. Life Library of Photography, Time, Inc., NY, 1970.

Photography in General

Cooper, Joseph D. *Nikon, Nikkormat Handbook.* Amphoto, Garden City, NY, 1977. (Though written for Nikon's equipment, it contains a huge amount of general information on photographic equipment and picture-taking techniques; has a good section on close-up work.)

Horenstein, Henry. *Beyond Basic Photography: A Technical Manual.* Little, Brown & Co., Boston, MA, 1977. (An intermediate-level text on darkroom techniques, lighting, and large camera operation.)

Neblette's Handbook of Photography and Reprography: Materials, Processes, and Systems. John M. Sturge, ed. Van Nostrand Reinhold Co., 7th edition, NY, 1977. (A very thorough *technical* treatise on photographic science.)

Upton, Barbara and John Upton. *Photography.* Adapted from the Life Library of Photography, Educational Assoc., Boston, MA, 1976. (A good text for a general

introduction to the camera, darkroom techniques, and photography.)

Vestal, David. *The Craft of Photography.* Harper & Row, Pub., NY, 1975. (Also a good comprehensive text but at a somewhat more advanced level than Upton and Upton's book.)

Peripheral Reading

Edgerton, Harold E. *Electronic Flash, Strobe.* McGraw-Hill, NY, 1970. (The father of electronic flash describes—very technically—the inner workings of this important tool; recommended for the builder of custom units.)

Gilmore, C. P. *The Unseen Universe: Photographs from the Scanning Electron Microscope.* Schocken Books, NY, 1974. (It's true, you will not be able to put this down! Close-up photography with electrons produces pictures having magnification, depth of field, and resolution orders of magnitude greater than photography with light; record grooves, dandruff, hair, insect eyes, it's all there.)

Gregory, R. L. *Eye and Brain: The Psychology of Seeing.* McGraw-Hill, NY, 1973. (Not about photography directly, but should be read by everyone who sees; how we see and perceive; fascinating; for the layperson.)

Guggisberg, C.A.W. *Early Wildlife Photographers.* Taplinger Pub. Co., NY, 1977. (When you see what our predecessors had to work with, you'll really feel humble.)

L-5 Index to Kodak Information. Eastman Kodak Co., Rochester, NY. (An absolute must for the technical photographer (and very useful to everyone else); lists every piece of technical literature—all inexpensive— published by Kodak; has order form; updated annually.)

The Larousse Encyclopedia of Animal Life. McGraw-Hill, NY, 1967. (The animal kingdom in one 6-lb. book; has many excellent close-up photographs.)

The Photography Catalog: The Best Equipment, Materials, Techniques, and Resources. Norman Snyder, ed. Harper & Row, NY, 1976. (A little of everything about almost

everything in photography; a great book to take to bed.)

Popular Optics. Edmund Scientific Co., Barrington, NJ, revised edition, 1976. (For those who like to build their own light sources, projectors, enlargers, etc.; many how-to-build-it tips for the gadgeteer technical photographer.)

Resources for Specific Subjects

Abbott, R. Tucker. *Seashells of the World.* Golden Press, NY, 1962.

Arnold, Augusta Foote. *The Sea-Beach at Ebb-Tide.* Dover, NY, 1968.

Boys, C.V. *Soap Bubbles: Their Colors and Forces Which Mold Them.* Dover, NY, 1959.

Dana, Mrs. William Starr. *How to Know the Wild Flowers.* Dover, NY, 1963.

Emerton, James H. *The Common Spiders of the United States.* Dover, NY, 1961.

Fogden, Michael and Patricia Fogden. *Animals and Their Colors: Camouflage, Warning Coloration, Courtship, Territorial Display, and Mimicry.* Crown Pub., NY, 1974.

Hanenkrat, Frank T. *Wildlife Watcher's Handbook: How Hunters, Birders, Naturalists, and Photographers Can Get Close to Wild Animals and Birds.* Winchester Press, NY, 1977.

Headstrom, Richard. *Adventures With a Hand Lens.* Dover, NY, 1976.

Klots, Alexander B. and Elsie B. Klots. *1001 Questions Answered About Insects.* Dover, NY, 1961.

Krieger, Louis C. C. *The Mushroom Handbook.* Dover, NY, 1967.

LaChapelle, Edward, R. *Field Guide to Snow Crystals.* University of Washington Press, Seattle, WA, 1969.

Oman, Paul W. *How to Collect and Preserve Insects for Study.* Reprint from pp. 65–78 of *1952 Yearbook of Agriculture.*

Sargent, Charles Sprague. *Manual of the Trees of North America.* Vol. I-II, Dover, NY, 1965.

Snedigan, Robert. *Our Small Native Animals: Their Habits and Care.* Dover, NY, revised edition, 1963.

Villiard, Paul. *Moths and How to Rear Them.* Dover, NY, revised edition, 1975.

Some Good Periodicals

American Photographer. 485 5th Ave., NY, NY 10017. (A much more sophisticated, serious periodical about photography in general than the traditional monthlies.)

Audubon. 950 3rd Ave., NY, NY 10022. (Journal of the Audubon Society; beautiful.)

Functional Photography. PTN, Inc., 250 Fulton Ave., Hempstead, NY 11550. (For the scientific photographer.)

Geo. 450 Park Ave., NY, NY 10022. (A new American edition of a well-established European periodical. Similar to *National Geographic,* but not as politically conservative.)

Industrial Photography. U.B.P., Inc., 475 Park Ave. South, NY, NY 10016.

Journal of the Biological Photographers' Association. P.O. Box 1057, Rochester, MN 55901.

National Geographic. 17th and M Streets, NW, Washington, DC 20036. (Frequently contains superb natural science articles illustrated with excellent photographs.)

National History. American Museum of Natural History, Central Park West at 79th St., NY, NY 10024. (Chronicles the interests of, and exhibits at, this wonderful museum.)

Photomethods. Ziff-Davis Pub. Co., 1 Park Ave., NY NY 10016. (Written for the industrial photographer.)

Scientific American. 415 Madison Ave., NY, NY 10017. (Sophisticated, but non-mathematical exploration of current interests in all branches of science.)

Smithsonian. 900 Jefferson Dr., Washington, DC 20560. (Chronicles the interests of, and exhibits at, the renowned Smithsonian Institution.)

They don't all work.

Index